Items should be returned on or before the last date
shown below. Items not already requested by other
borrowers may be renewed in person, in writing or by
telephone. To renew, please quote the number on the
barcode label. To renew online a PIN is required.
This can be requested at your local library.
Renew online @ www.dublincitypubliclibraries.ie
Fines charged for overdue items will include postage
incurred in recovery. Damage to or loss of items will
be charged to the borrower.

Leabharlanna Poiblí Chathair Bhaile Átha Cliath
Dublin City Public Libraries

Dublin City
Baile Átha Cliath

PEARSE STREET BRANCH
BRAINSE SRÁID PIARSACH
TEL. 6744888

Date Due	Date Due	Date Due
0 4 APR 2011		
1 4 SEP 2012		
2 8 AUG 2015		

ARLEN
HOUSE

Pauline Bewick at 75: A Photo Biography

is published in 2010 by
ARLEN HOUSE
42 Grange Abbey Road
Baldoyle
Dublin 13
Ireland
Phone/Fax: 353 86 8207617
Email: arlenhouse@gmail.com

Distributed internationally by
SYRACUSE UNIVERSITY PRESS
621 Skytop Road, Suite 110
Syracuse, NY 13244–5290
Phone: 315–443–5534/Fax: 315–443–5545
Email: supress@syr.edu

ISBN 978–0–905223–91–9, paperback
978–1–85132–010–3, limited edition hardback

Typesetting ⦙ Arlen House
Printing ⦙ Brunswick Press
Cover Photography ⦙ Nina Finn-Kelcey

1928:	Alice Graham marries John Corbett Bewick
1929:	Their first daughter Hazel is born
14/4/1931:	Pat Melia born to Ethel and Patrick Melia
4/9/1935:	Pauline born in Northumbria to Alice Graham and Corbett Bewick
early 1938:	Alice runs away from the Bewick family, takes pseudonym 'Harry', ends up in Kenmare, Co Kerry. Pauline does her first sketches there
late 1938:	Death of Corbett Bewick. Harry returns briefly to UK for the funeral
1944:	Move to Portrush, Londonderry and Belfast
1945–48:	Return to Britain, to progressive schools in Wales and England, then to a conventional school in Wargrave
1949:	Return to Ireland travelling around in a van, lived in houseboat brought over from England, then in Killarney at the Lodge of the Cahernane Hotel
1950:	Move to Dublin to enroll in Art School, purchase of 51 Frankfort Avenue
1952:	Depart Dublin Art School. Met Pat Melia at the D'Arcy sisters' party
1953–	Performs as a nightclub singer at Clover Club, O'Connell Street, is offered work with the Pike Theatre as stage designer and actor
1956:	First trip to Paris with Pat
1958–62:	Split with Pat and move to London, Mediterranean trip with Barry Laverty and friends, sojourn in Hydra, Greece
1963:	Pat and Pauline marry
1964:	Rent flat in Upper Mount Street, Dublin
1965:	Purchase house in Heytesbury Lane, Dublin
1966:	Daughter Poppy born
1970:	Daughter Holly born
1972:	First visit to Tuscany. Pat appointed to Killarney hospital and family move back to Kerry
1975:	Move to permanent home at Caragh Lake, near Glenbeigh
1979:	Death of Harry Bewick
1985:	50th birthday inspires collection of major exhibition, 'From Two to Fifty' at the Guinness Hop Store, then Cork and Belfast, a biography *Pauline Bewick: Painting a Life* by James White and a film by David Shaw-Smith
1989–1990:	Move to the South Pacific Islands for first of two visits
1991–1992:	Return to the South Pacific for another year
1995:	Poppy marries Conor Mulvihill. The Yellow Man exhibition and book
1996:	Grandson Aran Mulvihill born
1998:	Holly marries Luca Bellucci, grand-daughter Chiara Bellucci born
2001:	Grandson Adam Mulvihill born, grand-daughter Giada Bellucci born
2005–2007:	Major donation of her master works of art to the Irish State
2010:	Celebrates 75th birthday with new exhibition at the Taylor Galleries

ACKNOWLEDGEMENTS

I am extremely grateful to the following for their indispensable help in the compilation of this book:

Pat Melia
Pauline Bewick
Poppy Melia
Holly Melia
Nina Finn-Kelcey
Kate Landers
Alen MacWeeney
Nutan
Con Kelleher
Antoinette O'Shea
Maria Simonds-Gooding
John and Pat Taylor
Adrienne Foran and Gareth Hickey, Brunswick Press, Dublin

A particular thanks to the Bewick Melia family for welcoming me into their home for the month of July, and granting me undisturbed access to family files, photographs and press cuttings.

Most of the photos reproduced in this book are not of press standard and are not posed. Many are simply snapshots of particular moments in time, captured to record that memory. All photos were chosen by me, and if I had to do this another time, no doubt I would make a different selection from the thousands of images available. Many of the photos are aged or of poor quality, but have been chosen because of their importance to the story of the Bewick Melia extended family.

Most of these photos have never been published before. I hope you enjoy the story they tell.

Alan Hayes
Dublin - Galway
August 2010

Pauline Bewick: A Life in Painting

Pauline Bewick is a well-known figure in Ireland – there have been a huge number of articles written about her since the early 1950s, she has made numerous TV and radio appearances, and countless public appearances at artistic, community and cultural events. She has had tremendous success as an artist, with her work being sold throughout the world and held in huge esteem. Her books have been bestsellers, and she has continued to dream up, and turn into reality, many other creative projects.

There is a long-standing fascination about her life, in particular about her unconventional upbringing and her emergence since the 1950s as an artist who has always had something different to say, one who has always been a breath of fresh air. Part of the reason for this, I think, is that Bewick has always tried to be accessible – she welcomes and is interested in people. She has a particular rapour with women, as she has painted the different stages of women's lives. Her honesty has won her many admirers.

Bewick has told the story of her unconventional life many times, often by using the art she has created along the journeys, both physical and emotional, of these past 75 years. At the same time she has also kept the other physical records of her life, the numerous letters, diaries, press cuttings and photographs. Her obsessive personality has meant that she records events and then stores them away meticulously, but never needing to see the past. She always wants to live in the present and work for the future. When she turned seventy in 2005, she used that opportunity to donate a major archive of her paintings to the Irish State, images that she had kept for many decades. These paintings now form a permanent record of the 'Seven Ages' of a woman's life.

Pauline Bewick was born on 4 September 1935 in Northumbria, England into a family descended from the naturalist and wood engraver Thomas Bewick. However the formative influence in her life was not from her (possible) father John Corbett Bewick, but her mother, Harry, a creative, unconventional character. Her birth name was Alice, but she was told her real name was unlucky and that the name 'Harry' suited her better. So that was it, and for the rest of her life she was known as Harry Bewick. Having run away from her husband and the Bewick family, Harry chanced on meeting Pat Newling, a Kerry woman running a hotel in Letchworth, who told her of her orphaned niece and nephew living on a small farm in the wilds of Kerry. Harry offered to move to Kerry and foster the two children, Lucy and Michael. So started the journey to Ireland which was to shape Pauline Bewick's life in such a distinctive way.

It all started in Kenmare when Harry gave Pauline a little book with blue striped lines, and in that book in 1938, at the tender age of 2½, Pauline did her very first

sketch, a dancing girl. She later recalled that she felt so happy in Kerry, and so was drawing her own feelings at the time. From Pauline's first sketch, her mother Harry encouraged her and kept all her finished work. "Harry believed in living in the present and throwing the past away, but she kept all my early paintings in a battered suitcase which she brought on all our journeys". These paintings were de-acidified and preserved by the National Gallery of Ireland. For most paintings Harry saw the work in progress, but the artist remembers she didn't interfere, except to write the titles. "Harry had fallen madly in love with Ireland, and she would write the title of each painting in Irish. I was too young to write. Everything my sister Hazel and I painted was 'totally brilliant' in her view. She was a huge support to us both".

Pauline's artistic skills were developing and she was being exposed to interesting and engaging images, such as visiting travellers, friendships with Kerry characters, the Kenmare regatta and the classics presented by Anew McMaster's travelling repertory company. Her early days in Dourus school were memorable because of a sympathetic teacher, Miss Murphy, who recognised she had a learning disability and encouraged her artistic skills.

Those happy times ended when Lucy suddenly died from galloping meningitis and it was decided to send Michael to Switzerland 'for the air' to prevent him developing TB. (Michael did live to a good age and he had loving memories of Harry and those years living together as a family). After Lucy's death and with Michael gone, Harry felt it was time to move on, and a nomadic existence commenced. Over the following years they lived in a houseboat, a caravan, a railway carriage, a gate lodge, a workman's hut and a suburban house. They lived in Portrush, Derry and Belfast for a brief period, before deciding to return to Britain. Between 1944–1948 Pauline attended progressive schools and conventional schools in Wales and England – times which were both exciting and thought-provoking for the young artist. She went to progressive schools at Blackbrook, Monmouthshire and St Catherine's in Bristol. "At the second progressive school in Bristol, I remember dancing naked on the lawn to Tchaikovsky's *Dance of the Sugar Plum Fairy*, thinking how wonderful and graceful I was!" They met John Watling there, a World War II conscientious objector and philosopher. He became a lifelong friend. "He was one of the nicest people I ever met. There had been no male influences apart from Michael, who was a boy, so John was the earliest father figure in my life".

Leaving the progressive school they lived in a caravan in Salford before travelling the Kenneth and Avon Canal in a houseboat called Janty and settling in Henley-on-Thames. Living on that houseboat Pauline painted many of the images and ideas she was exposed to, always encouraged and supported by her mother. Harry, however, did not want Pauline to sign her paintings 'Bewick', and encouraged her to use her middle name, and sign herself as 'Pauline Gale' or 'Pauline G'. The young artist only started signing her proper name on her work after enrolling in the Dublin Art School in 1950. "1 thought a lot about what went on around me and the unusual

conversations Harry was having with progressive school teachers on subjects like conscientious objection and abortion. Painting ideas was a way of sussing out things I couldn't understand ... Harry often talked about the South Seas and of Margaret Mead's studies of the people there, so I painted what I thought were South Seas people. Harry wore a lipstick called Tahiti Pink in those days".

John Watling fell in love with Nicandra McCarthy, Augustus John's model, who joined them on their journeys. Returning to Ireland in 1949, they travelled around in a van, looking for somewhere to settle. After her unconventional schooling Harry decided to enroll Pauline in art school. A visit to the Cork Art School ended swiftly when Harry was told that life drawing wasn't allowed. "That is ridiculous", Harry informed them. The Dublin Art School accepted Pauline and Harry bought a house in Frankfort Avenue with a loan from the building society where she rented rooms to students and opened a vegetarian restaurant in the kitchen (Sheila Fitzgerald was the only customer). Pauline painted the images of this period – life in art school and at home, making new friends, beginning to fall in love, "cuddling up, dancing, wearing big hoopy earrings and going to hops". Pat Cahill, one of Harry's tenants, would tell their fortunes. These years marked the ending of childhood and beginnings of adulthood.

Bewick began making connections in the creative world in Dublin. She worked as a singer in a nightclub in O'Connell Street and met Carolyn Swift and Alan Simpson of the Pike Theatre. She started working in the theatre as a designer and actor. Working in stage set she painted the irises of artificial eyes and drew advertisements. She did cover illustrations for *Icarus,* a Trinity College magazine, and soon was given a commission by the Dolmen Press to illustrate Thomas Kinsella's *Thirty Three Triads.* Her interest in the wider world is clear with her paintings from this period encompassing themes of race, sexuality and gender. A hectic cultural life is represented by trips to the theatre and clubs seeing Marcel Marceau and the Kabuki dancers. During her first trip to Paris, she watched Sidney Bechet's mistress stir the bubbles out of his champagne.

Friendships developed with Dublin characters like John Molloy, Desmond Barry, Sebastian Ryan and Jewish poet Leslie Daiken. A lifelong friendship began in art school with Barry Laverty, daughter of the writer Maura Laverty, and with Barry's future husband, the artist Philip Castle. The entry of Pat Melia, a young medical student at Trinity, into her life started a relationship which has lasted almost sixty years, with few hiccups, and is still going strong.

By the late 1950s, Bewick accepted that she couldn't make a living as an artist in Dublin, and so moved to London. There she shared a house, firstly with Edward Fitzgerald and then with Sally Travers who had an interesting social life centring around exotic men friends. When Travers' uncle Micheál Mac Liammóir visited he would entertain and perform for the two young women. "I had a very good gay friend and we often went to gay clubs and West Indian clubs". In 1960 Bewick was

commissioned by the BBC to sketch a new children's TV show, *Little Jimmy* which received great ratings and was a critical success. The money earned from the BBC paid for Bewick to go on a Mediterranean cruise with Barry Laverty and Philip Castle who had married. In Greece she met Costos and fell in love with him. "I had a wild streak in me and fell for wild men". But Costos "was a bit too macho ... I couldn't live with a man who was dictatorial, and so I picked Pat".

On returning to Dublin, Pauline Bewick and Pat Melia lived in a flat in Upper Mount Street, before borrowing money and buying a house in Heytesbury Lane. Bewick then started mulling over whether or not to have babies. While she was concerned about over-population and the dangers of nuclear war, they decided to go ahead. Pregnancy and early motherhood were strange experiences for her, "hormones made me feel quite strange and lonely ... I found bringing up little babies boring. It wasn't very stimulating! Didn't thrill the boots off me! I painted the conflict inside women", which is significant in many of her paintings.

Their first daughter, Poppy, was born in 1966, and Holly in 1970. Both girls were painted regularly throughout their childhoods, as has Pat Melia been over the past fifty years. The artist has had a reliance on her husband to read aloud because of her dyslexia. "He can be very self-willed and I can be quite bossy, and when he wouldn't read to me one night, I painted him with horns". Friendships were developed with Luke Kelly and Seán Mac Réamoinn. "Luke Kelly was fascinating to me. He just represented Dublin to me. Once I met him on Stephen's Green and he had lost his two front teeth and I thought it was just like the old Georgian houses crumbling".

After decades of a semi-nomadic lifestyle, a permanent move came in 1972 when Pat Melia was offered a job in Killarney Psychiatric Hospital and the family moved to Kerry. It was thirty-five years from Bewick's first journey to that county. The family lived firstly in Killarney town. Bewick felt self-conscious and shy there. In their front garden she crafted a sculpture of a pig, much to some passerbys' dismay! Her three famous paintings 'Floating in Lough Leane', 'Small Town Lady Letting Loose' and 'Flying over the Cathedral' are great representations of women, who, feeling repressed, decide to set themselves free. Bewick got great pleasure when one of the earliest women to be ordained to the priesthood in England choose the latter painting as the cover of her ordination missal.

Leaving Killarney, the family moved to their idyllic home at Caragh Lake near Glenbeigh in 1975. There, over the last thirty-five years, Bewick has been inspired to paint the images which have made her an international name. These dream-like, hypnotic images of the beauty and cruelty of nature, female (and sometimes male) sexuality, fascination with cultures and religion, are images which will remain forever an integral part of the artistic canon which Ireland has given to the world. Many of these paintings are now part of Bewick's permanent donation to the State.

Over these years she has experimented with a number of different media, creating designs for wine labels, linocuts, bronzes, ceramics, collages, wall hangings,

and, in particular, tapestries, some of which were woven in the 1980s by local artist Regine Bartsch. In 2002 while driving through France, an unexpected opportunity arose to visit Aubusson, world-famous for tapestries. Since the 1950s Bewick had admired tapestries created in Aubusson and she used this opportunity to commission new ones from a master weaver, Bernard Battu, there.

In the early 1970s Pat Melia and Pauline Bewick visited their artist friends Barry and Philip Castle in Tuscany, fell in love with the area, and bought their own house there. They regularly visit Tuscany where daughter Holly now lives with Tuscan husband Luca and their two children, Chiara and Giada. The stunning Tuscan landscapes are a great contrast with the Kerry landscapes painted regularly over these decades. The artist believes "you have to go out and experience nature, rather than just paint it in your head". She also enjoys representing human lives in nature, turning humans into other animals.

Her fiftieth year, 1985, was a major creative year for Bewick, as she compiled a huge retrospective exhibition of 1500 pieces, 'From Two to Fifty', shown in the Guinness Hop Stores, Dublin, the Crawford Municipal Gallery, Cork and the Ulster Museum, Belfast. David Shaw-Smith made a documentary on her work, *Pauline Bewick: A Painted Diary*, shown internationally on television and in film festivals, and Dr James White, former director of the National Gallery, published the first critical examination of the artist, *Pauline Bewick: Painting a Life* (Wolfhound Press). In the late 1980s in Tuscany, Bewick created the initial sketches for her ideal character, the Yellow Man. At this stage of her life she was trying to find both her ideal human being, and the ideal society.

Inspired by the many conversations Harry had had with her philosopher friends about the South Seas way back in the 1940s, Bewick decided to move there for one year, not as a tourist, but to live in community with the locals. She was embraced by the islanders and witnessed many of their customs and ways of life, again seeing at close hand the beauty and cruelty of humans and nature. Life was hard, sometimes they were hungry, and she discovered it was not an ideal society, but she was happy. Bewick made many long-standing friendships, including Jon and Elaine Krupnick and Nerida de Jong, and she had a relationship with Utanga. After that first year, she made another journey for a year to finish writing her book, *The South Seas and a Box of Paints* (Art Books International).

Since returning to Ireland, Pauline Bewick has found her greatest happiness and contentment with Pat Melia in Kerry. She continued to work on her Yellow Man concept, mounting a huge record-breaking exhibition in the Royal Hibernian Academy, Dublin and writing and illustrating a book, *The Yellow Man* (Wolfhound Press). In that book, Bewick writes of the Yellow Man's life in starkly spiritual text which reveals her own philosophies of life.

The Yellow Man often sits by his house in the shade of an aged, fertile vine, its clumps of young grapes dulled with bloom. The vine-leaves curl. Acid green

shoots reach skywards and onwards from its gnarled grey trunk. Crickets grate their monotonous call. Year in, year out, the Yellow Man lives alone. No-one comments on the colour of his skin, his nakedness or his antennae. Maybe it's because he doesn't make judgements, is not grasping. Like nature he is just there, simply there. He has no history. His vision is unattached to the past. He looks at an object without knowledge of it. His questions don't demand an answer. He is complete, yet open for more. His changing body doesn't surprise him. He's young, old, blushing, excited; his antennae flush, shrink and grow. He lives his silent life observing, alert, empty, without guilt, unconditioned – yet in tune, alone.

On reaching seventy in 2005, Bewick made the decision to offer her master collection of art to the Irish State. It was warmly accepted by John O'Donoghue TD, then Minister for Arts, Sports and Tourism, at the Abbey Theatre in November 2005:

> For almost seventy years she has drawn much of her inspiration for her art from her Kerry surroundings and from Irish life and mythology. Pauline is an extremely talented and extraordinarily prolific painter. While we are gathered this evening to mark the occasion of this wonderful publication of Pauline's works, I must refer to her recent display of enormous generosity in donating the works from her master collection to the State. On behalf of the Irish people I would like to thank Pauline for this overwhelmingly generous gift.

President Mary McAleese officially opened the Waterford Collection in 2006 and called it "one of the loveliest acts of generosity ever given to our nation":

> The wealth of tapestries, wall hangings, watercolours and sketches and the sheer variety of media and subjects take us on Pauline's life journeys – the journeys through physical landscapes as varied as Kerry and the South Pacific, and the interior journeys where emotion and thought, passion and reflection are translated into such intriguing images.

Her donations to the State now hang permanently in the Waterford Institute of Technology and in Killorglin Library Place and are available for the perpetual enjoyment of the public. They form an internationally unique record of one woman's life from two to seventy, they are an invaluable social record of twentieth-century Ireland and are a great inspiration to all who aspire to creativity.

Now, at the age of seventy five, she shows no signs of, or indeed the desire to, slow down. She has recently developed artistic designs for windmills, has created the concept for an opera and is working on a number of other projects. She regularly devises, or is offered suggestions for, other exciting projects, and wishes that she could have another lifetime to do all the things she desires to do.

In her 75th year she is not afraid of old age, but rather continues to focus on the excitement of creating art.

BEGINNINGS

Two of the most important influences in Pauline Bewick's life are her mother, Alice May Graham (1903–1979), and her husband Patrick Inglis Melia, both of whom gave Pauline almost unconditional freedom to express herself in art.

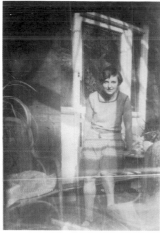

Alice as a young woman

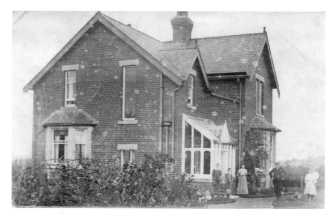

The Graham family home, Stocksfield, Tyneside

Art school days: Alice (rear)

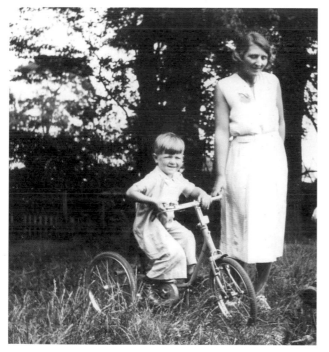

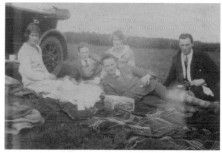

The Melia home, nr Wrexham, Wales

Pat with his mother Edith, c 1935

Edith Mary Inglis was born into a Liverpool seafaring family. She married Patrick Melia from Roscommon who emigrated to Wales c 1922. Their second son Pat was born in 1931.

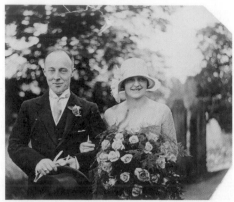

Corbett Bewick and Alice Graham on their wedding day, c. 1928

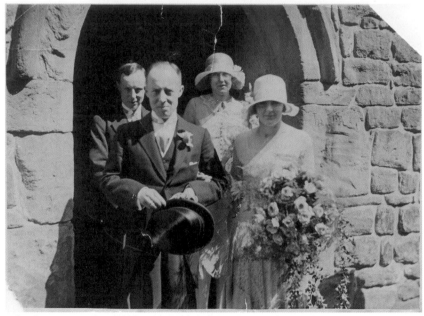

Corbett and Alice Bewick with best man Tommy Bewick and bridesmaid Janet Kidd.
On the back of the photo Alice wrote "Harry and Corrs Wedding - UNBELIEVABLE!"

Alice with her daughter Hazel, c 1929

Pauline was born on 4 September 1935. Her mother later claimed that Corbett Bewick was not her father, rather a young man with whom she had a passionate relationship.

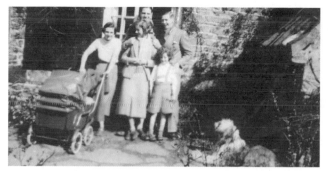

Alice with pram, Hazel in shorts

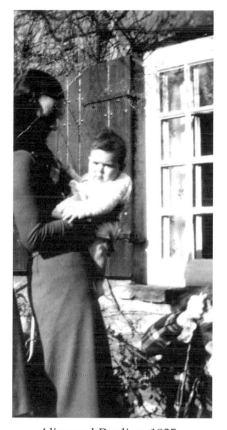

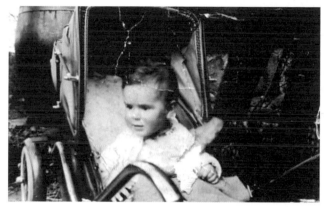

Pauline in pram, 1937

Alice and Pauline, 1935

Pauline on a Pedestal 1938

In 1938 Alice ran away from her alcoholic husband, taking her two young daughters. They arrived in Letchworth where Alice intended to enrol Hazel in the local progressive school.

INTRODUCTION TO IRELAND

Wandering around looking for a place to stay for the night, Alice spotted the Garden City Hotel. She knocked on the door, but a woman with a strange accent told her they were not yet open for business. Seeing Alice's dismay, the hotelier took pity on her and invited in the family. She introduced herself as Pat Newling from Kenmare, Co. Kerry, Ireland. After putting the girls to bed for the night, Pat and Alice chatted for hours in the warm kitchen. When Alice accidentally broke a cup, Pat exclaimed, "You're just like Harry our gardener who's always breaking things. From now on you'll be called 'Harry'". And so she was.

Pat Newling told Harry Bewick of her worry about Lucy and Michael O'Shea, her orphaned niece and nephew living in Gleninchaquin, Co Kerry with their uncle, Buttons, the local postman. Harry immediately offered to move to Ireland to give the children a more stable home. So started their Irish adventure.

Their house at Cillah East, Kenmare

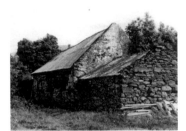
The shed where they sometimes slept

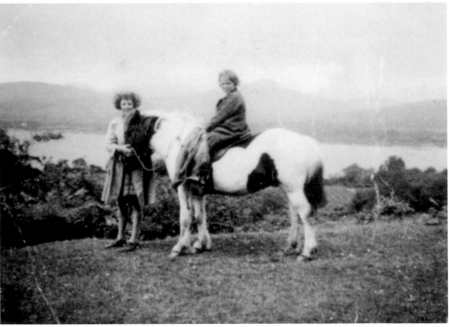
Kenmare 1943: Hazel with Pauline on Shamrock

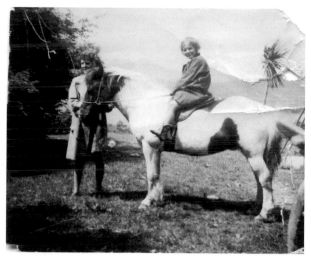

Kenmare 1943: Hazel with Pauline on Shamrock

The living room

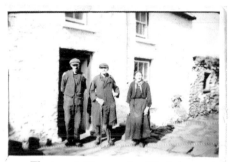

Their neighbours, the Healy's

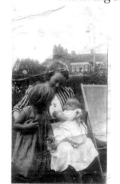

Pauline with Betty Player,
sister of Pat Newling

Hazel on a horse

Harry found life in Ireland fascinating and integrated very successfully into the local community, despite her vegetarianism, her North of England accent and her eccentricities like sleeping outdoors and her unconventional parenting.

She was interested in telling the story of their life in Kerry and took the opportunity to ask for help from George Bernard Shaw at the Parknasilla Hotel. He sent her a hand-written postcard in November 1943 giving advice on how to get published.

TRAVELLING AGAIN

The family lived very happily for six years at Cillah East with Lucy and Michael, until Lucy's sudden death from galloping meningitis. As both their parents had died from TB, it was decided to send Michael to Switzerland for the 'good air' and to learn the hotel business. Harry reluctantly decided to leave Kerry and move to the North of Ireland. Hazel missed her Bewick grandparents and so she moved back to England. Harry wrote the story of this first stay in Kerry in her bestseller *A Wild Taste* (London, 1958, 1987).

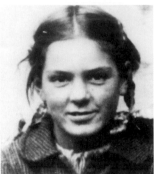
Pauline in Belfast, 1944

In Belfast, Harry and Pauline lived in a caravan behind an advertising board opposite a rubbish dump. One of their neighbours was a disabled street artist. Pauline attended a local school, but Harry soon despaired of conventional education and decided to move back to Britain to enrol at a progressive school. They lived at progressive schools in Blackbrook, Monmouthshire and at St Catherine's, Bristol. Here they met John Watling, a WWII conscientious objector who later did a Ph.D. in Philosophy and became a lecturer at University College London. They were kindred spirits and remained lifelong friends.

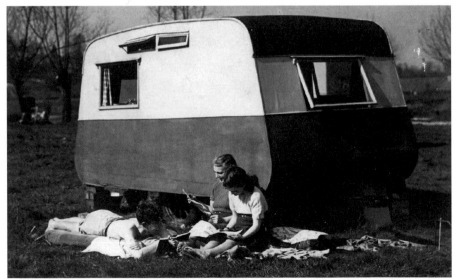
John Watling, Harry and Pauline outside their caravan, Wargrave, c. 1946

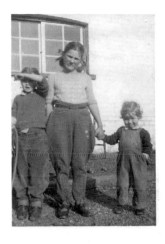

Pauline in England with Betty Player's children. Betty was the sister of Pat Newling, Letchworth hotelier, and aunt of Lucy and Michael O'Shea in Cillah East, Kenmare

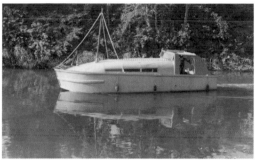

Janty: "This is the cruiser when I bought it for £500" wrote Harry, before converting it and filling it with light

Janty pulling Tranquil, their neighbours' boat

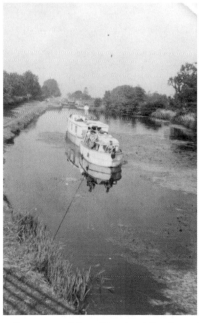

Janty pulling Tranquil approaching Devises Lock, with the families on deck

RETURN TO IRELAND

Puck Fair, Killorglin, 1948

Pauline, 1949

1949

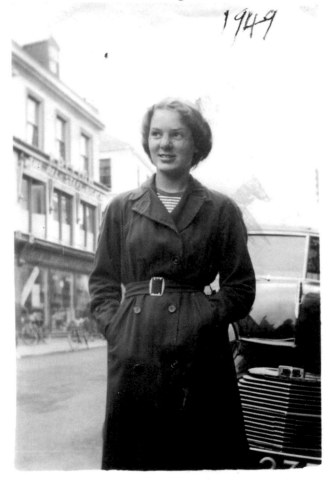

Pauline in Killarney, 1949

With Betty Player's children
at Rossbeigh, Co Kerry, 1949

At the Gap of Dunloe, 1949

To Dublin and to Art School

Dublin Art School, 1950

Art School Hop

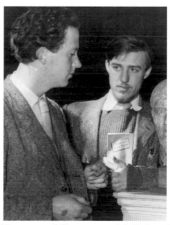

Desmond Barry and Michael
Morrow at Art School

FRANKFURT AVENUE, RATHGAR

Harry got a loan from a building society and bought a house at 51 Frankfurt Avenue, Rathgar, where she rented out rooms to students.

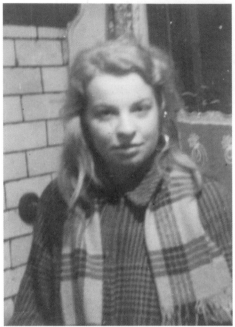

Pat Cahill, 1951

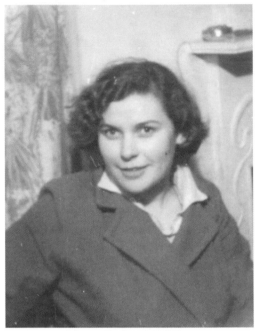

Mary Graham, 1952

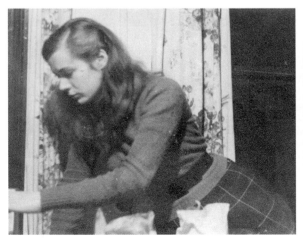

Bizzy Hallinan, 1952

Peter Murray and Harry in the garden

Peter Murray and Harry writing and typing in the back garden, probably Harry's follow-up to *A Wild Taste*, this time based on their life in Dublin. She scrapped it. Later Peter Murray joined Pauline on their Mediterranean cruise with his girlfriend Nuala O'Faolain.

Troy Kennedy Martin

Student at Trinity College, co-creator of BBC's *Z-Cars* and writer of *The Italian Job*

Harry sunbathing in the back garden

Desmond Barry was one of Pauline's first boyfriends

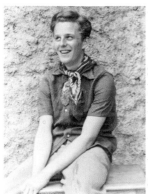

Edward Fitzgerald, 1952

Edward lived at 76 Frankfurt Avenue with his mother Sheila. She ran an art therapy studio there, with students including Paul Durcan and Mary Paula Walsh. Sheila was the sole customer in Harry's vegetarian restaurant at No 51.

Edward was close friends with Pauline and she shared a house with him in Chalcot Crescent, London. She loved him for his gayness and his joy of life.

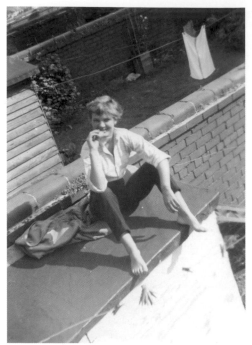

Pauline on the roof, 1951 Pauline in the backyard, 1951

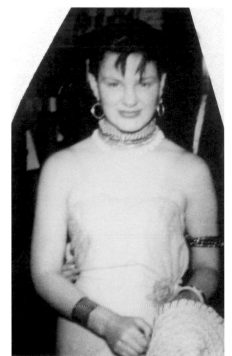

Dublin Art School, Arts Ball, 1952

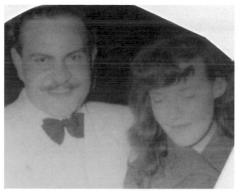

Botros Hana Botros, a TCD student and Barry Laverty, artist

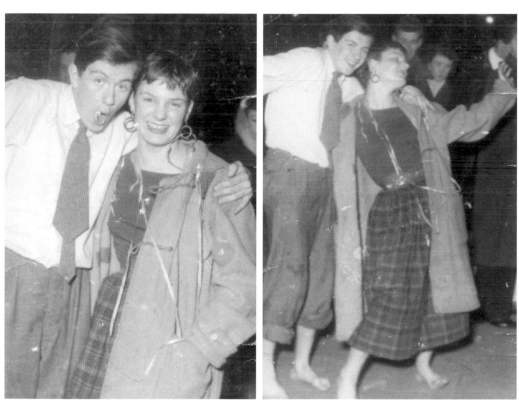

Pat Melia and Pauline at a party, December 1952, shortly after they first met

Leslie MacWeeney, artist

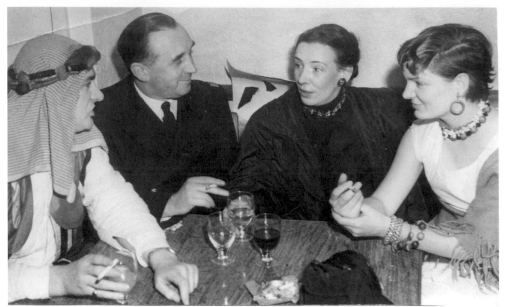

With John Butler and Maura Laverty at the Arts Ball, 1953

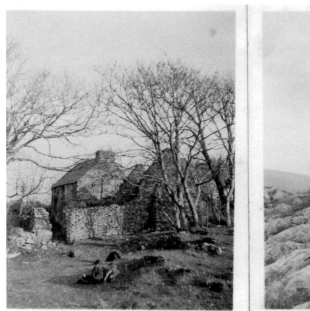

Harry and Desmond Barry with an auctioneer on an island in Kenmare Bay.
On the back of the photo Harry wrote "the island we might buy", 1953

Pauline and Pat in Limerick, 1954

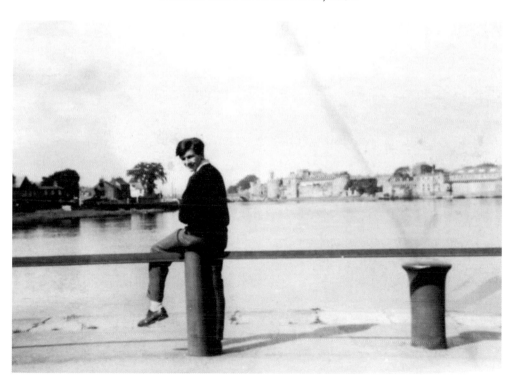

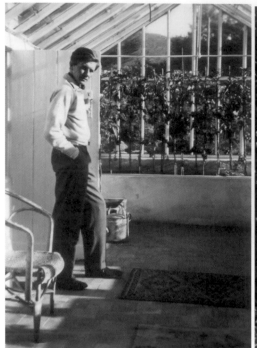

Pat at Mucksna Lodge, Kenmare, 1954 At Villefranche-sur-Mer, France, 1957

Pat swimming at Gleesk, County Kerry, 1954

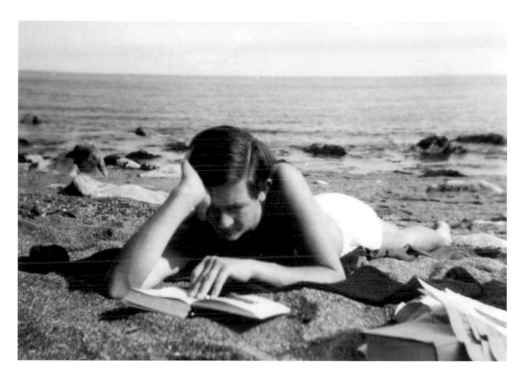

Pat, Harry and Pauline at White Rock, Killiney, County Dublin, August 1955

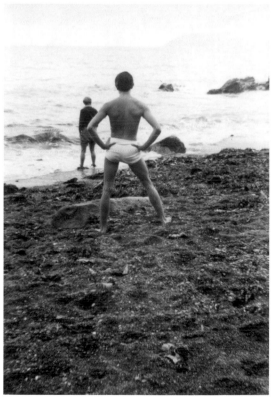

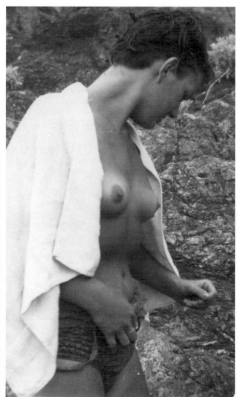

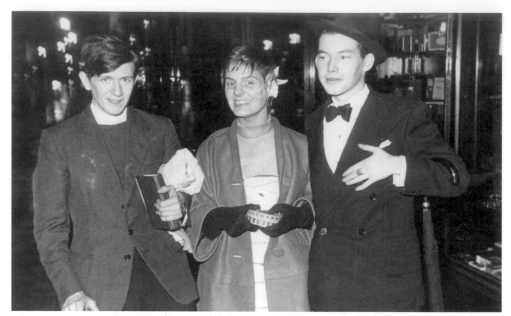

Pat, Pauline and Sebastian Ryan, Arts Ball, 1956

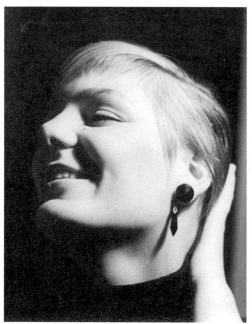

Pauline at MacWeeney's

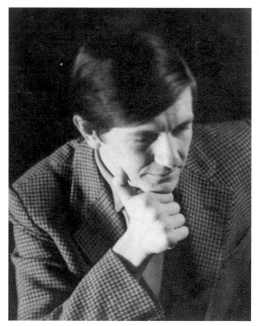

Pat studying

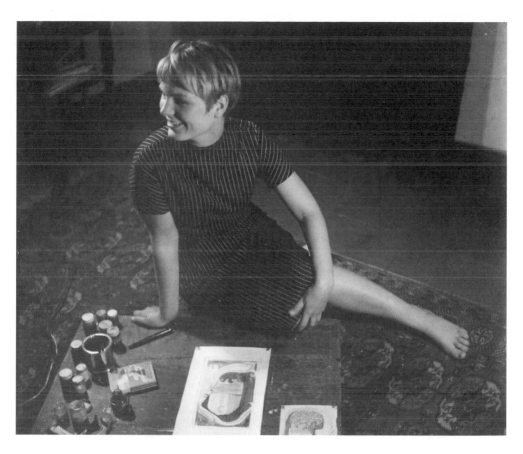

Pauline designing artwork for 'Fingal's Cave' pub

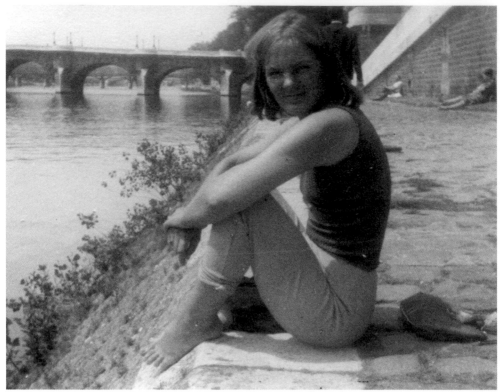

In Paris, 1956, Pat and Pauline stayed at the Hotel du Dragon. They crossed over the Pont des Arts to the Right Bank for picnic lunches of baguette and camembert

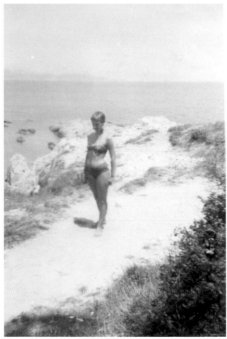

St Tropez, 1956

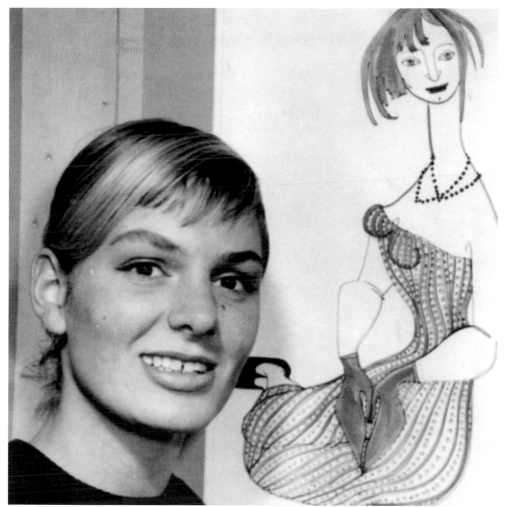

Pauline's first exhibition at the Clog Gallery, Dublin, 1957, opened by Seamus Kelly, Quidninc of *The Irish Times*. Some time later they noticed that recorded in the visitors' book was the name, "J D Salinger, Vermont".

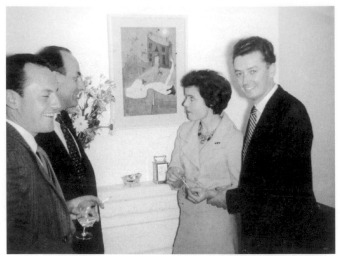

London, 1958, at Dr John Latham's flat,
with Dr Michael Latham, Joan Schellenberg and Michael Wooley

At Edward's Flat, London, 1959

Pauline's room had no windows, but a hatch that led into a kitchen. After Edward's tragic early death, Pauline lived with Sally Travers, niece of Micheál Mac Liammoir. She got a job with the BBC, illustrating a children's TV programme, 'Little Jimmy'. With the money made from this show, Pauline was able to tour the Mediterranean in 1960/61.

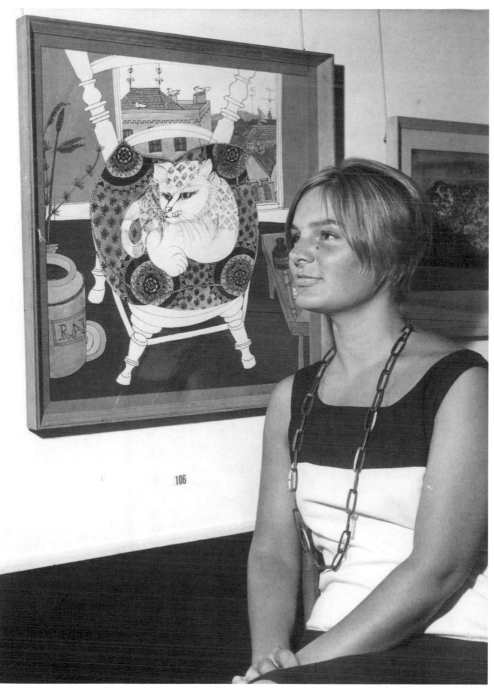

106

1959: Wearing a necklace designed by Picasso, given to her as a gift by Dr John Latham

EUROPEAN INTERLUDE

Barry Laverty and Philip Castle had bought a boat, the 42-foot Carn Ingli, and were sailing the Mediterranean, so Pat, and later Pauline, embarked on the journey. In 1960 Pat joined at Dover. After a refit at Chichester Harbour, they sailed for Le Harve, then through the rivers and canals of France to the Mediterranean.

1960: Pat on the Carn Ingli at Sciara, Sicily

Extracts from Pat Melia's memoir, *Three Friends in a Boat* (forthcoming)

"Back to the dreamy meditation, but not for long. Something has happened, the faint smudges barely discernable up-channel have changed into a long procession of merchant-men sailing down-channel in line-ahead formation with two or three cables distance between each other, travelling at about 15 knots, the speed difficult to estimate. A fine sight with their bright paint work shining in the summer breeze. But what are we going to do? How are we going to penetrate their tight formation and get on the Southern, French side of the line? We discussed it briefly. Our skipper decided that we would cross the wake of one of the ships close to its stern, thus giving us as much time as possible to get out of the way of the following ship. None of us was really sure who had the right of way, and certainly none of us wanted to try conclusions with one of the enormous merchant-men. So on we went. We knew that once we had crossed the wake and could see the onward coming merchant-men's port side, we would be safe. But

instead of slipping behind us, the peak of the bow of the following ship followed us and started to bear down on us. It was a frightening few seconds (it felt like minutes). I looked up at the lone helmsman on the bridge of the merchant man. After a few moments he swung back on to his course and his joke was over. This was one of the many times I have vowed to give up sailing and take up carpet bowls instead".

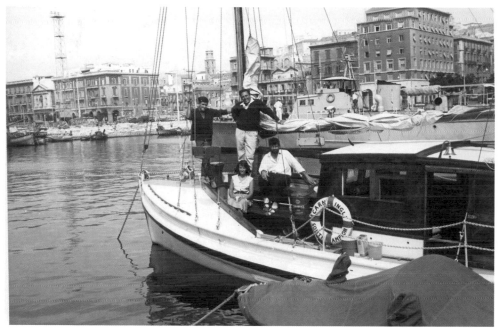

1960: Pat, 'Sardinian Bruno', Barry and Philip on the Carn Ingli, Cagliari, Sardinia

"It is now dark. We are sailing for Cap d'Antifer, a prominent sea-mark about 20 miles north-east up the coast from Le Harve. Once we close with the coast we will turn south-west and hug the coast until we get to Le Harve. It is my spell at the wheel. What is required is that I should steer in a straight line for Cap d'Antifer. Not so easy in the dark because the lighthouse only flashes once every 20 seconds. To my surprise its flash does not appear dead ahead where I expected, but maybe as much as 30 or 40 degrees of deviation from our hoped-for course. Improvement was a struggle, but at last we were hugging the coast, not too close in, and keeping a keen eye out for the pierhead lights leading us in to Le Port du Havre. Suddenly I saw lights about 20 feet above us. After a few moments of astonishment I realised we were about to ram a lead-in light buoy for the port channel. I had never seen a big buoy for ocean-going ships before, and didn't recognise what it was immediately, but just in time I put the helm down and swung to starboard and narrowly missed the enormous structure swaying just above and ahead of us. It was all over very quickly and I don't think Philip and Barry down in the cabin realised how near we were to a collision".

When the main sail blew out, Pat, Barry and Philip stayed for a month at Cagliari, Sardinia, for repairs and to fix engine problems. They became friendly with Bruno, a lecturer in veterinarian science, who became known as 'Sardinian Bruno'.

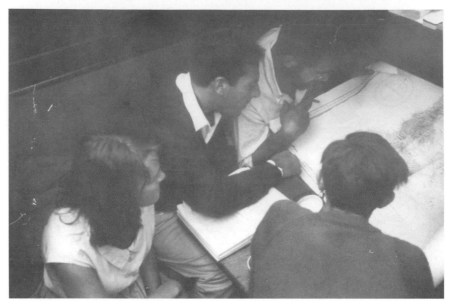

Barry, 'Sardinian Bruno', Philip and Pat, Carn Ingli cabin, 1960

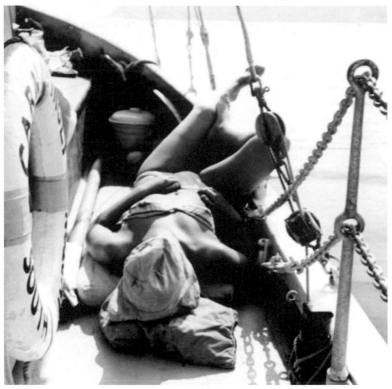

Pauline sunbathing on deck

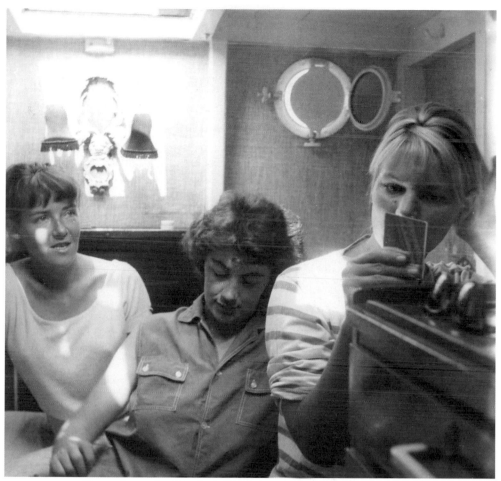

Barry Laverty, Nuala O'Faolain and Pauline in the cabin

When Pauline was going on a date with a local plumber (below), Nuala O'Faolain joked: 'It's not fair. Pauline. You get all the boys!'

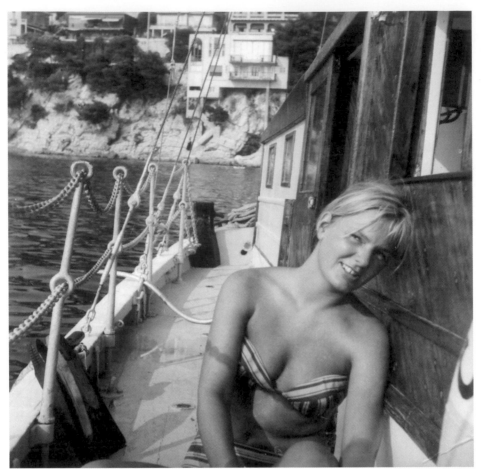

Pauline on deck

Pauline left the boat at Greece after meeting Costas Legacus. She lived with him for a number of months on the island of Hydra.

Hydra, Greece, 1961

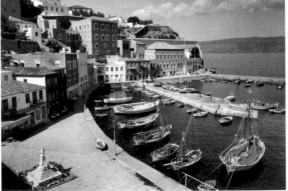

After Pauline's return from Greece, she reconciled with Pat, and in 1963 they married. Their honeymoon was spent travelling Europe over a few months. They drove to Paris in an Austin Healy Sprite sports car, then on to Gargellen, Nice, Pisa, Florence, then back to Paris and London. Afterwards a visit to Harry at her cottage and glasshouse in Laragh.

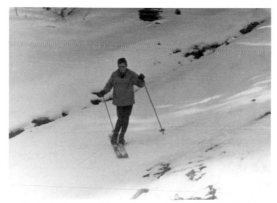

Pat skiing at Gargellan, Austria, 1963/64

Pauline

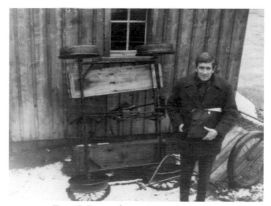

Pat, Montafon, Austria, 1964

They returned to Gargellen the following winter, 1964, and almost got caught in an avalanche. They stayed to help dig out victims and survivors. Both Pat and Pauline still remember this incident in stark detail.

Hazel, Harry and Pauline in Newcastle for Hazel's wedding

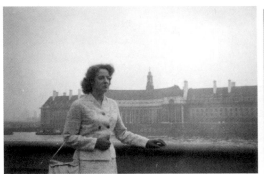
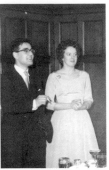

Hazel with her husband Neil Cherrett on their wedding day

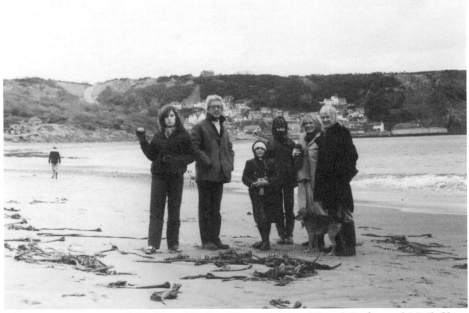

Pauline, Pat, Poppy and Holly with dog Foxy visiting Hazel, Judy and Neil Cherrett, 1980, North-East England

Pat at St Patrick's Psychiatric Hospital, Dublin

Pat on RTÉ, 'Discovery', 1966

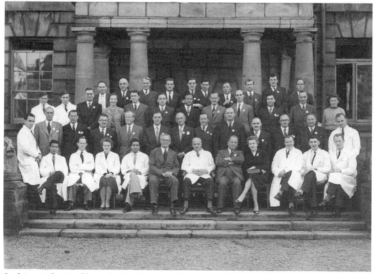

Pat (2nd left) with staff and visiting colleagues at the Rotunda Hospital, c. 1957

Pat was on the teaching staff at Trinity College Dublin from 1965 to 1972

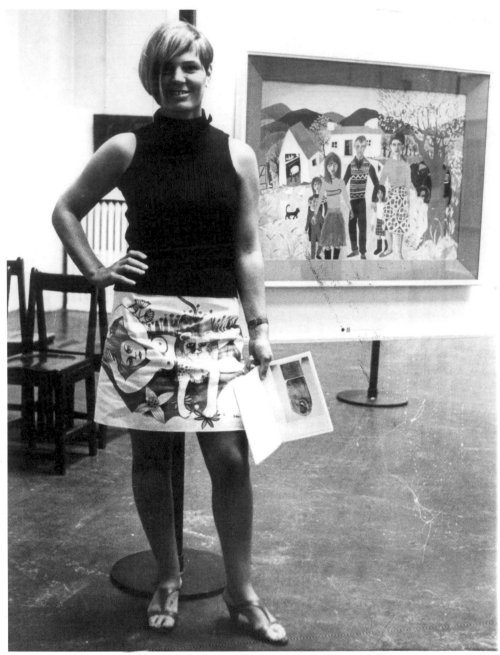

At the Exhibition of Living Art, Dublin, 1965

When only one painting was selected for the exhibition, Pauline painted a second one on her linen skirt. This skirt is now part of her 'Seven Ages' permanent collection.

They lived in a rented room in Mount Street "Camp Teddy", a visiting friend

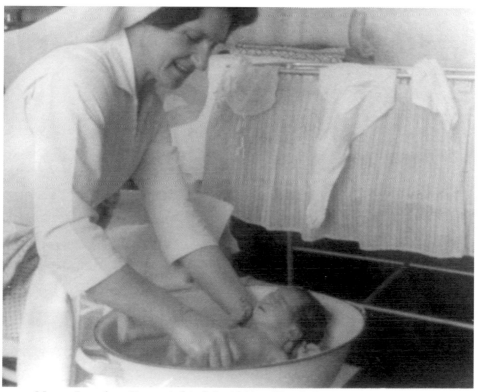

Nurse Lynch at Poppy's birth in 1966 at Hatch Street Nursing Home.
It was a private hospital which cost £100 and was nicknamed the 'Hatchery'.

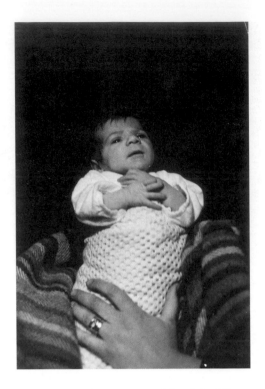

1966: Poppy and Pauline at Alen MacWeeney's

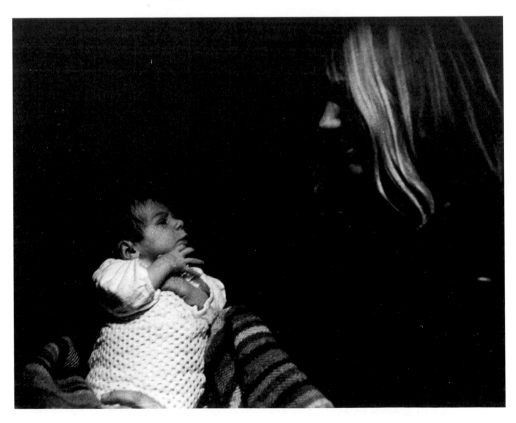

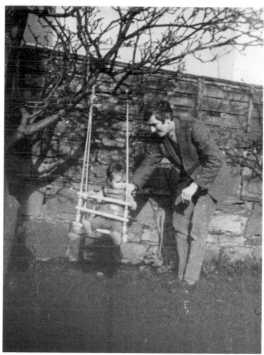

1967: Pat with Poppy on a swing at their recently bought house on Heytesbury Lane

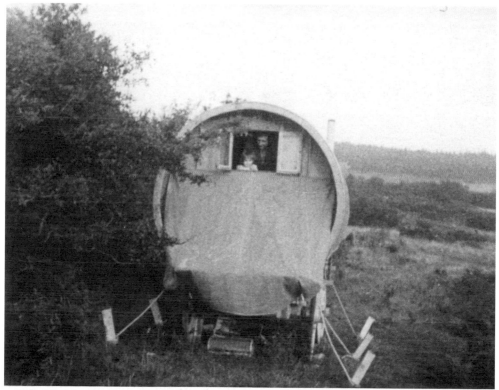

1968: Pat and Poppy at Ballard, near Glendalough in their Romany-style caravan.
It had two double beds, an iron stove, and was very comfortable.

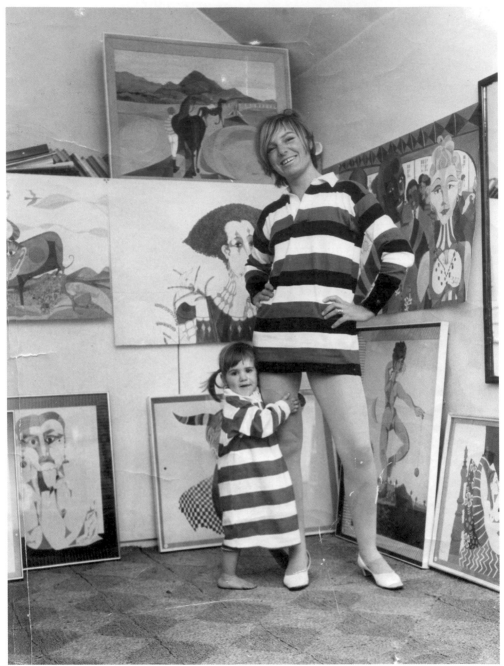

Pauline and Poppy at Heytesbury Lane, Dublin

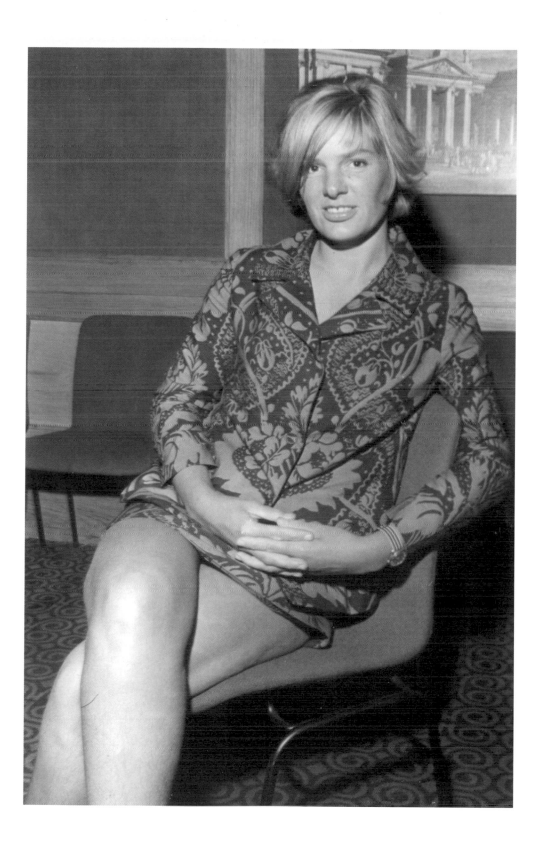

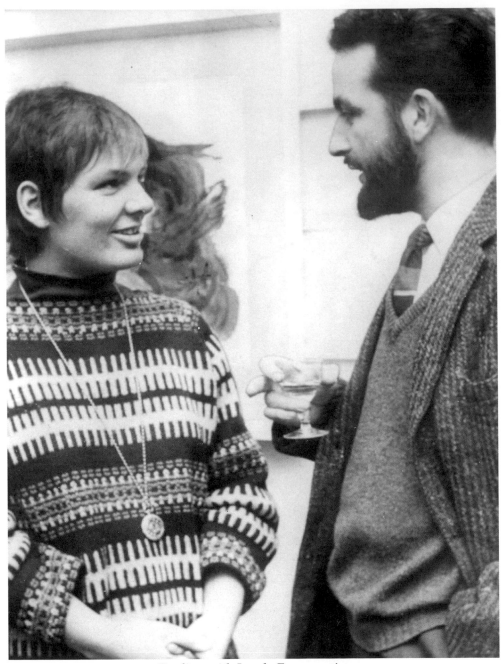

Pauline with Jan de Fouw, artist

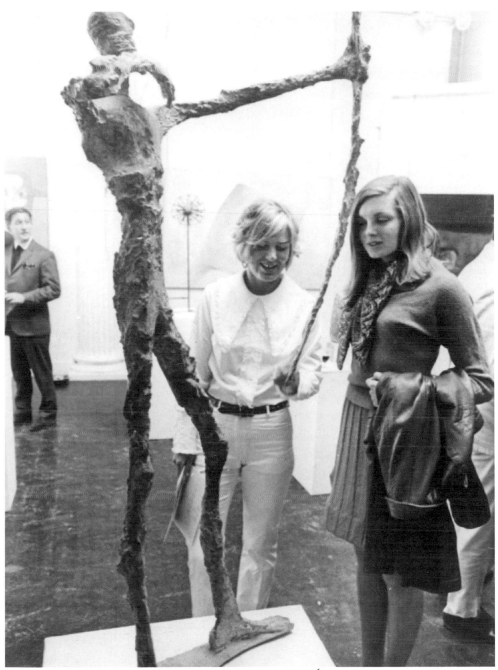

At the Exhibition of Living Art with Áine O'Connor

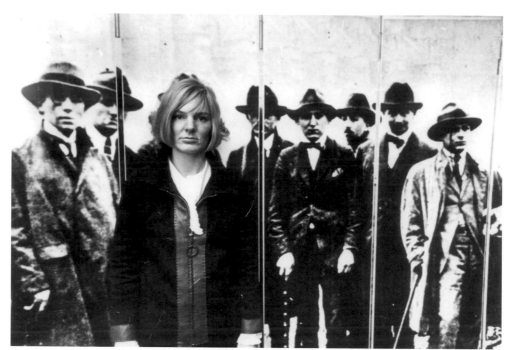

At a Dada exhibition

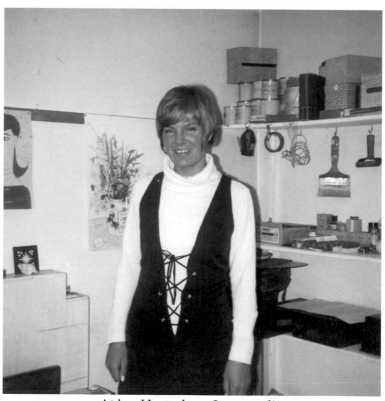

At her Heytesbury Lane studio

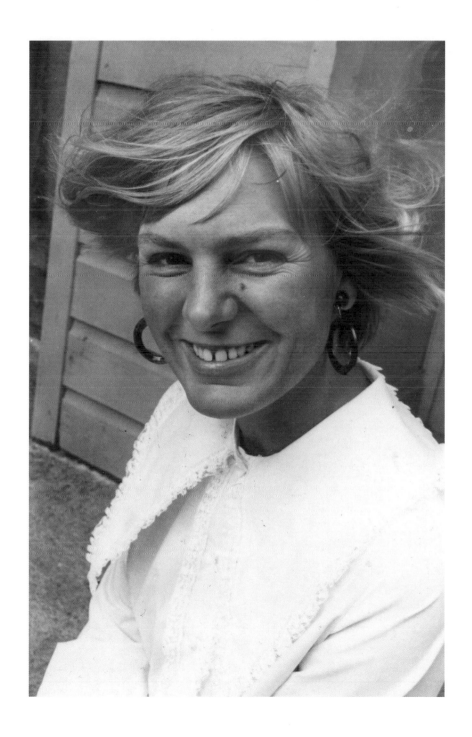

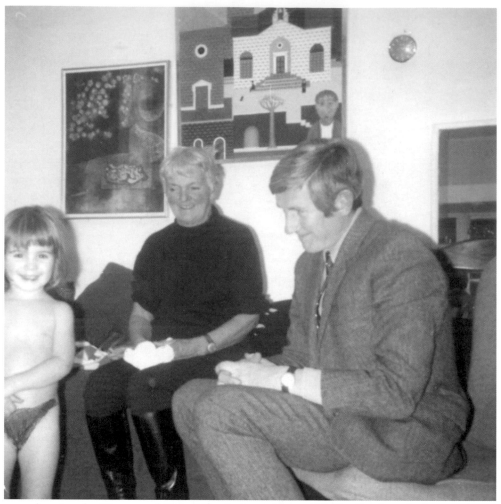

Poppy dancing for Harry and Pat at Heytesbury Lane; a Philip Castle painting on the wall

Clothes swop party at Heytesbury Lane

Sir Basil Goulding at the Dawson Gallery, c 1969

1971: Holly at John Watling's holiday home at Gleesk, Sneem, County Kerry

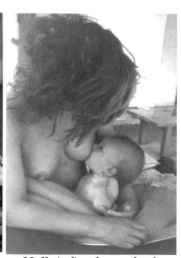

1970: Holly's birth Holly's first breastfeed

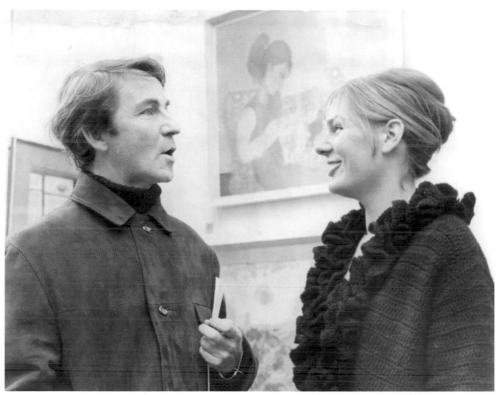

1972: Paul Smith, novelist, at Pauline's Dawson Gallery exhibition

1972: Seán Mac Réamoinn, broadcaster, opening Pauline's Tuscan exhibition
at the Italian Cultural Institute, Dublin

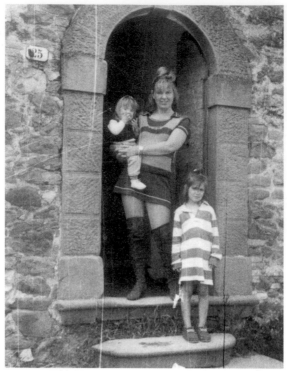

1972: Pauline, Poppy and Holly in Tuscany

Worried about IRA terrorist attacks in Dublin, the family visited Barry Laverty and Philip Castle in Tuscany, and, with the help of a loan from Harry, decided to buy part of an old farmhouse (below) at the cost of £5000.

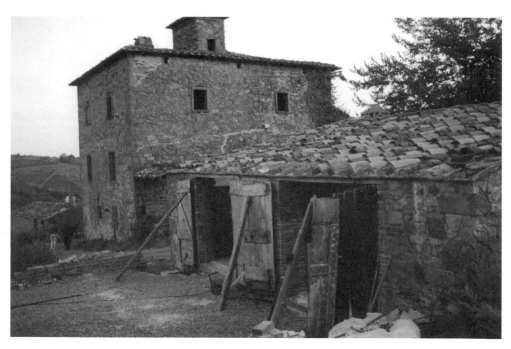

1971: Pat with Holly at Milltown, Co Kerry

1972: Holly and Poppy

1973: Homage to Picasso

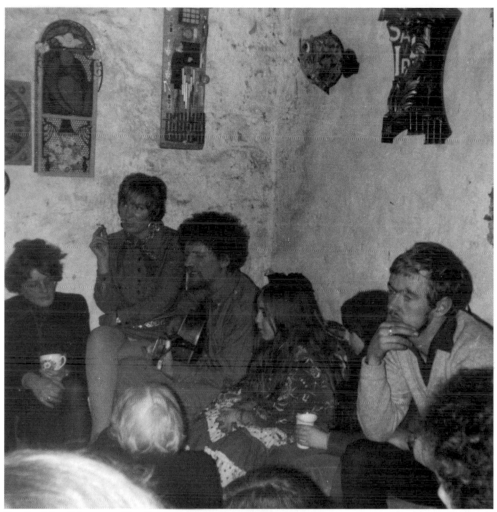

Leslie MacWeeney, Pauline, Luke Kelly, Trinny Navarro at Harry's cottage, Laragh

1973: Luke Kelly in makeup as 'King Herod' backstage

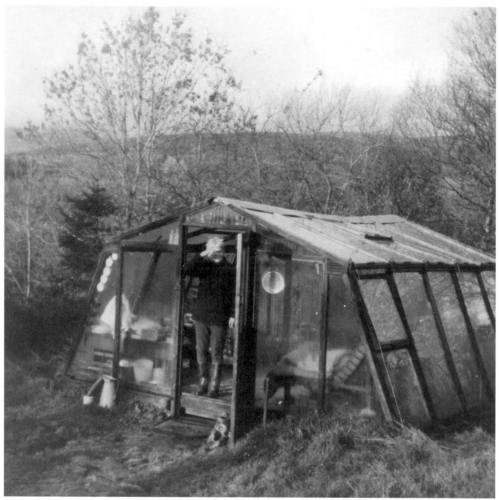

Harry at her glasshouse in Laragh, Co Wicklow

In the 1960s and 1970s Harry held exhibitions at the Neptune Gallery, St Stephen's Green; The Davis Gallery, Capel Street and at the Laragh Craft Centre. In a feature article on her in 1964, *The Irish Times* referred to her as an "ageless wood nymph". Harry and the family laughed about that for years afterwards.

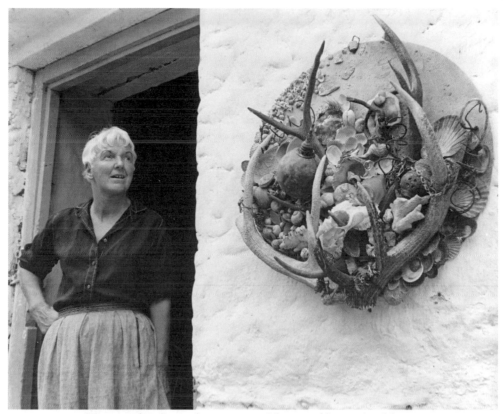

Harry at her Laragh cottage, with one of her assemblages

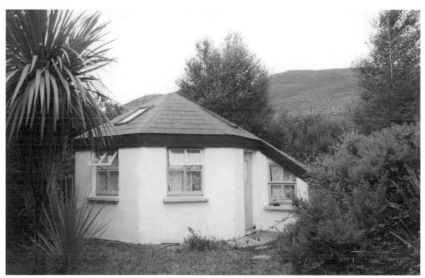

The little house built for Harry at Caragh Lake, Kerry

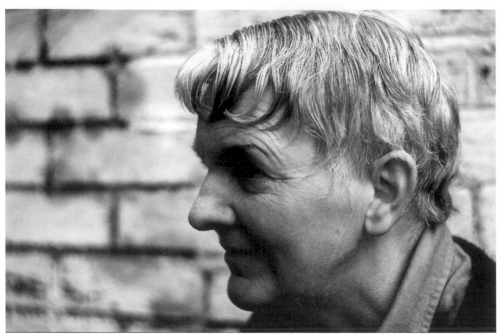

Harry, looking like Krisnamurthi, her hero

1973: Pat's mother Edith with Pauline, Poppy, Holly and Aoife Kane, with Foxy the dog at Gortroe, Killarney.

The family moved back to Kerry when Pat got a job at Killarney Psychiatric Hospital.

MAKING A PERMANENT HOME IN KERRY

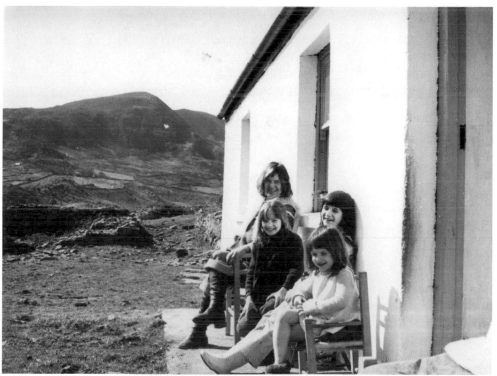

1974: Pauline, Poppy, Holly, with Aoife Kane, at Caragh Lake, Kerry

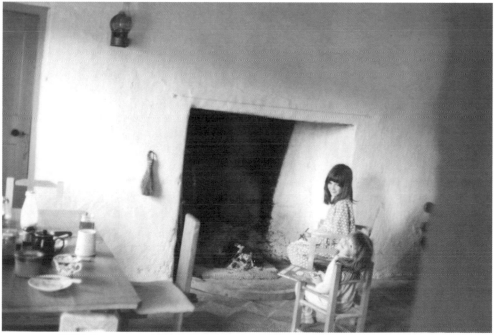

1975: Poppy and Holly at their new house at Caragh Lake, Kerry

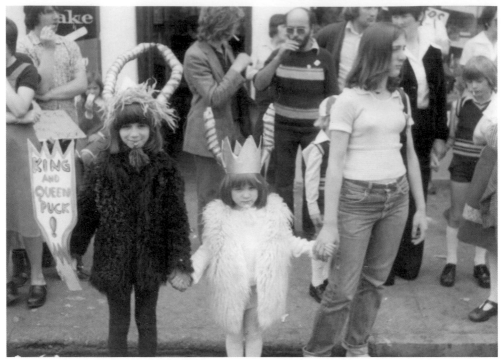

Poppy, Holly and Kathy, their au-pair from America, at Puck Fair

Poppy won a medal for painting

Holly and Shelly

On holiday in Paris, August 1975

Holly

Pat and Teddy

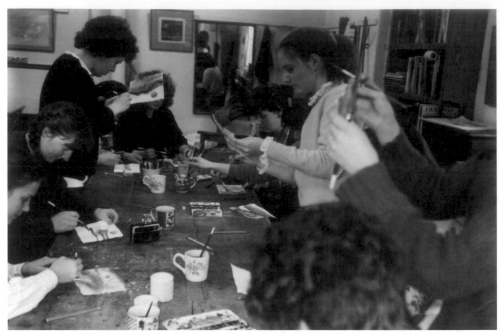

Teachers and students having an art class at the family house,
including Helena Devine, Sheila Kingston, Katrin Holtkott and Holly

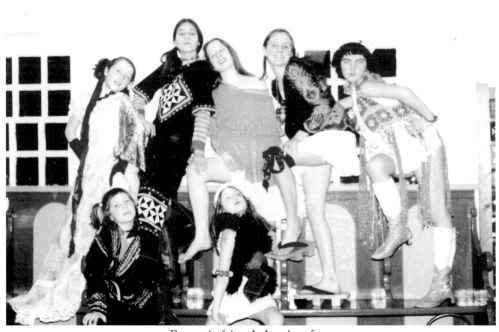

Poppy's friends having fun:
Eimear Murphy, Poppy, Geraldine O'Shea, Katrin Holtkott, Helen O'Riordan, Saskia
Holtkott and Holly

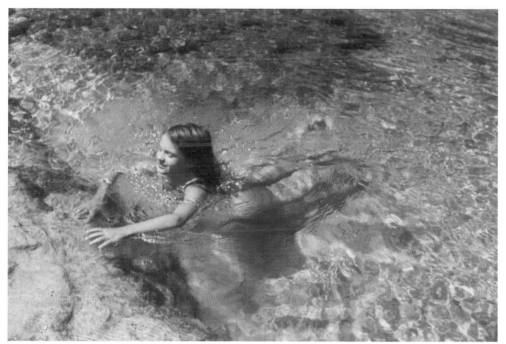

Holly swimming at Gleesk, County Kerry

Cats and dogs at home

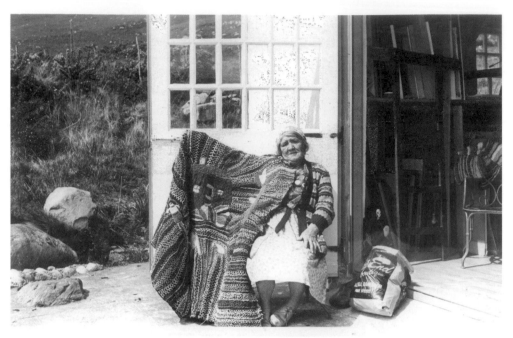

Pauline commissioned Ella Coffey to embroider wall hangings, cushion covers and dresses

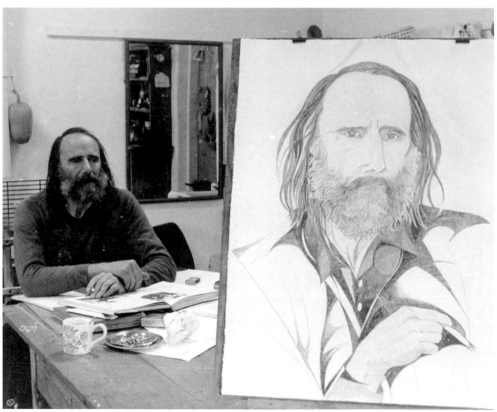

1978: John Godley, Baron Kilbracken, sitting for his portrait

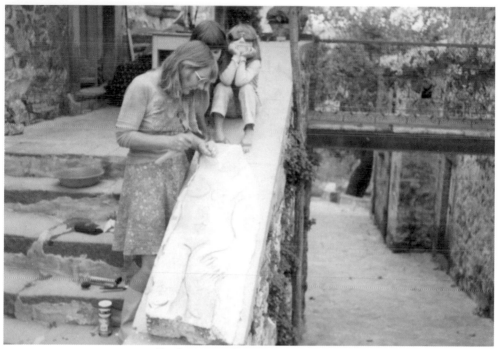

Sculpting at Bricciano, Tuscany

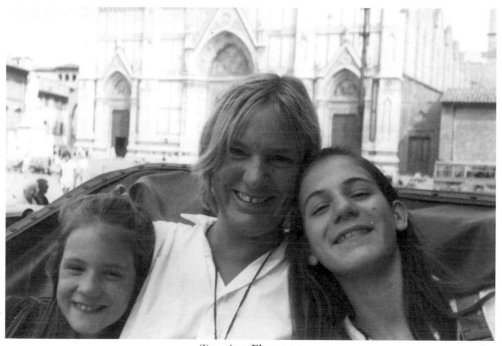

Touring Florence

With Holly in Volterra, choosing alabaster to sculpt

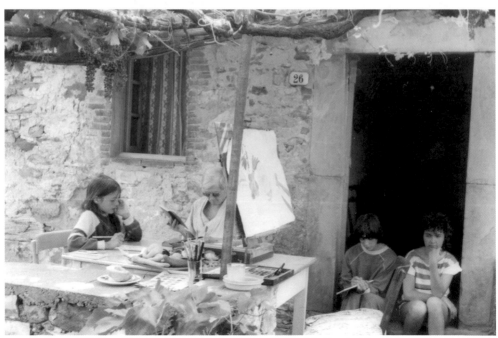

Holly, Poppy and Helen O'Riordan with Pat in Tuscany

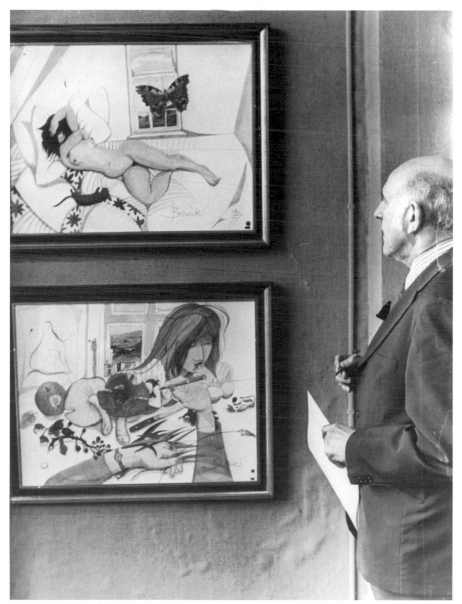

Gerald Goldberg at the Cork Arts Society Gallery Exhibition, 1978

Zouz, Switzerland, 1981

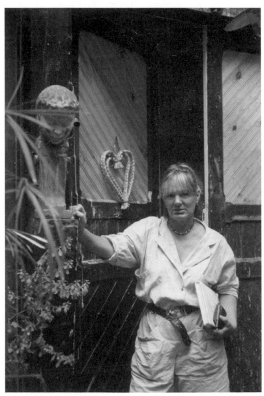

Paris, 1981, a sketch book in hand

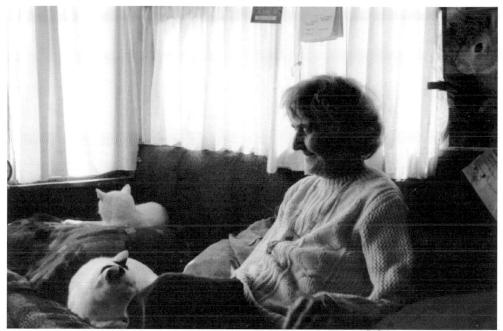

1982: Visiting Sheila Fitzgerald in Mayo, former neighbour at Frankfurt Avenue

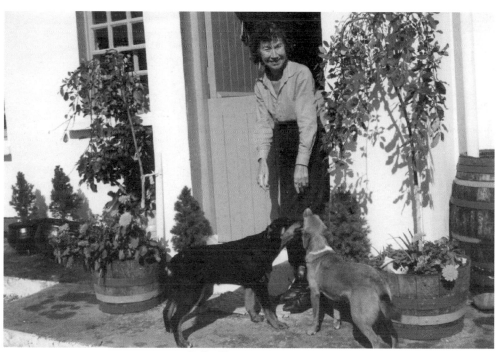

Sally Travers visiting

Sally and Pauline had shared a flat in London in the early 1960s. She was the niece of Micheál Mac Liammoir, who envied her love of coloured boyfriends.

1980s: The family at their home at Caragh Lake, Kerry

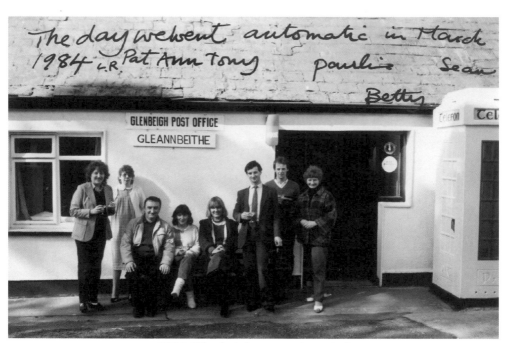

1984: Glenbeigh goes automated
Pictured are Pat McSweeney, Ann Joy, Tony McSweeney, Dolores Sweeney, Pauline,
Brendan Sweeney, Sean Sullivan and Betty O'Shea

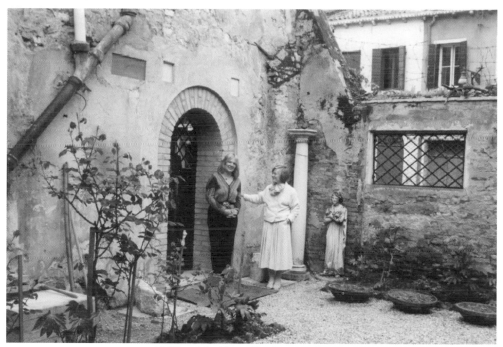

1985: with Clare Boylan in Venice

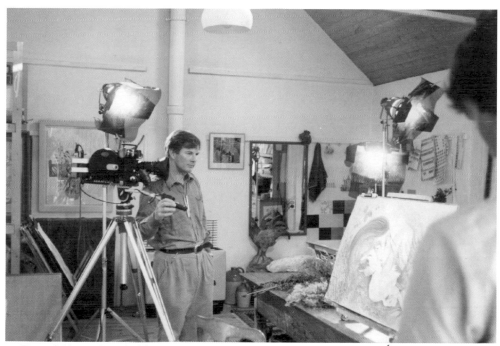

David Shaw-Smith filming 'A Painted Diary' broadcast on RTÉ and Channel 4
and shown in Paris and at the Los Angeles film festival

1986: Pat Taylor preparing to hang the 'Two to Fifty' collection of 1500 paintings at the Guinness Hop Store, Dublin

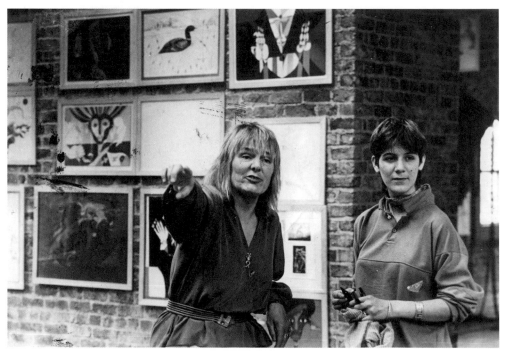

1986: Pauline and Poppy at the Guinness Hop Store

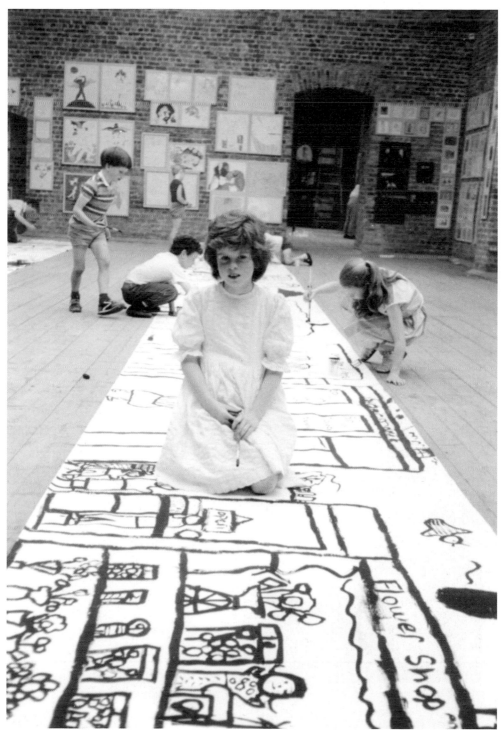

Children's art sessions at the 'Two to Fifty' exhibition, Guinness Hop Store

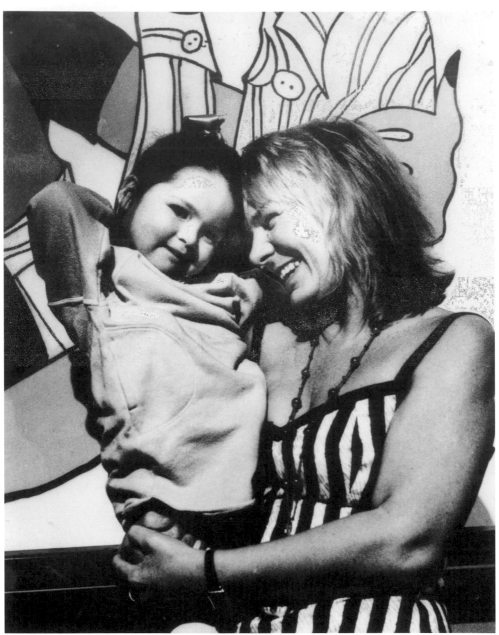

At the 'Two to Fifty' exhibition, Guinness Hop Store

A glimpse of the 'Two to Fifty' exhibition

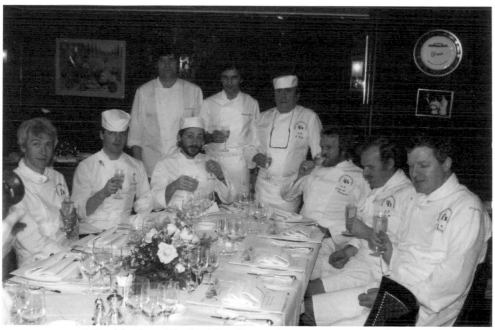

World-Class Chefs at La Gavroche restaurant, London

Each chef prepared a course, for example, Albert Roux, the starter, Worrall, the main, White, the desert, and so on, while Pauline sketched the evening into a bound book which was auctioned for charity.

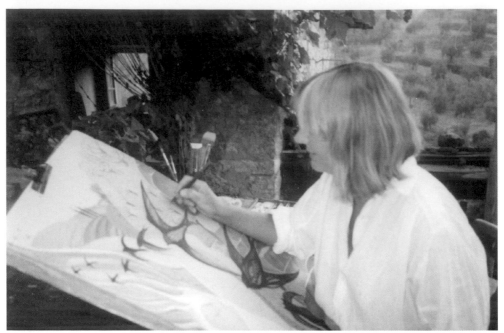

1986: painting a Tuscan scene

1987: Holly, Poppy and her boyfriend Conor Mulvihill at Cork Airport

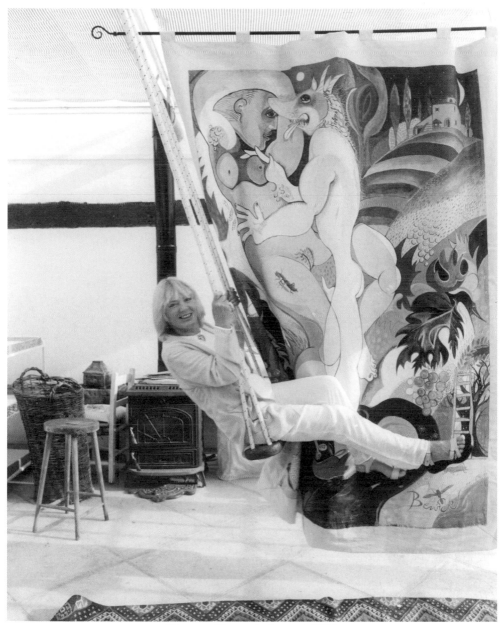

'Tuscan Dream', August 1986

In Tuscany with Philip Castle and Barry Laverty Castle

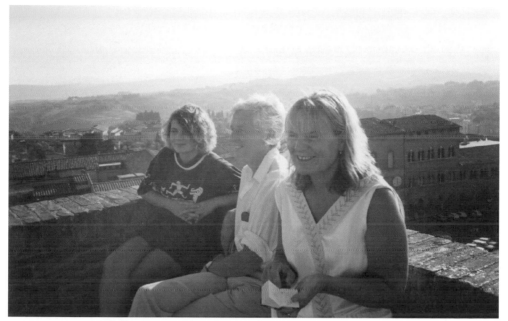

Holly, Pat and Pauline at the top of a tower in Siena

Pauline bathing at the Lecci Pool, near Gaioli, Tuscany

Family picking cherries in Tuscany

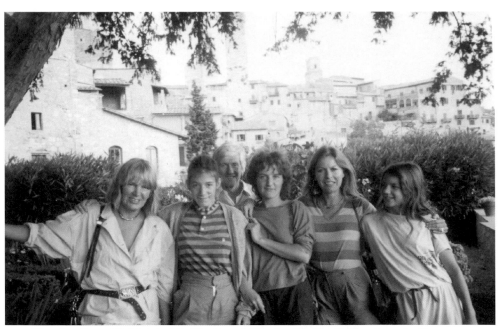

The family with Katrin Holtkott and Denise Melia, Pat's niece, in Tuscany

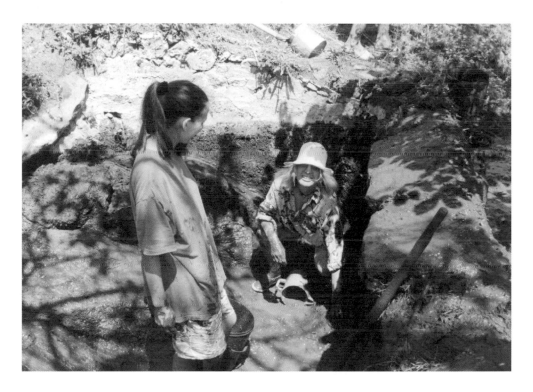

Poppy, Pauline and Conor emptying mud from the wash pool in Bricciano, Tuscany

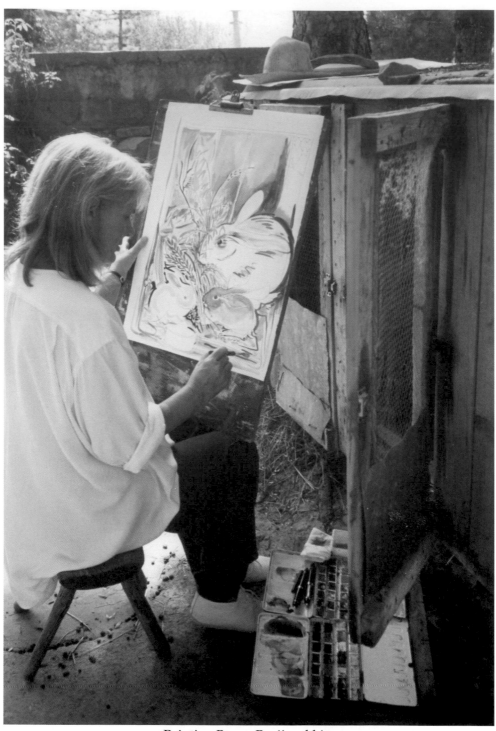

Painting Bruna Rosi's rabbits

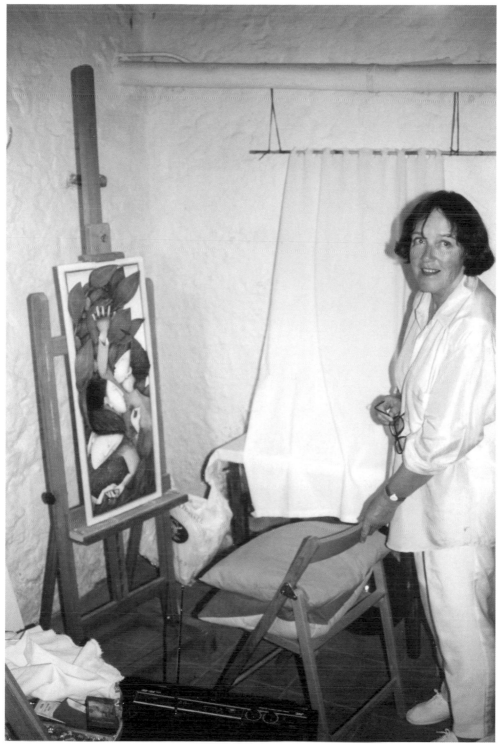

Barry Laverty Castle painting at her studio in Bricciano, Tuscany

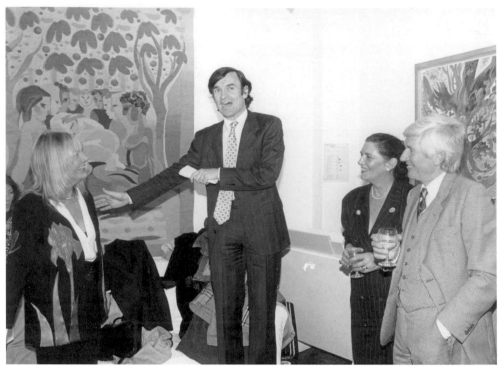

1987: Professor Anthony Clare opening Pauline's exhibition in London

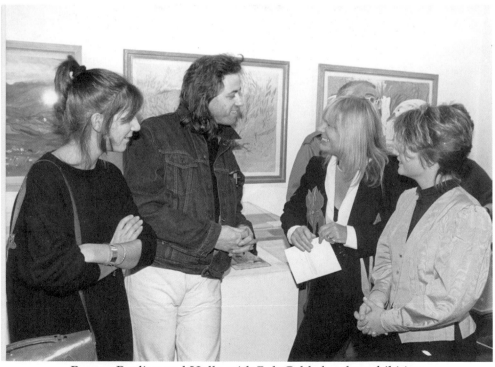

Poppy, Pauline and Holly with Bob Geldof at the exhibition

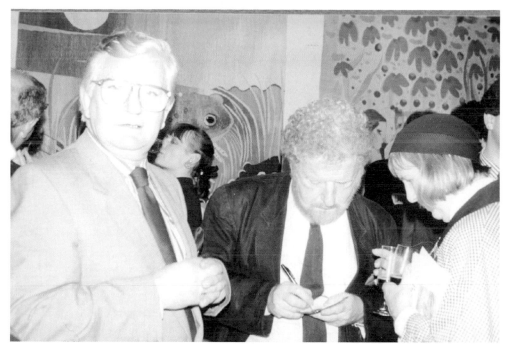

T.P. McKenna (Pauline's colleague from the Pike Theatre in the 1950s), Sam Stephenson
and Peggy Jordan

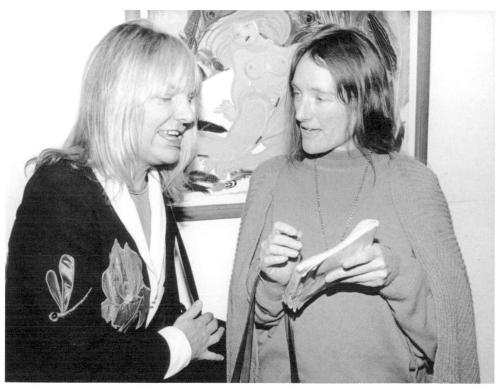

Being interviewed by Philippa Pullar

Back at home in Kerry, with Star and Leo

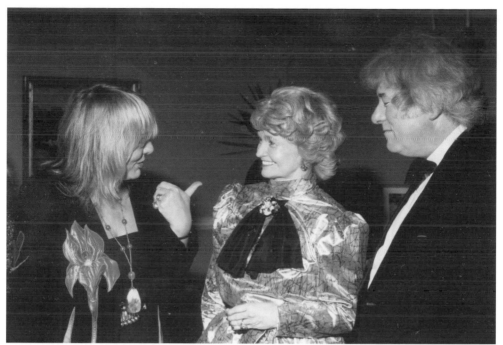

Margaret Heckler, American Ambassador, and Seamus Heaney at a US Embassy dinner

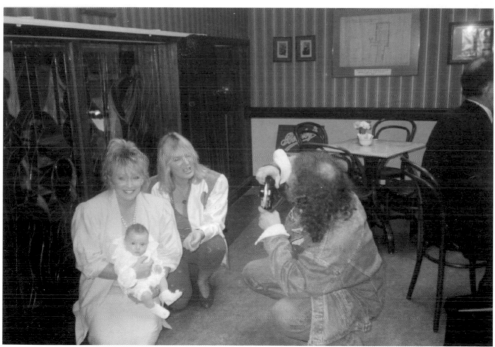

Adele King (Twink), her daughter and David Agnew at Bewley's
with Pauline's stained glass

With family friends Patricia Bianchi and Niall Mac Monagle

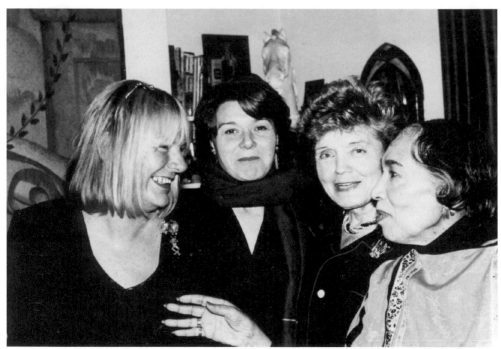

With Barbara Flynn, Sheelagh Fraser and Elizabeth Walsh

In 1989 Sheelagh Fraser threw a party for Pauline before she left for the South Seas, "Oh how I'd love one last fuck before I die!" exclaimed one aged famous actress.

THE SOUTH PACIFIC

Tired of years of constant activity in Ireland, and worried about the state of the world, Pauline fulfilled her desire, nurtured from the 1940s by her mother, to live in the South Seas and to explore if it really was the perfect society. She lived there from 1989–90 and 1991–92.

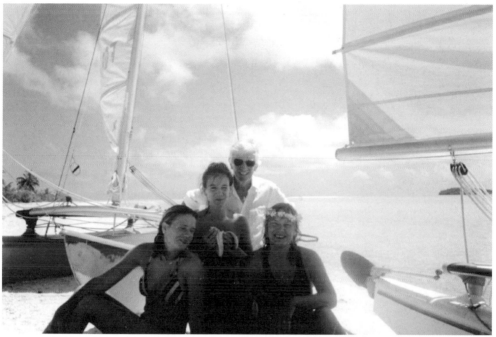

1989: The first trip to the South Pacific

Poppy, their friend Mahi and Holly outside the hut where the family lived

Holly and Poppy were recorded by Raratonga TV
doing the hula dance for tourists on Aitutaki

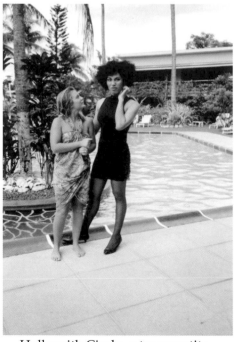

Holly with Cindy, a transvestite

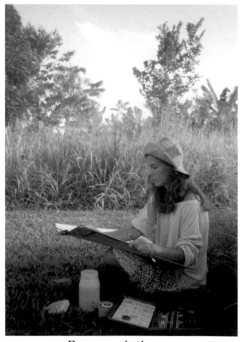

Poppy painting

Molangi, a lady chief on Savai'i, showing her secret thigh tattoos

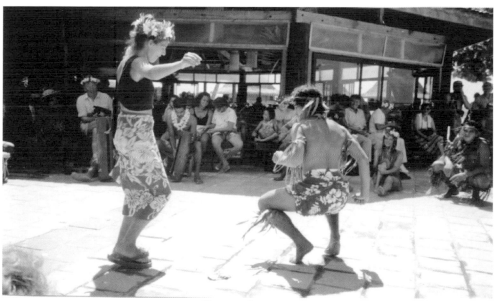

Poppy dancing

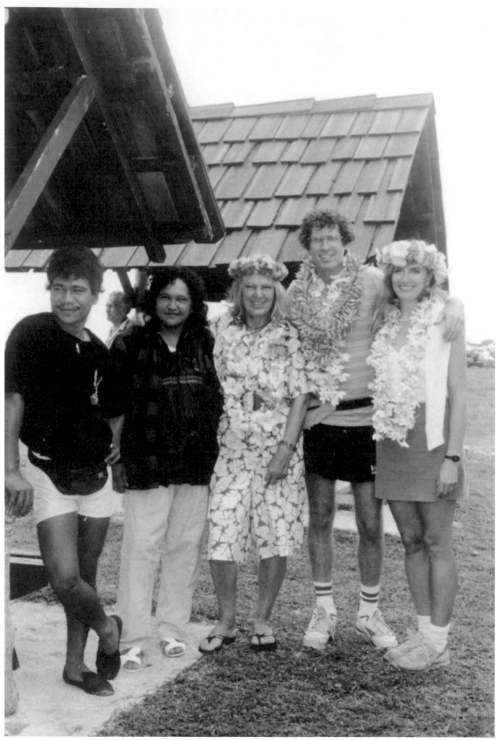

Utanga, his sister Mee and Bob Ruddick and Gery Greer, writers of children's literature from Hawaii who spend months annually in the South Seas

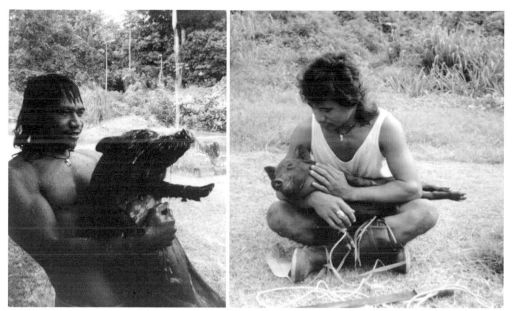

Utanga with a wild pig nicknamed 'Tina Turner'

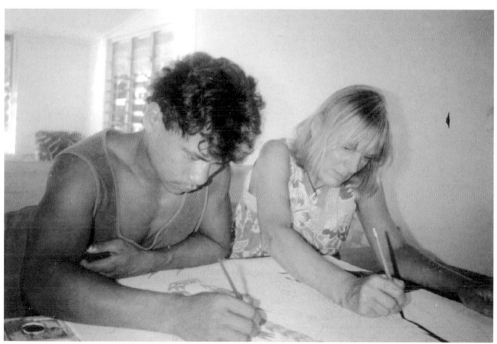

Utanga working on a painting with Pauline

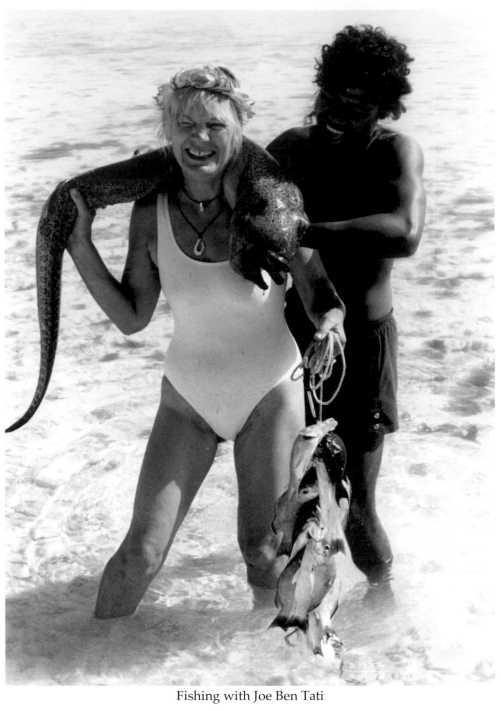

Fishing with Joe Ben Tati

Meeting Emile Gauguin, grandson of the artist

New Zealand Joe, wearing a Yellow Man t-shirt, with Utanga's paintings on wall

Pauline with Nerida de Jong

A chain of islanders checking each others' hair for nits

Pauline and Utanga fishing for dinner

Painting volcanic lava on Savai'i

Visiting on Western Samoa

Pauline dancing with Utanga

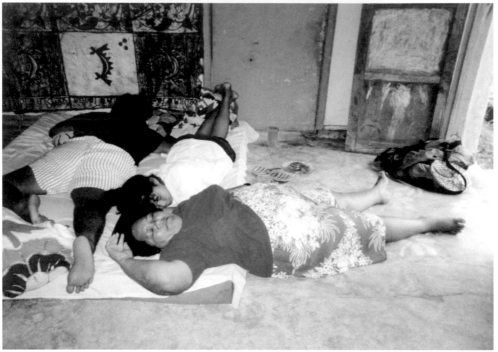

Islanders resting on Pauline's floor, Mo at the fore

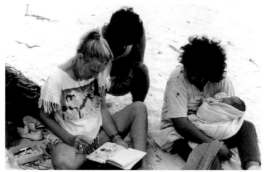

Pauline, Utanga and Mimi with baby on Aitutaki

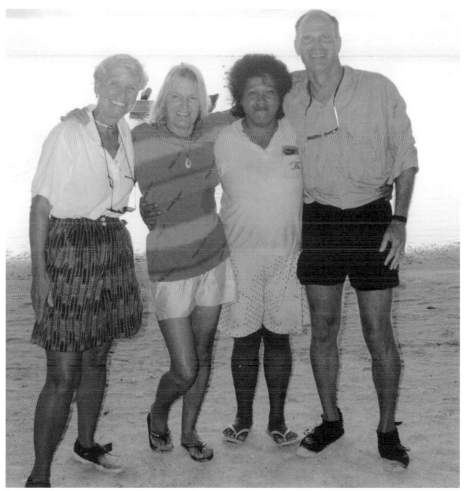

Pauline and Mo meeting Elaine and Jon Krupnick from Florida. Jon is the author of a highly-regarded book, *Pan American's Pacific Pioneers*

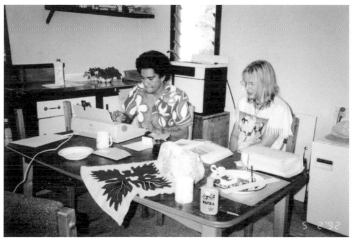

Dictating book *The South Seas and a Box of Paints* to New Zealand Joe

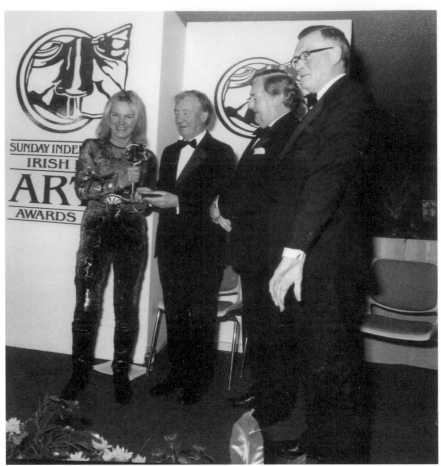

1990: Sunday Independent Irish Arts Awards with Charles Haughey

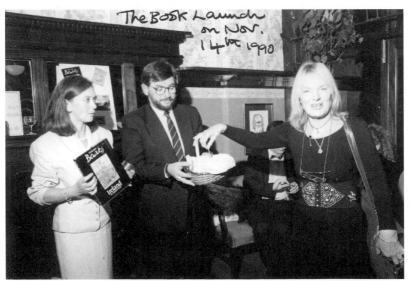

1990: Launch of book *Pauline Bewick's Ireland: An Artist's Year* (Methuen) with Ann Mansbridge, Methuen Editor, and Edwin Higel (rep)

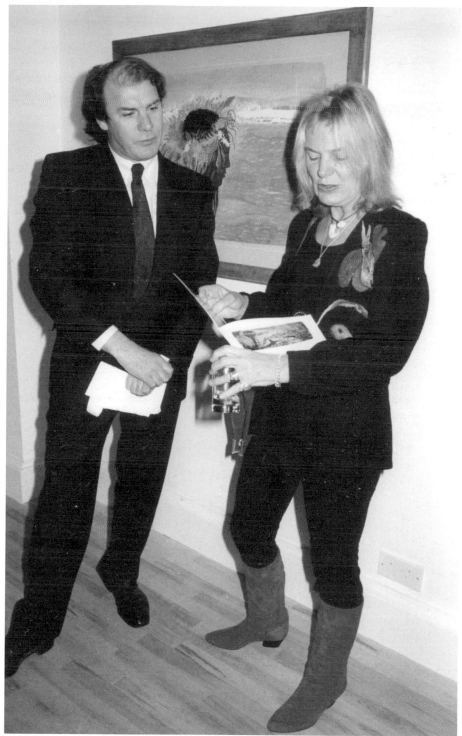

With John Taylor at the Taylor Galleries' South Seas exhibition, 15 November 1990

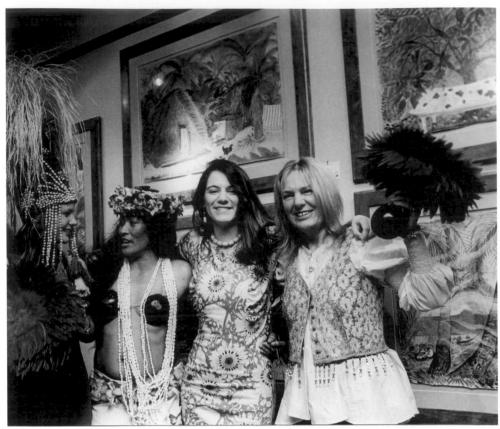

Joint South Seas exhibition with Holly, Poppy and Pauline at the Catto Gallery, London

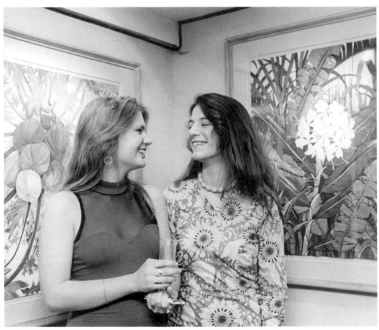

Catto exhibition

1992: At the Chelsea Arts Club on her return from the South Seas

Gino Rosi, the inspiration for the Yellow Man

The Yellow Man window

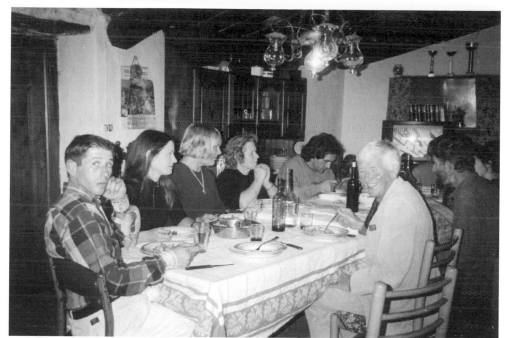

Luca Bellucci, Holly's partner, at his mother Marina's farmhouse with Martsea, his sister and with Donald Hope, their neighbour (and former student of John Watling in London)

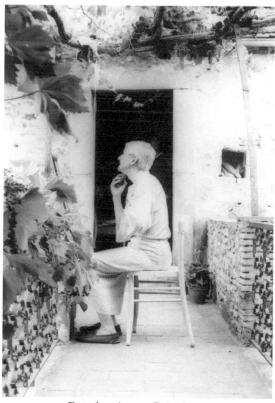

Pat shaving at Bricciano

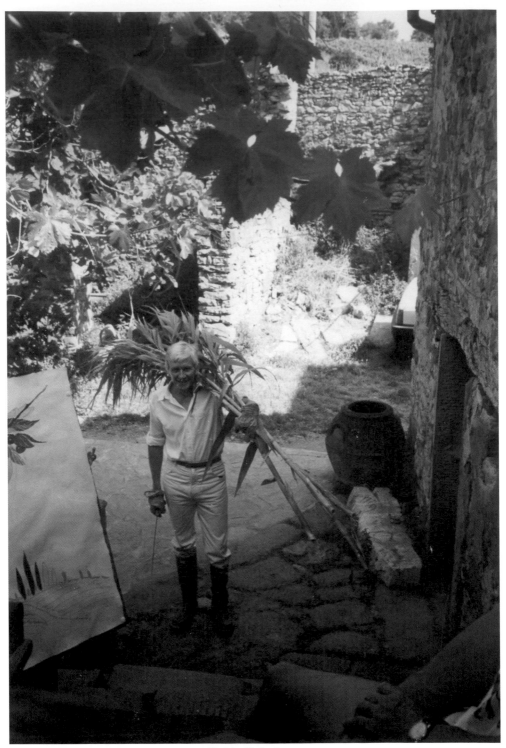

Pat in Bricciano

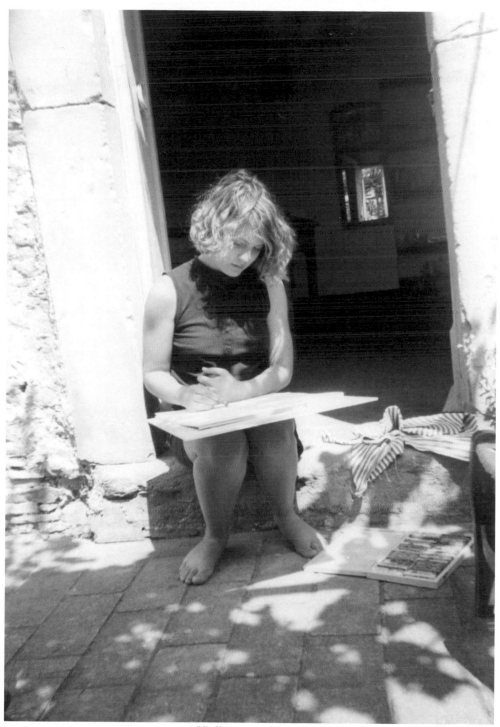

Holly in Bricciano

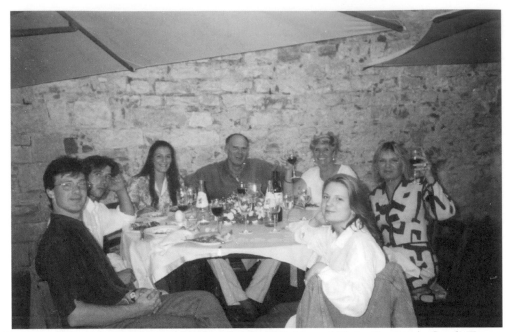

Conor, Luca, Poppy, Pauline and Holly at dinner with Jon and Elaine Krupnick, Gaioli, Tuscany

Kitchen door, Bricciano

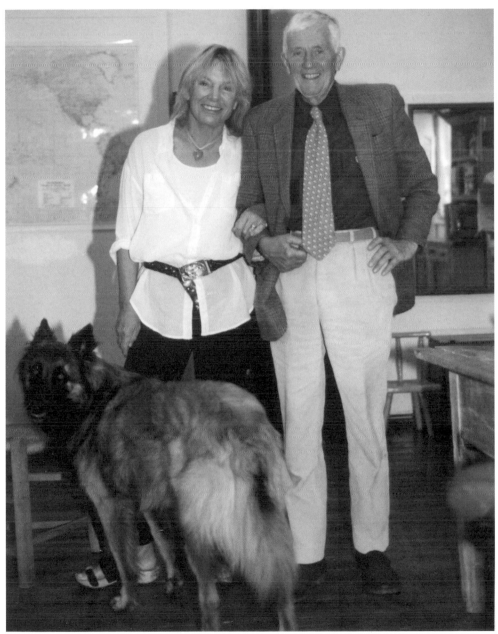

Pauline and Pat, with Leo

1991: Poppy working on fabric design at the Crescent Workshop, Kilkenny

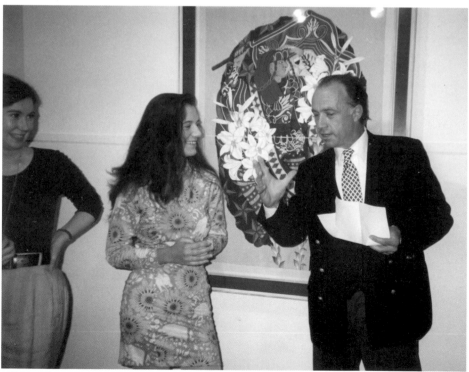

1992: The Prince Colonna Di Stigliano opening Poppy's solo exhibition at the Rubicon Gallery, Dublin, with gallery owner Josephine Kelliher. Poppy's painting 'Palio Man' is in the background.

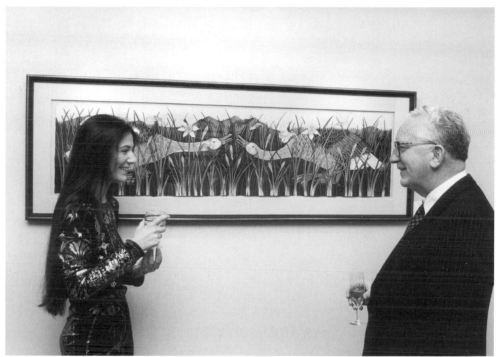

The Irish Ambassador His Excellency Mr Joseph Small with Poppy at the Catto, 1995

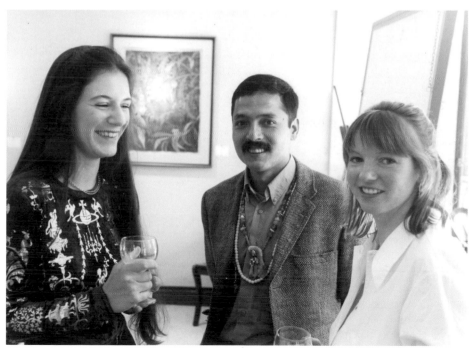

Poppy with Romio Shrestha and Sophie Shaw-Smith at the Catto, 1995

Star and Leo outside Pauline's studio – knowing they cannot walk on the Yellow Man carpet

At the family home at Caragh Lake, Kerry

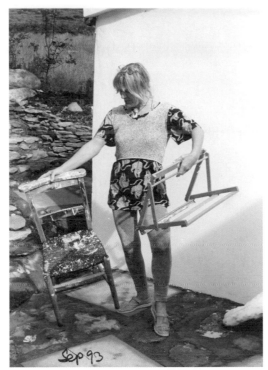

In Kerry, September 1993

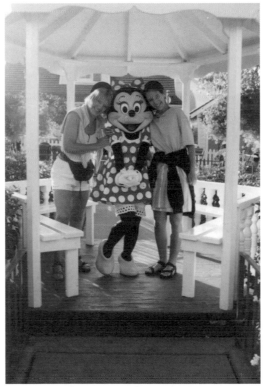

In Florida visiting the Krupnicks, 1994, here on a Disney trip

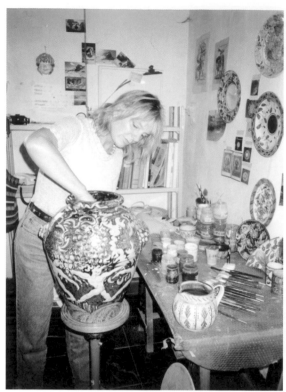

Pauline and Poppy creating ceramics at the Rampini Studio, Tuscany, 1994

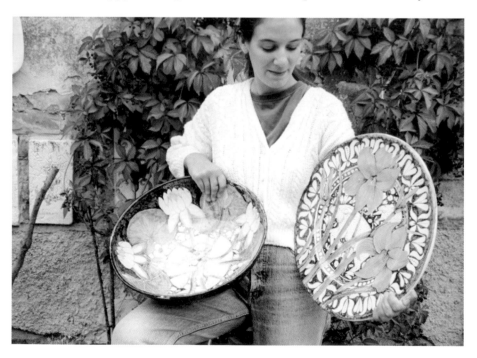

1995: Poppy and Conor's wedding day with Luca and Holly (above) and travelling across Caragh Lake on Dan O'Connor's boats, florally decorated by Rose Cunningham (below)

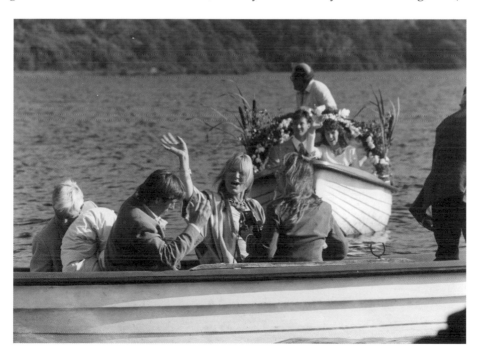

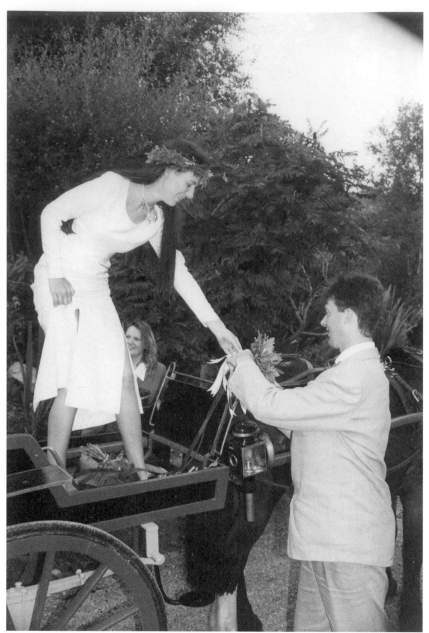

On Pat Griffin's trap up to the family home

Betty O'Shea with Pat and Poppy

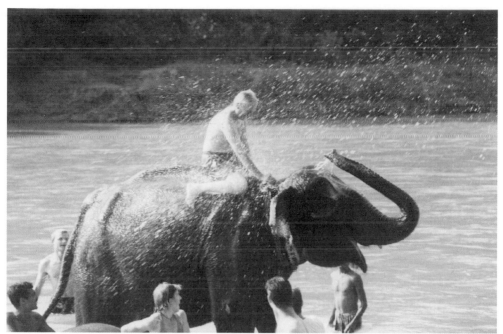

1995: Pat on elephant in Nepal

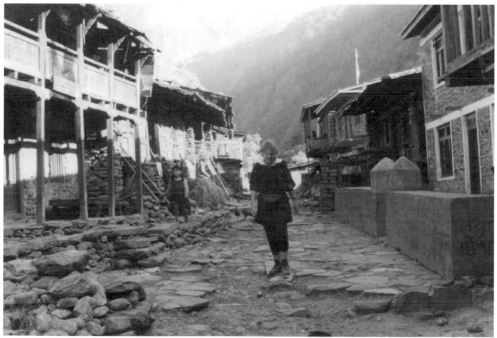

1995: Pauline at Syabru Besi

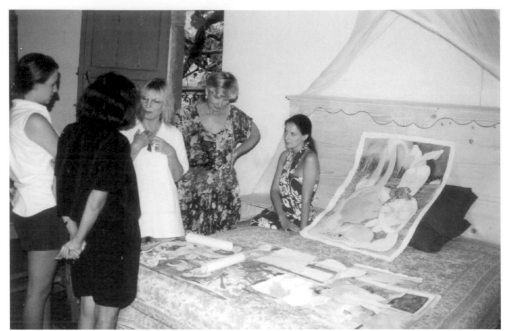

Showing Yellow Man paintings in Tuscany

"Millionaires' Day", Kerry

One man said: "I've 13 grandchildren and I've left
each one 13 million dollars. Isn't that neat?"

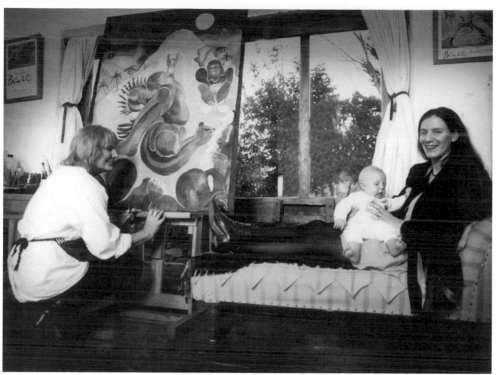

Aran, born 1 November 1996

Aran started painting with Pauline from a young age

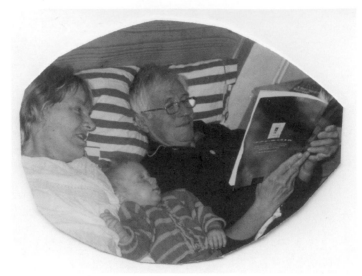

Pat reading *The Yellow Man* to Aran and Pauline

The Bewick Suite at Arbutus Lodge, Cork

Aran with The Yellow Man doll made by Ashling Nelson

1996: The record-breaking Yellow Man exhibition at the Royal Hibernian Academy, Dublin

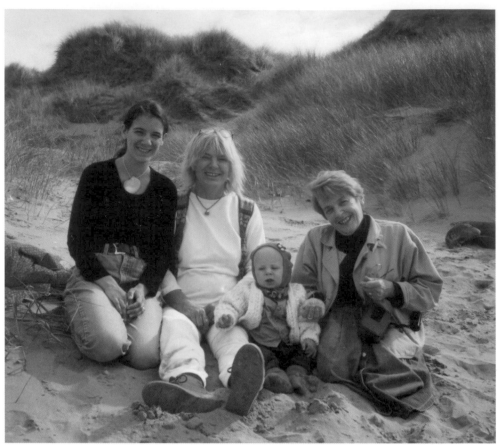

Poppy, Pauline and Aran, with Leslie MacWeeney

Poppy with Hazel and Alen MacWeeney and Bee the dog

Helen, Amanda and Eliza O'Shea, 3 January 1997

Puck Fair, 1997

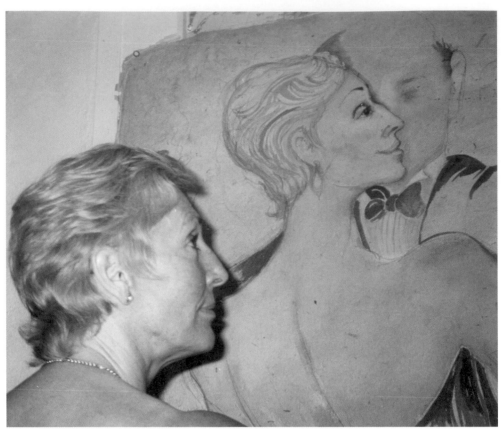

Jackie Dutton, 1998

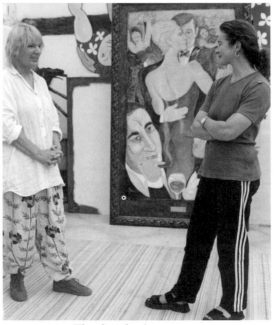

The finished painting

1998: On a skiing holiday to Austria, with Conor, Pat, Holly, Luca's son Matteo, Luca, Poppy and Aran

1998: Washing the car for Holly's wedding

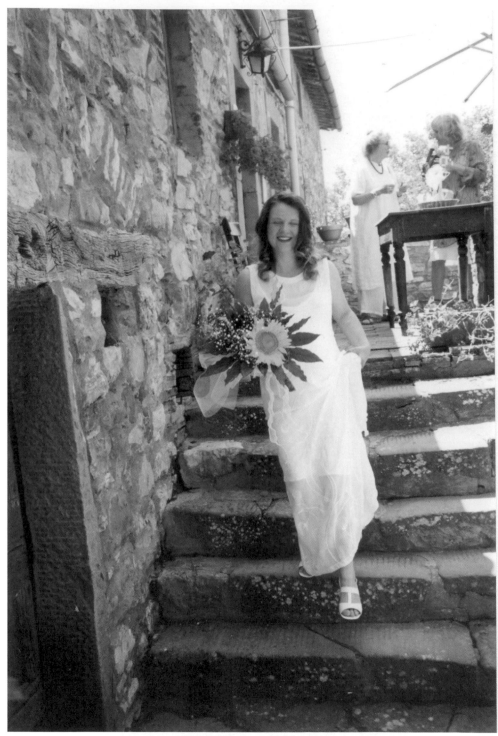

1998: Holly's wedding day

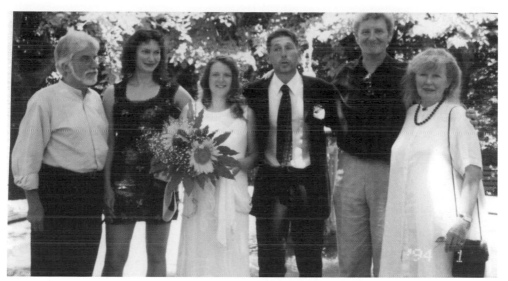

1998: Ed Cowan, Regine Bartsch, Holly and Luca, Mike O'Neill and Nuala Fitzgerald Cowan in Tuscany

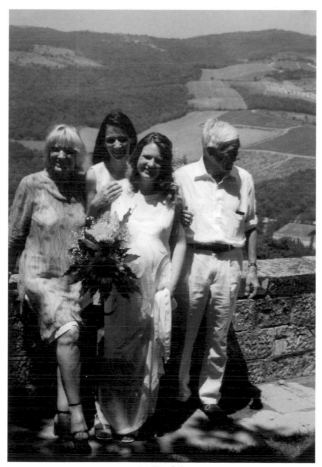

At Radda

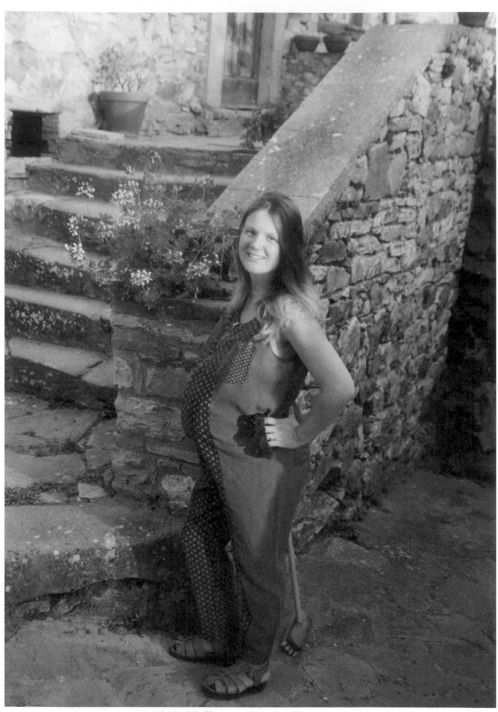

1998: Holly pregnant at Bricciano

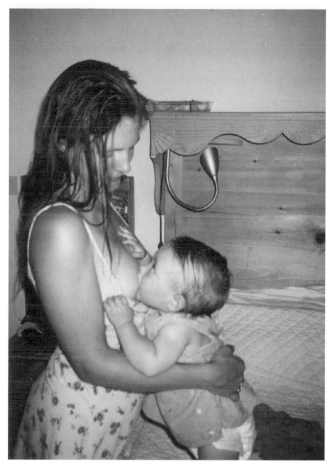

Holly breastfeeding

Pauline did a painting with pupils of Curraheen National School

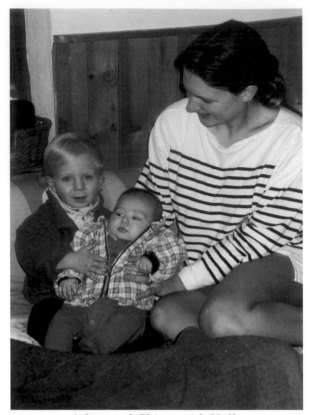

Adam and Chiara with Holly

Friends and neighbours at Pauline and Pat's party: Betty, Regine, Patty, Madeleine,
Annie, Michael, Catherine, Jon, Christy, Poppy, Mick, John and Pat

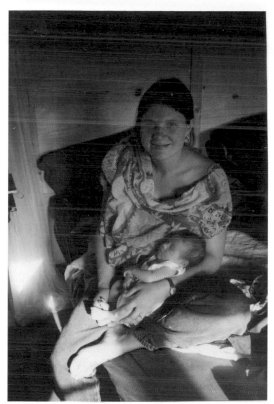

1998: Holly with Chiara

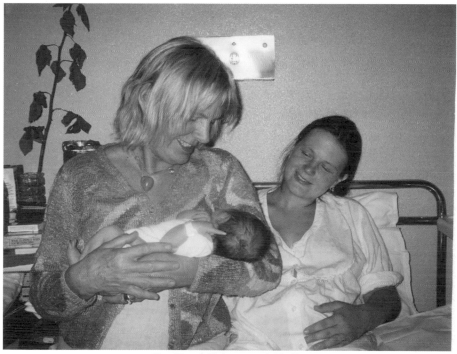

Pauline, Chiara and Holly

Dan O'Connor, neighbour, boatman and stonemason,
with visitors Romio Shrestha and Sinead O'Connor

Helena O'Connor, Pat Piggott and John Piggott, neighbours

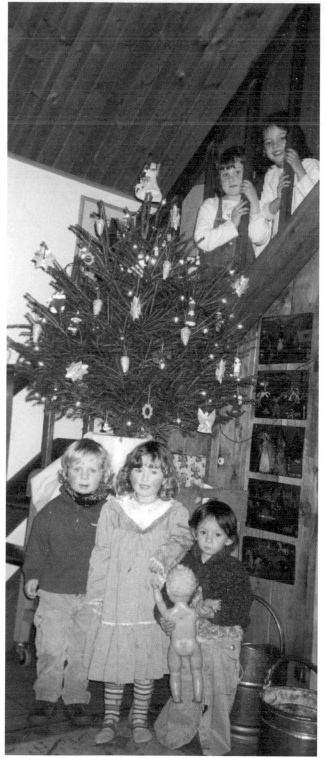

Aran, Róisín, Topaz, Niamh and Amber at the family home

On the right are the wood offcuts that Hazel Bewick painted in Kenmare in the 1940s.

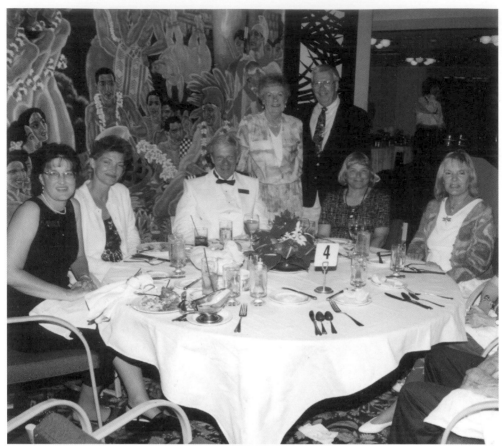

1999: At the Captain's Table on a cruise of the Hawaiian islands

Hawaii 1999: Visiting friends Gery and Bob first met on Aitutaki

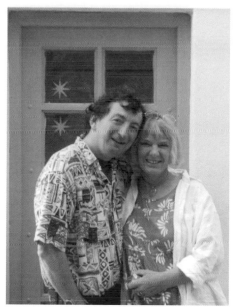

Nutan in Kerry to photograph Pauline for a feature article

1999: Holly introduced the writers Charles and Elizabeth Handy to Pauline and Pat in Tuscany

On a holiday along the west coast of Ireland

Family friends Easkey Britton, her sister and mother NC from Rossnowlagh, Co Donegal

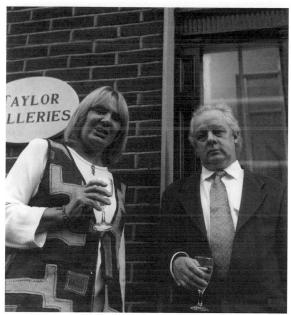

1999: Taylor Galleries exhibition opened by Jim Sheridan

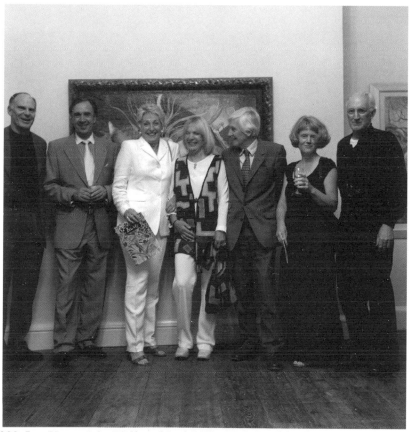

1999: Jon Krupnick, Cliff and Jackie Dutton, Pauline, Pat, Dorothy Smith
and Alen MacWeeney at the Taylor Galleries exhibition

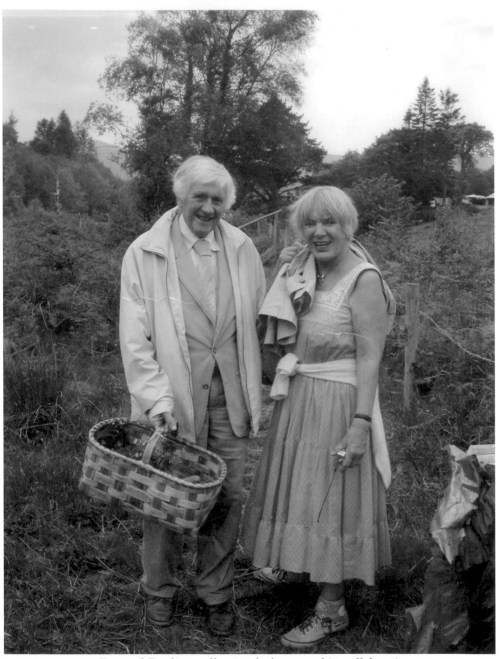

Pat and Pauline collecting boletus and jerroll fungi

2000: Pat skippering in New Zealand

2000: Pat being confronted by a Maori chief in New Zealand

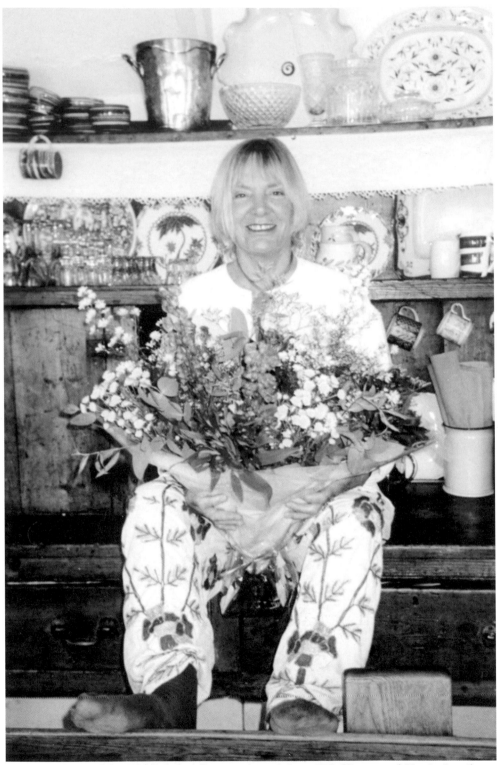

4 September 2000: 65th birthday flowers from Mary O'Sullivan and Kevin Lenihan

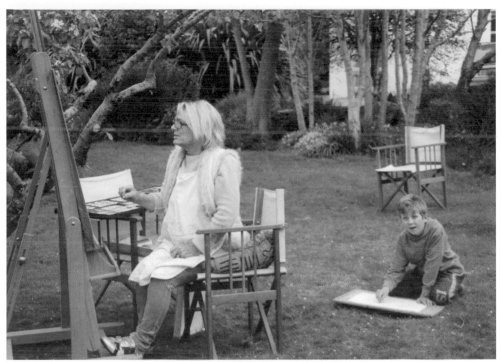

Pauline and Aran painting

Wearing Charles Bird's felt hat

Clare Boylan and Nuala Fitzgerald Cowan

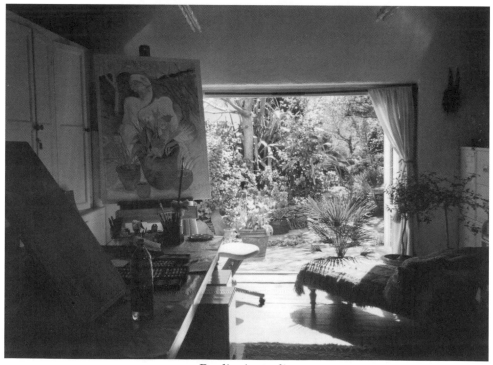

Pauline's studio

2000: Meeting Mo Mowlam

Pauline with Adrienne Foran, award-winning printer of *Pauline Bewick's Seven Ages* paperback (2006), and the hardbacks *Seven Ages* (2005) and *Kelly reads Bewick* (2001) which won the Book of the Year Award and the overall Print of the Year Award.

Visit from Bill Cullen, Norma Smurfit and Jackie Lavin with their pilot

Jackie Lavin in Pauline's studio, with the Yellow Man

Pauline with Sophie Shaw-Smith and Lainie Keogh

The Knight of Glin, Desmond Fitzgerald and Olda admiring a Yellow Man ceramic plate

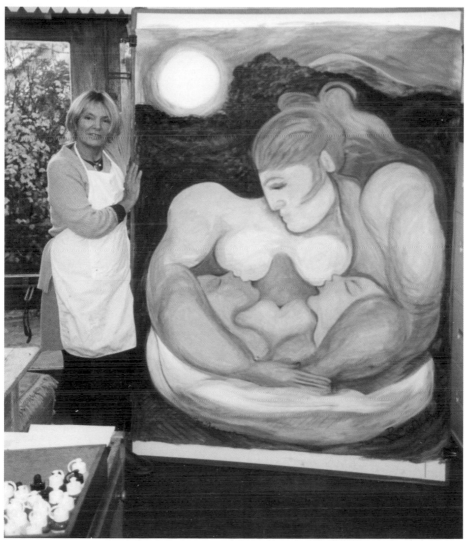

Pauline with 'Mother and Twins'

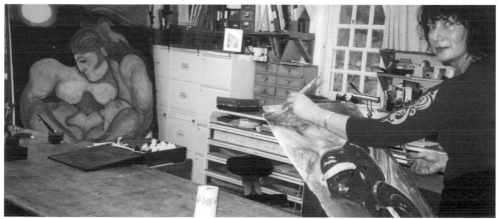

Regine Bartsch painting in Pauline's studio

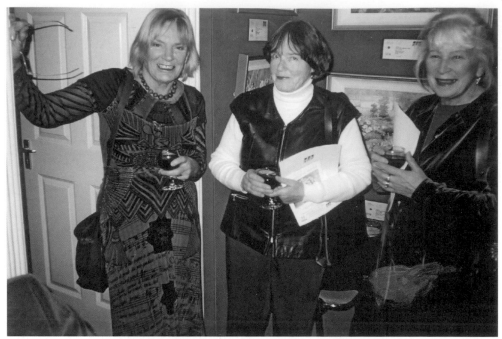

Pauline with Barry Laverty Castle and Hilary Pyle

Pauline's studio

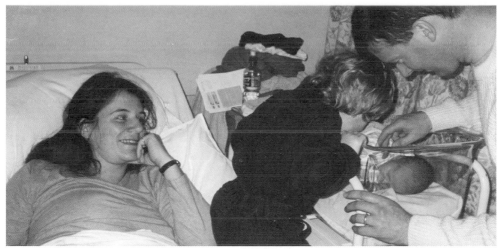

2001: Adam's birth, Poppy, Aran and Conor

July 2001: Visit and art class with the Ryan family from the US

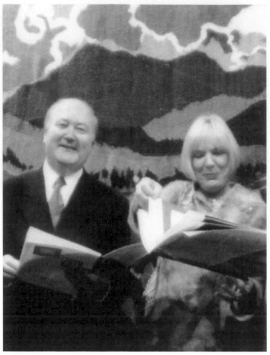

2002: In Tullamore with Conor Brady, editor of *The Irish Times*, opening an exhibition

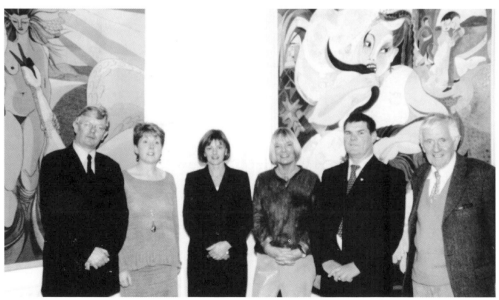

Seamus Hosey opening an exhibition at Heywood Community School, Laois

Dinner party with Clare Boylan, Philip Castle, Pat and Barry Laverty Castle

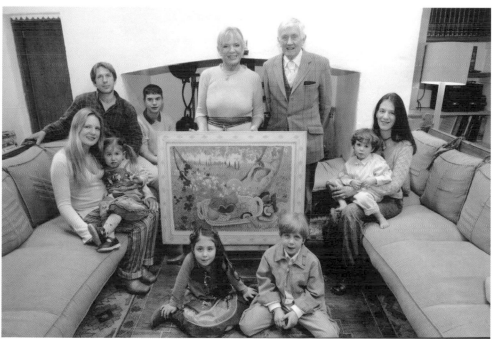

2002: Holly, Giada, Luca, Matteo, Pauline, Pat, Poppy, Adam, Aran and Chiara, with painting 'Holly Pregnant'

April 2002: On the Hudson River, Pauline's first visit to New York

Suitcase painted with New York scenes

Maria Simonds-Gooding purchasing one of Pat's 'primitive' paintings

Visit from relatives from England

Painting the Madonna for
the Killeen on Lady's Island

Edel Connolly, Rita Kelly, Romio Shrestha
trekking the hills of Kerry

July 2002: Boat journey to an island for a picnic lunch and fashion show, with Mary O'Sullivan, Kevin Lenihan, Regine Bartsch, Dan O'Connor, Sophie Shaw-Smith, Antoinette O'Shea, Mike O'Sullivan, Helena O'Connor, Betty O'Shea and Pat Melia

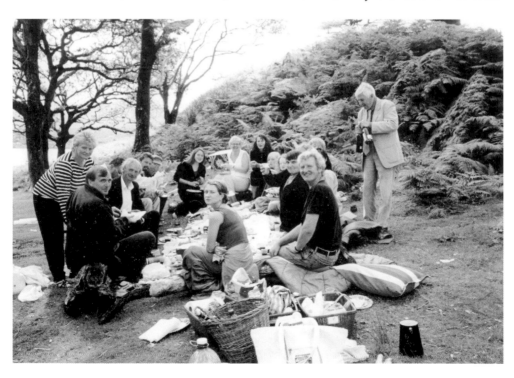

Poppy

Sinead Deignan, UCC, former studio assistant to Pauline

Mary O'Sullivan, Larry Powell and Anne Harris at the Taylor Galleries

Camille O'Sullivan and accompanist at the United Arts Club after exhibition party

Conor Kavanagh, Aengus Fanning and Bill Cullen

Dr Abdul Bulbulia, Maria Simonds-Gooding and Katharine Bulbulia at the Taylor Galleries

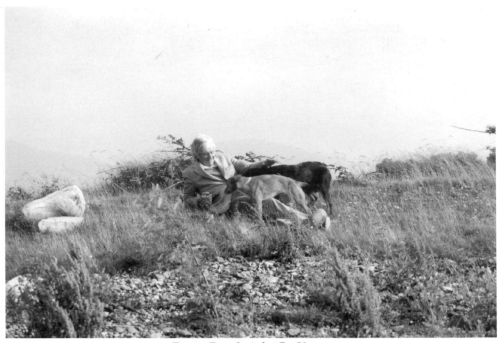

Pat at Rossbeigh, Co Kerry

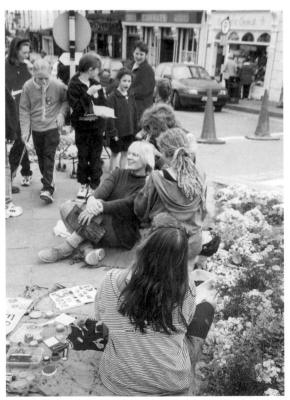

Putting plaits in Pauline's hair at Westport

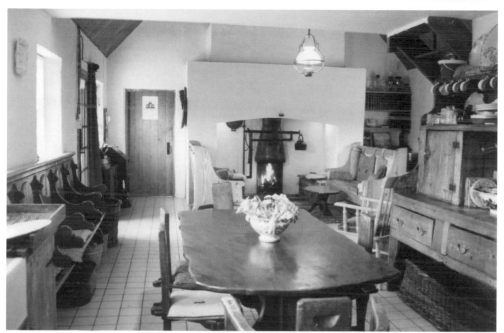

The kitchen and living room at the family home

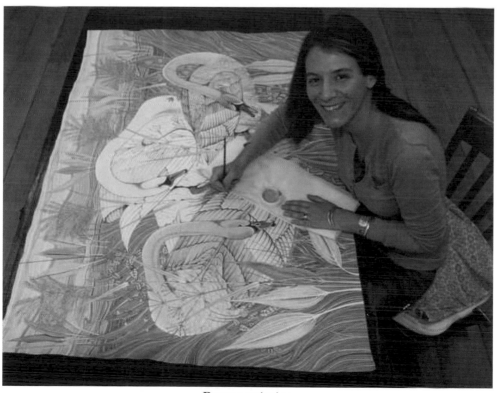

Poppy painting

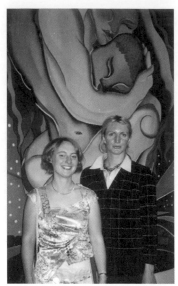

2003: Ruth Lysaght, 'Lovers and Stars' Aubusson tapestry

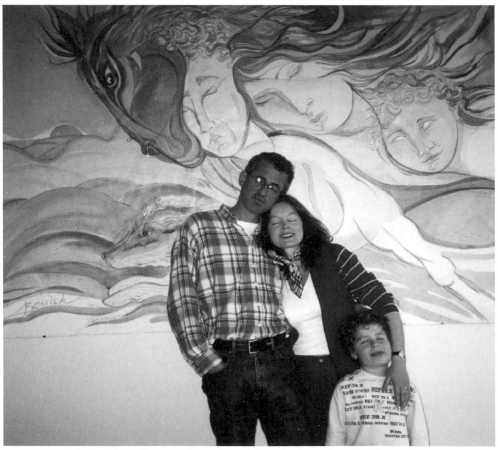

Marie Moynihan and family with painting 'Family Dreaming'

With sketch book in hand

2005: Pauline in Paris, pastel painting Notre Dame

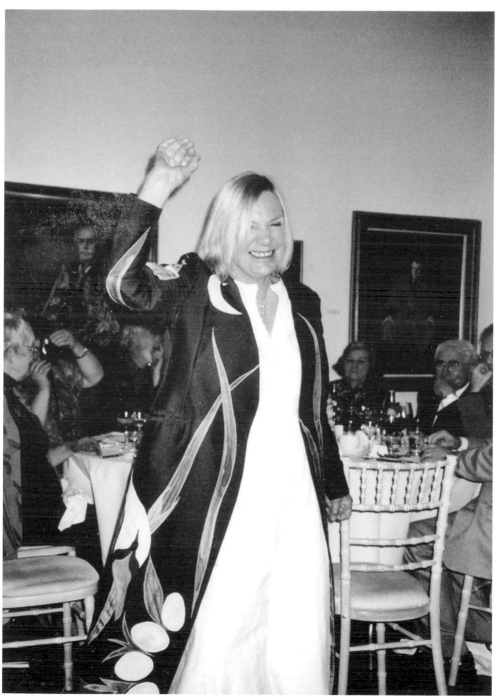

At the Royal Hibernian Academy dinner

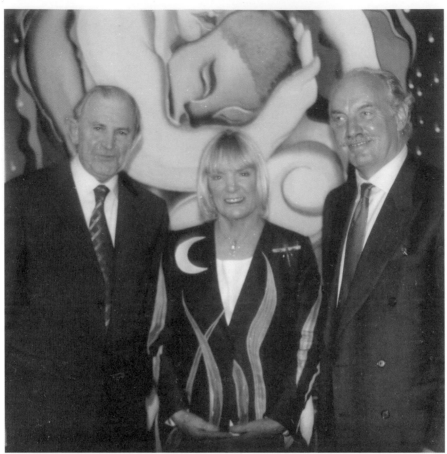

2005: Cork exhibition hosted by Owen O'Callaghan and opened by Dermot Desmond

2005: Pauline, Sydney, Nina, Poppy, Easkey, Mike, Regine and Pat at Ballymaloe

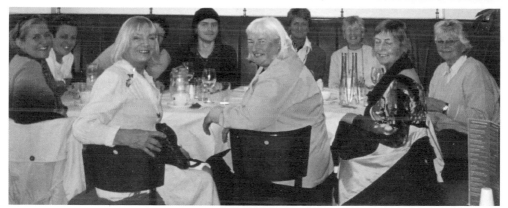

2005: After exhibition dinner at Luigi's restaurant, Cork, with Nina Finn-Kelcey, Edel Connolly, Rita Kelly, Chris O'Connor, Kate Landers, Marie-Clare Stacey and Monica Phelan

Adam

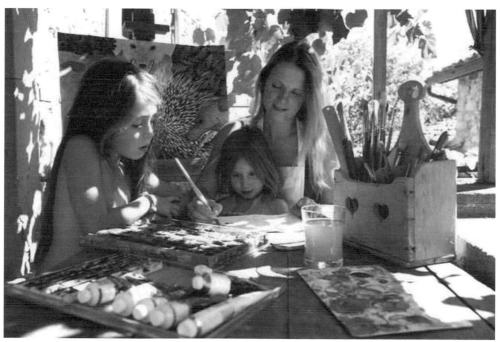

2005: Chiara, Giada and Holly at Bricciano, Tuscany

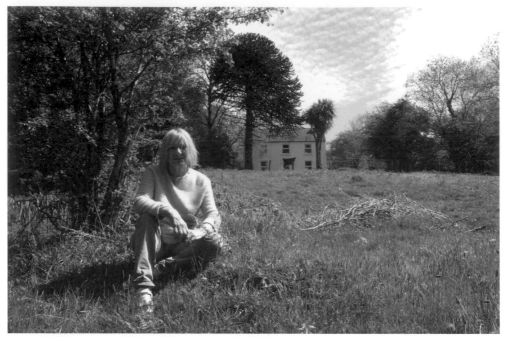

2005 at Cillah East, the house where they lived in the 1930s and 1940s

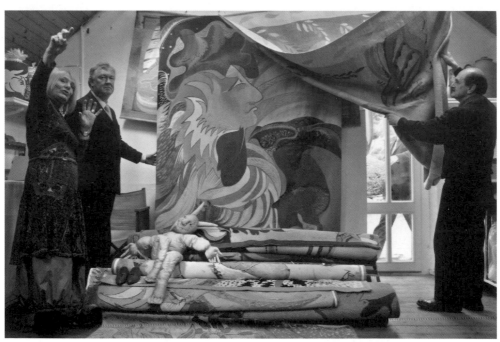

Martyn Bell, artist, showing John O'Donoghue, TD, Minister for Arts, some of the art Pauline was to donate to the Irish State

Antoinette O'Shea, Pauline and Pat Kenny in the RTÉ green room after the *Late Late Show*

Marguerite Grey, Mairead McLoughlin and Bernie McGrath at the Abbey Theatre launch, by poet Cathal Ó Searcaigh, of Pauline's *Seven Ages* 70th birthday retrospective book

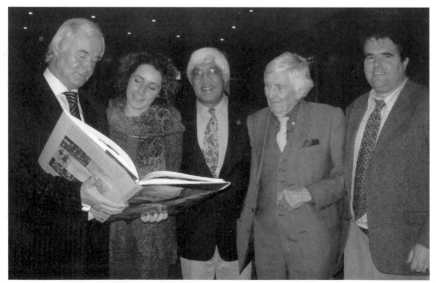

Minister John O'Donoghue at the Abbey Theatre admiring *Seven Ages* with Claire Keegan, Dr Abdul Bulbulia, Dr Pat Melia, and Pat Keegan of Solo Arte

Kenmare 2005: With the children of Michael O'Shea, whom Harry fostered in Kenmare in the 1930s and 1940s, at Gerry O'Shea's Prego restaurant

With Tim Goulding, artist

Josephine Vahey, Jay Murphy and Brian Bourke at the Galway City Library launch of *Seven Ages*

September 2006: Rossbeigh races when Pauline was president

2006: Holly, Giada and Chiara visiting Kerry

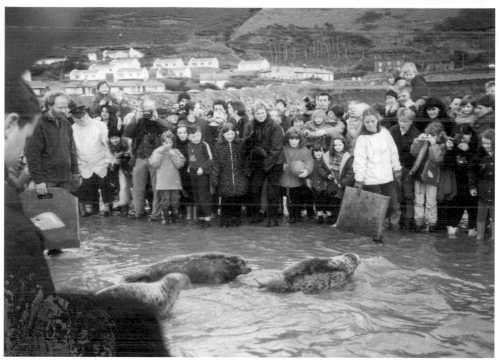

Saving the seals at Rossbeigh

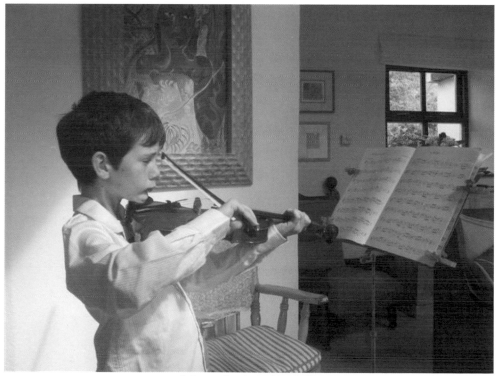

Adam playing the violin

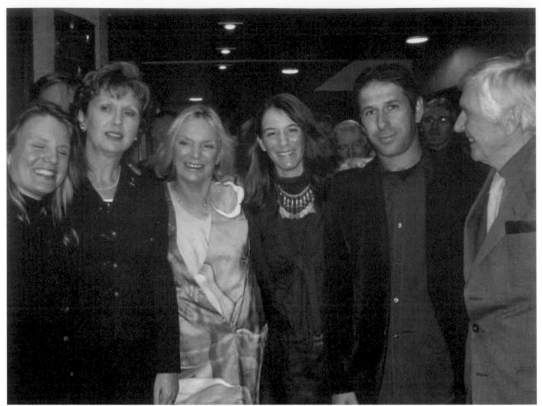

2006: President Mary McAleese opening the Waterford 'Seven Ages' collection,
with Holly, Pauline, Poppy, Luca and Pat

Wearing Ann Kearn's Life Coat

December 2006: Family visit to the South Seas
Pauline with Adam;
Pauline meeting another Pauline, named after her;
Aran and Chiara at Moorea, Tahiti

December 2006: Family visit to the South Seas;
the huts where they stayed,
Luca;
Chiara, Aran and Pauline painitng on Moorea

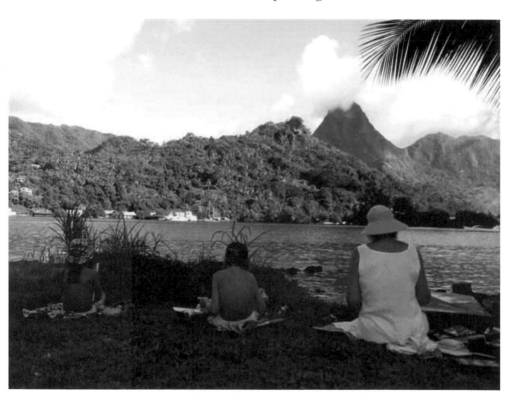

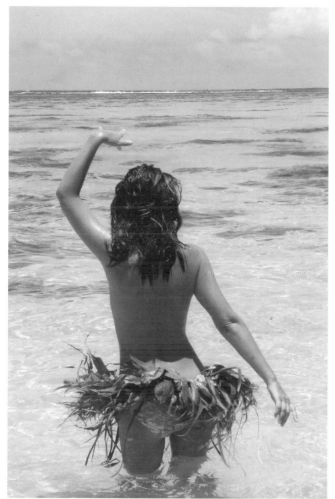

2006: Poppy at forty

Conor and Pat

2007: In front of a Bewick wall-hanging at the National Concert Hall wearing Ann Kearn's Yellow Man coat; Sitting in the Merrion Hotel, under her Tahiti painting

Pauline and Rosaleen Lenehan at the Chester Beatty raising money for charity

2007: The Midnight Court: Wearing the gold frog found under a stone in 1940s Kenmare
With Evelyn Byrne and Professor Kieran Byrne at the Shelbourne launch

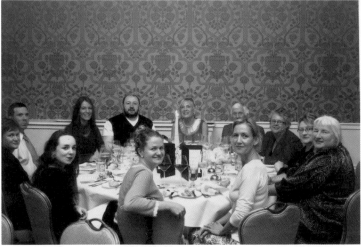

Ann Kearns, Conor, Poppy, Alan Hayes, Pauline, Pat, Mary Paula Walsh, Kay Conroy,
Kate Landers, Nina Finn-Kelcey, Sydney, and Sadbh McCormack

May 2007: Giada and Bambi

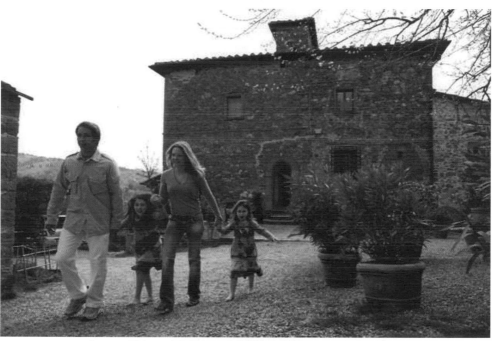

Luca, Chiara, Holly and Giada, at Bricciano, Tuscany

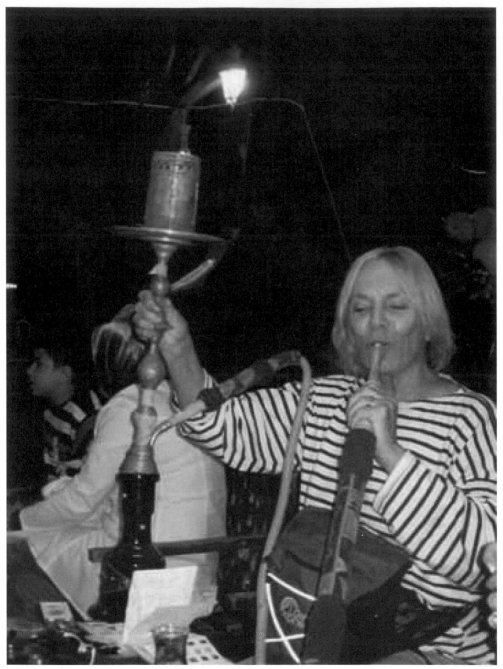

2008: Turkey

2008: Istanbul

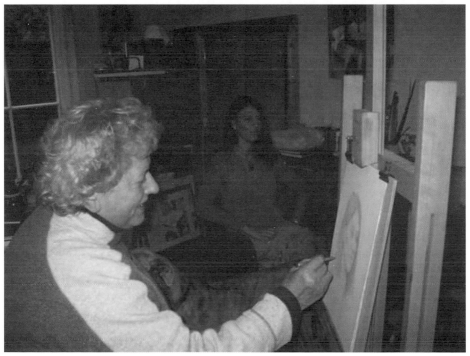

Poppy being painted in 2008 by Benita Stoney, award-winning portrait painter

2008: Holly's family holiday to the Seychelles

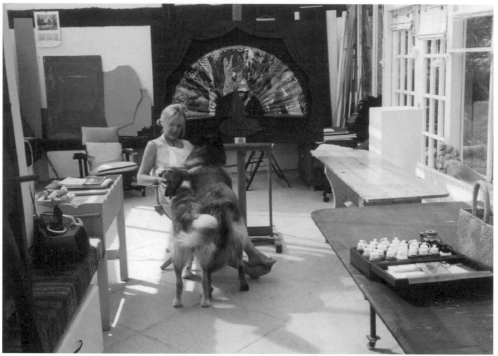

One of the set designs for 'Five Fans for Alma'

Pauline created the concept for an opera based on Kokoschka's love for Alma Mahler. It is currently being produced by Ethna Tinney.

2008: Rolling in the mud flowing out of Holly's new well which was being dug that day

2009: Carnevale

2009: China

Walking the Great Wall

December 2009: Monte Carlo, Monaco

At the Angel Film Awards where Noel Kearns' film, 'The Enchanted Island' was awarded a prize. Pauline has admired his work since seeing his short film 'The Cleaner'.

'Woman Awake', designed by Ann Kearns

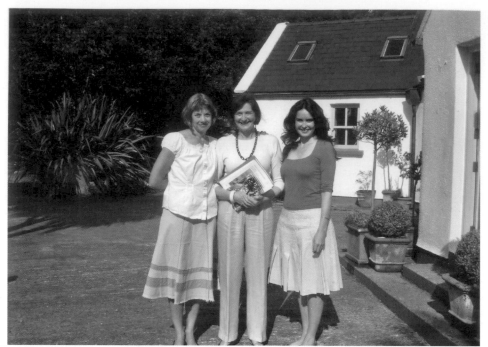

Hazel MacWeeney, Maureen Ryan, Friends of the National Gallery, and Audrey Ryan

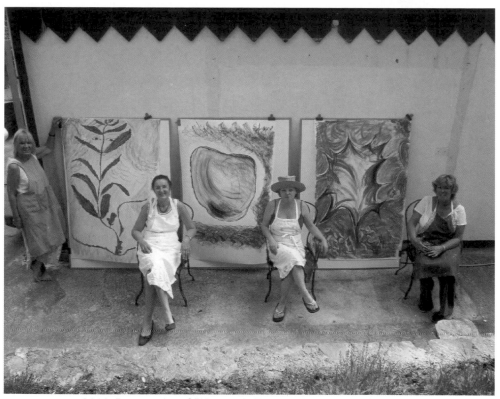

2010: International Women's Forum art sessions in Kerry
with Maureen Gaffney, Helen Shaw and Caroline Preston

Pauline tells Buddha tales with the grandchildren

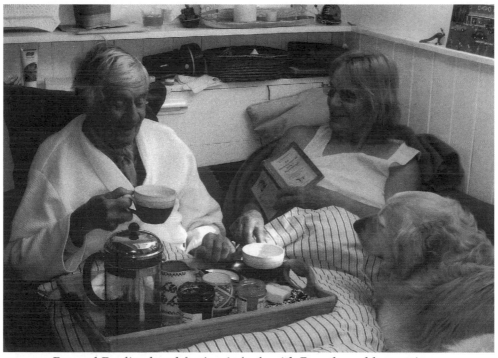

Pat and Pauline breakfasting in bed, with Ben, the golden retriever

The painting continues daily

INDEX

SOURCE BOOKS AND COLLECTIONS OF DOCUMENTS

C. Booth, *Life and Labour of the People of London* (1902–3)

E. Chadwick, *Report on the Sanitary Condition of the Labouring Population of Great Britain 1842* (reprinted Edinburgh, 1965, ed. M. Flinn)

S.G. Checkland and E.O.A. Checkland, *The Poor Law Report of 1834* (Penguin, 1974)

B.S. Rowntree, *Poverty: A Study of Town Life* (1902)

E.P. Thompson and E. Yeo (eds), *The Unknown Mayhew: Selections from the Morning Chronicle 1849–50* (Merlin Press, 1971)

S. Webb and B. Webb, *English Poor Law History* (reprinted Cass, 1973)

PERSONAL ACCOUNTS AND CONTEMPORARY FICTION

C. Dickens, *Hard Times* (OUP, 1989)

E. Gaskell, *Mary Barton* (Penguin, 1970)

P. Keating (ed.), *Into Unknown England 1866–1913* (Fontana, 1976)

J. London, *People of the Abyss* (Panther, 1963)

M.P. Reeves, *Round about a Pound a Week* (Virago, 1979)

R. Roberts, *The Classic Slum: Salford Life in the First Quarter of the Century* (Penguin, 1990)

F. Thompson, *Lark Rise to Candleford* (Penguin, 1973)

R. Tressell, *The Ragged Trousered Philanthropists* (Grafton, 1965).

HEINEMANN ADVANCED HISTORY

M. Brown and N. Madge, *Despite the Welfare State* (London, 1882)

W.H. Burn, *The Age of Equipoise* (Allen & Unwin, 1882)

K. Coates and R. Silburn, *Poverty: The Forgotten Englishmen* (Penguin, 1970)

F. Crompton, *Workhouse Children: Infant and Child Paupers under the Worcestershire Poor Law 1780–1871* (Alan Sutton, 1997)

M.A. Crowther, *The Workhouse System* (Methuen, 1981)

A.V. Dicey, *Law and Public Opinion in England during the Nineteenth Century*, 2nd edn (Macmillian, 1914, rev. 1962)

D. Englander, *Poverty and Poor Law Reform in Nineteenth-century Britain 1834–1914* (Longman, 1998)

D. Englander, and R. O'Day (eds), *Retrieved Riches: Social Investigations in Britain 1840–1914* (Ashgate, 1995)

E.J. Evans, *Social Policy 1830–1914* (Routledge & Kegan Paul, 1978)

S. Fowler, '"Draining the Bog": Charities and the Poor in the Nineteenth Century', *Modern History Review* (April, 1998)

D. Fraser, 'Poor Law Politics in Leeds' *Publication of the Thoresby Society*, 53 (1970)

D. Fraser, *The Evolution of the British Welfare State* (Macmillan, 1973)

E. Halévy, *The Growth of Philosophical Radicalism* (Faber, 1924, Eng. transn, 1928)

G. Himmelfarb, *Poverty and Compassion* (Knopf, 1992)

W.C. Lubenow, *The Politics of Government Growth* (Newton Abbot, David and Charles, 1971)

P.R. Hastings, *Poverty and the Poor Law in the North Riding of Yorkshire 1780–1837* (University of York Borthwick Institute of Historical Research, 1982)

G. Himmelfarb, *The Idea of Poverty* (Vintage, 1984)

K. Laybourne, *The Evolution of British Social Policy and the Welfare State* (Keele University Press, 1995)

O. MacDonagh, 'The Ninetenth Century Revolution in Government: A Reappraisal', *Historical Journal*, (1958)

E. Midwinter, *The Development of Social Welfare in Britain* (OUP, 1994)

H. Parris, 'The Nineteenth Century Revolution in Government: A Reappraisal Reappraised' *Historical Journal*, 3 (1960)

D. Roberts, *The Victorian Origins of the British Welfare State* (Yale University Press, 1960)

R.H. Tawney, *Religion and the Rise of Capitalism* (Penguin, 1938)

P. Thane, 'Women and the Poor Law in Victorian and Edwardian England' *History Workshop Journal*, 6 (1978)

P. Thane, *Foundations of the Welfare State* (Longman, 1982)

E.P. Thompson, *The Making of the English Working Class* (Gollancz, 1963)

G. White (ed.), *In and Out of the Workhouse: The Coming of the New Poor Law to Cambridgeshire and Huntingdonshire* (Ely, 1978)

K. Williams, *From Pauperism to Poverty* (Routledge & Kegan Paul, 1978)

P. Wood, *Poverty and the Workhouse in Victorian Britain* (Sutton, 1991)

Bibliography

Many books have been written on poverty, the Poor Law and public health, and the following titles are recommended as being particularly useful. They have been divided into three sections to relate to the three sections of the book. However, these are not intended to be discrete: books recommended for the AS sections could be used at A2 and vice versa.

AS SECTION: POVERTY AND THE POOR LAW, 1815–1914

A. Brundage, *The Making of the New Poor Law* (Hutchinson, 1978)
F. Crompton, *Workhouse Children* (Sutton, 1997)
J.R. Hay, *The Origins of the Liberal Welfare Reforms 1906–1914* (Macmillan, 1975)
P. Horn, *The Victorian Town Child* (Sutton, 1997)
N. Longmate, *The Workhouse* (Temple Smith, 1974)
E. Midwinter, *Victorian Social Reform* (Longman, 1968)
J.D. Marshall, *The Old Poor Law 1795–1834* (Macmillan, 1968)
M.E. Rose, *The English Poor Law* (David & Charles, 1971)
M.E. Rose, *The Relief of Poverty 1834–1914* (Macmillan, 1972)
J.T. Ward (ed.), *Popular Movements 1830–59* (Macmillan, 1970)

AS SECTION: PUBLIC HEALTH, 1815–75

M. Flinn, *Public Health Reform in Britain* (New York, 1968)
S. Halliday, *The Great Stink of London* (Sutton, 1999)
N. Longmate, *King Cholera* (Hamish Hamilton, 1966)
N. Longmate, *Alive and Well: Medicine and Public Health 1830–the present day* (Hamish Hamilton, 1970)
E. Midwinter, *Victorian Social Reform* (Longman, 1968)
J.T. Ward (ed.), *Popular Movements 1830–50* (Macmillan, 1970)
A.S. Wohl, *Endangered Lives: Public Health in Victorian Britain* (Dent, 1983)

A2 SECTION: SOCIAL POLICY AND DEBATE, 1815–1948

M. Blaug, 'The Myth of the Old Poor Law and the Making of the New', *Journal of Economic History*, 23 (1963)
H.M. Boot, 'Unemployment and Poor Law Relief in Manchester 1845–59', *Social History*, 15 (1990)
R. Boyson, 'The New Poor Law in North East Lancashire 1834–71' *Transactions, Lancashire and Cheshire Antiquarian Society*, 70 (1960)

3 With reference to these three sources and to your own knowledge, consider the view that 'Little was done by local authorities to improve public health before 1875 because without scientific advancements nothing could be done.'

(20)

How to answer this question. The question is asking you to show your understanding of the issue of public health reform, based on the extracts, and using your own knowledge.

- Source A suggests that steps were being taken to improve public health although these steps were not always fully recognised by contemporaries.
- Source B suggests that little was achieved until flushing lavatories were widely used. This implies that a scientific understanding of the benefits of carrying sewage away was necessary before progress could be made.
- Source C suggests that the real barrier to improvements was not a lack of scientific knowledge but the power of vested interests.

Your own knowledge should be based on Chapters 10, 11 and 12, as well as Section 3.

Remember always to use your own knowledge and to refer to the sources in your answer.

- Decide whether or not you agree with the quotation, or whether you think the issue was more complicated than a straight 'Agree'/'Disagree'.
- Plan a line of argument, or linked series of points, you want to make in your answer.
- Select, from the sources and from your own knowledge, relevant material to back the points you are making. In making this selection, you must show that you understand the demands of the question. In other words, it must all be relevant to the question you have been asked to answer.
- Aim for creating a synthesis between the sources and your own knowledge.
- Come to an independent judgement that you can sustain; it must be more than a simple assertion.

> 1 Study Source A and use your own knowledge. How valid is Asa Briggs'
> opinion about sanitary reform at this time? (10)

How to answer this question. The question is asking you to evaluate Asa Briggs'
interpretation of the sanitary reform scene in the 1840s by testing it against your own
knowledge of the situation.

- Avoid simply summarising the extract and/or the interpretation it contains.
 Show that you appreciate that Briggs is only writing about Manchester and is not
 focusing on the impact of national legislation in this period.
- The best answers will be analytical throughout: aim for this and range as widely as
 you can in your evaluation of Briggs' interpretation. Economic, political and social
 perspectives are all relevant here. You might point out, for example, that legislation
 was piecemeal and limited; that most legislation was permissive; and that
 conditions were still determined by individual and group vested interests.
- Remember to support what you say with factual detail, either supporting Briggs or
 showing where his interpretation (in this extract) is deficient.

> 2 Study Source C and use your own knowledge. How useful is Source C to
> an historian of public health? (10)

How to answer this question. The question is asking you to evaluate Source C for
utility (usefulness) and to relate this to how an historian might use the source and
what problems he or she would be likely to encounter.

- Remember that utility and reliability are linked but they are not the same. An
 historian can find both reliable and unreliable sources useful because they tell, for
 example, things about the author and what he or she believed or wanted to express
 about a person, event or situation even when they are not reliable sources of
 information about the situation itself.
- Avoid simply describing the source. You will need to explain its meaning, but
 embed this in showing what point the cartoonist is trying to make. For example,
 the cartoon suggests that aldermen were wholly against reform and that the good
 intentions of the Commissioner of the Board of Works were likely to come to
 nothing. But this could be a distorted view and this could, or could not, be of use
 to the historian.
- Use your analysis of both the content of the source and the argument of the
 cartoonist to form a judgement about 'How useful?'
- Consider the point that this cartoon is one person's perspective of a particular
 attempt to bring about public health reform. It may be selective in its focus in
 order to be humorous and entertain the readers of *Punch*, rather than dealing with
 the wider issues.

SANATORY MEASURES.

LORD MORPETH THROWING PEARLS BEFORE ———— ALDERMEN.

Cartoon entitled 'Sanatory Measures' which appeared in 'Punch' in 1848.

Questions

Before answering these questions, you should read Section 3 'To what extent were the obstacles to the establishment of a public health system in the nineteenth century philosophical or practical?' and Section 4 'Nineteenth- and twentieth-century social reform: from laissez-faire to collectivism?', and, where you need clarification of the arguments and factual underpinning, refer back to the relevant material in the AS part of the book.

Remember that all these questions require you to use both your knowledge and the sources in your answer. The best answers will blend the two in an informed way to present an argument or make a case.

discuss how far government policies in response to substantial and long-term unemployment from the 1920s reflected caring or informed attitudes.

- The best answers will make a sustained argument from both the sources and from your own knowledge and will concentrate very clearly on the quotation in the question. Here you should make explicit reference to governments' understanding of the reasons for changing attitudes (for example, concerns for specific groups, concerns about economic waste, findings of scientific research, political pressures from a larger and better informed electorate).

Sources-based questions in the style of AQA

Source A

Writers like Carlyle, Mrs Gaskell and Engels underestimated the significance of the changes in local government which gave Manchester its first borough council in 1838. They ignored many of the manifestations of increasing interest in local reform which led the Manchester Improvement Committee in 1844 to describe the health and comfort of the working classes in the worst areas of Manchester as a subject of vital importance. By means of such measures as the Borough Police Act of 1844 and the Sanitary Improvement Act of 1845, Manchester was drafting, however inadequately, a local sanitary code and was giving a lead to most of the other large towns in the country.

From Victorian Cities *by Asa Briggs, published in 1963.*

Source B

In Leeds the mortality rate failed to fall before the mid-1870s. The sewerage system had little impact upon sanitary conditions until the 1880s when the number of water closets in use began to increase considerably. Undoubtedly, the council's spirited defence of privy and ashpit system did nothing to hasten the change. In many respects Leeds, with its privies and its epidemic victims lying under canvas, was not unique, but simply presents an exaggeration of the worst features to be found in other towns.

From Municipal Reform and the Industrial City *by B. Barber, published in 1963.*

How to answer this question. This question is asking you to analyse and evaluate change and to support this by the appropriate selection and deployment of your own knowledge.

- Select what you are certain is a turning-point and about which you know a great deal. Whatever you select must make a difference between what went before and what followed after.
- Your answer must focus sharply on your chosen policy and link this to the concept of a turning-point.
- You must show how your turning-point is related to earlier, and possibly later, changes.
- In showing your understanding of the concept of a turning-point, you must show a clear grasp of 'before' and 'after'. For example, you might argue that Liberal commitment to welfare reforms, based at least on some degree of redistributive taxation, represented an important turning-point. It was certainly condemned as 'socialism' by its opponents.

> 3 Study Sources B and C and use your own knowledge. 'In the period 1830–1939, governments adopted an increasingly informed and understanding attitude towards the causes of poverty in Britain.' How far do you agree with this judgement? (16)

How to answer this question. This question is asking you to show your understanding of the process of change over time. It is asking you to use two of the given sources AND your own knowledge. If you only work with the sources, or use your own knowledge by itself, you cannot score highly. Remember, you will get credit for the way in which you select appropriate material from across the whole period and use it to support your argument.

- You should be able to identify government attitudes to poverty from the sources or from your own knowledge. For example, you might use Sources A and B to suggest that contemporaries did not feel that government attitudes were either 'informed' or 'understanding', but this won't get you many marks.
- A better answer would show that you could extract some understanding about attitudes to poverty from the sources and from your own knowledge, or that you could focus on government attitudes to the causes of poverty, using your own knowledge without specific reference to the sources.
- Good answers will explain the extent to which attitudes to poverty changed over the period. This explanation will draw on the source material and on your own knowledge. You should be able to make some comment on the phrase 'increasingly informed and understanding'. You could, for example, show an awareness that the government was much better informed about the causes of poverty by 1914 than it had been when it accepted the Poor Law Commission's Report. You might also

government for improvement. The cause of the unemployed was taken up especially by the Labour Party and the Trade Unions.

From A History of Britain from 1867 *by John Martell, published in 1988.*

Questions

Before answering these questions, you should read Section 2 'How far did attitudes to the poor change between 1834 and 1948?' and Section 4 'Nineteenth- and twentieth-century social reform: from laissez-faire to collectivism?', and, where you need clarification of the arguments and factual underpinning, refer back to the relevant material in the AS part of the book.

You should remember that the focus of questions here will be on the process of change over a long period of time. You should be able to demonstrate your understanding of this, as well as your understanding of the context within which these changes took place. The examiner will expect you to be able to construct a developmental account, in which events or factors are included for their significance in creating change and/or maintaining continuity.

1 Study Sources A, B and C. What similarities, and what differences, do these sources reveal about the role of government in dealing with the problems of the poor? (4)

How to answer this question. This is a low-mark question, so do not spend too much time on it. Your answer should be brief, clear and concise and relate only to the source material.

- At the very least, you should be able to spot a simple theme running through all three sources. This theme could be, for example, the apparent harshness of government in its dealings with the poor. You must always support what you say by direct reference to factual examples.
- You should be able to write extended statements about all three sources that show you understand that the extent of government involvement seemed greater by the 1930s with sophisticated devices like means testing (Source C) in operation. You could show that similarity may be seen in the government coming up with policies to 'deal' with the poor. You could also make clear cross-references between the visual evidence of Source A and the impression of 'miseries' identified in Source C.

2 Chose any ONE government policy, or piece of legislation, passed in the period 1850–1914 which you consider to have been a significant turning-point in government attitudes towards the poor. Explain why you think that it was a turning-point. (10)

SOURCE-BASED QUESTIONS

Sources-based questions in the style of Edexcel
Source A

MEN'S CASUAL WARD, WEST LONDON UNION.

Inmates of a London workhouse, c.1840.

Source B
We, the radicals of Barnsley, have minutely discussed the leading features of the Poor Law Amendment Act and also its cruel operations on the suffering poor, and we have come to the conclusion that a vote of censure . . . be passed upon the said Act . . . moreover, we express an anxious wish that it be repealed. We also call upon all good men to exert themselves in those encounters with the enemies of popular rights.

A notice printed in the Leeds Times, *5 March 1836.*

Source C
The miseries of the unemployed were made worse immediately after the National Government had been formed [in 1931]. In making their cuts, the National Government both reduced the amount that was paid in dole and also set up a means test. This involved a close examination of all the sources of income received by the unemployed worker's family . . . Enforced idleness, biting poverty, and overwhelming desperation at their plight and the failure of governments to bring any real improvement [in the mid-1930s] were the main problems facing the unemployed. Many unemployed therefore sought to put pressure on the

How to answer this question. The focus of the question is clear: it is on the changing attitudes to poverty over a long period of time. You are also required to give an assessment of the extent of this change.

- You will not be expected to have detailed knowledge of all the developments that occurred between the Poor Law Amendment Act of 1834 and the 1943 Beveridge Report. What you will be expected to do, however, is to show that you are aware of change and continuity throughout the period (relating, of course, to attitudes to and provision for poverty) and that you can select relevant factual detail to support what you say.
- Remember, too, that 'popular attitudes' are expressed in a number of ways (art, novels etc) and that politicians also respond to changing attitudes among their electorate.
- Plan your essay carefully. It is well worth spending time on this, rather than 'thinking on your feet' as you are writing. Structure your argument by making a list of the points you want to make, and the evidence you are going to use to support each point.
- In addressing the question, you will need to cover some or all of the following areas:

 - the attempt of the 1834 Act to address need, but which succeeded in establishing a system that was hated and feared and did much to change popular attitudes to poor relief;
 - the success of the 1834 Act in gaining the support of those who had to pay for poor relief and who therefore saw no reason to support change;
 - art and literature as opinion makers and expressions of attitudes;
 - pressure from the newly enfranchised (after 1867) and the political parties' awareness of the increasing importance and power of the working classes combining to lead to the Liberal reforms at the beginning of the twentieth century;
 - the lively debate at the beginning of the twentieth century about costs and contributions;
 - the impact of means testing in the inter-war years as a vehicle for change;
 - the Beveridge Report, proposing to establish a safety net 'from the cradle to the grave' with universal contributions and universal benefits, as a response to public opinion that seemed determined to press for change;
 - the continuity provided by the ongoing debate about the cost of providing for the poor and about which sections of the community should pay for it.

Good answers that score high marks will be those that have an analytic structure and which give a sound and well supported assessment of change and continuity over time, and which will address directly the question 'How far?'

A2 ASSESSMENT: SOCIAL POLICY AND DEBATE, 1815–1948

ESSAY QUESTIONS

In order to gain high marks in any essay question set by any of the awarding bodies at Advanced Level, you will be expected to do the following:

- **Analyse** throughout your essay, not just in concluding sentences to paragraphs or in a concluding paragraph to the essay. Analysis should be evident in the way you plan your essay to present an argument to the examiner. Remember that there is a clear difference between narrative (telling the story) and analysis (putting forward a line of argument).
- **Support** your line of argument with carefully selected evidence. The evidence you select must be accurate and it must be relevant to the point you are making. Remember that you are not trying to impress the examiner with how much you know, but with how you can use what you know to make or support a point.
- **Think** carefully and try to reach independent conclusions based on the evidence you are presenting. The examiner will not expect you to be original, but will expect you to have reflected on what you have read in this and other books. And the examiner will expect you to explain in your own words the ideas you have picked up.
- **Communicate** your ideas clearly. This involves structuring your essay so that each paragraph makes a separate, and supported, point. It also involves using accurate spelling and correct grammar.

Essay question in the style of OCR

> 1 How far did popular attitudes to poverty, and the ways in which poverty should be dealt with, change between the Poor Law Amendment Act of 1834 and the Beveridge Report of 1943?

Before answering this question, you should read Section 2 'How far did attitudes to the poor change between 1834 and 1948?' and, where you need clarification of the arguments and factual underpinning, refer back to the relevant material in the AS part of the book.

CONCLUSIONS

Historians are trapped in the time and place within which they are working: they are part of its culture and they are bound by their own, individual imperatives. As such, an historian's interpretation of the past can only be partial. But this does not mean it is invalid. Each different interpretation opens up new perspectives and fresh insights. Perhaps the full history of poverty and welfare cannot be written until poverty itself is abolished – a utopian ideal we are far from achieving. As the original, brave design of the welfare state becomes further eroded, new dogmas will arise with beguiling slogans to sell them. A strong and perceptive historical vision will be required for the third millennium if cant is to be revealed and welfare appropriately deployed to destroy poverty.

workhouse. She analyses the function of the workhouse; this approach enables her to place it within the whole context of institutions where clients 'live-in'. She emphasises that, because by the end of the nineteenth century the workhouse began to offer a higher standard of care for the vulnerable than their families could provide, it became the ancestor of many of today's institutions. Yet this provision, she argues, was inexorably linked to the shame of pauperism. Any institutional solution to poverty and the giving of welfare had to free itself from the taint of pauperism if it was to succeed.

THE WHIG INTERPRETATION

It could be argued that the welfare state, because it was immediately widely accepted by the general public in the 1950s, had erased the image of pauperism and the shame of having to receive welfare from a state institution. Indeed, historians like **David Roberts** and **Derek Fraser** argue strongly for a line of development from the Poor Law Amendment Act and its implementation in the nineteenth century, through the Liberal reforms at the beginning of the twentieth century, to the establishment of the welfare state 40 years later. They argue for a **Whig interpretation of history**, maintaining that legislators and administrators learned from the mistakes of their predecessors, and ultimately arrived at a system that provided welfare for the citizens of the state, from the cradle to the grave, in a wholly acceptable way.

POSTMODERNIST INTERPRETATIONS

Toward the end of the twentieth century, the original concept of the welfare state was coming under attack, throwing doubt upon the Whig interpretation of welfare. Two main strands of historical writing and historical interest have arisen as a result. Some authors and researchers began to focus on areas of history that had been neglected by those intent on creating grand explanations. For example, **Pat Thane** focused on the impact on women in 'Women and the Poor Law in Victorian and Edwardian England'; **Frank Crompton** focused on workhouse children in his 'Workhouse Children: Infant and Child Paupers under the Worcestershire Poor Law 1780–1871'; while **Simon Fowler** concerned himself with alternative forms of philanthropy in '"Draining the Bog": *Charities and the Poor in the Nineteenth Century'*. Other historians, arguing that 'welfare for all' was a bridge too far, point to the importance of Victorian morality. **Gertrude Himmelfarb** argues that it was this loss of the idea that morality should be linked to welfare that brought about the confusion that surrounded the welfare state in the late twentieth century.

problematical when data culled from central records seems to conflict with what appears to have been happening in the localities. This problem was highlighted by the work of Karel Williams.

THE DISSIDENT VIEW

Karel Williams in *From Pauperism to Poverty* uses a mass of statistical information to support his belief that outdoor relief for able-bodied males was abolished by 1850. Unlike local historians who argued the opposite, he used the figures supplied by the Poor Law Board. While local boards of guardians had the power, and the ability, to dispense outdoor relief to able-bodied men, all such cases had to be reported to the Poor Law Board. The huge discrepancy between Williams' findings and the findings of local historians could not, he argued, be accounted for by simple mistakes or wilful evasion. The puzzle remains unsolved.

BACK TO BASICS

Some historians have 'leap-frogged' the Webbs and their worthy, biased work and have gone back to the report of the Royal Commission itself, on which the 1834 Poor Law Amendment Act was based. The Marxist historian **R.H. Tawney** spent his working life criticising the corrupting effects of capitalism and so it is no surprise to find in his *Religion and the Rise of Capitalism* a swingeing attack on the report and on the ways in which the commissioners handled the 'evidence' they were using to make far-reaching conclusions. 'The student' he concluded 'realises with something like horror, that three generations of men and women have been sacrificed to what, when it is examined critically, turns out to be nothing more or less than a gigantic historical blunder.' A reworking of the commissioners' evidence and statistics by Mark Blaug shows the commissioners to have ignored, or misunderstood, the enormous mass of data with which they were dealing. In his *The Making of the English Working Class* the Marxist historian **E.P. Thompson** castigated the 1834 Poor Law Amendment Act and its subsequent administration by men like Chadwick and Kay as being 'the most sustained attempt to impose an ideological dogma, in defiance of the evidence of human need, in English history'.

THE SOCIOLOGICAL APPROACH

Other historians have looked at the workhouse itself as an institution. **M.A. Crowther** focuses on the management of the poor within

prevent it. The **dominant ideology** of the mid-nineteenth century, they maintained, was one of individualism in which the demands of the market (those paying for relief) were met and the state denied any responsibility for its members. By the end of the first decade of the twentieth century, this had been replaced by a new relationship between state and individual, where the state accepted responsibility for its most vulnerable members.

REACTION TO THE COLLECTIVIST APPROACH

Helen Bosanquet was not an historian, but the doughty secretary of the Charity Organisation Society and editor of the *Charity Organisation Review* between 1908 and 1921. She wrote many articles and published some important studies on poverty and the poor. Strongly opposed to state intervention, her denunciation of the Webbs' approach to welfare formed the basis of much critical work of later historians and so her attitudes and views are included here. She could not detect the switch to curative and preventative principles by which the Webbs set great store, and accused them of using 'evidence' selectively to fit their own theories. In 'English Poor Law Policy', which she wrote for the *Economic Journal* in 1910, she criticised them still further, not only for their narrow administrative approach to the Poor Law, but also for their failure to pay any attention whatsoever to the ways in which the Poor Law was adapted to meet local conditions. For many years this was the plank upon which all criticisms of the Webbs were based.

LOCAL STUDIES

This latter thrust of Helen Bosanquet's criticism had to wait some 50 years until it was met in earnest. From the 1960s onwards, there have been many detailed studies of the operation of the Poor Law Amendment Act in the localities. These emphasise, not just the traditional view of the stubbornness of local worthies in seeking to retain the pre-1834 situation, but the very real attempts made to adapt the new Poor Law to local conditions in order to ameliorate suffering. Studies like **R. Boyson's** 'The New Poor Law in North East Lancashire 1834–71', **Derek Fraser's** 'Poor Law Politics in Leeds', **G. White's** 'In and Out of the Workhouse: The Coming of the New Poor Law to Cambridgeshire and Huntingdonshire', **P.R. Hasting's** 'Poverty and the Poor Law in the North Riding of Yorkshire 1780–1837' and **H.M. Boot's** 'Unemployment and Poor Law Relief in Manchester 1845–59' all show that uniformity in Poor Law administration was an ideal that was rarely achieved in reality. However, laudable though local studies are, there is a flip-side. The wealth of local detail makes an overall picture very difficult to establish, and is even more

SECTION 5

How have historians interpreted the issues surrounding poverty and welfare in the nineteenth and twentieth centuries?

Fabian socialism
The Fabian Society was founded in 1884 by a group of left-wing intellectuals. Their aim was 'the reconstruction of society in accordance with the highest moral principles'. These moral principles were socialist ones, but were often slightly at variance with mainstream socialist thinking. For example, in 1900 they supported the Empire believing it could be turned into a vast welfare state. Society members wrote hundreds of pamphlets and constituted a hotbed of ideas for the newly emerging Labour Party. Among the most important members in the early days were Sidney and Beatrice Webb, and Bernard Shaw.

Those who have written, and who are writing, about poverty and welfare are, of course, a product of their times and their interpretations reflect contemporary attitudes to welfare and poverty. Many of them, because of their personal and professional involvement in welfare, have helped to create the climate of opinion and some have helped bring about legislative change. All of them have contributed to, and participated in, the ongoing debate about the causes of, and remedies for, poverty.

THE COLLECTIVIST APPROACH

Sidney and Beatrice Webb published their *English Poor Law Policy* in 1910, and their three-volume *English Poor Law History* in 1927–9. These were central texts that provided the early basis of comment, analysis and criticism of the nineteenth-century Poor Law. The first publication contained a chronological analysis of the development of public policy; the second, a description and analysis of the old Poor Law in one volume followed by a detailed analysis in two volumes of the workings of the Poor Law Amendment Act from 1834 to the abolition of boards of guardians nearly 100 years later. But the Webbs themselves were not disinterested observers. Committed **Fabian socialists**, their home was a centre of discussion and debate about social enquiry and policy. This debate was not purely academic: the Webbs were involved as active Poor Law reformers in nearly every major welfare initiative at the end of the nineteenth century and in the early twentieth century.

The Webbs believed firmly in collectivism and the primacy of the state in bringing about change through its institutions. Their writings, therefore, focused on the administrative aspects of the Poor Law Amendment Act. They sought to show that the main principles underpinning the Act of 1834 – the creation of a national system of relief, less eligibility and the reduction and eventual abolition of outdoor relief – had been gradually abandoned. By the beginning of the twentieth century, they argued, the administrative arrangements that supported these principles were being used to support different principles – those that were curative and preventative. The state was seeking, not to relieve poverty but to cure and

When this failed, the collectivist state moved in but had to release itself from the straitjacket of the Poor Law before it could offer effective relief to its citizens. Thus, the social reforms of the Liberal administrations at the beginning of the twentieth century were introduced, quite deliberately, outside the structure of the Poor Law. In this way, relief was disassociated from shame and personal failure: the way in which relief was offered was at least as important as the relief itself. Later in the century, the universal acceptance of the welfare state was due in no small measure to the receipt of welfare having been freed from the stigma of pauperism. The Poor Law, indeed, cast a long shadow.

area or department. Chadwick used the structure of the Poor Law to gather evidence for his 1842 *Report on the Sanitary Condition of the Labouring Population of Great Britain* and this evidence was supported by information supplied by the Office of the Registrar-General.

LAISSEZ-FAIRE AND COLLECTIVISM

Laissez-faire, at least in social issues, seemed to represent a sort of 'golden age', a time legislators looked back to with regret when they, albeit with a show of reluctance, had to bring in mandatory legislation in an attempt to ameliorate the situation. Private charity and philanthropy were the Victorians' bulwark against total state involvement. Once this was seen to be inadequate, the legislative and administrative floodgates were wide open and the collectivist state marched in. This is the key to collectivism: the deliberate intervention of the state into the daily lives of its members through Acts of Parliament that were at first permissive and then compulsory and directive, backed by central agencies and inspectorates. This pattern was replicated in every field of social reform.

THE ZENITH OF COLLECTIVISM?

Collectivism continued throughout the twentieth century, reaching two peaks – the first prior to the First World War and the second following the Second World War. The first wave, associated with Asquith and Lloyd George, had the 1908 Old Age Pensions Act and the 1911 National Insurance Act as its mainstays. The second, basing its legislation on the Beveridge Report, can be seen as the zenith of collectivism, drawing all the main threads of social legislation into one, unified format where the citizen was guaranteed protection from the cradle to the grave. But practical necessity and political pragmatism necessarily temper what is achieved. The needs of a state's citizens half way through the twentieth century are not the same as that same state's citizens 50 years later. Unprecedented and unexpected factors have called into question many of the premises on which the Beveridge Report was based.

CONCLUSIONS

In 1834 the Poor Law Amendment Act created a universal system of relief; yet, by its test of less eligibility and connotations of shame and disgrace, it deliberately reduced its clientele. Much of the social policy in the years after 1834 were attempts to ameliorate the more stringent aspects of the Poor Law Amendment Act, and to move away from rugged individualism to an era of permissive legislation supported by charity.

DO THE FACTS SUPPORT THE THEORIES?

In order to chart a way through the contending interpretations of the role of the state in nineteenth- and twentieth-century social reforms, it is necessary to be clear about several issues.

First, some of the state interventions were quite obviously ad hoc responses to an immediate crisis – like the cholera epidemics. Social policies, such as they were, were geared to meet real and pressing problems, not to meet some theoretical device, such as Utilitarianism.

Second, an important feature of nineteenth- and twentieth-century legislation was the relationship between local and central government. Time and again, especially in the field of public health, it is possible to see a pattern whereby the state first gave local authorities permissive powers and then made those powers mandatory. The Poor Law Amendment Act, too, relied on local administration for its proper implementation, although this didn't always work in the direction expected and required by central administration. And finally, once the state became involved, this involvement developed its own momentum as civil servants drafted Bills to tighten up and extend existing legislation and issued streams of rules and regulations concerned with the administration of, for example, workhouses and the removal of nuisances.

THE ROLE OF UTILITARIANISM

It remains to consider the part played by Utilitarianism. The position is complicated because of the methodology followed in the nineteenth and twentieth centuries. The use of commissions to enquire into the facts, a course of action based on the commission's report, and 'professionals' to implement the course of action determined and laid down by legislation – this was pure Utilitarianism, whether or not those involved were Utilitarians. Furthermore, avowed Utilitarians, like Edwin Chadwick, and avowed non-Utilitarians, like John Simon, could end up following the same course of action – Chadwick because his beliefs led him to support centralisation and state intervention, Simon because he realised that he wouldn't get anywhere without compulsion.

Administrative feedback led to a new and deeper involvement by the state. John Simon's draft of the 1866 Sanitary Act, for example, was based upon his experience as Chief Medical Officer of Health to the Privy Council, a post he held from 1858. Once professionals were appointed, a sort of spontaneous growth of bureaucracy and administration became possible and sometimes led to further legislation. This wasn't confined to

Paternalism
Where an institution, usually the state, acts towards people as a parent might. This is interpreted as stating (or even believing) that it is working in the best interests of the person or people concerned, but is doing so without consultation or specific permission.

Collectivism The theory that people (or institutions) working together are the key to change. Often used when referring to the involvement of government, usually via legislation, in social matters.

is a whole raft of rules, regulations and legislation to be taken into account. So how can this apparent paradox, of increasing state legislation during a previously defined period of laissez-faire individualism, be resolved? Various historians have given us different explanations:

- There could be a real difference between theory and practice. People genuinely did believe in the laissez-faire principle but they had to accept that some of the problems thrown up by an industrialising society were such that they had to be dealt with in a reactive, not proactive, way by the state. (**W.H. Burn**, *The Age of Equipoise*, 1964)
- Theory and practice were different in different areas of state and society. People could therefore accept a laissez-faire view of economics and, for example, support free trade, but at the same time accept that the government had to intervene in, for example, issues that affected public health. (**Elie Halévy**, *The Growth of Philosophical Radicalism*, 1928)
- Utilitarianism was not, in fact, an individualist theory but was really a combination of collectivism and individualism. Indeed, some historians argue that Dicey was wrong in equating Bentham's Utilitarianism with individualism because in reality it proposed strong centralised action on the part of government. The less extreme view sees Utilitarianism as containing elements of individualism and collectivism that would be more or less dominant depending on the context within which the idea was being used. (**H. Parris**, *The Nineteenth Century Revolution in Government: A Reappraisal Reappraised*, 1960)
- The relaxed doctrines of laissez-faire were completely overcome by the enormity of the problems they were facing. Administrators simply had to cope and put together, piecemeal, a series of measures that were reactive rather than proactive. This reaction to events developed its own momentum, and so evolved, almost accidentally, a strong state administration, involved in the day-to-day lives of all its citizens, whether they were at home or at work. (**Oliver MacDonagh**, 'The Nineteenth Century Revolution in Government: A Reappraisal', 1958)
- The administrative state that was evolving in Victorian times had little to do with the concepts of collectivism or individualism. It evolved as a compromise between two models of government: the traditional, that emphasised historic rights and customs and local self-government, and the incremental, that had no predetermined programme of action but approached each problem and challenge empirically. (**W.C. Lubenow**, *The Politics of Government Growth*, 1971)

SECTION 4

Nineteenth- and twentieth-century social reform: from laissez-faire to collectivism?

The social problems resulting from poverty and disease, and the responses of government and individuals to those problems, have dogged every civilisation down the ages and across all continents where people have lived together in societies. What made the nineteenth- and twentieth-century response uniquely interesting was that it was made in reaction to a rapidly industrialising society where, for the first time, thousands of people lived out their domestic and working lives in close proximity. Of course, there had been destitution, crippling illness, low life expectancy and fraudulent malpractice in pre-industrial Britain, but the industrial revolution forced what had once been isolated and private onto the centre stage, and made these issues large-scale and public.

EARLY THEORIES

The bedrock of all ideas about the role of the state in nineteenth-century social policy was promulgated by **A.V. Dicey** in *Law and Public Opinion in England during the Nineteenth Century* which was first published in 1905. He saw the century as being divided into three. The first three or so decades he regarded as being a period of Tory **paternalism**. These were followed by around 30 years of Utilitarian reform, dominated by the concept of **individualism** and marked by a minimum of state activity, until about 1865–70, when collectivism and wholesale state intervention took over. This **collectivism** continued, so Dicey's supporters maintain, until the last decades of the twentieth century, when individualism again became the byword for the relief of social problems and collectivism a safety net.

CHALLENGING THE ORTHODOXY

This is a neat pattern with which to overlay the past, but does it stand up? Between the early 1830s and, say, 1870, the state became increasingly involved in the lives of its citizens. It supported paupers; forbade the employment of women and children underground; enforced vaccination; and insisted on the civil registration of births, deaths and marriages. If a definition of the 'state' is extended to include local authorities, then there

interests, and those of the ratepayers who elected them, before the wider interests of the community. Power struggles were common within local councils as the trend increased toward abolishing small interest groups, such as lighting and paving commissioners, and forming one unified body to administer public health matters. Political wheeling and dealing delayed reform. It took Birmingham, for example, fourteen years to establish one unitary authority to oversee public health.

Politics was sometimes about party politics. In Leeds in the 1830s, for example, the Tories were all in favour of a publicly funded scheme for water supply to the city until the Liberals gained control of the council. Then, the Tories switched their allegiance to a water supply funded by private enterprise. On the other hand, the Pikists and anti-Pikists, at loggerheads over the Rivington Pike scheme to bring water to Liverpool, contained both Liberals and Tories on each side.

Overlaying all local issues was the shadow of power being exercised from a central authority in London. No matter how divided local authorities were among themselves, they united against the threat of centralisation. Indeed, when Lord Morpeth introduced the Public Health Bill in 1848, local authorities up and down the land petitioned against the degree of centralisation this would introduce. They were afraid of loss of power and patronage in their own towns and cities; they were afraid of being controlled by London-based bureaucrats; and, perhaps above all, they were afraid of being forced to incur expenditure over which they had no control. The permissive 1848 Public Health Act was the uneasy compromise that resulted from this pressure.

CONCLUSIONS

The main areas of argument and disagreement over the implementation of public health measures in the first decades of the nineteenth century can be loosely grouped under four headings: political, ideological, technical and financial. Each issue was present to a greater or lesser extent in every local authority area; the degree to which one was more important than the others depended on local personalities and local circumstances. Taken together, they explain the permissive nature of national legislation before 1875 and the differences in implementation of public health measures in towns and cities throughout England and Wales.

Furthermore, these dual payers were adding to the value of their neighbours' houses as one Leeds ratepayer pointed out:

I have £1,000 worth of property and have been at considerable expense in getting water. My neighbour has the same (but no water) and his property will be considerably benefited by having water brought to it and mine can't possibly be benefited at all. Is it just that I should be made to contribute a yearly sum towards furnishing his estate with water and increasing the value of his property?

This cry of 'Is it fair?' dogged all attempts at social reform in the twentieth century as well as the nineteenth. The basic complaint, echoing down the decades, is that the provident are being penalised to pay for the profligate. The only major public health reform where this didn't apply was the National Health Service, and this was probably because the relationship between taxation and expenditure on the service was not so obviously direct, and because the benefits were freely available to all clients. At the end of the twentieth century, with NHS funding becoming central to any debate on welfare, the whole question of 'fairness' was again raised, but this time linked to affordability and limited resources.

Individual liberty

The second major ideological issue to be addressed in Victorian times was that of individual liberty. What powers did, or should, a local authority have to infringe an individual's liberty? Should house owners be compelled to connect their houses to a sewerage system? Leeds City Council, on issuing a regulation for whitewashing slaughterhouses in 1838, was severely rebuked by the *Leeds Intelligencer*:

The legislature has not yet given them the authority to dictate to tradesmen in what way they shall carry out their business, as how often they shall whitewash their buildings ... and if they are once permitted to usurp such an authority ... then no man's place of business or even private house would be safe.

This raises the age-old question of where and at which point individual liberties should be sacrificed to the common good. Frequently, those shouting loudest about individual liberties were those with a vested interest in inaction. Forceful sanitary reform depended upon a strong central authority, whether that be exercised from the city hall or Parliament, and it is here that ideological issues begin to merge with the political.

POLITICAL PRESSURES

Politics is all about power and the exercise of power. In local government, power was often in the hands of vested interests – the water companies, the shopkeepers and the builders – who frequently put their own

A bad-tempered and protracted dispute arose over whether or not the city should build an extensive system of interlocking reservoirs and pipe systems at Rivington Pike, outside Chorley (Lancashire), in order to supply Liverpool with water. 'Anti-Pikists' opposed the scheme, claiming that sufficient water could be obtained locally, freeing money for other schemes; 'Pikists' claimed there was no other way to bring good, clean water to Liverpool, asserting there was no greater priority than public health. In the end, the Pikists won, but it was a pyrrhic victory. The Rivington Pike scheme proved insufficient for Liverpool's needs and more water had to be sought elsewhere in the 1860s.

It gradually became clear that the sheer physical size of the job of supplying large cities with water and disposing of their sewage required considerable engineering skill and expertise. Local authorities would not, and some could not, commit the necessary funds; they did not have the expertise to decide between rival claims of disputing civil engineers; nor, necessarily, the will to prioritise public health.

FINANCIAL BURDENS

Closely tied in with the experts v. laypeople issue was the problem of money. Public health schemes did not come cheap, and, where town councillors did not fully appreciate the need for them, they were not prepared to dig too deeply into their pockets. There was no glamour in drains, and no high profile for those promoting them. On 17 October 1846 the *Leicester Chronicle* reported the case of a local councillor who supported the building of a town hall in preference to a sewerage system: 'He did not care to meddle with the dirty work of Town Drainage. There was no glory to be gained in washing sewers with cold water, laurels were only to be won by the builders of Town Halls.' Willing to pay almost any sum for almost any improvement at the height of an epidemic, worthy citizens (often with their own private supply of water) called for economy once the danger had passed. This ebb and flow of public willingness to contribute to public health bedevilled many schemes, and raised the thorny problem of who should pay.

IDEOLOGICAL ISSUES

Fairness
The problem of who should pay for public health schemes raised ideological issues. Better-off people paid for their own water supplies and for their own sewage removal and disposal. If money to pay for supplying water to all houses in a city was to be raised through the rates, then those who had already paid were paying twice.

spewing their contents onto adjoining fields. The failure of this scheme was nothing to do with Chadwick's belief in miasmas. Indeed, none of his schemes depended upon the accuracy or otherwise of the particular theory of disease in which he believed.

EXPERTS v. LAYPEOPLE

The two main engineering feats needed to create a viable public health system in nineteenth-century Britain were the provision of a steady supply of good, clean water and the disposal of sewage, which was increasingly in liquid form after the use of flushing lavatories became widespread. Chadwick strongly advocated the use of glazed, round pipes to carry water-borne sewage away – but how were laypeople to judge the appropriateness or otherwise of any particular pipe or method of disposal? This really was the nub of the problem. Laypeople – local councillors – were expected to make judgements on issues far beyond their competence. They were unable to assess the benefits of a 2-foot, as opposed to a 1-foot, fall, or the merits of glazed as opposed to unglazed facing bricks. Almost inevitably, decisions were made on the basis of prejudice, vested interests, parsimony and ignorance.

The sanitary engineer Robert Rawlinson was called in to Whitehaven in 1849 when the death rate rose to 49 per 1000, more than twice the national average. In his report to the Whitehaven board of health he stated:

such of the opposing gentlemen as I could prevail upon to accompany me in my personal inspection, declared in the strongest terms that they had no idea of the state of things existing around them. But this I have found in every town I have visited; few beside the medical gentlemen know anything of the utter wretchedness and misery produced by want of proper sanitary regulations.

Even where town councils were firmly set on sanitary reform, there were problems. Liverpool, on Merseyside, provides a telling example. Formerly one of the filthiest cities in Britain, Liverpool came to the fore in public health initiatives by having its own Sanitary Act in 1846. This gave the Tory city council enormous powers.

The Act itself covered dwellings as well as the more usual issues of the water supply and the removal of nuisances; it enabled the city authorities to deal effectively with the 20 per cent of city dwellers who lived in cellars. The medical officer of health appointed under the Act, Dr W.H. Duncan, was exemplary in the way in which he wrote his annual reports to pinpoint specific problems, and Liverpool set about improving the health of its citizens. There remained the knotty problem of an effective water supply.

that the commissioners selected the evidence to suit their own, preconceived arguments about poverty and the poor. It may well be that the report lacked somewhat in specificity – critics say that this was because Chadwick expected to become a commissioner and so didn't think it necessary to spell out what he intended to do. The point is that, six months after the report was published, legislation mirroring the report's recommendations passed through Parliament with hardly any voice raised in opposition. Six years after the publication of the *Report on the Sanitary Condition of the Labouring Population of Great Britain*, which contained equally carefully collected and collated data, no comparable legislation had passed through Parliament. Why not?

Chadwick had seemed clear that the powers needed to implement measures to prevent disease would have to be stronger than the 1835 Municipal Corporations Act. In fact, Chadwick wanted a centralised and uniform administrative structure to be set up, similar to that put in place for administering the Poor Law. It is true that his report was rather vague on detail, but so was the Poor Law report. Chadwick himself, in 1842 as in 1834, assumed that detailed solutions would emerge in discussion and debate after the report was published. The two firm proposals he did make – for water-borne disposal of sewage and for the appointment of medical officers of health – were adopted. Detailed discussion did take place in the context of the Health of Towns Commission, but implementation of specific proposals did not come until 1848, and, even then, the legislation was permissive, not mandatory. It may be that the Chadwick of 1834 was simply proposing that which the majority of middle-class voters and ratepayers wanted, anyway. He was riding the tide, not swimming against it. But 1842 was a different matter altogether. Chadwick and his supporters in the sanitary reform movement were proposing a radical and controversial solution that many people were not minded to accept.

MEDICAL ISSUES

The issue central to medical developments in the mid-nineteenth century centre around the causes of disease and the pivotal discovery of Pasteur and later refinements of his germ theory in the 1860s. Ironically, this had little direct relevance to public health. It is sufficient to know that there is a connection between dirt and disease without having to know what that connection is. A city that removes its midden heaps because of the connection between dirt and disease will have as much effect upon the health of its citizens as one that removes the midden heaps because it accepts Pasteur's germ theory. Indeed, Chadwick, for the whole of his life (and he died in 1890), adhered firmly to the miasmic theory of disease. Few of his proposals were silly. Perhaps his most foolish idea was to load raw sewage onto barges and have them plying up and down canals,

SECTION 3

To what extent were the obstacles to the establishment of a public health system in the nineteenth century philosophical or practical?

The Cholera Prevention Bill of 1834 had as its preface the phrase 'whereas it has pleased Almighty God to visit the United Kingdom with the plague called cholera'. And this was part of the problem. Beyond the various theories about the spread of disease, and even when Pasteur had shown, beyond all reasonable doubt, that germs caused disease, thousands of people hung on to the belief that disease was, somehow, the work of God. It was a punishment for sins committed, a reminder of the tenuous nature of life and of the random acts of a sometimes vengeful deity. So sanitary reformers had to battle, not just against vested interests and the middle classes' notorious aversion to paying for anything from which they could see no direct benefit, but against the gut belief of large sections of society that, whatever was done in the field of public health, a peculiarly nasty act of God would wipe out any benefits that otherwise might accrue. Moreover, dilapidated housing, polluted water and stinking privies were, to middle-class, mid-Victorian morality, the just rewards of immoral and debauched living. The poor, in other words, deserved their lot.

TURNING MORALITY ON ITS HEAD?

Edwin Chadwick's *Report on the Sanitary Condition of the Labouring Population of Great Britain* turned this view around. He demonstrated beyond reasonable doubt that there was a close correlation between housing, disease and life expectancy. This was the main point the report was seeking to establish. But Chadwick went further than this. He argued that insanitary living conditions were themselves the cause of low moral standards, not the reverse. This indeed was a body blow to mid-Victorian middle-class morality. How easy, though, would it be to set up the infrastructure of a public health system?

WHY WAS RELIEVING THE POOR EASIER THAN GIVING THEM GOOD DRAINS?

The *Report of the Commission of Enquiry into the Poor Laws* of 1834 was the result of careful collection and collation of evidence. It may well be

Poor Law. There were institutional reasons for this: the Poor Law itself was under attack from within, as some boards of guardians, encouraged by the Local Government Board, struggled to implement more humane ways of caring for paupers. But within the Board itself was a strong faction, fighting for a return to the principles of 1834. The fact that any reform of the Poor Law would involve a reorganisation of local government finances was, maybe, too complex a reform for Asquith and Lloyd George, intent on a speedy resolution to early twentieth-century poverty, to take on. They were intent, too, on providing a package to relieve poverty that was appropriately targeted and that would be freed from the stigma of pauperism. In this, they succeeded.

CONCLUSIONS

The nineteenth century saw a great change in attitudes to the poor and to poverty. At the beginning of the century, the prevailing attitude was one of individualism. The individual had to take responsibility for his or her own fate. If there was poverty, then that was the fault of the poor. The only people who were excused this were children, the sick, the old and the infirm. As the century progressed, a change in this prevailing attitude was perceptible. This change was reflected in novels and paintings, and was brought about by a combination of electoral reform, legislation affecting working practices, specifically targeted investigations and by worldwide economic changes. By the beginning of the twentieth century, few believed poverty was the result of personal failings; most accepted the need for society to support its most vulnerable members without stigma. At a time of considerable distress in the 1930s, the problem was not whether to relieve poverty, but how to do so with limited resources.

Economic considerations

The years 1870–1914 were marked by a restructuring in British agriculture. Some farmers experienced severe hardship, while others, mild prosperity. Businesses, too, were forced to readjust because of outside forces. It had, in many ways, been all downhill since the glory days of the Great Exhibition in 1851. The USA had spawned practical inventions like McCormick's reaping machine that speeded up and completely mechanised reaping, a sewing machine that could be worked by one person and could produce 600 stitches a minute, and a wide range of Colt revolvers made from interchangeable parts. By the end of the century, the USA's prairie lands had been opened up and Britain's free trade policy enabled cheap American corn to challenge sales, and ultimately production, of British grain. Britain's exports of cotton goods declined for the first time: between 1880 and 1900 the annual average decreased from £107m to £97m. The average growth rate of the British economy between 1873 and 1913 was 1.3 per cent, whereas that of Germany was 3.9 per cent and that of the USA 4.8 per cent. What had this to do with attitudes to poverty? If the middle and manufacturing classes could see their income being eroded by factors beyond their control, then maybe the poverty being experienced by sections of the working classes wasn't their fault, either.

SOCIAL INVESTIGATORS

It was in this whole context of social and political change that investigators like Charles Booth and Seebohm Rowntree conducted their surveys of poverty in London and York (see Section 1). Their findings helped fuel the debate on national efficiency that had, to a greater or lesser extent, been carried on since the 1860s when Lyon Playfair predicted the dire consequences of the neglect of technical education and physical efficiency. Reinforced by revelations about the health of army recruits during the Boer war, attitudes to poverty among those with the power and the will to make a difference had undergone a sea change. It was left to Sidney and Beatrice Webb to argue that a national minimum standard of life was essential both to national efficiency and imperial strength, and to Asquith (Liberal party politician and Prime Minister 1908–16) to ask:

What is the use of talking about Empire if here, at its very centre, there is always to be found a mass of people, stunted in education, a prey of intemperance, huddled and congested beyond the possibility of realising in any true sense either social or domestic life?

SIDE-STEPPING THE POOR LAW

The way was wide open for the Liberal welfare reforms of the early twentieth century. Yet these were not carried out within the aegis of the

MPs and confirm the monarch's choice of Prime Minister. After 1832 political parties gradually became professional organisations with membership lists and managers. The need to court the electorate became clearer, and with this came the requirement to present the electorate with attractive policies. Indeed, the political role of the public, after 1832, began to change. Many people believed that it was extra-parliamentary pressure that brought about the 1832 Reform Act, and, if the 'people' could be motivated to bring about political change, then maybe they could be motivated to bring about other sorts of change too. So, disregarding the detail of the Act, what it did was to create a climate of change – one in which people of all classes looked for things to be different.

Parliamentary reform remained an issue at Westminster, although never a burning one. Years of economic prosperity and gradual inflation had increased the number of voters by 400,000 under the old rules. By the 1860s many MPs could see nothing wrong in increasing the electorate to include the solid working classes, who could be trusted to use their vote sensibly, and after 1867 the electorate comprised a little short of 2 million men. A further Act of 1884 resulted in six out of ten adult men, including skilled artisans, having the vote. The major political parties now had to appeal to working men if they were to retain a hold on power. One way through – indeed, the only way through – was via appropriate and appealing social legislation. This approach had the added benefit of vanquishing, or at least trying to vanquish, the spectre of socialism that was stalking Europe and appearing in Britain in the guise of the Independent Labour Party (see page 80).

THE END OF LAISSEZ-FAIRE?

The increasing intervention of the state in the affairs of its citizens and the development of the idea of a corporate state are dealt with in detail in Section 4 (pages 204–10). This increasing tendency of the state to take action in the field of social reform pre-dates reform prompted by the fear of socialism on the part of Liberals and Tories at the beginning of the twentieth century.

In 1842, in the teeth of fierce opposition from mine owners, the state determined that women and children were not to work underground; a series of Factory Acts throughout the nineteenth century limited the hours and working conditions of men, women and children in textile mills; and, in 1875, the state threw away any idea that effective sanitation and the supply of clean water should be a purely voluntary matter (see page 148). By 1870 the state was fully involved in providing and maintaining an education system, making elementary education compulsory in 1880 and free in 1891. It was but a short step for a government to take on responsibility for the problems thrown up by poverty.

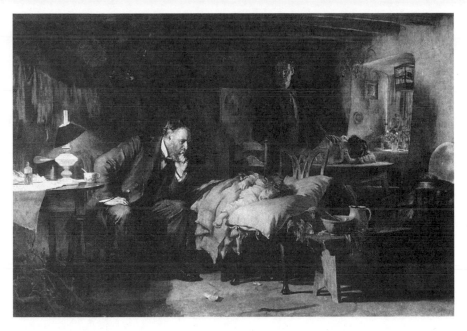

'The Doctor'
(exhibited at the
Royal Academy
in 1891),
engraved and
published by
Agnews, 1893.

classes. So how, in this context, can the Poor Law Amendment Act be explained?

It can be explained because the 1832 Reform Act did less than was proclaimed. Power was not transferred to the middle classes. It is true that, after 1832, most middle-class men did have the vote, but the composition of the reformed Parliament remained very much the same as the composition of the unreformed Commons. Few mill owners and iron masters had the time, the influence or the financial resources to stand for Parliament. Great landowners and their supporters retained a stranglehold on high office. While it is true that many great landowners had bought their way in and had not found themselves with thousands of acres by an accident of birth, those aspiring to political power still saw land as their way to achieving that power. William Gladstone, traditionally regarded as a great reforming Prime Minister and whose family made their millions in Liverpool trade, bought land as a way to political power and was elected to Parliament for the first time immediately after the 1832 Act to represent Newark, a seat in the pocket of the Duke of Newcastle. Although there was some redistribution of seats, around 70 seats remained in the direct control of great landowners, and, with the secret vote decades away, old practices continued. 'Reform' Robert Peel had argued 'that you may preserve'.

Although the Reform Act retained continuity with the past, there were telling ways in which a change in attitudes to 'ordinary' people was signalled by 1832. In the eighteenth century, general elections did not signal a change in government but were simply an opportunity to elect

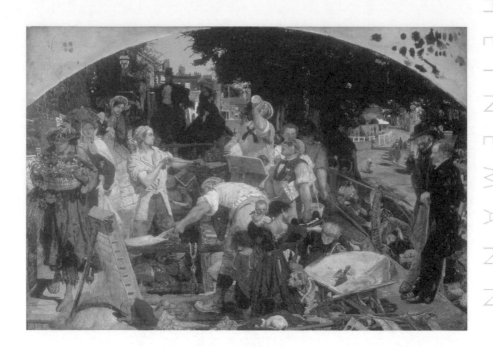

'Work' by Ford
Madox Brown
(painted
1852–63).

brought forcibly to the attention of the more radical end of the reading
public. In 1872 the London publisher Jerrolds issued a set of wood
engravings by Gustav Doré (1832–83), entitled *London: a Pilgrimage*
which shocked with its graphic illustrations of destitution. Respectable
painters took up the relatively new subject matter. Some, like Ford
Madox Brown (1821–93), presented an idealised representation of poor
working people.

Others, like Sir Luke Fildes (1824–1927) painted the poor in a far more
realistic way (see page 1), while some painted in his style but tinged their
realism with sentimentality.

Engravings were mass produced – and they were mass produced because
they were bought and hung on the walls of the respectable well-to-do and
middle classes. Attitudes were changing.

POLITICAL CHANGE

The 1832 Reform Act pre-dated the Poor Law Amendment Act by some
two years. Were they linked in some way by attitude or outcome? What
do they tell us about Britain in the early 1830s? The Reform Act
supposedly transferred power to the middle classes, swept away rotten
boroughs and transferred their seats to the growing industrial towns.
Dramatic change indeed, and a move like this, supposedly heralding the
beginning of the march of the common man, could be expected to be
reflected in attitudes to those lower down the scale than the middle

imprisonment for debt in the Marshalsea provided background to the early chapters of *David Copperfield* (1849–50). He went on to become the most prolific of Victorian novelists, publishing his novels in weekly parts that sold tens of thousands of copies. The ways in which he portrayed poverty and the poor therefore had a tremendous influence in forming public opinion. He consistently emphasised two points: the poor were people, with hopes and desires like everyone else; and the workhouse system was a mindless, cruel institution that dehumanised clients and carers alike.

While *Oliver Twist* (1837–8) is perhaps Dickens' most damning indictment of the workhouse system, other novels contain telling vignettes. *Bleak House* (1852), although a bitter satire on the courts of chancery, contains pen portraits shedding insight onto the plight of the poor: Jo the crossing sweeper, for example, describes how he feels excluded from normal human life and contact. In *Our Mutual Friend* (1864–5) Betty Higden reacts with intensity to the very idea of the workhouse.

Mrs Gaskell (1810–65), the wife of a Manchester doctor, used her understanding of the plight of the urban poor in *Mary Barton* (1848) to explain how desperation drove the poor to Chartism. An active humanitarian, the 'message' of her novels was one of reconciliation between respectable society and its outcasts. Impressed by her work, Dickens insisted it was published in part-form in the journals he used for his own writings – *Household Words* and *All the Year Round* – and so they gained as wide a readership as his own.

Benjamin Disraeli (1804–81), the Tory MP for Beaconsfield, an accomplished novelist and later Prime Minister, used his novel *Sybil* (1845) to describe

two nations; between whom there is no intercourse and no sympathy; who are as ignorant of each other's habits, thoughts and feelings, as if they were dwellers in different zones, or inhabitants of different planets; who are formed by a different breeding, are fed by a different food, are ordered by different manners, and are not governed by the same laws. 'You speak of' said Egremont hesitatingly 'the rich and the poor'.

Art and artists

As the century progressed, the magazine *Punch* published cartoons depicting the plight of the poor (see the cover of this book and pages 95, 153, 165 and 222) and the journal the *Illustrated London News*, engravings of urban and rural poor as well as paupers. Images of the poor and paupers were being

exercise self-help was open to them, too. Everyone, no matter how humble, could raise themselves and their families to a position of prosperity. There was no need, either, to pay vast amounts in poor rates because most of the poor could raise themselves out of poverty. Only the genuinely destitute needed help.

In *Self Help*, Samuel Smiles wrote:

The spirit of self-help is the root of genuine growth in the individual; and, exhibited in the lives of many, it constitutes the true course of national vigour and strength. Help from without is often enfeebling in its effects, but help from within invariably invigorates. Whatever is done for men or classes, to a certain extent takes away the stimulus and necessity of doing for themselves; and where men are subjected to over-guidance and over-government, the inevitable tendency is to render them comparatively helpless.

How immensely comforting to the middle classes, and how deeply depressing to those crossing sweepers and mudlarks, rag-and-bone men and slop-workers of Mayhew's acquaintance.

The debilitating effect of charity

Embedded in the work of people like Samuel Smiles was the idea that any help from government would be debilitating. It would take away from the poor any inbuilt motivation and drive they might otherwise have had to help themselves. 'Solving' poverty by giving money to the poor was a disastrous route to take. It had created all the problems inherent in the old Poor Law and had led to the change of direction heralded by the Poor Law Amendment Act of 1834.

The unyielding attitude of the Charity Organisation Society was based on the ideas of Smiles and others. A powerful institution in the 1870s and 1880s and supported by the wealthy and influential, it adamantly gave aid only to those whom it judged would benefit, morally as well as materially, from such help. The COS's proud boast was that it used 'scientific principles to root out scroungers and target relief where it was most needed'.

THE CHALLENGE OF NEW IDEAS

Novelists and novels

Novelists both reflect and direct the attitudes of the society within which they are working. Three, in particular, had tremendous impact on Victorian attitudes to the poor, to poverty and to welfare.

Charles Dickens (1812–70) experienced poverty at first hand. His work in a blacking yard when he was 12 years old and his father's

SECTION 2

How far did attitudes to the poor change between 1834 and 1948?

In any society at any one time there are commonly held attitudes and beliefs. But, just as there are commonly held attitudes, so there are individuals who do not, for a variety of reasons, hold those attitudes. Sometimes they hold onto older beliefs. Sometimes their own thinking and their own experiences lead them to challenge accepted beliefs and this challenge becomes, in time, a new orthodoxy which is itself challenged in time.

The middle-class beliefs and attitudes that supported the old Poor Law were a combination of benevolent paternalism, self-interest and desperation. 'The poor', they were told by preachers who rarely preached to those in poverty, 'always ye have with you'. It was this 'always' that was so worrying. Regarded as a drain on the rates and a threat to an ordered society, the solution proposed by the Poor Law commissioners in 1834 was readily accepted by those expected to support paupers. The underpinning philosophy of Utilitarianism gave credibility and a specious respectability to a severe regime designed to deter rather than support.

POVERTY AS A CREATION OF THE POOR

The dominant attitudes to poverty in the mid-nineteenth century were clear. The poor had themselves created the poverty in which they lived. Their lifestyle – the drunkenness of men and prostitution of women, the poorly nourished babies, the filthy children and the hovels in which they lived – was essentially of their own choice. Some concession was made for widows, orphans, the sick and the old; but generally, with a bit of effort on their own part, no able-bodied person need live in poverty.

Self-help

The 'effort' which the poor were supposed to put into lifting themselves out of the abyss was generally termed 'self-help'. It was this that contributed to the idea of a punitive workhouse. If people were to avoid poverty, then they had to make their own arrangements for if and when they fell upon hard times. In 1859 Samuel Smiles published his book *Self Help*: it was an immediate best-seller, presumably among the middle classes, for it supported them in their prejudices and their position in society. Through self-help, it was possible to accumulate wealth without having to show concern for your neighbours because the opportunity to

1915	In charge of welfare department of the Ministry of Munitions.
1918	Published *The Human Needs of Labour* in which he argued for a minimum wage and family allowances.
1921	Published *The Human Factor in Business* in which he argued for industrial democracy.
1923	Became Chairman of the Rowntree Chocolate Company.
1941	Published *Poverty and Progress*, his second survey of poverty in York, carried out in the 1930s.
1951	Published *Poverty and the Welfare State*, his third study of poverty in York.

CONCLUSIONS

The work of Henry Mayhew, Charles Booth and Seebohm Rowntree was of great significance in moving forward the debate about the causes of poverty. They went beyond the head counting of census takers, the number crunching of statisticians and the selective evidence taking of commissions. Though modern sociologists and survey takers find their methodology flawed, that does not detract from the very real impact they had on contemporary understanding about the nature of poverty. Mayhew began the challenge to the accepted orthodoxy that the poor were the authors of their own misfortune; Booth found conclusively that most poverty was the result of income that was so low that survival without squalor was impossible; Rowntree attempted a more sophisticated analysis of poverty by using such indices as diet, housing and clothing to determine an irreducible minimum income on both a primary and secondary scale. Low earnings, irregular employment, large families, sickness and old age – not drunkenness and idleness – were the root causes of poverty in the nineteenth century, and Mayhew, Booth and Rowntree showed this to be so.

poverty was caused by incomes that were so low even good managers could not cope. During the First World War, Rowntree had worked on ways in which a minimum wage could be determined, involving surveys of actual budgets and diets. This was to be the basis for his 'cash poverty line' used in the 1936 survey: 30s 7d for the primary poverty line and 43s 6d for secondary poverty. More generous than the devices used to calculate the 1899 poverty lines, he included allowances for rents to pay for better housing than most poor people were able to afford, and augmented their actual payments on food to allow for a better diet.

However, Rowntree's methods in 1935 were almost as subjective as those he had used 36 years earlier. The basis of his survey was all the households in York where the wage earner was bringing in less than £250 a year. And how did he select these families? By interviewing all the households in the streets where they were most likely to be living. All in all, his survey involved 16,362 families and some 55,206 people, comprising about 57 per cent of the total population. Evidence of actual income was not gathered on these visits: that was obtained from employers and by inspired guesswork.

Rowntree recognised that what constituted 'obvious want and squalor' had changed profoundly since 1899 and did himself warn against any superficial comparison of data. But a reworking of his figures does show that, between 1899 and 1936 in York, primary poverty diminished significantly (possibly by as much as 30 per cent) while relative poverty remained more or less constant.

Benjamin Seebohm Rowntree (1871–1954)

1871	Born in York, the third child of Joseph Rowntree (the chocolate magnate) and his wife Emma Seebohm. Educated at the York Quaker Boarding School and Owen College, Manchester.
1897	Appointed director of his father's successful company. Taught on Sundays at York Adult School.
1901	Published survey of poverty in *York Poverty, A Study of Town Life*.
1907	Became friendly with David Lloyd George and influenced Old Age Pensions Act (1908) and National Insurance Act (1911).
1913	Published *The Land*, a report on rural conditions in Britain, undertaken at the request of Lloyd George. Published *How the Labourer Lives*, a study of 55 farming families.

While it is clear that Rowntree's survey covered all the identifiable working-class families in York, it is equally clear that there are some problems with the ways in which he arrived at his conclusions and these have been identified by historians and sociologists (for example, **M. Brown** and **N. Madge** and **K. Coates** and **R. Silburn**). Certainly, precise statements about numbers, percentages and income levels must be treated with caution. Rowntree was unable to ascertain the exact wages of many workers and estimated them: 'In the case of skilled workers, the earnings were assumed to be the average wage which obtains in the district for the particular trade.' Thus, his frequent use of two decimal places cannot be justified by the crude nature of his data.

He does, too, describe how he arrived at the number of people who were living in primary and secondary poverty, and this can be open to criticism as being too subjective.

My investigator noted as being in poverty those families who were living in obvious want and squalor. From this total number I subtracted those who were living in 'primary' poverty; the remainder represented those who were living in 'secondary' poverty. Now, in order to ascertain the number who were living in 'primary' poverty … it was necessary first to ascertain what were the minimum sums upon which families of different sizes could be maintained in a state of physical efficiency. Having settled these sums, it was only necessary to compare the income of each family with the standard in order to see whether that family was above or below the 'primary' poverty line … the fixing of my 'primary' poverty line depends absolutely upon a money basis, the fixing of my 'secondary' poverty line depends upon observations regarding the conditions under which families were living.

Subjective though these criteria and analyses were, at least they were more or less consistent. It must be remembered, too, that the distinction between 'primary' and 'secondary' poverty was not designed to identify the poor. That had already been done. It was intended to use them to describe the nature of that poverty. It should also be noted that the criteria used by Rowntree to identify the poor did not here include income. Poverty was identified by that which was visible to the investigators. Thus, a family of poor managers with a higher income than a family of good managers on a lower income would be classed as 'poor' when the latter would not. In this, Rowntree's criteria were similar to those used by Booth and so their findings can, with some justification, be compared. They both found that around 30 per cent of a total urban population were living in poverty at the end of the nineteenth century. And both investigators suggested that poverty was a state that was beyond the control of the poor.

How had Rowntree's analysis of poverty changed by 1936?

Rowntree's second survey was started in 1935 and reported in 1941. It employed a new device with which Rowntree hoped to demonstrate that

What did he discover?

Rowntree found that about 28 per cent of the population of York were in 'obvious want or squalor'. Using what information he could gather about their wages, he worked out the minimum wage that would be necessary for a family to live in a state of simple 'physical efficiency', with sufficient food, fuel, shelter and clothing. At this sum – 21 shillings – he drew his 'poverty line'. Rowntree was able to demonstrate that around 10 per cent of the population of York were living below this poverty line. There was no way in which they could ever make ends meet. They were living in 'primary poverty'. What of the remaining 18 per cent? These, Rowntree found, were living in 'secondary poverty' – teetering on the brink of primary poverty, with the bare necessities of life but without any leeway for emergencies and certainly not for savings. The death of the main wage earner, a trade slump resulting in lay-offs or even a child's illness could throw the poor family into primary poverty. This, of course, overlaid the concept of a lifetime poverty cycle that Rowntree had developed.

How reliable were his findings?

Helen Bosanquet of the COS immediately attacked Rowntree's findings in much the same way as she attacked those of Charles Booth. As with Booth, she claimed he had overestimated the level of poverty by setting the poverty line too high. Yet, to set a line at 21s 8d was to set it almost ridiculously low, as price indices show.

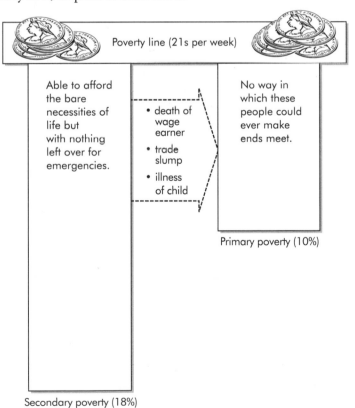

Poverty line (21s per week)

Able to afford the bare necessities of life but with nothing left over for emergencies.

- death of wage earner
- trade slump
- illness of child

No way in which these people could ever make ends meet.

Primary poverty (10%)

Secondary poverty (18%)

Rowntree's findings about the reasons for 'primary poverty' in York in 1899.

BENJAMIN SEEBOHM ROWNTREE

Benjamin Seebohm Rowntree (usually known as Seebohm Rowntree) was a devout Quaker all his life: this tended to dominate his attitude to society in general and his own workforce in particular. Believing that healthy, contented workers were also efficient workers, he championed democracy in the workplace, a minimum wage, family allowances and old age pensions. He conducted three surveys of poverty in York that provided a wealth of statistical data and which supported the findings of Charles Booth in London, thus showing that primary poverty was more widespread than had originally been thought.

What did he set out to do?

Seebohm Rowntree stated that his primary aim was 'to ascertain not only the proportion of the population living in poverty, but the nature of that poverty'. He set out to conduct an enquiry into the poor in the city of York in much the same way as Charles Booth was doing in London. He hoped, in his first survey, to build on Booth's work and give more precision to Booth's idea of a 'poverty line'. Rowntree was to complete three surveys in all: the second on poverty in York in 1936 and the third on poverty in York in 1950.

How did he conduct his investigations?

Rowntree's first general survey of York was carried out in 1899 and his findings published in 1901. He used one full-time investigator who made house-to-house visits, and relied, too, on information from clergymen, teachers and voluntary workers. Rowntree was focusing on the working classes in York whom he defined as those families where the head of the household was a wage earner and where no servants were employed. Altogether, 11,560 households were visited (almost all the wage-earning households in York) and information obtained about 46,754 people, almost exactly two-thirds of the total population of the city.

How has his work been interpreted?

Later historians and sociologists have been lucky: Booth's original notes and those of his fellow investigators have survived, unlike those of Mayhew and Rowntree. It is therefore possible to go back to the beginning, rework his figures and reconsider.

The view that Booth's defined classes were an uneasy mix of the economic and the moral is represented by **J. Brown**, who argues strongly that Booth's moral preoccupations influenced his work. He shows that, by dividing the working classes into various strata and by focusing on classes A and B, Booth is reflecting a common fear of contemporary politicians and social reformers, that the respectable poor would be infected by contact with classes A and B during periods of social distress. **Karel Williams** approached Booth's work from a slightly different perspective, pointing out that as part of his investigation Booth surveyed schoolteachers for their views on how many children were in poverty. This suggested a figure of 45 per cent, much higher than the 30.7 per cent projected by school visitors. Yet Booth provided no explanation for this, and other, apparent discrepancies in the evidence.

But, no matter how valid the criticisms, they must not detract from the enormous importance of Booth's work in producing the data to move forward the debate on poverty and in undermining the commonly held nineteenth-century view that poverty was the result of personal character deficiencies.

Charles Booth (1840–1916)

1840	Born, the son of a wealthy Liverpool entrepreneur who was head of the Lamport and Holt Steamship Company. Educated at the Royal Institution School in Liverpool.
1862	On the death of his father, ran the company and, with his brother Alfred, expanded it considerably. Wide business interests throughout the world.
1871	Married Mary Macaulay, niece of the historian Thomas Babington Macaulay. Settled in London with Mary and their two children. Became involved, through his wife's relatives, in the intellectual life of London, debating social and economic issues with such people as Sidney and Beatrice Webb and Octavia Hill.
1884	Made a Fellow of the Royal Statistical Society.

- Some 30.7 per cent of the population of London lived in poverty.
- Most poverty was caused by under-employment, low-paid employment and, in particular, irregular employment.

What solutions did he propose?

Booth saw classes A and B as providing the biggest problems. Class A, he believed, could be fairly easily dealt with through established charities and individual acts of philanthropy, coupled with rigorous policing. His solution to the problems caused by class B was to take them out of the labour market altogether. He saw them as lacking the ability to better themselves and, because of this, dragging down classes C and D. He proposed putting them in state-run labour colonies, thus freeing up employment opportunities for classes C and D who were better able to manage them. In this way, they would rise out of poverty and the poor, while remaining poor, would be able to live above his 'poverty line'.

How reliable were his findings?

Despite the mass of detail and careful analysis provided in Booth's seventeen volumes, and the very obvious thoroughness of his approach, there were contemporary criticisms. Booth himself supplied the basis of modern criticisms:

I made an estimate of the total proportion of people visibly living in poverty, and from among these separated the cases in which the poverty seemed to be extreme and amounted to destitution, but I did not enter into the questions of economical or wasteful expenditure.

Thus, Booth did not take into account income when defining poverty, but relied upon observation only. This subjective and unreliable measure can lead to criticism that his investigation was flawed.

The most strident contemporary criticism came from Helen Bosanquet of the COS. She objected to the social survey method developed by Booth because it had no underpinning philosophy or principle. She believed that his 'poverty line' was flawed because she disputed the 'facts' on which it was based as they were produced by the, to her, dubious survey method; she condemned the 'false air of definiteness' it conveyed. She attacked the statistical basis of Booth's findings, claiming that it underestimated the income level of poor families. She, of course, championed the family case-work approach of the COS and criticised Booth's workers who, although they did spend time living in poor quarters, tended to rely on primary research findings of such people as school board members and teachers. This does tend to shed some doubt on the reliability of Booth's findings, a view that has been developed further by historians in the last decades of the twentieth century.

and idlers, and people who sometimes took on occasional work. Booth believed people were born into this disordered class and rarely escaped from it. This class was the residuum – the very dregs of society.

- **Class B** consisted of about 7.5 per cent of the population who were the casual, low-paid workers. Most of them were dockers, who were employed on a daily basis and had no security of employment. Booth believed these people were, because of their mental, moral or physical state, incapable of bettering themselves.

- **Class C** were slightly better off than class B (here there is the problem of the shading of boundaries) but the irregular nature of their work meant that life was a constant struggle for survival.

- **Class D** had low incomes (less than 21 shillings a week) but their work was regular and so they were able to budget for survival.

- **Class E and Class F** together made up about 51.5 per cent of the population who were in regular employment that paid enough to enable them to lead comfortable lives. Class E earned up to 30 shillings a week and class F were the best-paid skilled artisans.

- **Class G and Class H** were the lower and upper middle classes who made up 17.8 per cent of the population.

So, what did this detailed analysis reveal?

Reasons for poverty in classes A and B and classes C and D.

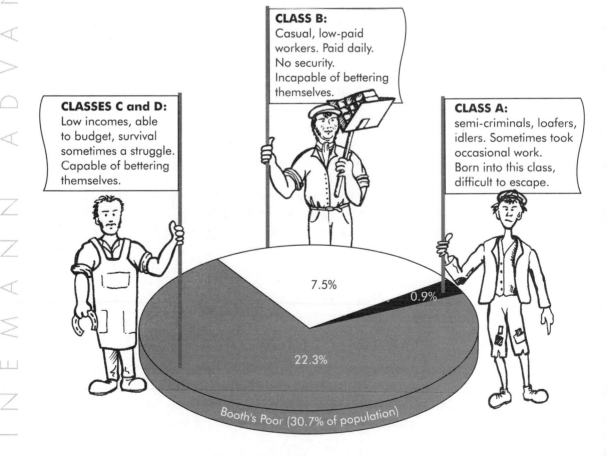

CLASS B:
Casual, low-paid workers. Paid daily. No security. Incapable of bettering themselves.

CLASSES C and D:
Low incomes, able to budget, survival sometimes a struggle. Capable of bettering themselves.

CLASS A:
semi-criminals, loafers, idlers. Sometimes took occasional work. Born into this class, difficult to escape.

7.5%

0.9%

22.3%

Booth's Poor (30.7% of population)

How did he conduct his investigations?

Booth's investigation was originally intended to last for three years but, although his findings were published on a regular basis, the whole enquiry took closer to seventeen years to complete. Obviously, the same team of people couldn't work on the project for that length of time. Booth was a constant factor – the lynchpin of the whole enterprise – but at any one time he had upwards of 35 men and women working with him. Where Booth differed from other project managers was that his team, mostly university educated, were more fellow-collaborators than dogsbodies. While Booth controlled their work, he expected them to contribute ideas and to take responsibility for writing specific sections of the final work.

Some examples will serve to show how intermeshed and yet wide-ranging Booth's investigators and investigations became. Jesse Argyle had started out as one of Booth's steamship company clerks. A cockney with an excellent knowledge of the east end of London, he became invaluable as Booth's secretary and office manager. But he was more than this. An able and perceptive interviewer, he was responsible for investigating poverty in Walthamstow and wrote up his findings for the final publication as well as contributing an article on silk manufacture. He became a Fellow of the Royal Statistical Society in 1892. Graham Balfour was a Fellow of the Royal Statistical Society and at one time its President. He set up the enquiry into poverty in Battersea, supervised it and wrote it up for publication. Octavia Hill – granddaughter of Dr Southwood Smith, and renowned for her housing schemes and support of the Charity Organisation Society – made contributions on model dwellings and their influence on the character of the poor. Beatrice Potter – cousin of Mary Booth and later to marry the Fabian Sidney Webb – wrote articles on the docks, the wholesale tailoring trade and the Jewish community. Clara Collett worked as an interviewer for Graham Balfour and contributed findings in her own right on women's work and girls' education. Ernest Aves was a sub-warden of Toynbee Hall when he was drafted in to help Beatrice Potter with her enquiry into sweated trades. He went on to work on the furniture trades in the east end of London and was an important influence upon the way the research was organised and data analysed, although Booth was the mainstay here.

What did he discover?

Booth and his team divided the population into classes. Although Booth acknowledged that the classes shaded into each other and that no sharp distinctions were really possible, he firmly believed that an appreciation of the differences between the classes was fundamental to understanding the causes of poverty.

- **Class A** consisted of about 0.9 per cent of the population who were people at the bottom of any social hierarchy: semi-criminals, loafers

1849	Cholera epidemic: Wrote an article for the *Morning Chronicle* on the impact of cholera on Bermondsey, a working-class area of London. Suggested to the editor that the newspaper carry out an investigation into the condition of the labouring classes in England and Wales. The *Morning Chronicle* published an article a day for the rest of 1849 and most of 1850. Mayhew wrote two articles a week about the poor of London; researchers working with him wrote about the rest of the country.
1850	Fell out with the *Morning Chronicle* and began publishing his investigations independently in a series of 63 weekly pamphlets at 2d each.
1860–1	Collected articles on London, published in four volumes as *London Labour and London Poor*.
1864	Wrote *German Life and Manners in Saxony*.
1865	Wrote *The Boyhood of Martin Luther*.
1874	Published book based on newspaper articles *London Characters*.

CHARLES BOOTH

Charles Booth was a wealthy, serious-minded entrepreneur, whose social conscience drove him to investigate the nature of poverty in London. He employed a team of up to 35 co-workers over a period of some seventeen years to undertake a detailed study of the poor in London. Their findings moved the debate forward in that Booth was convinced that most of the poor were in distress through circumstances beyond their own control.

What did he set out to do?

Charles Booth's involvement in the intellectual and socially aware radical circles in London led him to reject the hard line of the Charity Organisation Society (COS) that poverty was the fault of the poor. On the other hand, he was not (as a successful entrepreneur) prepared to go as far as some thinkers and blame the capitalist system itself for creating poverty. It seems likely, however, that it was the investigations of one of these Marxist thinkers, Henry Hyndman, that provided the trigger that set Booth off on his mammoth task. Booth quite simply could not accept the conclusion of Hyndman's street-by-street survey in the east end of London, that 25 per cent of the population lived in abject poverty. After some involvement with the 1885 Mansion House Enquiry into Unemployment, Booth was ready. He was not going to be content simply to describe the conditions in which the poor lived; he wanted to discover not just how the poor lived, but why they lived as they did. He wanted to explore the idea that there might be structural explanations for poverty, not just moral ones.

work as 'a mass of incidents of low life, told with dramatic intensity and simplicity by the actors themselves'.

How has Mayhew's work been interpreted?

Modern assessments of Mayhew's work vary as wildly as the views of his contemporaries. Ruth Glass (1955) and **Gertrude Himmelfarb** (1984), for example, criticise his methodology and the consequent unreliability of his findings, Himmelfarb going as far as to say that Mayhew 'merely popularised and dramatised' the social problem of poverty. On the other hand, **E.P. Thompson and Eileen Yeo** (1971) praise Mayhew for the way in which he harnessed his journalistic skills to higher social purposes, Eileen Yeo expressing disappointment that Mayhew simply did not have the genius of a Karl Marx to turn his observations into social theory.

But, perhaps most importantly of all, Mayhew:

- challenged the accepted idea that the poor were responsible for their own poverty; and
- warned of the consequences of inaction.

Henry Mayhew (1812–87)

1812	Born, one of six sons and eleven daughters, of Joshua Mayhew, a London lawyer, and his wife Mary Ann Fenn. Educated Westminster School. Joined his father's law practice, as did all his brothers. All boys, except one, left for careers in journalism and most were lively, witty, risk-taking failures.
1831	Started on a career in journalism. Worked mainly for two London journals, *Figaro in London* and *The Thief*.
1834	Wrote play *The Wandering Minstrel*.
1838	Wrote play *But However*.
1841	Started and co-edited a new journal *Punch Magazine* with a fellow journalist Mark Lemon.
1842	Sold *Punch* to Bradbury and Evans. Mark Lemon stayed on as editor, Mayhew as adviser and writer. Continued writing for *Punch* until 1845.
1844	Married Jane Jerrold.
1845	Started new journal *Iron Times* but ended up in the bankruptcy courts a year later.
1847	Wrote novel *The Good Genius*.
1848	Wrote novel *Whom to Marry*.

What did he discover?

Mayhew sorted and sifted, analysed and categorised all the interviews he had logged in. From this he drew certain conclusions:

- The level of poverty in which the 'London street folk' lived was desperate and could not be considered acceptable.
- The primary reasons for this poverty were low wages, unemployment and physical or mental handicap.
- There was a very real threat of social revolution if the plight of the poor was ignored.

How reliable were his findings?

Ever since the publication of *London Labour and London Poor*, there have been criticisms of Mayhew's methodology, his findings and his conclusions.

In general, the criticisms point out that his investigations were not systematic and his statistics were unreliable. His focus on marginal occupations skewed his findings and gave an exaggerated picture of the extent of poverty in London. His journalistic leanings and his need to make a living led him to be less than scrupulous with the truth and he went for the more lurid and colourful descriptions of the plight of the poor. Some of his interviews were fixed and all had the interviewer's prompts and questions omitted when they were finally published. While all of these criticisms contain an element of truth, they must not be allowed to detract from the very real contribution Mayhew made to the mid-nineteenth-century perception of poverty, to contemporary middle-class awareness of what it meant to be poor and to the shift that was beginning to take place in people's understanding of the causes of poverty.

How significant was Mayhew's work to contemporaries?

Mayhew himself described his work as being 'the first commission of enquiry into the state of the people undertaken by a private individual, and the first "blue book" ever published in twopenny numbers'. He was correct in that it did have enormous immediate impact. His pamphlets sold around 13,000 a week and others were inspired to embark upon similar surveys. Contemporary radicals – for example, G.J. Harney, editor of the Chartist journal *Red Republican* – applauded his work and authors such as Dickens and Thackeray emphasised the importance of his observations, Thackeray describing them as 'Wondrous and complicated misery'. After Mayhew's death, an obituary in *The Athenaeum* praised him as the originator of a school of journalistic philanthropists. Indeed, the labouring poor themselves viewed him as some kind of saviour, a finder of jobs and a worker of miracles. On the other hand, in 1887 the Fabian writer and social investigator Beatrice Potter dismissed Mayhew's

insufficient for the satisfaction of their wants'. This, however, was not enough and Mayhew needed to find a firm rationale for his enquiry – a basis on which he could build and which he could use as a constant point of reference. He was neither a statistician nor an arithmetician, and had never served on a royal or parliamentary commission, but he was an avid reader of official publications. Scrutinising these for methods, evidence and argument, he devised his own unique approach to social investigation. He aimed to use direct personal accounts from the poor themselves to present a scientific analysis of the structure of working-class London. He saw himself, too, as an intermediary, explaining and describing the lifestyle of one class to another.

How did he conduct his investigations?

The full title of Mayhew's work, when it was finally reproduced as a four-volume book, was *London Labour and London Poor: A Cyclopaedia of the Condition and Earnings of Those That Will Work, Those That Cannot Work and Those That Will Not Work*. This reflects his initial diagnosis that 'I shall contemplate (the poor) in two distinct classes, viz., the honest and dishonest poor, and the first of these I propose subdividing into the striving and the disabled – or in other words, I shall consider the whole of the metropolitan poor under three separate phases, according as they will work, they can't work and they won't work.' Mayhew's initial starting-point was the low-paid trades such as the Spitalfield weavers and slop workers; he then moved to the people employed in the more central trades like tailors, cabinetmakers and boot and shoe makers. He virtually ignored heavy and light industry, such as engineering and printing, and totally ignored domestic service. Much of his survey focused on those living on the margin: the dockers and glass-eye sellers, the crossing sweepers and mudlarks, the dredger-men and the prostitutes.

Mayhew insisted that nothing would do but face-to-face interviews with his subjects. This was not always easy to achieve and his methods were unorthodox. He sent cabs to collect working people and bring them to the offices of the *Morning Chronicle* where they were interviewed; he talked to workers in back rooms where trades union meetings were being held; he visited men and women at their places of work and in their homes; he held meetings in lodging houses where the poor were encouraged to talk; and he invited the poor into his own home and talked to them there.

Maintaining that the voice of the poor had to be heard, Mayhew claimed that he recounted the interviews exactly as they were heard, using the language and pronunciation of the poor, and as written down by himself, his brother Augustus and the two former missionaries who assisted them.

For example, William Langton who founded the Manchester Statistical Society was also heavily involved in Liverpool's Provident Society that organised visits to the poor in order to encourage cleanliness and sobriety.

Royal and parliamentary commissions – anecdotes or evidence?

- The evidence given to royal and parliamentary commissions had, since the eighteenth century, been published in 'blue books', so called because of the colour of their bindings. They were available to any interested party to read and reproduce in discussion papers and pamphlets.
- Between 1832 and 1846, there were over 100 royal and parliamentary commissions enquiring into such things as the employment of children in factories, the workings of the old Poor Law and the sanitary condition of large towns.
- The commissions used a series of question-and-answer techniques to amass information about a whole range of social and economic issues.
- The assumption behind this amassing of data was that the more that was known about a specific issue, the more obvious would be the right course of action.
- Although the prejudices of the commissioners determined the questions they asked and those they summoned to appear before them, there is no evidence that their findings were deliberately rigged. By assuming that the 'facts' spoke for themselves, they overlooked the need to consider the ways in which they arrived at the 'facts'.

It is against this background and within this context that the work of three great social investigators – Henry Mayhew, Charles Booth and Benjamin Seebohm Rowntree – must be considered.

HENRY MAYHEW

Henry Mayhew is something of an enigma. The details of his life are a combination of the sketchy and the detailed, and are at times wildly contradictory. His funeral, for example, has been variously described by contemporaries as well attended and indicative of his continuing popularity, and one of obscurity and near destitution. Later, historians and sociologists have criticised his maverick methods and unsound conclusions; others have praised his thoroughness, attention to detail and ability to illuminate the lives of the dispossessed.

What did he set out to do?

Henry Mayhew's brief from the *Morning Chronicle* was to provide a reliable account of the earnings of a sample of the working population of London. These he defined as 'all those persons whose incomings are

censuses is well documented. Many regarded them as, at best, an invasion of privacy and, at worst, a device that could be used by governments against the interests of the people.

- However, **private census taking** had a long tradition, especially in the industrial heartland of Britain. Liverpool, for example, held a census of its inhabitants every ten years in the eighteenth century, as did Manchester. These were seen as less threatening because the local authorities had very limited powers of taxation and could be seen to have local interests (vested or otherwise) at heart.
- **Ecclesiastical censuses** were taken from time to time by the Anglican church. They were usually used to enforce orthodoxy and, because of this, tended to count different things in different ways, depending upon what the authorities were wanting to enforce at that particular time. In 1563, for example, households attending church were counted; in 1603, communicants. In 1851 the government sponsored Horace Mann's census of religious attendance. His census counted all those who attended church (all Christian denominations) on a particular Sunday. Two fairly amateur religious censuses of London were also attempted: William Robertson Nicol's for the *British Weekly* in 1886 and George Cadbury's for the *Daily News* in 1901.

Statistics – social and political arithmetic?

- Statistics were used for social and economic purposes from about the seventeenth century. Early statisticians – Gregory King and Charles Davenant, for example – believed that quantitative measures were the best to use for obtaining valid evidence about social and economic issues. While they were preoccupied with the importance of trade as an indicator of the country's wealth, and King in particular with estimating population growth, statisticians gradually began to apply their skills to issues such as poverty and the health of the people.
- In the eighteenth century, statistics were used to fuel the debate about population. In particular, by the end of the century there was great fear that overpopulation would have serious social and political consequences. Although this fear tended to be based on speculative calculations, there was a growing confidence that empirically derived data would somehow engender action – and that this would be the best action to solve whatever problem was being investigated.
- The nineteenth century saw a growth of semi-professional statistical societies. The Manchester Statistical Society was founded in 1833, the Royal (London) Statistical Society in 1834, Birmingham in 1835, Bristol and Glasgow in 1836 and Liverpool, Leeds and Ulster in 1838. The Manchester Statistical Society was particularly important in that it pioneered house-to-house surveys. Membership of these societies is important. Although members were all firmly wedded to the belief that ideas should follow the amassing and evaluation of facts, few were arid theorists. Most were actively involved in some form of philanthropy.

How effective were the social investigators of the nineteenth and early twentieth centuries?

Now, what I want is, Facts. Teach these boys and girls nothing but Facts. Facts alone are wanted in life. Plant nothing else, and root out everything else. You can only form the minds of reasoning animals upon Facts: nothing else will ever be of any service to them.

So begins Charles Dickens' novel *Hard Times*. Written in 1854, it was a ruthless parody of Utilitarianism. Yet it was the amassing of 'facts' by people like Henry Mayhew, Seebohm Rowntree, Beatrice Webb and Clara Collett that was to challenge and eventually change the Utilitarian thinking that underpinned social policy throughout most of the nineteenth century.

CONTEXTUALISING VICTORIAN AND EDWARDIAN DATA COLLECTION

Victorian and Edwardian investigation – whether it was the investigative journalism of Henry Mayhew, the questionnaires of Edwin Chadwick, the interviews by royal commissions or the collection of data by Charles Booth and Seebohm Rowntree – was nothing new. For hundreds of years, investigations and surveys had provided the evidence to underpin social policy, and it is important to consider the work of the Victorians in the whole context of the history of data collection.

Counting and number crunching – for what purpose?
- The **Domesday Book of 1086** is perhaps the most well-known early survey; updated frequently after 1250 by 'extents'; the information so gained about population and landholdings formed the basis of medieval taxation.
- The **1377 Poll Tax** and the **Hearth Tax returns of 1662–90** were different types of taxation and provide invaluable indices of social, economic and demographic change. The Hearth Tax required a count of all hearths (and levied a tax of 2 shillings per hearth) and the Poll Tax, a count of all males over the age of 16.
- **National censuses** have an even older pedigree, and were well known in ancient times. Most rulers had a desire to know what they held in terms of land and people, and then to tax it. In modern Europe, however, censuses had no place until the eighteenth century, and then they were, again, closely linked to taxation. The first national census in modern times was held in Sweden in 1749, but it was not until 1801 that Britain followed suit. Indeed, British suspicion of national

A2 SECTION: SOCIAL POLICY AND DEBATE, 1815–1948

INTRODUCTION

There has been a considerable amount of historical research and debate about social policy in the nineteenth and early twentieth centuries. The following sections focus on the main areas of the debate.

Section 1: How effective were the social investigations of the nineteenth and early twentieth centuries? focuses on the data collections of Henry Mayhew, Charles Booth and Seebohm Rowntree.

Section 2: How far did attitudes to the poor change between 1834 and 1984? looks at the ways in which the perceptions of the poor, the reasons for poverty and where responsibility for poverty was to be found, changed over time.

Section 3: To what extent were the obstacles to the establishment of a public health system in the nineteenth century philosophical or practical? examines the problems faced by those attempting to introduce a comprehensive public health system.

Section 4: Nineteenth- and twentieth-century social reform: from laissez-faire to collectivism? examines the theories underpinning and developing from the changing responses of government.

Section 5: How have historians interpreted the issues surrounding poverty and welfare in the nineteenth and twentieth centuries? considers the different ways in which historians have interpreted changes in poverty and welfare provision.

HEALTH FOR ALL, 'FROM THE CRADLE TO THE GRAVE'

In 1941 the government appointed a committee of inquiry to investigate existing social security schemes, and suggest improvements. A senior civil servant, Sir William Beveridge, chaired the committee and had sole responsibility for the outcomes of the report. *Social Insurance and Allied Services* (often called simply 'the Beveridge Report') was a best-seller when it was published in 1942. It proposed far-reaching reforms, based upon Sir William Beveridge's belief that social problems were all linked. He vowed to do battle with the 'five giants on the road of social progress': want, disease, ignorance, squalor and idleness. Beveridge's Report was the foundation of the welfare state that proposed to look after people 'from the cradle to the grave'.

- The attack on disease was led by the Minister of Health in the new Labour government, Aneurin Bevan.
- The 1946 National Health Service Act laid down that the whole range of medical treatment, including by dentists and opticians, was provided for everyone.
- The Medical Practices Committee allocated new general practitioners so that everywhere in the country was adequately covered.
- All hospitals (except the big teaching hospitals) were nationalised and England and Wales divided into regions, each with a regional hospital board.
- Local councils provided midwives, health visitors, district nurses and ambulances.
- Health centres were set up, where doctors worked together as a team.
- All these services were free at the point of delivery, and were financed from taxation.

- **1940** School meals, up to 1940, were offered only to the children of the poor. From July 1940, the government began encouraging local authorities to provide subsidised school meals, regardless of parents' income.
- **1940** The government introduced a national milk scheme. Children, expectant and nursing mothers were entitled to half price (and, in some cases, free) milk.
- **1941** Cod-liver oil and blackcurrant juice (later replaced by orange juice from the USA) were provided for expectant mothers and young children.
- **1941** From September, one-third of a pint of milk was available, free, for all children at school. (This was restricted to primary schools in 1968 and abolished altogether in 1971.)

INSURING AGAINST DISEASE

At the beginning of the century (see pages 90–4) the Liberals had introduced a national insurance scheme that gave health and unemployment insurance to 12 million working people. This was gradually extended:

- In 1925 health insurance was extended to cover widows, orphans and the over-65s.
- By the 1930s, 20 million people were covered by health insurance and 14 million workers were entitled to claim unemployment benefit. But millions fell outside the scheme and, even when workers were covered, their families were not.
- Doctors and dentists charged fees that were too high for most working-class people to afford, and they had to accept second-class treatment by being on a doctor's 'panel' – a kind of savings club operated by individual doctors which poorer patients could draw on when they were sick.
- Many doctors, fearful that their bills would not be paid, refused to practise in the inner cities where public health provision was often poor and people were frequently sicker and in need of all-round medical care and advice.

rehoused close to their old homes, but mainly in tower blocks.

MASS PREVENTION OF DISEASE

The twentieth century saw closer and closer involvement of government in the prevention of disease.

- **1922** The Ministry of Health ordered all milk to be pasteurised or sterilised so that tuberculosis (TB) could not be passed on to people from cattle.
- **From the 1930s** vaccines to prevent diphtheria were given to many children. During the Blitz, the Ministry of Health intensified its campaign against the disease, which was likely to spread rapidly in the crowded conditions of air-raid shelters. While wartime deaths from diphtheria rose alarmingly in other European countries, in Britain they fell to 25 per cent of the pre-war figure.
- **In the 1930s** sulphonamide drugs were developed. They targeted specific diseases: the first ones, influenza and pneumonia.
- **1938** Drs Florey and Chain worked on Alexander Fleming's discovery of **penicillin**, and in 1941 ran a small-scale trial on six people that was successful. The Americans found a way of growing large amounts and it was available to troops from 1942. After the war, it was available to civilian doctors.

DIET AS AN AID TO PUBLIC HEALTH

Better diet helped to improve the health of the average person. In the 1930s, for example, the average family spent more on fruit than it did on bread. But the Second World War severely restricted the amount of good-quality food available to people.

- **1940** Food rationing introduced, and became increasingly strict as the war progressed. Many people ate a healthier diet than ever before.

KEY FEATURE

Penicillin An antibiotic drug, originally taken from cultures of the fungus *Penicillium*, and later made artificially. Many penicillins are given by mouth or by injection to treat bacteria infections.

virtually impossible to build houses that lower paid workers could afford.

- **The 1919 Housing Act** Government subsidies given to local councils and private builders to enable them to build affordable housing for people on low incomes. Estates of 'council houses', with gardens, piped water and inside lavatories sprang up and were let to people on lower incomes. Waiting lists were common.
- **1930** A special slum clearance subsidy was offered, with the aim of encouraging councils to pull down slums and rehouse their inhabitants at rents they could afford.
- **1933** Councils asked to prepare five-year programmes for the abolition of slums. In the inter-war years, two-thirds of all houses built were sold to owner occupiers. The housing 'problem' was almost solely that of providing houses to rent for those on a low income.
- **Late 1930s** Most houses in towns and cities had piped water and were connected to a sewerage system, but only about 50 per cent had a hot water tap and a fixed bath.

In 1939 the Second World War intervened and all housing programmes were suspended. About one-third of Britain's housing stock was destroyed or damaged during the war (1939–45).

- **1945** An emergency drive converted army huts and aeroplane factories into temporary accommodation. Prefabricated houses were built from factory-made sections and put up on concrete bases. The 'prefabs' were supposed to last for ten years but many still stand today, for example in Bristol.
- **The 1946 New Towns Act** This aimed to build new houses and move people from the run-down centres of existing towns; new towns were to have development corporations that were to ensure the towns were planned with separate zones for housing, shopping, industry and open spaces. Among the first twelve (started in 1950) were Crawley, Harlow, Corby, Stevenage and Peterlee.
- **In the first ten years after the war** three-quarters of all new housing was council built and owned.
- **By 1967** 900,000 slum houses had been pulled down and 2.5 million people rehoused. Many had been

POST-SCRIPT

Public health, 1900–46

This section gives a brief overview of the changes and developments in public health in the first half of the twentieth century. It is intended to give factual reference points to underpin discussion in the A2 sections about, for example, increased state involvement in public health.

HEALTH AND HOUSING

The improving health of men, women and children at this time was closely linked to the provision of soundly built housing with good ventilation, plenty of light and with connections to clean water and a sewerage system.

- **1902** Ebenezer Howard wrote *Garden Cities of Tomorrow* showing how the facilities of a city could be brought together with the health of the countryside into planned new towns.
- **1903** Building of Letchworth, the first garden city, began.
- **1920** Building of Welwyn, the second garden city, began.

Indeed, the origins of the new towns built after the Second World War (see page 171) owe much to Ebenezer Howard's reforming reaction to the appalling conditions of late Victorian London. Under normal conditions, house building lagged behind population growth, but, during the four years of the First World War, house building stopped altogether and house repairs were minimal. Returning soldiers found that Prime Minister Lloyd George's promise to clear the slums and create 'homes fit for heroes' rang hollow. After 1918 a dramatic rise in the cost of building materials slowed any rebuilding programmes and made it

- To gain the highest marks you must formulate a developed, analytical argument that takes account of national and local initiatives and begins to consider their effectiveness. How could the state (however you define it) be considered responsible if the initiatives fail?

public health. Originally, he believed legislation should be permissive. He now believes local authorities should be compelled to use the powers at their disposal.

> 2 What arguments were used by those who were opposed to making public health provision compulsory? (7)

How to answer this question. This question is asking you to remember what you have read and learned about the topic and, from what you know, to select what is appropriate and use it. You should, at all costs, avoid making vague generalities. The points you make must be supported with hard factual evidence.

- One of the most common and most powerful arguments against compulsory public health provision was that of cost. Make explicit reference to individuals/groups who objected on cost grounds and, if you can, quote some costings.
- You should be able to focus in specific detail on one or more of the groups which opposed compulsory public health measures because they had an interest in providing it privately. A good example would be the water companies which quite obviously wanted to keep the supply of clean water in their own hands.
- To get really high marks you should put this private v. public argument into its proper context by referring to the shift away from the prevailing orthodoxy of laissez-faire.

> 3 By what stages did the state begin to take over responsibility for public health between 1848 and 1875?

How to answer this question. Here, again, you have to remember what you know about the topic and select from what you know to answer the question in a direct way. Never be tempted to write all you know about public health between these two dates!

- At a basic level you should be able to pick out the main legislative milestones – 1848, 1866 and 1875 – and show how they empowered the state to become more and more vigorously involved in public health.
- Try to take this further and write a developed explanation that demonstrates that increasing state intervention in public health matters didn't happen in clearly defined steps. Consider, too, what is meant by 'state'. The state in the national arena, which usually means the government? Or the state on a smaller scale, which tends to mean local councils? Go beyond the national 'landmark' Acts and look at local initiatives, which sometimes took official intervention further than national legislation, and which sometimes lagged behind national legislation when it was permissive.

AS ASSESSMENT: PUBLIC HEALTH 1815–75

SOURCE BASED QUESTIONS IN THE STYLE OF EDEXCEL

Study Source A below and then answer the questions that follow.

Source A

I venture to submit that the time has now arrived when it ought not any longer to be discretional in a place whether that place shall be kept filthy or not. Powers sufficient for the local protection of public health having been universally conferred, it next, I submit, ought to be an obligation on the local authorities that these [powers] be exercised in good faith and with reasonable vigour and intelligence.

From the Annual Report of the City of London's Medical Officer for Health, John Simon, in 1865.

Questions

Before answering these questions, you should read Chapters 10 and 11 of this book.

> 1 Study Source A. What, according to Source A, is John Simon's attitude to public health? (5)

How to answer this question. The question is straightforward. It is asking you what you can glean from the source about John Simon's attitude to public health. You are not expected to bring in any external information. In other words, do not use anything you happen to know about John Simon. Focus on the source alone. It's not an easy source, so read it through carefully several times and ask yourself what he is really saying.

- At a very basic level, it is clear that John Simon is in favour of change. Once you have realised this, build on it. There is more to say!
- John Simon is arguing that permissive Acts (for example, the 1848 Public Health Act) have given local authorities the power to impose public health. He is proposing that local authorities should be forced to use those powers.
- For full marks you would need to be able to go still further and show the examiner that you understand Simon is expressing a shift in attitude to the provision of

- The 1875 Food and Drugs Act attempted to define unadulterated food.

In general, implementation of the Food and Drugs Acts was patchy, and any prosecutions resulted in ridiculously small fines being levied. However, a start had been made and the state was moving inexorably to protect its most vulnerable members.

SUMMARY QUESTIONS

The purpose of this section is to help you consolidate your thinking about persistent public health problems.

1 In what ways did the control of diseases (apart from cholera) become matters of public health and not individual medical care?

2 Why did it take so long to improve Britain's housing stock? What impact did this have on public health?

3 Look at the picture on the front of this book. It was published in *Punch* in July 1858, at the time of the Great Stink. What is the message of the cartoon? What choice was made and how was that choice put into effect?

4 How far had human and industrial effluent ceased to be a public health problem by 1875?

5 Why was public health such a large-scale problem in the nineteenth century?

Evidence for food adulteration can be found in reports of various government departments and select committees, but it wasn't until Dr Hassell published his *Food and Its Adulteration* in 1855 that a government committee on the subject was appointed. This resulted in a sequence of Acts that were varying in their effectiveness:

- The 1860 Food and Drugs Act enabled local authorities to appoint analysts who could investigate food if a complaint was received.
- The 1872 Adulteration of Food, Drink and Drugs Act enabled local authorities to order an investigation of specific foodstuffs even if no complaint had been received.

THE USE OF ADULTERATION.

Little Girl. "IF YOU PLEASE, SIR, MOTHER SAYS, WILL YOU LET HER HAVE A QUARTER OF A POUND OF YOUR BEST TEA TO KILL THE RATS WITH, AND A OUNCE OF CHOCOLATE AS WOULD GET RID OF THE BLACK BEADLES?"

This cartoon from 'Punch', published in August 1855, formed part of a campaign the magazine waged against food adulteration.

- Pickles got their green colour from copper shavings.
- Cheese rind was coloured with red lead.

Initially acclaimed, Accum was forced to flee the country on what appears to have been a trumped-up charge of mutilating books. As well as drawing people's attention to the nature of the food they were eating, his meticulous descriptions instructed a whole new generation of food adulterers.

In 1830 an anonymous publication again alerted people to the dangers of adulteration. Called *Deadly Adulteration and Slow Poisoning Unmasked: or Disease and Death in the Pot and Bottle*, it aimed at sensationalism:

- oil of vitriol in gin;
- opium in beer;
- burned bones in bread;
- ground stone in flour.

Public interest in food adulteration was revived and kept alive by *A Treatise on the Falsifications of Food*, written in 1848 by John Mitchell, an analytical chemist who had studied food adulteration for some years. He found that food adulteration had increased since Accum's findings were made public:

- Every sample of bread he looked at contained alum and sometimes potato as well.
- Samples of flour contained chalk, pipe-clay and powdered flints.
- Beer contained sulphate of iron which gave it a good 'head'.
- Eight factories in London dried used tea leaves and supplied them to fraudulent dealers who sold them on as 'fresh'.

The rich and comfortably off could, of course, afford to buy their food and drink from high-class, reputable suppliers. It was the poor, already debilitated by poor living and working conditions, who had to bear the brunt of food adulteration.

the Parliamentary Select Committee on the Protection of Infant Life heard evidence from all over the country. It was told that at a Manchester day-nursery every single child was infested with lice and they all had to be debugged every day.

By 1875 the situation had improved for many people. In Edinburgh, for example, over 50 per cent of those with houses of a rateable value less that £5 had piped water, whereas in West Bromwich the figure was 16 per cent. An investigation into urban water supplies by the Local Government Board found that there were huge areas without easy access to cheap, clean water.

Food

Large-scale adulteration of food was only possible in industrial, or industrialising, societies. In earlier times, there were always cheats and liars who passed off lightweight loaves of bread and watered beer, for example, as the genuine article. But the deliberate, widespread adulteration of food for profit needed a consuming public, divorced from the producers of the food. In nineteenth-century Britain, food adulteration became a widespread and highly remunerative commercial fraud. It affected the health of the people by not giving them the nutrients they thought they were purchasing; it frequently made them ill and sometimes killed them.

One of the first people to highlight the problem was analytical chemist Frederick Accum who published his *Treatise on Adulterations of Food and Culinary Poisons* in 1820. He found that nearly all foods and drinks were adulterated to some extent, and he exposed methods and named names. Some of the most common adulterations Accum found were:

- Bakers used alum to whiten cheap flour in order to pass off their loaves as being of high quality.
- Brewers put a dangerous poison containing picrotoxin into ale and porter, along with hartshorn shavings, orange powder, caraway seeds, ginger and coriander.
- Tea was mixed with ash, sloe and elder leaves that had been curled and coloured on copper plates.

villas of the middle classes reveal no lack of water for washing clothes, cooking and personal hygiene.

For the poor it was different. The poor, in the middle of the nineteenth century, had to queue for their water at standpipes and street plugs, and carry it back home through dirty streets and courtyards. This must have been an arduous, backbreaking business, and one frequently undertaken by children. For the poor – living in crowded, bug and rat infested rooms, sometimes below the level of the street, off fetid alleys and courtyards – trying to keep clean must have been a dispiriting business. It was no wonder that many gave up the attempt. Most of the poor, quite simply, smelled and in some cases they stank.

Edwin Chadwick's 1842 *Report on the Sanitary Condition of the Labouring Population of Great Britain* (see page 135), edited by Michael Flinn in 1965, quotes John Liddle's observations on the washing of clothes by the poor of Whitechapel (London). John Liddle was the medical officer of health for the area.

They merely pass dirty linen through very dirty water.* The smell of the linen itself, when so washed, is very offensive, and must have an injurious affect upon the health of the occupants. The filth of their dwellings is excessive, so is their personal filth. When they attend my surgery, I am always obliged to have the door open. When I am coming downstairs from the parlour, I know at a distance of a flight of stairs whether there are any poor patients in the surgery.

[*It is likely that this 'dirty water' was urine. The poor frequently stored their urine in stone bottles until it was very strong and then used it to wash their clothes, believing it to be an effective cleansing agent.]

The objection of railway managers to workmen's trains and of Church of England congregations and clergy to the attendance of the poor in their midst was based as much on their smell and the offence this gave to 'respectable' people as on anything else. While the smell itself did not produce disease (except to those adhering to the miasmic theory) it was indicative of conditions in which disease flourished. Typhus and TB were common and diphtheria, scarlet fever and measles regular child-killers. For the poor, body lice and nits were commonplace; bedbugs, living in straw-filled mattresses, ever constant companions. In 1871

works there … sending out thousands and thousands of cubic feet of gas and smoke close to private residences. I ask the individuals who live there if they do not suffer in their health. They say 'No, it is all good for trade, we want more of it, we find no fault with smoke.'

Domestic pollution was slightly different. To attempt to put controls on the domestic hearth was seen by most people as being a gross interference in the 'Englishman's castle' – his home. Furthermore, any attempt to control discharges from the domestic hearth would involve inspection, another invasion of the domestic citadel.

The 1875 Public Health Act (see page 148) did consolidate restrictions against 'nuisances', but there was a 'get-out' clause for industries:

No offence of creating excessive smoke can be construed if fireplaces and furnaces are constructed in such a manner as to consume as far as practicable, having regard to the nature of the manufacture or trade …

Proper and effective control of smoke pollution had to wait until the last decades of the twentieth century.

SCARCE WATER AND ADULTERATED FOOD: THE ACCEPTABLE FACE OF INDUSTRIAL BRITAIN?

Water

A ready supply of clean water is an essential concomitant of a decent public health system. Yet, for most people living in Victorian Britain, the supply was hardly 'ready' and rarely clean. The East London Waterworks, for example, did not supply water on Sundays; a Staffordshire waterworks turned off supplies every night in order to build up pressure in the mains; and in many parts of the country the supply of water was, at best, erratic and not always of good or even reasonable quality.

The well-to-do had water piped to their houses and stored in huge cisterns in attics and cellars. For them, water did, usually, come at the turn of a tap. In the 1840s, 20 per cent of Birmingham houses and 10 per cent of Newcastle homes had water piped in. Household accounts for the country houses of the rich through to the comfortable

Country being so named produced lavatory pans and sewerage pipes; and the alkali works that poured hydrochloric acid into the air produced cheap soap and washing powders.

Parliamentary papers of 1843 reveal that an official stated that in Manchester:

nearly 500 chimneys discharging masses of the densest smoke; the nuisance has risen to an intolerable pitch, and is annually increasing, the air is rendered visibly impure, and no doubt unhealthy, abounding in soot, soiling the clothing and furniture of the inhabitants, and destroying the beauty and fertility of the garden as well as the foliage and verdure of the country.

In 1867 the Royal Commission on Rivers Pollution stated in its third report that:

Although it has usually been considered an impossible feat to set the Thames on fire it was found practicable to set the Bradford Canal on fire, as this at times formed part of the amusement of boys in the neighbourhood. They struck a match placed on the end of a stick, reached over and set the canal on fire, the flame rising six feet and running along the water for many yards, like a will-o-the-wisp.

London fogs were known as 'London peculiars' and were really heavy smog: a blend of smoke and fog with a high sulphur and hydrocarbon content that were lethal to those with respiratory troubles. By 1875 over 150 tons of fine soot were discharged into the atmosphere every day from London's domestic fires. A city the size of Glasgow could burn up to 1 million tons of coal a year – on domestic fires and in gas production and manufacturing industries.

In order to control, or attempt to control, industrial pollution, it was necessary to show that what was clearly unpleasant was also poisonous. This required sophisticated chemistry and record keeping, as well as the will to change. Too frequently, industrial pollution and prosperity were seen as necessary partners. For example, a member of the local board of health for Darlington argued in 1866 that the town needed its smoke:

The question as I look at it is whether Darlington is to be a manufacturing town or not ... If I go to Middlesborough I see large

- The market in human waste virtually collapsed due to the importation of guano (solidified bird droppings) that was cheaper, easier and more pleasant to handle.
- There was a lack of co-ordination and standardisation between the different commissions operating in any one town.

But help was at hand. In 1856 Joseph Bazalgette was appointed chief engineer to the Metropolitan Board of Works and submitted his plan for a complete sewerage system for London to the board. The protracted disputes that followed were abruptly ended by the Great Stink and Disraeli's Metropolis Management Amendment Act, which allowed Bazalgette to begin work. By 1864 London's sewage was taken by barge to the Maplin Sands; dumping sewage at sea continued until 1998. Although these events describe happenings in London, the pattern and sequence was followed throughout Britain.

Industrial effluent

Industrialising Britain was a dirty, smelly place that polluted the atmosphere and the earth. It was also a place that produced enormous wealth. 'Where there's muck, there's brass' was not said lightly in the industrial towns of the north. And herein lies the paradox. The Lancashire mills that belched smoke over the squalid rows of back-to-back houses produced cotton goods that were essential to personal hygiene; the potteries that led to the Black

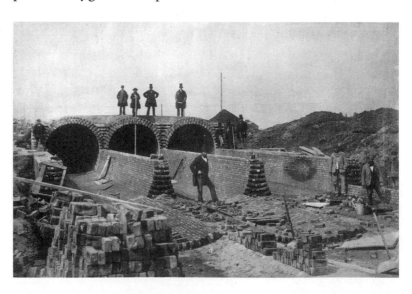

Constructing sewers in 1862.

almshouses and a hospital for his workers. This benevolent paternalism was resented by some, derided by others but accepted with alacrity by those who willingly swapped some individual freedoms for fresh air, clean water and decent housing.

ENVIRONMENTAL POLLUTION: A NECESSARY EVIL?

Human effluent

In June 1858 Members of Parliament fled the building. They left the corridors and libraries, tea rooms and the chamber of the House of Commons itself. This was no bomb scare or fire. This was the summer of the Great Stink, when soaring temperatures had turned the river Thames into a stinking, malodorous sewer. The reasons for this are not hard to find. Thomas Cubbitt, builder and developer of most of fashionable Victorian London, gave evidence in 1840 to the Select Committee on the Health of Towns:

Fifty years ago nearly all London had every house cleansed into a large cess pool. Now sewers have been very much improved, scarcely any person thinks of making a cess pool, but is carried off at once into the river. The Thames is now made a great cess pool instead of each person having one of his own.

Several factors combined to make the situation worse:

- The flushing water-closet – invented in the sixteenth century by Sir John Harrington and refined and sold by Joseph Bramah and Thomas Crapper in the nineteenth century – removed human waste very effectively from houses and into sewers. The sewers, however, led directly to rivers and other water courses.
- As towns grew, farms became more remote and the cost of transporting human waste to them to manure the fields increased. For poorer families, the cost became prohibitive and they allowed the waste to accumulate until it became a hazard.
- Edwin Chadwick's plan of using canal barges to spray human waste on the fields alongside the canals was impractical when put into effect.

Joseph Chamberlain (1836–1914) Born in London, Joseph was educated at University College School and went to work in Nettleford's screw factory in Birmingham. He retired when he was 38 years old, having made a fortune. He entered politics and in 1868 was elected a Birmingham town councillor, and in 1873–6 the city's mayor. He became MP for Birmingham in 1876; four years later he was in the Cabinet as President of the Board of Trade. A radical social reformer, he embarked on a massive slum clearance programme in Birmingham, built housing for the poor, set up free public libraries and art galleries, and took gas, water and sewerage systems into the control of the city council. He had little regard for the aristocracy, believing they should pay for their privileges. Queen Victoria was not amused. He broke with the Liberal Party in 1886 because he distrusted Gladstone and opposed his Home Rule policies. In 1895 he became Colonial Secretary in Salisbury's Conservative–Unionist government, where he supported expansion in Africa. He resigned in 1903 so that he could promote his own policy of tariff reform, which was based on giving preferential treatment to imports from the colonies and protection for colonial industries. In 1906 he left public life because of a stroke and died on the eve of the First World War.

health. Faced with cholera epidemics and endemic 'dirty' diseases, the authorities had to fall back on the expedient:

- The Common Lodging Houses Acts of 1851 and 1853 laid down that all lodging houses were to be registered and inspected by the police. However, the Act was badly drafted and rarely enforced.
- The Nuisances Removal Act of 1855 empowered local authorities to combat overcrowding, as a nuisance, with fines and prosecution.
- The Sanitary Act of 1866 (see pages 146–7) placed limitations on the use of cellars for occupation.
- The Artisans' Dwelling Act of 1868 (sometimes called Torren's Act) gave local councils the power to force a landlord to repair an insanitary house. If he did not, the council could buy it and pull it down.
- The Artisans' Dwelling Act of 1875 (sometimes called Cross's Act) gave local councils the power to clear whole districts, not just individual houses.

These last two Acts were permissive. Some councils adopted them with alacrity. Birmingham, for example, began a huge slum clearance programme under the direction of its progressive mayor **Joseph Chamberlain**. He persuaded the town council to buy 4 acres of slum houses and tumbledown workshops in the city centre. In their place, the council built new law courts and a shopping centre. The people who had lived there had to make shift as best they could. The main problem with the Artisans' Dwelling Acts was that they made no provision for the compulsory housing of those made homeless by slum clearance. So the dispossessed simply moved on, to create a slum somewhere else. It was not until 1890 (for London) and 1909 (for the rest of the country) that councils were obliged to rehouse at least half of the people evicted in their slum clearance programmes.

Elsewhere, men of substance took a different attitude and were not dependent on Acts of Parliament before they could act. Titus Salt, a wealthy Bradford millowner, moved his factory and its workers out of a filthy, polluted environment to the purpose-built village of Saltaire. He first built a new mill, and then houses, a school, park,

Recovery are of fearful extent. (Committee Report Book, Leeds, when, under the authority of the 1842 Leeds Improvement Act, permission was sought to demolish the cottages)

Was the way forward to be one of compulsion or of state-built housing to the required standard that would be cheap enough to house the poorest in the community? There was no clearly defined government housing policy until the last two decades of the nineteenth century. Some towns and cities had inserted clauses in their own private Improvement Acts that empowered them to have some control over new building, sewerage connections and cellar dwellings. These were:

- Leeds and Liverpool in 1842
- Manchester in 1844/5
- Nottingham and St Helens in 1845
- Burnley and Newcastle in 1846.

The 1844 Metropolitan Building Act gave the London authorities similar powers. However, to give controls to an authority was not the same as that authority actually acting upon them. Hundreds of new buildings did not conform to the regulations that were supposed to govern them.

It was the Local Government Act of 1858 (see pages 145–6) that set out model by-laws, and ten years later some 568 towns were using them. However, although building regulations were generally available in the 1860s, their impact was less than it could have been. Vested interests fought them through the local courts; localities developed their own variants; and there was always the problem of enforcement. The Public Health Act of 1875 (see page 148) set out very clearly what the powers of local authorities were with regard to building regulations, and it was because of the firmness and clarity of this Act that standard local government by-laws were laid down in 1877. These sought to regulate such things as the width of streets, the height of buildings and systems of drainage.

However, all these were primarily concerned with new buildings. It was going to take years before these building regulations had any sort of cumulative effect on public

In 1870–3 a second smallpox epidemic, in which 44,000 people died, resulted in a draconian Act:

- The compulsory 1871 Vaccination Act made it obligatory for local health boards to appoint vaccination officers and imposed fines of 25 shillings on parents who refused to have their children vaccinated, with imprisonment for those who did not pay the fine.

In theory, all should have been well. But this emphasis on compulsion resulted in a groundswell of opposition and a strong anti-vaccination movement. Their arguments ranged from fear of central government interference in local government affairs, through to the rights of the individual to choose to take a chance with death, to religious objections against the injection of impurities in the blood. These fears were ameliorated in 1898 by the insertion of a 'conscience clause' in the Smallpox Act.

HOUSING: A PUBLIC HEALTH ISSUE?

The pressures of a growing population upon the existing housing stock during the first half of the nineteenth century have been described and explained on pages 112–14. The health of the poorer and most vulnerable people in Britain was dependent to a large extent upon the provision of good-quality housing. But that housing had to be cheap if the poor were to afford it, and herein lies the problem. No speculative builder was going to build good-quality housing that was also cheap. No landlord was going to charge lower rents than he could obtain on the open market for properties he owned.

These extracts from documents relating to the notorious Boot and Shoe Yard in Leeds illustrate the problem:

The Boot and Shoe Yard cottages are said to pay the best annual interest of any cottage property in the borough. (*The Sanitary Conditions of the Labouring Population – Local Reports*, 1842)

The property proposed to be purchased consists of the Boot and Shoe Yard ... which is a disgrace to the town and from which locality the number of cases sent to the Infirmary, the Dispensary and the House of

Scarlet fever killed children: 95 per cent of all cases were in children under 10 years old and most died. In 1863 scarlet fever killed 34,000 and in 1874, over 26,000. Children, playing with siblings and friends, readily transmitted the disease, both inside and outside the home. In 1869 John Simon, Chief Medical Officer to the Privy Council, called for strict quarantine to be enforced and local authorities responded slowly. Where quarantine was enforced, the death rate fell dramatically.

Diphtheria, often appearing on death certificates as 'croup' or 'throat fever', was a killer too, and was closely linked by the Registrar-General with scarlet fever. A highly contagious disease, it spread rapidly, particularly among children, in crowded and poorly ventilated living conditions. About 25 per cent of those contracting the disease died.

Not all diseases waited upon the physical improvements of sewerage systems and better housing for their control, nor upon the acceptance of the germ theory of disease.

Smallpox had been a controllable disease since Edward Jenner's discovery of a vaccine in 1798, but until the mid-1830s was intermittently used by the well-to-do and comfortably off. After 1834 the smallpox vaccine was made available, free, to Poor Law vaccinators but vaccination was voluntary. The dangers of this were highlighted by the epidemic of 1837–40 in which around 42,000 people died and thousands more were disfigured for life.

What was to be done? A safe vaccine was readily available but people were reluctant to use it. The government began a gentle move to compulsion:

- The permissive 1840 Vaccination Act meant anybody could be vaccinated free of charge by the Poor Law vaccinators.
- The compulsory 1853 Vaccination Act made it obligatory for parents to have their children vaccinated within three months of birth. This made vaccination more common, but it was administered in a haphazard way.

KEY FACT

Smallpox A highly contagious, and sometimes fatal, disease caused by a virus. People who catch smallpox usually have a high fever and a rash. The spots turn into pustules that can scar a person for life. Human beings are the only carriers of smallpox and so vaccination is very effective; so effective, in fact, that there have been no recorded cases of smallpox anywhere in the world for many years.

KEY FACTS

The causes of tuberculosis
Tuberculosis (usually called TB) can be an airborne infection spread by inhaling droplets infected by the tuberculosis bacterium, or it is caught by drinking milk from cows that have bovine TB.

other diseases and was not itself notifiable until 1912. Tuberculosis affected all classes, but hit hardest those who

- had poor nutrition;
- lived or worked in overcrowded, badly ventilated conditions.

More than any other disease, the incidence of tuberculosis charts the public health of a community: to be controlled it requires adequate housing, diet and clean milk. Deaths from tuberculosis, for example, were 50 per cent higher in back-to-back houses than in other kinds. An improved housing stock and better diet resulted in the death rate from the disease being halved by the end of the century. Moves by local authorities to, for example, prevent spitting in public places, helped too.

A 'Punch' cartoon of January 1872 demonstrates the concerns of the affluent with their own effluent.

UTILE CUM DULCE.

Inquisitive Gent. "YOU WILL—A—THINK' ME VERY INDISCREET—BUT I CANNOT HELP WONDERING WHAT THIS ELABORATELY-CARVED AND CURIOUSLY-RAMIFIED STRUCTURE IS FOR. IS IT FOR ORNAMENT ONLY, OR INTENDED TO HEAT THE HOUSE, OR SOMETHING?"

Fastidious Host. "O, IT'S THE *DRAINS!* I LIKE TO HAVE 'EM WHERE I CAN LOOK AFTER 'EM MYSELF. POOTY DESIGN, AIN'T IT? MAJOLICA, YOU KNOW. . . HAVE SOME CHICKEN?"

in 1869 there were 4281 deaths from typhus in England and Wales and in the 1870s they averaged 1400 a year. While there is some evidence that the disease-carrying micro-organism was itself weakening as the century progressed, it is certain that the progressive removal of heaps of excrement and the cleansing of polluted wells and repair of leaking cesspits hastened its decline.

The increasing use of cotton bedding and clothing – which was much more easily washed than woollen items – helped too. It must be remembered that not all lavatories were connected to cesspits or sewers. Many working-class homes used dry-ash pans supplied by their local council. This method of disposing of human waste was certainly an improvement on the earlier uncertain and unreliable efforts of night-soil men. Flushing lavatories – the ideal – were not effective until running water was laid on to all houses which were then connected to a sewerage system which discharged safely.

Typhoid was only separately identified from typhus in 1869 and, indeed, it had very similar symptoms. But typhus was spread mainly by body lice; typhoid mainly by infected water. Thus typhoid hit people in all social classes and all manner of lifestyles. Prince Albert died of it in 1861. Ten years later, his eldest son was a guest of the Countess of Londesborough at her country house outside Scarborough where many guests contracted the disease. He survived a severe attack, but his groom and the Earl of Chesterfield died. The most likely cause of typhoid was the contamination of water by human waste.

Typhus, typhoid and cholera were all so-called 'dirty' diseases, intimately connected with putrefying waste matter, intestinal, and producing high fevers and diarrhoea. They were killers. But there was another raft of diseases that were respiratory and pulmonary: less dramatic but killers nonetheless.

Tuberculosis, the 'white plague', probably accounted for one-third of all deaths from disease in the nineteenth century. 'Probably' because it was sometimes confused with

The causes of typhoid
Typhoid is a bacterial infection carried in contaminated milk, water or food. It thrives in situations where human waste can contaminate water. The most common symptoms are headaches, coughs, watery diarrhoea and high fever. Some people do not display the disease, but are carriers and can transmit it to others.

This diagram to show how the 'ash pan method' worked was published in the Supplementary Report to the Local Government Board in 1874.

CHAPTER 12

Persistent problems?

Cholera and sewerage tend to dominate any study of nineteenth-century public health. This is inevitable because of the drama of the four killer epidemics and the struggle to establish the need for clean water and the separation of drinking water from sewage. But there were persistent problems that daily affected thousands of people throughout Britain. Among these were endemic diseases such as typhoid, typhus, tuberculosis, diphtheria and scarlet fever and the slum housing that enabled these diseases to prey upon the population. For the poor and working classes, life was a daily struggle to find clean water and unadulterated food, coupled with hazards over which they had no control, such as factory effluent and raw sewage.

DISEASE: A PERSONAL OR A PUBLIC HEALTH PROBLEM?

Disease affected people in all walks of life. To the well-to-do, it meant tragedy and disruption. To the poor it meant tragedy and the threat of pauperism. So, for thousands, disease was inexorably linked to poverty and the fear of the workhouse. The control of endemic killer diseases was not completely dependent on the discovery of a cure, but on preventative measures like personal and domestic cleanliness, adequate domestic living arrangements, clean water and effective sewerage systems. And so, the prevention of disease was inextricably linked to effective public health.

Typhus, sometimes known as Irish fever or gaol fever, was endemic in nineteenth-century Britain. It hit the country in epidemic proportions in 1837 and 1839, and again in 1847 when 10,000 died in the north-west alone. From the middle of the century, however, the disease was in decline:

In July 1854 *The Times* campaigned against Chadwick:

We prefer to take our chance with cholera and the rest than be bullied into health. There is nothing a man hates so much as being cleansed against his will, or having his floors swept, his walls whitewashed, his pet dungheaps cleared away, or his thatch forced to give way to slate, all at the command of a sort of sanitary bombaliff. It is a positive fact that many have died of a good washing. All this shows the extreme tenderness with which the work of purification should advance. Not so, thought Mr Chadwick. New mops wash clean, thought he, and he set to work, everywhere washing and splashing, and twirling and rinsing, and sponging and sopping, and soaping and mopping, till mankind began to fear a deluge of soap and water. Mr Chadwick has very great powers, but it is not so easy to say what they can be applied to. Perhaps a retiring pension, with nothing to do.

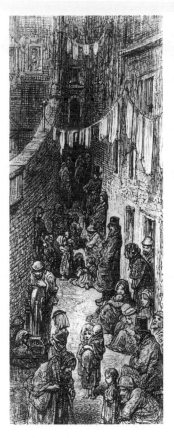

There was no cause for complacency, as Gustav Doré's engraving of a London backstreet in the 1870s makes clear.

SUMMARY QUESTIONS

The purpose of this section is to help you consolidate your thinking about public health legislation.

1 Why was the 1848 Public Health Act a permissive Act and not a mandatory one?

2 What were (a) the advantages and (b) the disadvantages in making public health legislation permissive?

3 Why did public health legislation move from being permissive to compulsory?

4 Read the extract from *The Times* newspaper above.

a On which elements of opposition to public health reform is the newspaper focusing?
b Why is the newspaper attacking Edwin Chadwick?
c Do you think the newspaper is really recommending its readers to take their chance with cholera?
Use the extract from *The Times* newspaper and your own knowledge in your answer.

adviser to the Imperial Department of Health in Berlin, where he carried out most of his research until the end of his career. Robert Koch built on the work of Louis Pasteur and found the connection between specific diseases and the bacilli that caused them. He isolated the organism that caused anthrax in cattle (1876) and tuberculosis (1882). In 1883, while in India, he identified the cholera bacillus in infected water. In 1905 he was awarded the Nobel prize for medicine.

KEY PERSON

William Farr (1807–83), chief statistician at Registrar-General's Office
A qualified doctor who never practised, William Farr was appointed chief statistician to the newly set up Office of the Registrar-General, a post he held until 1879. From 1 July 1837, all births, deaths and marriages in England and Wales had to be registered there. By insisting that doctors certified the cause, and not simply the fact, of death, Farr was able to produce statistics that were invaluable to public health reformers. He used his position to advocate public health reform, drawing attention to the wide variations in mortality between different areas of the country. A supporter of the miasmic theory of disease, the 1866 cholera outbreak finally convinced him that cholera had to be water-borne.

This great consolidating Act remained the foundation of all public health work until 1936.

WHY WAS THERE OPPOSITION TO PUBLIC HEALTH PROVISION IN THE 1850s AND 1860s?

Opposition to public health reforms was not so much opposition to the reforms themselves as to a variety of issues that were highlighted by the pressure for reform. These issues varied in their importance from place to place and local priorities changed over time. This is why some areas embraced reform wholeheartedly, others dragged their feet and some refused point-blank to have anything to do with it.

- Improvement schemes of any kind cost money. Property owners spent money to have clean water piped to large cisterns in their own houses, and for sewers or cesspits to hold waste from their inside lavatories. They were loath to pay out again, via local taxes, to have similar facilities provided for their neighbours when, they argued, there would be no benefit to themselves.
- Many people felt that government was encroaching on their individual liberties by requiring them to, for example, remove dung heaps from their properties or whitewash a slaughterhouse.
- Vested interests – for example, directors of local water companies – were usually represented in local government and often on local boards of health. They were unlikely to vote for measures that would reduce their company profits.
- The civil engineering problems posed by sewerage and water supply schemes were barely understood by lay people on local boards of health; this caused delay and, occasionally, the implementation of inappropriate systems.
- Chadwick himself – one of the three commissioners on the General Board of Health set up by the 1848 Public Health Act – irritated, annoyed and angered many because of his bullying tactics.

WHAT WERE THE PRESSURES FOR FURTHER CHANGE?

- In 1867 the Reform Act effectively gave the vote to working men in towns. Politicians had to pay attention to their problems, which included public health issues.
- There was a third cholera epidemic in 1865–6, in which 20,000 people died.
- In 1865 **Louis Pasteur** (1822–95) proved conclusively that germs caused disease and were not caused by it. **Robert Koch** built on Pasteur's work.
- In 1869 a Royal Commission on public health was set up which revealed that conditions in towns were little better than when Chadwick had been masterminding investigations some 30 years earlier.
- In 1871 a Local Government Board was set up. This consolidated the functions of the Local Government Act Office, the **Registrar-General's Office**, the medical department of the Privy Council and the Poor Law Board. The president was usually a member of the cabinet. (See page 62.)
- The 1872 Public Health Act ensured that the whole country was covered by sanitary authorities (town councils and local boards in urban areas and guardians in rural ones); their sanitary duties were made compulsory and they each had to appoint a medical officer of health.

The 1875 Public Health Act

This Act broke no new ground: it was primarily a consolidation and codification of about 30 previous laws. It established that:

- Every part of the country had to have a public health authority.
- Every public health authority had to have at least one medical officer and one sanitary inspector to ensure that the laws on food adulteration, housing, water supplies and cleansing were enforced.
- Local authorities had wide powers to lay sewers and drains, build reservoirs, parks, public baths and public conveniences.

Louis Pasteur (1822–95)
He was a French chemist and bacteriologist who held many academic posts and from 1867 worked as a professor of chemistry at the Sorbonne. His early work was chemical, firstly on crystals and then on micro-organisms. He found that fermentations were caused by organisms, not by spontaneous generation. Working on this, his investigations into animal diseases had good results, enabling him to make the link, again, between germs and disease. He proved conclusively that germs caused disease, not the other way round. In 1865 he tackled silkworm disease and then chicken cholera and rabies. The deaths from typhoid of two of his daughters started his investigations in human diseases and their prevention by inoculation. He worked on septicaemia, cholera, diphtheria, fowl cholera, tuberculosis and smallpox. In 1881 he found a vaccine for fowl cholera and, four years later, one for rabies. He tried but failed to find a vaccine against the human version of cholera.

Robert Koch (1843–1910)
He was a German doctor and bacteriologist who worked first on wounds, septicaemia and splenic fever. This gained him a seat on the Imperial Board of Health in 1880. He was appointed government

spread of disease but, unlike Chadwick, changed his mind as evidence supporting the germ theory gradually became available.

bullying and outright opposition. Much pressure for progress came from the local authorities themselves. However, too often lack of specific powers was used as an excuse for inaction. On 3 February 1865 the *Leeds Mercury* recorded:

> There was no power to compel the owners of property to sewer land before building human habitations on it … no power to compel the sewering and paving of the multitudinous new streets … no power to forbid cellar dwellings … no power whatever to compel the owners of old property to connect their dwelling houses with the drains.

Simon gradually became convinced that the government had to be persuaded to embrace compulsion. In his annual report of 1865 he wrote:

> I venture to submit that the time has now arrived when it ought not any longer to be discretional whether a place is kept filthy or not.

As a direct consequence of this sort of advice, in 1866 Parliament passed a new Sanitary Act:

- Sanitary powers that had been granted to individual local boards of health under the 1848 Act were made available to all local boards.
- Local authorities were made responsible for the removal of 'nuisances' to public health. If local authorities failed to act, central government could do the work of improvement and charge the local authorities.
- The definition of 'nuisance' was extended to domestic properties and included overcrowding.
- Local authorities were given the power to improve or demolish slum dwellings.

For the first time, compulsion was a significant element of an Act of Parliament dealing with public health. No longer did the state direct and advise local authorities: it could now compel them to act. In this sense, the state was, from this point on, directing public health reform.

Why were these two linked Acts of Parliament needed, so soon after the 1848 Public Health Act? The ten years in between had shown a gradual acceptance by local authorities of the need for more powerful local public health bodies. But there was considerable hostility towards the General Board of Health and its commissioner Edwin Chadwick. He had to go, and a more acceptable way of centralising and controlling public health provision had to be found. Splitting the powers and functions of the old General Board of Health between the Local Government Act Office and the Privy Council medical department was the solution. It was a clever one, too.

One of the main functions of the old General Board of Health had been to approve loans to local authorities for public health projects. This function was continued, although slightly differently. The permission of the Local Government Act Office was needed for all loans that local authorities wanted to raise in order to carry out public works. It was just a short step for the Privy Council medical department to carry out the relevant inspections where public health projects were involved. In other words, it was central government direct (as in the Privy Council) that for the first time became involved in the administration of public health in the localities. In the ten years up to 1868, 568 towns set up boards of health and began implementing public health reforms.

THE 1866 SANITARY ACT

A key mover behind this new Sanitary Act was **John Simon**. He had been London's first medical officer of health in 1848 and medical officer to the General Board of Health in 1855. In 1858, when the General Board of Health was wound up, he became the first medical officer to the medical department of the Privy Council.

Simon worked within the permissive framework set up by the 1848 Act, seeking to persuade local authorities to accept public health systems. By working with the current of local opinion, and walking away where he could do no good, he achieved more than Chadwick had done by

John Simon (1816–1904)
A surgeon at St Thomas' Hospital (London), he later lectured in pathology at the hospital medical school. A founder member of the Health of Towns Association in 1844, in 1848 he became medical officer of health for the City of London and Chief Medical Officer for Health to the Privy Council in 1858. He was a superb administrator, finding ways round seemingly insurmountable problems. When, for example, the City of London refused to supply him with disease and mortality returns, Simon invoked the Nuisances Removal and Disease Prevention Act of 1846 and got the data he wanted. He built up a system of house inspection by City police and Poor Law medical officers, and published weekly reports on their findings that shocked the City authorities into action. He promoted an Act that made the adulteration of food illegal, and that permitted local authorities to employ public analysts to check food. He supported vaccination and trained vaccinators, supporting a law that prosecuted parents for refusing to have their children vaccinated against smallpox. Simon's contemporaries regarded him as the greatest exponent of practical public health reform.

Like Chadwick, he was initially a firm supporter of the miasmic theory of the

He described one privy that served the needs of over 60 people, and of the contents of lean-to privies saturating the walls of houses. He wrote of the sewerage:

In the sewers already laid there appears to have been no regard paid to the general system, inclination, depth, capacity, form or construction; some are four, five, and even ten feet deep, while others are level with the surface of the streets, and in form are square with stone sides and tops, but without bottoms.

Clearly, the 1848 Public Health Act did not have the same impact as the 1834 Poor Law Amendment Act. The reasons for this were many:

- The public and government were not convinced that order had to be brought from the bewildering multiplicity of private Acts relating to public health.
- Medical knowledge was not giving clear messages.
- Vested interests in, for example, water companies, remained strong.
- Local improvement commissioners, where they existed, feared the loss of their powers.
- Sanitary engineering was expensive.

Despite all its failings, however, the 1848 Public Health Act does demonstrate that the government was prepared to do something. It was prepared to provide a solution for towns and cities trying to fight their way through the morass of private and local legislation to achieve some sort of standard of public health. It was prepared, too, to intervene on behalf of the most vulnerable members of society to nudge their local authorities in the general direction of providing for their care.

THE 1858 LOCAL GOVERNMENT ACT AND THE 1858 PUBLIC HEALTH ACT

- The General Board of Health was abolished.
- The powers of the General Board of Health were given to a new Local Government Act Office.
- A medical department of the Privy Council was set up.
- Local boards of health were given powers to take preventative action and appoint officials.

second cholera outbreak to hit Britain. The General Board of Health was almost totally caught up in coping with this, and only when the epidemic had died down could it focus its whole attention on more general public health issues.

There were some clear successes:

- By the beginning of 1850, 192 towns had asked for the new public health regulations to be applied and the Act had been applied to 32 of them.
- By 1853 this had risen to 284 petitions and there were 182 towns where the Act had been applied.

However, this has to be put in context and set against the strength of vested interests and the reluctance of many local authorities to pay for something they considered unnecessary:

- In Lancashire only 400,000 of its 2.5 million people were living under some sort of public health board.
- Of the 187 major towns (those with a mayor and corporation) in England and Wales, only 29 had the powers of draining and cleansing in the hands of one board; 30 had absolutely no powers over public health because they were in the hands of independent commissioners; 62 had no public health authority whatsoever.
- Local boards of health, where they were set up, were frequently simply the existing town corporation under a different guise. Consequently, they were governed by the same vested interests and moved in the same slow and cautious way. Sometimes this was because they were constrained by pre-1848 private Improvement Acts; more often, hesitancy was due to a reluctance to spend money and a general ignorance of sanitary engineering and of the need for it. Frequently, for example, lavatories flushed into sewers that emptied into the nearest watercourse from which drinking water was taken.

In 1850 General Board of Health inspector William Ranger reported on the condition of the city of Darlington, which had trebled its population since 1800.

- Because it had to apply where conditions were very poor, people were desperate for any remedy and were unlikely to put up any serious opposition.
- Piecemeal implementation meant that those who were suspicious or wary could see for themselves how the Act worked to improve public health and would push for its introduction in their own towns and cities.

On the other hand, many would argue that its weaknesses were:

- It did not apply to London – which had its own Act in 1848 to establish the Metropolitan Commissioners of Sewers – or the City of London with its own City Sewers Act.
- It did not apply to Scotland.
- Before a local authority could adopt the Act, at least 10 per cent of those rated for poor relief had to petition to have it applied. The General Board of Health then sent an inspector who could, if he thought it appropriate, authorise the town council to carry out the duties laid down by the Act. Where there was no town council, the General Board of Health could set up a local board.
- The Act *had* to apply only where the death rate in a district was more than 23 per 1000 living. (The national average was 21 per 1000.) Then the General Board of Health could force a local authority to set up a local board of health.
- Local boards of health were to have considerable powers over basic public health requirements: drainage, building regulation, nuisance removal and water supply. But no local board of health was required to take on the wider public health considerations that included such things as parks and baths.
- The power to appoint a medical officer of health did not become obligatory until 1875.

How effective was the 1848 Public Health Act?

It is immediately obvious that there were so many ways in which the Act could be avoided or undermined that its impact, and therefore effectiveness, was almost bound to be patchy. It got off to a bad start, too, in that the immediate effects of the Act were overshadowed by the

'unwholesome' houses, accumulations of filth and foul drains and cesspools.

- The 1846 Baths and Washhouses Act enabled local authorities to provide baths and washhouses out of public money.
- In 1847 the Towns Improvement Clauses Act defined the rights of towns to lay water supplies and drainage schemes and to control nuisances.

These Acts shared a common characteristic: they only applied if the authorities wanted them to. Obviously, the Liverpool Act is different from the others, but the Liverpool authorities specifically asked for the Act so it's reasonable to assume that they wanted to enforce its provisions. All the other Acts were there if any local authority wanted to take advantage of them. Was this to be the pattern of things to come?

THE 1848 PUBLIC HEALTH ACT

- A General Board of Health was set up, which reported to Parliament.
- Local authorities were empowered to set up local boards of health.
- Local boards of health were to manage sewers and drains, wells and slaughterhouses, refuse and sewerage systems, burial grounds and public baths, recreation areas and public parks.
- Local boards of health could finance projects by levying local rates and buying land.

But this Act was **permissive**: it did not apply everywhere to all local authorities throughout the country. This was at once a great strength and a great weakness. It could be argued that its strengths were:

- Because it only applied where local people wanted it, there was little or no opposition to it and so implementation, unlike that of the Poor Law Amendment Act, was relatively smooth.

CHAPTER 11

Legislation: solving problems?

In the nineteenth century, as now, the effectiveness of legislation depended on many factors. Some of these factors are:

- the acceptance by the general public that the legislation is necessary and/or desirable;
- the lack of legal loopholes in the legislation;
- the existence of an infrastructure to implement the legislation;
- the existence of personnel to implement the legislation.

In the 1840s not all of these factors were present all of the time for all of the legislation connected with public health reform.

THE EARLY SANITARY LEGISLATION, 1846–8

The 1844 report of the Royal Commission into the Sanitary Condition of Large Towns and Populous Districts marked a mid-century appraisal of the sanitary condition of Britain. Almost immediately it was followed by some minor legislation designed to hold the situation until the main Public Health Act could be prepared:

- The Liverpool Sanitary Act was passed in 1846. This was an Act limited just to Liverpool. It made the corporation a health authority and empowered it to appoint a medical officer of health. The town council was given powers to carry out sewerage, drainage and water supply improvements – and it appointed W.H. Duncan as the first medical officer of health in Britain.
- 1846 saw the first of a series of Nuisance Removal Acts. These were designed to enable justices in petty sessions courts to prosecute those responsible for 'nuisances'. Nuisances were generally defined as being

SUMMARY QUESTIONS

The purpose of this section is to help you consolidate your thinking about the impetus for public health reform provided by enquiries and reports.

1 Why were reports on people's living conditions considered necessary in nineteenth-century Britain?

2 Which report do you consider to have been the most influential at the time? Why?

When the first report was published in 1844, it upheld Chadwick's findings. Of the 50 towns investigated, 42 were found to have bad drainage and 30 poor water supplies. The second report in 1845 contained proposals for future legislation, and included a long memorandum from Chadwick explaining the recommendations on sewerage, drainage and water supply. It recommended that:

- central government be given extensive powers to inspect and supervise local sanitary work;
- local sanitary districts be set up, with authority over drainage, sewerage, paving and water supplies;
- local sanitary districts be given powers to raise money for sanitary schemes through local rates.

HEALTH OF TOWNS ASSOCIATION

All the published reports did not seem to move the public and so Chadwick set about a propaganda campaign to raise public awareness. Part of this was the Health of Towns Association, formed in 1844 and organised mainly by Southwood Smith. It had a central committee in London and branches in most main provincial towns. Its aim was simple: to mount a propaganda campaign for public health legislation. Members gave public lectures, published and distributed informative pamphlets and produced a *Weekly Sheet of Facts and Figures*.

Chadwick, although not officially a member, was its virtual leader, directing operations, finding material for the association to use in propaganda and writing many of the association's reports. Meanwhile, all those working for change in public health waited for government to act.

- He explained why these apparently simple measures had not been implemented and suggested ways round the obstacles:

The chief obstacles to the immediate removal of decomposing refuse in towns and habitations have been the expense and annoyance of the labour and cartage required ...

This expense may be reduced to one-twentieth or to one-thirtieth, by the use of water and removal by improved and cheaper sewers and drains.

For all these purposes, as well as for domestic use, better supplies of water are absolutely necessary.

The reaction to Chadwick's report ranged from anger to wholehearted acceptance, passing through disbelief and derision on the way. Home Secretary Sir James Graham was reluctant to act on the findings and conclusions of what was, officially at least, a purely private and largely personal report. He set up a Royal Commission on the Health of Towns with the purpose, not of questioning Chadwick's findings or even his conclusions, but to investigate more fully the legislative and financial side of his recommendations. Chadwick, meanwhile, busied himself, at Graham's request, with a report on burial practices and with giving official and unofficial briefings to the members of the Royal Commission.

REPORT OF THE ROYAL COMMISSION INTO THE SANITARY CONDITION OF LARGE TOWNS AND POPULOUS DISTRICTS, 1844

The members of the Royal Commission were drawn from those who could be expected to know something about the subject they were investigating. Led by the Duke of Buccleuch, they included a geologist, a chemist, an expert on land drainage who was also a cotton mill manager and at least two engineers. Questionnaires were sent to the 50 towns with the highest annual death rates, and the returns studied by the commissioners themselves who also made official visits to the worst areas.

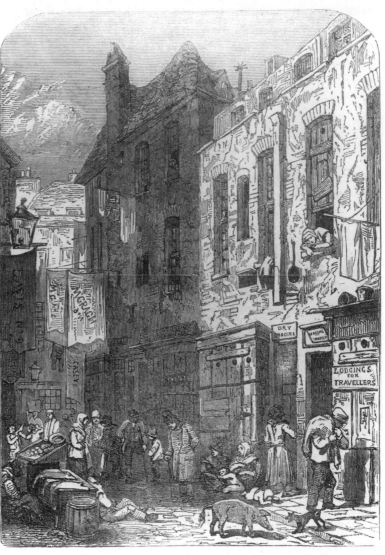

PICTURESQUE SKETCHES OF LONDON.—THE ROOKERY, ST. GILES'S.

The Rookery, St Giles (London) in the 1840s.

That where these are removed by drainage, proper cleansing, better ventilation ... the frequency and intensity of such disease is abated; and where the removal of the noxious agencies appears to be complete, such disease almost entirely disappears.

• He was very clear as to what had to be done:

The primary and most important measures, and at the same time, the most practicable, and within the recognised province of public administration, are drainage, the removal of all refuse from habitations, streets and roads.

Comparative chances of life in different classes of the community

Average age of the deceased

Place	Professional	Trade	Labourers
Truro	40	33	28
Derby	49	38	21
Manchester	38	20	17
Rutland	52	41	38
Bolton	34	23	18
Bethnal Green (London)	45	26	16
Leeds	44	27	19
Liverpool	35	22	15
Whitechapel (London)	45	27	22
Strand (London)	43	33	24
Kensington (London)	44	29	26
Kendal	45	39	34

It was the latter point that had the greatest impact. Chadwick demonstrated, beyond reasonable doubt, that there was a connection between disease and the environment.

Even though the figures in the table are depressed by the high rate of infant mortality, they made grim reading. They emphasised that there was a huge and probably preventable loss of life throughout the country.

Chadwick explained:

The annual loss of life from filth and bad ventilation are greater than the loss from death or wounds in any wars in which the country has been engaged in modern times.

Chadwick went further:

- He was very clear about the causes of the various diseases that led to so many premature deaths:

The various forms of epidemic, endemic and other disease are caused, or aggravated, or propagated chiefly among the labouring classes by atmospheric impurities produced by decomposing animal and vegetable substances, by damp and filth, and close and overcrowded dwellings ...

Edwin Chadwick now had the ammunition he wanted to make the case for a full-scale Poor Law enquiry. In 1839, prompted by Chadwick, the Bishop of London Dr Blomfield proposed in the House of Lords that a similar survey should be made of the prevalence of disease among the labouring classes. This time, however, the survey was to cover the whole country, and not just London.

Sir James Graham, the new Home Secretary, asked that the survey be completed and a report submitted by the beginning of the 1842 session of Parliament. Chadwick's report was in three volumes: two volumes of local reports from all over Britain, based on questionnaires sent to all local boards of guardians, and a third volume containing his own conclusions and proposals for the way forward. Almost immediately he hit a problem. The Poor Law commissioners refused to allow it to be published in its original form because it criticised the water companies, the medical profession and local administration. It named names, too. Eventually, in July 1842, Chadwick had the whole thing published under his own name and at his own expense.

REPORT ON THE SANITARY CONDITION OF THE LABOURING POPULATION OF GREAT BRITAIN, 1842

Chadwick's report was an epic document. In *Endangered Lives*, **Anthony Wohl** says that Chadwick 'skilfully wove the most lurid details and evocative descriptions, damning statistics and damaging examples into a masterpiece of protest literature'. It would be difficult to disagree. Chadwick:

- attacked the inadequacy of existing water supplies, drainage and sewerage systems supplies;
- pointed the finger at vested interests that stood in the way of improvement;
- stressed the connection between these, overcrowding, epidemics and death.

The three doctors Chadwick chose were all well known to him and all had previous experience in sanitary investigations:

- Neil Arnott, who had worked as a ship's surgeon for the East India Company where he had a particular interest in improving seamen's health and had made considerable progress in identifying connections between 'exotic' diseases like cholera and sanitation.
- James Kay, who had worked among, and reported on, the poor in Manchester and who later became a Poor Law commissioner in the eastern counties.
- Southwood Smith, who had worked for over ten years at the London Fever Hospital and as a physician to the Eastern Dispensary and the Jews' Hospital in Whitechapel.

Arnott and Kay investigated Wapping, Ratcliff and Stepney. They reported *On the prevalence of certain physical causes of fever in the Metropolis which might be prevented by proper sanitary measures.* Southwood Smith turned his attention to Bethnal Green and Whitechapel. His report was *On some of the physical causes of sickness and mortality to which the poor are particularly exposed and which are capable of removal by sanitary regulations, exemplified in the present condition of the Bethnal Green and Whitechapel districts, as ascertained by personal inspection.* Not exactly the most concise of titles, either of them. But their reports backed up what James Kay had found in Manchester and they went further in that, as their titles imply, they suggested how the situation could be improved. What was important about them, too, is that they received official sanction because they were published as appendices to the annual report of the Poor Law Commission. In this, they brought their conclusions to the attention of Parliament:

- In areas inhabited by thousands of people, healthy conditions could not be achieved under existing circumstances.
- The personal habits of people were of less significance in producing disease than overcrowding, poor ventilation, an inadequate water supply and a lack of proper refuse control.

Edwin Chadwick

(1800–90) Edwin Chadwick qualified as a lawyer and worked as a journalist. As a young man in London he joined the London Debating Society, a club for Utilitarians. He met John Stuart Mill, and Drs Southwood Smith and Kay Shuttleworth and ended up working full–time as Jeremy Bentham's secretary.

In 1832 he was appointed to the Poor Law Commission and his influence on the commission's report was enormous. After the passage of the 1834 Poor Law Amendment Act, he expected to be appointed as one of the three Poor Law commissioners but had to be satisfied with being its Secretary. He was largely responsible for the way in which the Act was implemented. Tactless, single-minded and fanatical, he made many enemies and during the 1837 general election there were public demonstrations against him.

As a commissioner on the Board of Health (1848–54) he campaigned for his vision of sanitary reform which culminated in the 1848 Public Health Act. His unshakeable belief in the miasmic theory of disease led him to advocate systems that flushed sewage into water courses. Irascible and dogmatic, he was rather pointedly pensioned off in 1854. However, he remains one of the prime thinkers and movers behind nineteenth-century welfare reforms.

found in almost unvariable alliance with dissipation, reckless habits and disease.

As well as demonstrating that dirt and diet affected the health of working people, James Kay threw into the equation (as did most nineteenth-century writers) the moral condition of the poor. The implication here, of course, was that 'dirty' living led to 'dirty' habits and proved to be a powerful motivational force for would-be reformers. This report was important, not simply for the information it contained, but because it set the scene for later investigations.

THE CONNECTION BETWEEN THE POOR LAW AND PUBLIC HEALTH

In 1837–8 London was hit by a typhus epidemic and the numbers applying for poor relief increased dramatically as a result. East London Poor Law guardians spent money from the poor rates on removing filth from the streets and on prosecuting negligent landlords. They were clearly acting upon the demonstrated connection between epidemics and living conditions. When the time came to have the East London union account books audited, the government auditors disallowed this expenditure. The Whig Home Secretary Lord John Russell referred the matter to the Poor Law commissioners. As their Secretary, **Edwin Chadwick** argued forcefully that, because disease caused pauperism, the prevention of disease and so the prevention of pauperism did fall within the competence of Poor Law guardians. The commissioners agreed with him. They went further. They authorised a pilot study on the connection between environment and disease in the worst areas of London, and detailed Edwin Chadwick to set it up.

It was important to Chadwick that the people he selected to work on this investigation were likely to come up with the solutions he wanted. Any reforms they recommended had to be based on the need for sanitary engineering, the disposal of refuse and the provision of clean water.

CHAPTER 10

Reports, investigations and enquiries: what was their impact on public health reform?

The nineteenth century was a time of investigating and reporting, of collecting and collating information. Many reports were local and went no further than the local town hall; others found their way to central organisations, like the Board of Health. Some reports were the result of the enquiries of select commissions, set up for specific enquiries by Parliament; others were generated by bodies such as the Poor Law Commission. These reports and enquiries sometimes resulted in the establishment of various associations, formed for a specific purpose, like the promotion of health in towns. Together they were to form public opinion and move the government to action.

THE MORAL AND PHYSICAL CONDITION OF THE WORKING CLASSES EMPLOYED IN THE COTTON MANUFACTURE OF MANCHESTER, 1832

This was one of the first detailed reports on the condition of a specific group of working people. The data were collected and the report compiled by **Dr James Kay**, who worked as a physician in Manchester for several years. He was one of the first people to demonstrate the connection between dirt and disease:

The state of the streets powerfully affects the health of their inhabitants. Sporadic cases of typhus chiefly appear in those which are narrow, ill ventilated, unpaved, or which contain heaps of refuse ... The confined air and noxious exhalations, which abound in such places, depress the health of the people, and on this account contagious diseases are also most rapidly propagated there ... The houses are uncleanly, ill provided with furniture ... they are often dilapidated, badly drained, damp; and the habits of their tenants are gross – they are ill fed, ill-clothed, and uneconomical ... Want of cleanliness, of forethought, and economy, are

SUMMARY QUESTIONS

The purpose of this section is to help you consolidate your thinking and understanding about the impact of cholera on public health provision.

1 Why did the first two cholera epidemics kill so many people?

2 Do you find John Snow's evidence about the significance of the Broad Street pump convincing? Why? Why did his findings take so long to be accepted in nineteenth-century England?

3 What impact did the cholera epidemics have on public health provision?

4 What was the message of the cartoon 'Death's Dispensary'? Do you find it surprising that it was published in 1860?

to be its last cholera epidemic. The East London Water Company, despite the work of Snow and Simon, continued to take its water from the river Lea and to supply it, unfiltered, to its hapless customers. When cholera reached London in 1866, it spread swiftly along the company's pipes and killed 4276 east Londoners while only 1639 died in the rest of London.

AND FINALLY ...

It was not until 1870 that John Snow's breakthrough in showing that cholera was water-borne received universal acclaim. John Simon, by then chief medical officer of health to the Privy Council, finally abandoned his attachment to the miasmic theory of disease, and in his annual report stated:

Not only is it now certain that the faulty water supply of a town may be the essential cause of the most terrible epidemic outbreaks of cholera, typhoid fever, dysentery and other allied disorders; but even doubts are widely entertained whether these diseases, or some of them, can possibly obtain general prevalence in a town except where the faulty water supply develop them ... Dr Snow, in 1849, was not able to furnish proofs of his doctrine ... but afterwards (and happily in great part before his premature and lamented death in 1858) distinct experiments, as well as much new collateral information, established as almost certain that his bold conjecture had been substantially right.

Joseph Bazalgette (1819–91) Born in Enfield (Middlesex), Joseph was the son of a naval commander and the grandson of a French merchant who was so wealthy he had been able to lend money to the Prince Regent, later George IV. At the age of 17, Joseph was articled to John MacNeill, who had worked with Thomas Telford as a principal road and bridge builder. In 1828 he became a graduate member of the Institute of Civil Engineers; by 1842 he had set up his own engineering business. Thirteen years later, Joseph was appointed Chief Engineer to the Metropolitan Board of Works. Within ten years, Joseph had designed and had ordered the building of 83 miles of main sewers, which discharged more than 400 million gallons a day into the Thames. In 1862 the Board was ordered to build an embankment along the Embankment from Blackfriars to Chelsea, which Joseph designed. He also modernised most of the bridges that spanned the Thames, built new ones for Putney and Battersea and designed the Blackwall tunnel under the Thames.

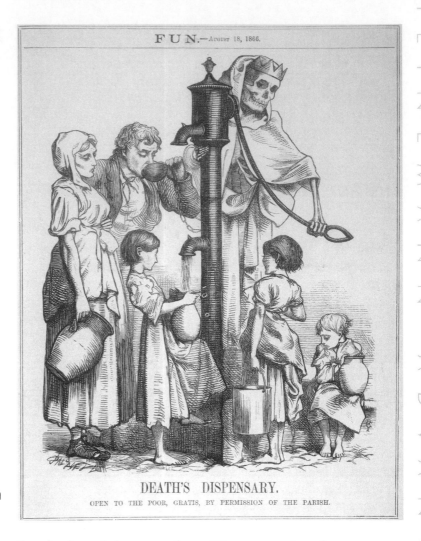

DEATH'S DISPENSARY.

OPEN TO THE POOR, GRATIS, BY PERMISSION OF THE PARISH.

This cartoon appeared in the magazine 'Fun' in 1866.

Lambeth took its water from Ditton, up-river from London, while Southwark took its water close to an outflowing sewer in Battersea. Even so, it was another ten years before the medical establishment accepted that cholera was a water-borne disease.

... AND JOSEPH BAZALGETTE

Joseph Bazalgette was the chief engineer of the Metropolitan Board of Works, whose design of a complete system of intercepting sewers kept the board and its political boss locked in fruitless argument (mostly about finance) until 1858. The new system, therefore, did not come in soon enough to save London from what was going

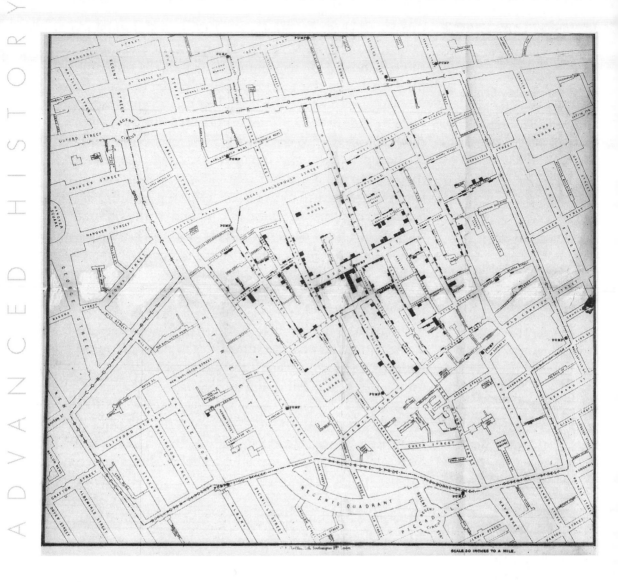

If the Broad Street pump did actually become a source of disease to persons dwelling at a distance, we believe that this may have depended … simply in the fact of its impure waters having participated in the atmospheric infection of the district … on the evidence, it seems impossible to doubt … that the geographical distribution of cholera in London belongs less to the water than to the air.

Snow's map of deaths from cholera in Broad Street, Golden Square (London).

A much larger study – by John Simon, medical officer of health to the City of London – covering 500,000 south Londoners was published in 1856. He showed that customers of the Lambeth Water Company had a death rate in the 1854 epidemic of 37 per 1000 compared with 130 per 1000 among those who took their water from the Southwark Water Company. What was the difference?

John Snow (1813–58) The eldest son of a Yorkshire farmer, at the age of 14 he was apprenticed to William Hardcastle, a surgeon in Newcastle-upon-Tyne. During this time he became a vegetarian and gave up alcohol. He worked as a colliery assistant and, while still unqualified, fought almost single-handed a cholera outbreak at Kellingworth colliery in Newcastle (1831–2). Moving to London, he became a medical student. Working at Westminster Hospital, he became a member of the Royal College of Surgeons in May 1838, a licentiate in the Society of Apothecaries in October 1838 and in 1844 graduated as an MD from London University. After doing some lecturing in forensic medicine, he worked as a general practitioner in Soho (London). Here he investigated the ways in which cholera spread and became interested in the anaesthetising properties of ether. Understanding the values and importance of other anaesthetics, he administered chloroform to Queen Victoria in 1853 at the birth of Prince Leopold and in 1857 at the birth of Princess Beatrice. He died in June 1858 as the result of a stroke.

that had dogged rich and poor, educated and untaught since the early 1830s. In 1831 **John Snow** had fought single-handed a cholera outbreak at Kellingworth colliery (Newcastle). In the years that followed, he became increasingly convinced that cholera was a water-borne disease, and in 1849 published *On the mode of communication of cholera*. It was well received by the medical profession and frequently referred to as 'Dr Snow's theory', but remained just that. This was partly because his own retiring nature didn't allow him to push himself forward, and partly because of the hold of the miasmic theory. The third cholera epidemic was to change this. The 1853 outbreak found him working as a general practitioner in Frith Street in Soho (London) and again struggling to contain and control the terrifying disease. His suspicions fell upon a pump in Broad Street, which enjoyed a high reputation locally for taste and purity. However, once John Snow had persuaded the authorities to lock the pump handle and its users were forced to go elsewhere, the number of deaths fell dramatically.

How did this come about? Updating his 1849 publication, Snow drew a map illustrating deaths from cholera in Broad Street, Golden Square, and the neighbourhood between 19 August and 30 September 1854.

Snow supported his theory with a vast amount of anecdotal evidence.

- Seven workmen, who lived outside the area but who were working in Broad Street and drinking from the pump, all died.
- The entire workforce of a nearby brewery, who were supplied with free beer, remained free of cholera.
- A widow, who used to live in the area and had a large bottle of Broad Street pump water delivered to her Hampstead home, died of cholera and none of her neighbours caught the disease.

Even so, the medical establishment was not impressed, as illustrated by this extract from the 1855 report of the Committee for Scientific Enquiry into the Recent Cholera Epidemic:

Anti-cholera precautions in Exeter: burning tar barrels to kill infection in the air.

Such complacency was shaken some fifteen years later (1848–9) when cholera again swept the country. But even then few local boards were set up to combat the epidemic. Where they were set up, they were quickly wound down once the epidemic had passed. Indeed, the Bridgend (Glamorgan) board reported: 'The Cholera having ceased for some days in this District, the board consider they may dispense with the services of Dr Camps.' Most towns and cities preferred to rely on their long-established, inefficient, ignorant and often corrupt improvement commissions.

ENTER JOHN SNOW ...

It was the third visitation of cholera (1853–4) that provided the answer to the question 'How is it spread?'

Take for dinner a moderate quantity of roast beef in preference to boiled, with stale bread and good potatoes, two glasses of wine with water, or an equivalent of good spirits and water, or of sound porter or ale. Eat garden-stuff and fruit sparingly, and avoid fat, luscious meats. In short, while under apprehension of cholera, use a dry nutritive diet, sparing rather than abundant. Observe great caution as to eating suppers, for cholera most frequently attacks about midnight, or very early in the morning.

This sort of advice could do no harm and maybe would do some good. What is important is that here central government is, for the first time, officially recognising that cleanliness, adequate clothing and food were necessary factors in public health. Later, Edwin Chadwick was to change the emphasis to water supply and sewerage.

What did the local boards do?

A number of cities were sufficiently frightened by the advance of cholera and did set up their own boards of health, as suggested by the central board. There were inspectors who did submit reports to their local board, and local boards sent returns to the central board. But this tended to be information gathering, not disease prevention or cure.

Almost immediately, legality became a problem. What legal right did the boards have to insist that people co-operate with them? Could individuals be compelled to have their houses limed? Could children be separated from parents and sent to fever hospitals? In 1832 temporary 'Cholera Acts' were passed to allow local authorities to enforce some measures and to finance them from the poor rates. Even so, and despite people's fear of cholera, local action was haphazard. Only the City of London and Birmingham made determined efforts to follow the guidance of the central Board of Health.

Local boards were only temporary, and, once the first cholera epidemic had died down, they were disbanded. In 1832 the *Annual Register* reported:

Everywhere cholera was much less fatal than pre-conceived notions had anticipated. The alarm was infinitely greater than the danger. When the disease gradually disappeared almost everyone was surprised that so much apprehension had been entertained.

commissioners to St Petersburg to assess the situation. Their report, coupled with general alarm among government officials, resulted in a temporary Board of Health being quickly set up. It consisted of the President and four Fellows of the Royal College of Physicians, the Superintendent-General of Quarantine, the Director-General of the Army Medical Department, the Medical Commissioner of the Victualling Office and two civil servants.

What did the Board of Health do?

- It advised local government areas to set up their own boards of health, which would be in a position to deal with problems at grass-roots level.
- It suggested that these local boards of health should include one or more magistrates, a clergyman, some 'substantial householders' and one or more medical men.
- It recommended that the local boards of health appoint district inspectors to report on 'the food, clothing and bedding of the poor, the ventilation of their dwellings, space, means of cleanliness, their habits of temperance'.
- It issued advice.

What advice did the Board of Health give?

- Houses were to be whitewashed and limed and all infected furniture and clothing were to be fumigated.
- People with cholera were to be put into strict quarantine.
- Food and flannel clothing were to be distributed to the poor.
- Temporary fever hospitals were to be set up.

In the absence of any knowledge about the causes of cholera, the Board of Health was understandably a trifle hazy about what people should do once they had caught the disease. It suggested a variety of remedies:

- bleeding by leeches;
- warm baths followed by rubs of castor oil and laudanum;
- plasters of mustard, peppermint and hot turpentine.

The Board of Health also offered dietary advice:

unemployment. They argued that not everyone in the
same household fell ill with cholera and so the theory
could not be true.

- The **miasmic theory** suggested that cholera was spread
 by a 'miasma of filth' that was breathed in from infected
 air. At least the results of this theory – the removal of
 heaps of excrement, for example – were steps in the right
 direction. The connecting of sewers to rivers and other
 water courses, however, was not.
- In 1831 *The Lancet*, a journal written by doctors for
 doctors, reported that a community of Jews in Wiesniz
 had kept themselves free from cholera by rubbing
 themselves with an ointment made from wine, vinegar,
 camphor, mustard, pepper, garlic and the crushed bodies
 of beetles.
- **Patent medicines** grew and multiplied, as did their
 claims. The most well known were Moxon's Effervescent
 Universal Mixture, Daffey's Elixir and Morrison the
 Hygienist's Genuine Vegetable Universal Mixture. All
 claimed to cure cholera, and, because many who took
 them undoubtedly did survive, they had a great
 following of those who believed in their curative
 properties.
- **Prayer** was recommended by all the main Christian
 churches. Cholera, many believed, was God's
 punishment for lax and immoral behaviour. Repent and
 all would be well. As with patent medicines, many of
 those who prayed for themselves survived, as did those
 for whom they prayed: prayer, the arguments went, was
 proven to be efficacious.

How did the government react?

Central government had done nothing about the endemic
fevers and 'dirty' diseases that were common among all
classes in all large towns and which claimed the lives of
thousands more people than cholera. Cholera, however,
was different. It was deadly, it was swift – and it was
capable of engendering fear in a way that typhoid and
tuberculosis could not. The government had to take
action.

In 1831, realising that cholera was fast approaching the
shores of Britain, the government sent two medical

In the same year there were 30 recorded 'cholera-phobia' riots in towns and cities throughout Britain. Principally affected were Birmingham, Bristol, Edinburgh, Exeter, Glasgow, Leeds, Liverpool, London, Manchester and Sheffield. These riots were not directed at the authorities for failing to contain the epidemic, but arose because of specific fears that:

- medical students were stealing bodies for their anatomy classes;
- doctors were murdering cholera victims;
- victims were being buried in unconsecrated ground;
- victims were being buried hastily, possibly before they were dead, and without proper religious ceremonies.

The Times newspaper wrote of 'great panic' and 'complete panic' but this is probably exaggerated. After all, the first two cholera epidemics occurred at a time of a great deal of political and social unrest: pressure for the reform of Parliament in 1831–2 and intense Chartist activity in 1848. But governments were not overturned and the fabric of society held firm.

A cure for cholera?

Thousands of people tried avoidance rather than attempt prevention or a cure. In Wolverhampton a local doctor described the city:

In all quarters there were the sick, the dying, the dead … The general silence of the city, save when broken by the tolling of the funeral bell … was most remarkable; the streets were deserted, the hurried steps of the medical men and their assistants, or of those running to seek their aid, alone were heard, while the one-horse hearse, occasionally passing on its duty, was almost the only carriage to be seen in the usually busy streets.

For those unwilling – or unable – to flee there was a host of remedies and preventatives from which to choose.

- The **contagionist theory** suggested that cholera was spread by contact with cholera victims. Eminently sensible, it met with considerable opposition. If true, it meant that houses, streets or even whole cities had to be put into quarantine. Opponents pointed to the potential loss of trade and consequent increase in poverty and

The causes of cholera
Cholera is caught by swallowing water or food that has been infected by the cholera vibro, a minute bacillus. This bacillus can live for up to a fortnight in water, and a week in meat, milk or cheese. It is most often spread by water contaminated by the excrement of cholera victims, or by flies that have fed upon the excrement.

CHAPTER 9

Cholera: the impetus for reform?

The symptoms of cholera
The first stage of cholera consists of violent, explosive diarrhoea and vomiting. Often the body loses several pints of fluid in a few minutes. Dehydration causes the patient to become shrunken and shrivelled. The second stage of cholera begins with acute pain in the fingers and toes. This spreads to the limbs and chest and is often accompanied by stomach cramps. The patient's features collapse and the skin turns black and blue. By now the patient is breathing with difficulty. If this stage is survived, collapse follows. This can last for a couple of hours to a week or more. The patient lies unmoving, with eyes turned up. Although conscious, the patient doesn't appear to hear or understand what is said and only occasionally replies in a feeble whisper. Coma and death soon follow.

There were two strong stimuli for reform in the 1830s: reports, investigations and enquiries of sanitary reformers, organisations and commissions, and disease itself. Together they provided the impetus for local reforms and, finally, reform on a national scale.

WHY DID CHOLERA EPIDEMICS LEAD TO PUBLIC HEALTH REFORM?

Cholera, travelling fast from Asia, hit Britain in four massive epidemics:

- 1831–2 resulting in 32,000 deaths
- 1848–9 resulting in 62,000 deaths
- 1853–4 resulting in 20,000 deaths
- 1866–7 resulting in 14,000 deaths.

The cholera epidemics, more than endemic diseases like typhoid and tuberculosis, had a profound effect upon the public and the legislators that was out of all proportion to their statistical importance. This was for two main reasons:

- the high percentage of fatalities (40–60 per cent) among those contracting the disease
- the speed with which cholera could strike.

In 1832 the *Methodist Magazine* commented:

To see a number of our fellow creatures, in a good state of health, in the full possession of their wonted strength, and in the midst of their years, suddenly seized with the most violent spasms, and in a few hours cast into the tomb, is calculated to shake the firmest nerves, and to inspire dread in the stoutest heart.

SUMMARY QUESTIONS

The purpose of this section is to help you consolidate your thinking and understanding of the nature of the public health problem facing Britain in the years before 1848.

1 Why did the Victorian 'dirty' diseases affect rich and poor?

2 What public health problems did a growing and mobile population pose?

3 Why did the industrial revolution affect working people's living conditions?

4 Look at the picture of Jacob's Island, Bermondsey. In what ways does it typify public health problems of this time?

5 Study the plans of back-to-back houses to be built in Little Horton, Bradford. In what ways would they have been (a) healthy and (b) unhealthy places in which to live? Would they present a greater or lesser public health hazard than the Jacob's Island houses?

6 What problems stood in the way of the development of an effective public health system?

towns and cities by individual medical people and administrators. Thomas Perceval and John Ferriar of Manchester were behind the formation of the Manchester Board of Health in 1795, and in Scotland Robert Graham, Robert Cowan and James Cleland published reports on public health in the early nineteenth century that prompted authorities to action. But the point is that this was piecemeal and initiatives were only applied locally. Given a different local administration with different personnel and different priorities, public health schemes would collapse.

Equally piecemeal were the many private Acts of Parliament obtained by local authorities that related to public health. London, for example, was administered by 300 different bodies with an interest in public health, and these operated some 250 Acts. Just one London parish, St Pancras, had sixteen paving boards acting under 29 Acts of Parliament. It was an administrative nightmare. The nightmare was not confined to London. In 1831–2, for example, the county of Lancashire had an Act passed for 'Lighting with Gas the Town of St Helens'; and the City of Exeter asked for an 'Act for better paving, lighting, watching, cleansing and otherwise improving the City of Exeter'. These, and many other private Acts of Parliament, allowed improvement commissioners to be elected by the ratepayers to deal with the specific problems detailed by the Acts. Many towns ended up with different sets of improvement commissioners dealing with, say, lighting, paving, street cleaning and other town improvements.

By the 1830s many people were beginning to criticise the corrupt nature of town improvement committees and, sometimes, the town corporations themselves. In some towns, elections were rarely held and the various groupings of officials became self-perpetuating **oligarchies**. Many operated to serve the interests of selected groups of citizens. Vested interests – from night-soil men to clergy and owners of water companies – were either paid off or, which was far more likely, represented on the improvement committees themselves.

It was becoming clear that the different ways of addressing public health issues were grossly inadequate.

dead were added, and the sheer quantity of burials made overcrowding a public health hazard.

From evidence given to the Select Committee on the Improvement of the Health of Towns, 1842:

Witness	In the year 1831 I was first employed by Mr Watkins the head grave-digger at St Clement's churchyard.
Question	How long did you work before you were taken ill?
Witness	I worked there between five and six years before I was taken ill. I got up one Sunday morning and went into the ground in Portugal Street. We had a grave to open. I believe it was ten feet. I went in and I completed the work, and I cut four or five coffins through in that piece of ground, and the bodies of some. I placed the flesh behind and I went home for my breakfast. It was our church time. We did not dare do any more till the people were in church, for the sound of cutting away the wood was so terrible that mobs used to be around the railings and looking.
Question	How many coffins have you dug through, and bodies cut through, to get to a depth of ten feet?
Witness	To get ten feet of ground you must cut through at least five or six. In the almshouses I could uncover and expose a dozen coffins within the hour.
Question	How near is the wood of the coffins to the surface?
Witness	There are coffins now within a foot of the surface.

HOW ADEQUATE WAS PUBLIC HEALTH PROVISION BEFORE 1848?

There were three main stumbling blocks in the way of adequate public health provision:

- lack of compulsory national legislation;
- opposition of **vested** interests;
- ignorance of the ways in which disease was spread.

This did not, however, mean that local authorities simply ignored the issue. Pioneering work was done in certain

Vested interest This phrase is used to suggest that people are more likely to support a measure if they, their families or social group will benefit from the measure. People with power – whether that power rests in land, money, trade or industry – will look very carefully at measures that might damage that power.

Water companies sometimes took their water from deep, natural underground reservoirs and springs, but more usually from local rivers. This picture of Jacob's Island, Bermondsey (London) illustrates the nub of the problem. The wooden shacks are privies emptying into the stream. The stream provides water for those living in the houses.

- Cholera hit Britain in four massive epidemics: 1831–2, 1848–9, 1853–4 and 1866. The first epidemic killed 31,000 and the second, 62,000.

Death

Victorians were familiar with death. Most parents could expect to lose some of their children. In some urban areas, one in four babies died before their first birthday. Brothers and sisters could expect at least one of their siblings to die, sometimes along with their mother in childbirth. The table of urban and rural death rates on page 136 indicates that many children, before they became adult, buried at least one parent.

A nineteenth-century children's street game ran:

Grandmother, Grandmother,
Tell me the truth,
How many years am I
Going to live?
One, two, three, four …?

Victorians buried their dead. The Anglican clergy had a vested interest in keeping all burials within their churchyards, but, as the death rate soared, the acreage of parish graveyards remained constant. London, for example, had 200 acres of cemeteries. Every year around 50,000

kinds are thrown from the doors and windows of the houses upon the surface of the streets. The privies are few in proportion to the number of inhabitants. They are open to view both in front and rear and are invariably in a filthy condition and often remain without the removal of any portion of the filth for six months.

Water was needed for washing, cooking and drinking; not only was it in short supply but it was expensive. Its supply, too, was controlled by vested interests in the form of private water companies. The middle classes had water piped to their houses and, because the supply was frequently irregular and uncertain, stored it in huge cisterns so that they could, quite literally, have water on tap. The poorer areas of towns and cities had to make do with standpipes, and the inhabitants queued with buckets and saucepans to buy what they could afford when the water company turned on the supply. People too poor to buy water, or to buy enough water for their needs, either didn't bother or took what they could from local wells and streams.

Disease

The connection between dirt and disease had been appreciated for hundreds of years, but what was not known was just what that connection was. That had to wait until 1867, when Louis Pasteur developed his germ theory of disease. In the first half of the nineteenth century, overcrowding, lack of sanitation and clean water meant that disease was rampant and life expectancy of the working classes was low, for the following reasons:

- People living in overcrowded, unsanitary conditions and without easy access to a supply of clean water housed body lice which spread typhus fever, from which many died. There were typhus epidemics in 1837 and 1839; an outbreak in 1847 killed 10,000 people in north-west England alone.
- Influenza, scarlet fever, tuberculosis (the White Plague) and measles were endemic and were often killers.
- Typhoid and diarrhoea were common.
- Smallpox raged 1837–40, killing over 12,000 people in 1840 alone, and scarring many more for life.

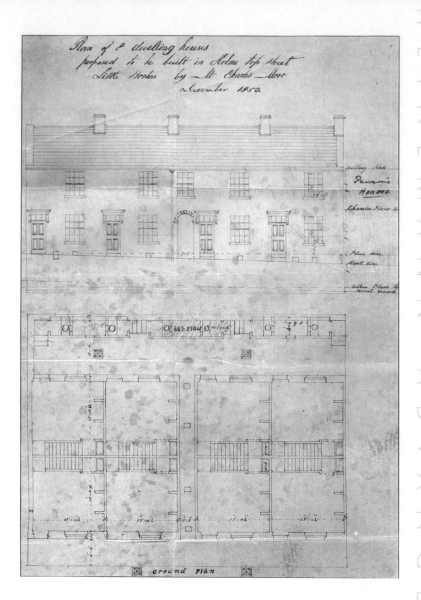

Plan of 'Eight dwelling houses to be built in Holme Top Street, Little Horton, Bradford', in 1852.

Street) had their own privies. These were ash privies where, instead of flushing, the users covered the contents with ash. Some middle-class houses had flushing lavatories. But these flushed either into a cesspit in the cellar or into a closed sewer. These, as with the ash privies, had to be physically emptied.

In 1845 houses in Leeds were described in Parliamentary Papers, volume 3 as being:

wholly unprovided with any form of drainage or arrangements for cleansing, one mass of damp filth. The ashes, garbage and filth of all

trouble to exhibit a trifling degree of cleanliness. But all this is as nothing compared to the courts and lanes, which lie behind, to which access can be gained only through covered passages, in which no two human beings can pass at the same time . . . every scrap of space left by the old way of building has been filled up and patched over until not a foot of land is left to be further occupied.

This extract from *The Condition of the Working Class in England* written by Friedrich Engels in 1844 creates a vivid impression of housing in industrial Manchester. It also reveals a new development. Prior to the industrial revolution, rich, poor and 'people of the middling sort' lived in close proximity in Britain's towns and cities. In industrialising Britain, the absence of affordable public transport meant that industrial workers had to be housed close to the mills and factories in which they worked. The middle classes moved out, beyond the pollution and smut-laden pall that covered the industrialising cities.

Most of the housing had to be newly built. These new homes varied wildly in style: rows of industrial cottages were common in the north, back-to-back houses in parts of industrial Lancashire and Yorkshire, enclosed courtyards in Birmingham and vast tenements in Glasgow. They varied also in standard. Many were poorly built, with floors being nothing more than bare boards over beaten earth. Others were planned carefully, but the most careful planner could not legislate for the number of families that would occupy a house designed for one.

Sanitation

It was the lack of services to a house rather than the house itself that caused problems, no matter how overcrowded it was with occupants. Most housing in the first half of the nineteenth century lacked drainage, sewerage and a regular water supply.

Lavatories (or privies) were usually outside, in the courtyards and alleys, and emptied into cesspits. Human waste collected in these cesspits that were, from time to time, cleaned out by 'night-soil' men. They piled what they had collected in huge dunghills and then sold it on to local farmers at a price per ton. Some houses (as in the back-to-back houses in the architect's plan for Holme Top

Urban communities responded, first, by using up and adapting existing 'vacant' living space and, second, by building new.

Cellars and attics were filled with working people and their families, and were used as workplaces as well. In the 1840s there were more than 10,000 woolcombers living and working in Bradford (West Yorkshire). In 1845 the Bradford **Woolcombers** Protective Society appointed a 'Sanatory Committee' to report on their living conditions. This extract is part of that report:

NELSON COURT – a great many woolcombers reside in this court. It is a perfect nuisance. There are a number of cellars in it utterly unfit for human dwellings. No drainage whatever. The Visitors [those compiling the report] cannot find words to express their horror of the filth, stench and misery which abounds in this locality, and were unable to bear the overpowering effluvia which emanates from a common sewer which runs from the Unitarian Chapel beneath the houses. Were this to be fully described, the Committee might subject themselves to the charge of exaggeration. We trust that some of those in affluent circumstances, will visit these abodes of misery and disease.

HOLGATE SQUARE – a miserable hole, surrounded by buildings on all sides. This place resembles a deep pit – no chance of ventilation; a number of men and women work in the cellars near charcoal fires. Seven feet below the service.

Many cities – London in particular – had large, rambling houses that were gently falling into dilapidation. These were snapped up by builders and potential landlords, out for a quick profit. The buildings were then divided up into as many tiny living spaces as possible for poor families to rent at as much as the landlord dared ask. Nicknamed 'rookeries' these houses became breeding grounds for disease and vice.

First of all, there is the old town of Manchester … Here the streets, even the better ones, are narrow and winding, as Todd Street, Long Millgate, Withy Grove and Shude Hill, the houses dirty, old and tumble-down, and the construction of the side streets utterly horrible. Going from the Old Church to Long Millgate, [there is] a row of old-fashioned houses at the right, of which not one has kept its original level; these are remnants of the old pre-manufacturing Manchester, whose former inhabitants have removed with their descendants into better-built districts. Here one is in a working-men's quarter for even the shops and beer houses hardly take the

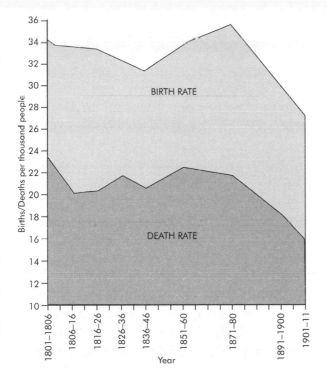

Birth and death rates in England and Wales, 1801–1911.

WHAT IMPACT DID THE INDUSTRIAL REVOLUTION HAVE ON PEOPLE'S LIVING CONDITIONS?

The influx of thousands and thousands of people into small market towns and cathedral cities that had had the fortune, or misfortune, to have one or more industries located there had a catastrophic effect on the existing housing and sanitation provision. This, in turn, led to the explosion of what the Victorians called 'filth diseases' such as typhoid, diphtheria, tuberculosis, scarlet fever and, most dreaded of all, cholera. Other nineteenth-century killers, like measles and whooping cough, became endemic.

Housing

Bad housing was nothing new and it certainly was not a product uniquely of the industrial revolution. There had been slums in medieval London and, throughout the centuries, agricultural labourers had lived in conditions that were frequently no better than those of the animals they tended. What was unique about the industrial revolution was that it resulted in widespread, dense overcrowding.

there was some concentration of people in fairly crowded conditions in London and some provincial towns, the vast majority of people lived, thinly spread, in rural areas. Apart from a couple of particularly virulent outbreaks of plague, there were really no opportunities for disease to get a hold. And there was certainly no perceived need for anything like a national public health system.

But change was to come: enormous, cataclysmic change. Between 1801 and 1851 the population of Britain doubled, and it had doubled again by the beginning of the twentieth century.

It was not just the size of the population that changed; the distribution changed, too. In 1801 around 33 per cent of the population lived in towns. This had increased to 50 per cent in 1851 and 72 per cent in 1891. The steady and relentless growth conceals the even more dramatic growth of individual towns. In the 1820s Bristol grew by 70 per cent, Bradford by 66 per cent, Leeds, Liverpool and Manchester by 46 per cent, Sheffield and Birmingham by 41 per cent. Censuses were held every ten years, and it was not uncommon for industrial centres to add one-third to their population at each count. Individual parishes, particularly in London where one-third of a million migrants settled in the 1840s, were overwhelmed.

Civil registration of births, deaths and marriages – introduced in 1837 – revealed a young, fertile and actively reproducing population in most urban centres. Urban birth rates were continually above death rates and so natural increase, from the 1840s, added to the increase from internal migration. But these global rates, too, conceal as much as they inform. In Manchester in the 1840s, for example, 57 per cent of babies died before their fifth birthday.

It was not so much the *fact* of urban growth that created public health problems, but the *rate* of urban growth. It was the pace of this growth that created almost insuperable problems and daunting challenges insofar as public health was concerned.

affected. It came, in some measure, from local authorities and, in a greater measure, from scientists, doctors, administrators and philanthropists who, sometimes working together and sometimes alone, were concerned about various aspects of health problems in society.

PEOPLE ON THE MOVE: A CRISIS IN THE MAKING?

In pre-industrial Britain, there were few pressing public health problems. True, there were no drains or sewerage systems, no clean piped water and no effective measures to prevent the spread of disease. From time to time, edicts and directives were issued by government and town councils regarding, for example, the removal of waste from the streets and the emptying of privies. There were periodic outbreaks, too, of **bubonic plague**. But while

Bubonic plague Highly infectious epidemic disease attacking the lymphatic system. It was carried by fleas that lived on rats, and transmitted to people via flea bites. Bubonic plague first appeared in Europe as the Black Death in around 1348–9 and returned at regular intervals, disappearing from England in 1660. Mortality rates were very high, particularly when the variant forms, septicaemic or pneumonic plague, developed.

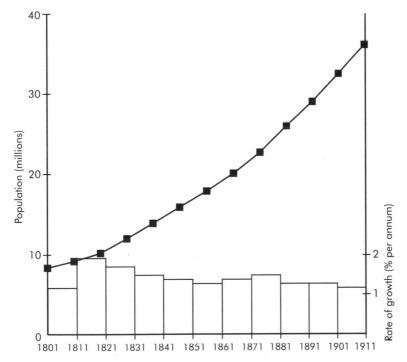

Population growth and rate of growth in England and Wales, 1801–1911.

AS SECTION: PUBLIC HEALTH, 1815–75

CHAPTER 8

Dirt, disease and public health: the nature of the problem

Poverty and pauperism affected the most vulnerable members of society: those who had few saleable skills and less education, who were at the mercy of market forces and the vagaries of employers. Disease, on the other hand, was no respecter of persons. Maria Woolf, wife of a struggling law clerk, died from cholera in 1849 when she was 32 years old and eight months pregnant. Her husband George survived the cholera only to die from tuberculosis two years later. Prince Albert, husband to Queen Victoria, died from typhoid on 14 December 1861 aged 42. Their daughter Alice died from diphtheria in 1878, when she was 35 years old.

The improvement in the health of the community has always posed problems for those intent on developing public health provision. There has to be appropriate technical skill and knowledge of sanitary engineering; there has to be appropriate medical knowledge about the cause and prevention of disease; and there has to be the willingness of the public, local authorities and Parliament to legislate and carry through and uphold that legislation. This was to be no easy task in a Britain wedded, in the early years of this period, to the doctrine of laissez-faire, and where the **germ theory of disease** was not known until the 1860s.

Pressure for change – for improvement in public health – came not from those most affected or likely to be most

KEY TERM

Germ theory of disease
By the beginning of the nineteenth century, most scientists and doctors knew of the existence of micro-organisms. Many believed that they were caused by disease, not that they were the cause of disease. Some people believed that disease was caused by miasma, or gases in the air.

In 1867 Louis Pasteur (1822–95) made the link between micro-organisms (commonly called germs) and disease. It was Robert Koch (1843–1910) who took the next step of linking specific diseases with certain microbes.

GETTING BETTER?

The desperate problems faced by the poor in depressed
areas tends to dominate images of the 1920s and 1930s.
But most people outside the depressed areas lived relatively
well. Families were smaller and wages were better.
Working hours had been reduced to around 48 a week,
and working conditions in the new factories were good.
Holidays with pay were becoming the norm, and many
took full advantage of increased leisure opportunities.
Poverty, therefore, was dependent not only upon
geography, but on the saleable and transferable skills of the
workforce.

HOW DID THE PEOPLE COPE?

In 1929 the whole system of workhouses and Poor Law guardians was abolished. By the end of the 1920s, most British workers were paying for their unemployment insurance out of their wages on the assumption that, if they were ever out of work, they could claim sufficient cash until they found a new job. Unemployment benefit was payable for fifteen weeks and, if people were still unemployed, they could move onto extended benefits – nicknamed 'the dole' – for a further 32 weeks. In normal circumstances, these 47 weeks of benefit would keep working people from poverty until they found employment.

But in the late 1920s and 1930s, circumstances were far from normal. In 1931 there were over 2 million people out of work. Government attempts to meet the crisis caused by the Depression pushed working people in the depressed areas deeper and deeper into poverty. Cuts in benefits and means testing hit hard at the most vulnerable, creating bitterness, misery and discontent. Those who could afford to move to areas where employment was plentiful, did so. Those who couldn't, generally suffered in silence. But there were exceptions:

- In 1934 the BBC invited a group of men and women to describe their experiences 'on the dole'.
- In 1936 the MP for Jarrow, Ellen Wilkinson, organised a hunger march to London in order to present a petition to the Prime Minister asking for help. The dismantling of the Jarrow shipyard had resulted in unemployment for 75 per cent of the working population and the people were desperate. When the men returned to Jarrow, they found their dole money had been stopped because they had not been available for work.

A great deal of sympathy was generated for those pushed deeper and deeper into poverty, but it seemed little could be done. Indeed, by 1934 the worst was over, although unemployment figures remained high until the Second World War (1939–45) mopped up all the available able-bodied adults.

land; between 1918 and 1939, a quarter of a million labourers left the countryside.

This was the background against which huge numbers of people struggled with poverty.

WHAT DID THE GOVERNMENT DO TO HELP?

Ramsay MacDonald's Labour government came to power in 1929 and struggled with the problems of providing unemployment benefits to thousands of workers when the numbers of those in work and paying the taxes that funded these benefits were dwindling fast. Faced with the Depression of 1929, Ramsay MacDonald formed an all-party National government. This government:

- cut the pay of people employed by the state: pay of teachers by 15 per cent, the police by 12.5 per cent and the armed forces, MPs and judges by 10 per cent;
- cut national insurance benefits and paid them for a shorter length of time;
- introduced a **means test** for the long-term unemployed on 'extended benefits' (the dole);
- set up the Unemployment Assistance Board in 1934 to take responsibility for the long-term unemployed;
- devalued the pound, and thus reduced its value in overseas markets, and took Britain off the gold standard, which meant that the pound sterling was no longer linked to gold;
- set up the Iron and Steel Federation in 1932 to supervise the demolition of old works and the building of some new ones;
- introduced a Special Areas Act in 1934 which financed projects in depressed areas (for example, a new steel works at Ebbw Vale, in south Wales);
- protected British agriculture from cheap foreign imports by introducing **state subsidies, import quotas** and **marketing boards**.

Wall Street crash In October 1929 there was a sudden fall in the value of shares on the New York stock market (Wall Street). Panic selling of stocks and shares by speculators in a market where no one wanted to buy resulted in investments becoming worthless overnight. This had a knock-on effect on all the financial markets in the world and caused a massive financial crisis and Depression.

customers building up their own industries or turning to the USA.

- Britain's share of world trade had been decreasing prior to 1914, and the war accelerated this trend.
- The situation worsened in 1929 when the **Wall Street crash** plunged the world into a financial crisis and Depression. British exports halved in value and the total of unemployed reached nearly 3 million.

How were different industries affected?

- **The cotton industry** was hardest hit, with Japan and India developing their own industries and competing with Britain in world markets; by 1938 Japan was exporting more cotton goods than Britain.
- **The woollen industry** wasn't so badly affected because a large proportion of its output was for the domestic market.
- **The coal industry** showed a steady decline: 1913 production figures were never equalled. Industries turned to electrical power and shipping converted to oil-fired engines. Furthermore, the coal industries of continental countries were in advance of Britain in their use of mechanical cutters and conveyors and therefore produced coal more efficiently.
- **Iron and steel** were variably affected. New iron ore fields were developed and led to the growth of towns like Scunthorpe and Corby. But pig iron exports declined and steel didn't revive until the late 1930s, stimulated by the threat of a new war.
- **Shipbuilding** was hit hard. Fewer merchant ships were needed because of the decline in international trade. By 1933 most yards were at a standstill and many were being dismantled.
- **New industries** grew and prospered, not in the old industrial heartland, but in the south Midlands and the south-east of England. These produced cars, fertilisers, chemicals, aeroplanes, medicines and cosmetics.
- **Agriculture** slumped after 1921 when wartime subsidies ended. The increased use of machinery for threshing, milking and harvesting accelerated the drift from the

Poverty in the inter-war years

This section gives a brief overview of the reasons for poverty in the inter-war years, the nature of that poverty and the ways in which governments and people reacted to it. In this way, it is intended to provide factual reference points to underpin discussion in the A2 sections about, for example, the nature of poverty.

POVERTY IN AN INDUSTRIALISED SOCIETY

The ability of people in an industrialised society to keep themselves from poverty depends very largely upon the health and prosperity of their country's industry, and upon the distribution of the wealth created by that industry. Thus, in Britain, poverty was closely tied in to the actions and reactions of industrial bosses, unions and government, as well as to the world economic situation.

INDUSTRY AFTER THE FIRST WORLD WAR

Immediately after the First World War, British industry flourished because of the tremendous demand, at home and abroad, for goods that had been in short supply between 1914 and 1918. Then, suddenly, just when everyone was talking about 'business as usual', this brief period of prosperity collapsed into Depression. By June 1921, 2 million people were out of work – one in seven of the working population. Unemployment was not to fall below 1 million until 1940.

How had this happened?

- The 1914–18 war had forced British industry to focus on supplying the armed forces, with the result that many overseas markets were lost for ever, with former

ESSAY QUESTION IN THE STYLE OF AQA

> What was the impact of the Poor Law Amendment Act on the relief of poverty up to 1841?

In order to answer this question, you will need to read Chapters 4 and 5 of this book.

How to answer this question. The question asks you to analyse the outcomes of the 1834 Poor Law Amendment Act in tackling the relief of poverty.

- Plan your essay before you start:
 - Identify the main features of the 1834 Poor Law Amendment Act.
 - Describe the impact these features had on the relief of poverty.
 - Include the main points of argument or analysis that you are going to use to answer the question. Examples of the main points you might include are:
 - the centralised administrative structure which sought to impose a national system irrespective of local needs;
 - the grouping of parishes and the building of union workhouses and the opposition this created;
 - the retention of the Settlement Laws;
 - the less eligibility principle and the workhouse test, the distress they caused to potential applicants;
 - the fall in the cost of the poor rates.
- Structure your essay:
 - Introduction: This should set out the case you are going to make.
 - Development: Here you should show your understanding of the main issues and support them by reference to specific examples.
 - Conclusion: This should be brief, to the point, and sum up your line of argument.
- Focus your essay:
 - Make sure your essay addresses the question in a direct way. Do not, for example, be tempted to describe the need for a new Poor Law.
 - Make sure you can support the points you make by direct reference to factual material. When writing, for example, about opposition to the PLAA, mention John Fielden and Todmorden, the armed riots in Oldham and/or the attack on one of the assistant commissioners in Bradford.
 - Write in short paragraphs and make sure each paragraph contains a specific, supported point.

- This basic understanding should be built on by matching what you can read in the sources with the arguments of the two men. Oastler, for example, regards food, clothing and freedom from confinement as the birthright of every Englishman. Langham Rokesby, on the other hand, has no problem with the workhouse taking away one of Oastler's perceived birthrights (liberty) and sees the fear of entering the workhouse as essentially beneficial in that more poor people are looking for work instead of seeking relief.
- You should be able to push this cross-referencing still further, and show the examiner that you realise the two men were, in fact, concerned with different aspects of poverty. Langham Rokesby is writing about the outcome of the implementation of the PLAA in one part of the country, while Oastler is directing his anger at the very fact of the PLAA itself and the whole concept of indoor relief.

5 Study Sources C and E and use your own knowledge. Do you agree with the author of Source E that the Poor Law Amendment Act had done little to improve either the material or moral condition of the working classes? (12)

How to answer this question. In answering this question you are asked to use both your knowledge and the two sources. If you rely only on the sources or solely on your own knowledge, you will not be able to gain more than half marks. The trick is going to be to blend what you know with the sources to which you have been directed.

- Begin with an opening statement that sets out clearly the direction in which your answer is to go. You may, for example, come down firmly in support of the view expressed in Source E, or firmly against it. On the other hand, you may think either the material or the moral condition had been improved and the other had not. In a sense, with questions like this, as long as your stance is reasonable and can be supported, it doesn't matter which viewpoint you take. There is no right answer.
- Present a number of clearly expressed points, supported from your own knowledge and from Source C. When you are using Source C, say so. Sometimes the content of a source you are supposed to use can look as if you are simply presenting your own knowledge, and so it is important to make it clear that you have understood what you are supposed to do, and that you are doing it! Phrases like 'As Source C states ...', 'The evidence of Source C makes it clear that ...' and 'Source C implies that ...' are all appropriate.
- Reach a conclusion and make sure that conclusion is supported. In doing this, don't go back and repeat all the arguments you have presented earlier, but make clear the weight you are putting on the pieces of evidence you have presented earlier. 'The arguments of x and y are convincing in the case they make out for ...' and 'By supporting a and b, they make it clear that ...' are phrases you can confidently use to summarise and conclude the case you are making to the examiner.

name), but Gilbert's Act in 1782 changed all this and workhouses could only be used for the impotent poor.

> 3 Study Sources A and B. How useful are these two sources as evidence about how the Poor Law worked before 1834? (5)

How to answer this question. It is important to realise that this question is asking you to evaluate the two sources: you will be analysing them and cross-referencing between them for utility. Utility means usefulness for a specific purpose – in this case, providing evidence for the workings of the Poor Law before 1834. Remember, you are not being asked to tell the examiner what you know about the workings of the Poor Law before 1834.

- You should be able to pick out appropriate surface features of the sources and show how they could be used. You could, for example, show how someone wanting to show the wasteful and corrupt nature of the old Poor Law could use Source B to demonstrate the prevalence of time servers and money uncollected under the old system. On the other hand, Source A could be used by those believing in Utilitarianism to show that the upkeep of workhouses under the old system was wasteful of resources and would not lead to the greatest happiness of the greatest number of people.
- The question asks 'How useful?' and you are, therefore, being asked to come to some sort of judgement. You could, for example, point out that the sources have limited use: Source A illustrates a London workhouse and Source B relates to a rural area, so it would be necessary to know how typical these were of Poor Law unions before coming to a conclusion as to the extent of their usefulness.

> 4 Study Sources C and D. How far does the argument presented by Richard Oastler challenge the conclusions of Langham Rokesby about the new Poor Law? (5)

How to answer this question. Before you begin to write an answer, you should be very clear as to what are the basic arguments of these two men. Langham Rokesby is arguing that the new Poor Law has brought about a great improvement in the moral character of the poor: that their dread of the workhouse has led the poor to look for work and that they are generally better behaved. Richard Oastler argues that the new Poor Law has turned poverty into a crime by forcing the poor to surrender their liberty, by entering a workhouse, in order to receive help.

- You must show that you understand, at the outset, that these two authors are coming to the Poor Law Amendment Act (PLAA) from very different positions. Langham Rokesby clearly supports it, and Richard Oastler, equally clearly, does not.

The New Poor Law did not provide any such solution, nor, despite the claims of the new central authority, the three Poor law Commissioners of Somerset House, can it be shown to have done very much to improve either the material or the moral condition of the working classes.

From The Relief of Poverty 1834–1914 *by Michael Rose, published in 1972.*

Questions

Before answering these questions, you should read Chapters 1–4 of this book.

> 1 Study Source B. What can you learn from this source about why the old Poor Law was often criticised? (3)

How to answer this question. This is typical of a low-mark question, so do not spend too much time on it. It requires a clear, concise, accurate and yet brief answer. Remember that you are being asked what you can learn from the source, so do not bring into your answer things that you know about but which are not shown in the source.

- You should be able to demonstrate your comprehension and extract reasons from the source without too much trouble. For example, overseers were incompetent, they lacked experience and skill, and they tried to get through the year with as little trouble as possible.
- You should, too, be able to show what you can infer from the source. For example, many overseers were farmers and so there was both a clash of interests and the opportunity for corruption. Many combined the job of overseer with other occupations, and so had little time to fulfil their obligations properly.

> 2 Use your own knowledge to explain the main functions of a Poor Law workhouse in the years before 1834. (5)

How to answer this question. Here, you will be expected to draw on your own knowledge, and not to base your answer upon the given source material.

- You should, at the very least, be able to make simple statements about the main functions of a pre-1834 workhouse. For example, they were built by parishes for their own poor; they were equipped with looms and other tools so that the paupers had goods to sell. But this won't get you very far.
- To obtain top marks you will need to show that you understand how the functions of a workhouse changed in the years before 1834. For example, after 1723 overseers of the poor could only give relief to able-bodied paupers for work they had actually done and workhouses were built to provide this work (hence the

Source C

Persons who never could be made to work before have become good labourers and do not express any dissatisfaction with the measure. In most parishes, the moral character of the poor is improving; there is a disposition to be more orderly and well behaved. So far as I can judge, from the enquiries I have made from time to time, and from conversations with respectable farmers and others, I may venture to say that the measure is working very satisfactorily; that the great body of the labouring poor throughout the union have become reconciled to it; that the workhouse is held in great dread; that there is a greater disposition to seek for employment, and but very few complaints of misbehaviour; and that cases of bastardy are on the decline.

Evidence given by Langham Rokesby Esq., Chairman of the Market Harborough Union, to the Poor Law commissioners. Published in their second Annual Report, 1836.

Source D

Remember, always that liberty – freedom from confinement as well as food and clothing – is the birthright of every Englishman, however poor. What, Sir, is the principle of the New Poor Law? The condition imposed upon Englishmen by that accursed law is, that man shall give up his liberty to save his life! That, before he shall eat a piece of bread, he shall go into prison. In prison, he shall enjoy his right to live, but it shall be at the expense of that liberty, without which life itself becomes a burden and a curse.

Thank God, the law of the land does not yet say – though the Commissioners of the New Poor Law have dared to say – that poverty is a crime, by which an Englishman may be deprived of the blessings of liberty.

From The Rights of the Poor to Liberty and Life *by Richard Oastler, published in 1838.*

Source E

So great was the fear of pauperism that the ruling classes were ready to believe the exaggerations contained in the Report of the Royal Commission on the Poor Laws. They were even prepared to accept, although with some modifications, the new system of poor law administration which it recommended, despite the fact that this contained a far greater degree of bureaucratic centralisation than would have been acceptable to them under normal circumstances. The New Poor Law was seen as a final solution to the problem of pauperism, which would work wonders for the moral character of the working man.

AS ASSESSMENT: POVERTY AND THE POOR LAW, 1815–1914

SOURCE BASED QUESTIONS IN THE STYLE OF EDEXCEL

Study the sources below and then answer the questions that follow.

Source A

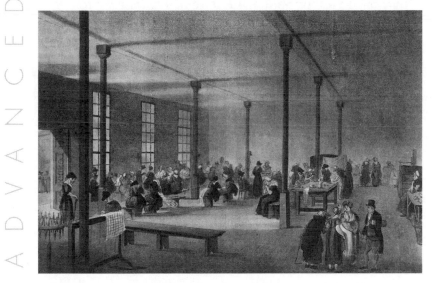

'The parish workhouse of St James', London', painted in 1809.

Source B

As a body, I found annual overseers wholly incompetent to discharge the duties of their office, either from the interference of private occupations, or from a lack of experience and skill; but most frequently from both these courses. Their object is to get through the years with as little unpopularity and trouble as possible. Their successors, therefore, have frequently to complain of demands left unsettled, and rates uncollected. In rural districts the overseers are farmers; in towns generally shopkeepers; and in villages usually one of each of those classes.

Evidence given to the Royal Commission on the Poor Laws by Assistant Commissioner S. Walcott, north Wales. Published in the Royal Commission's Report, 1834, Appendix A.

than antagonise them. Friendly societies, for example, were used in the administration of national insurance.

- Beneficiaries of the two major schemes – health and unemployment insurance – were expected to contribute to the schemes. Only pensions were funded solely by the taxpayer.
- The Liberal reforms did not cover everyone. They were not intended to be universal. Thousands of people were deliberately excluded from old age pensions and the national insurance scheme.
- Nevertheless, perhaps the most important factor attaching to the Liberal reforms was that they signalled a fundamental shift in attitudes to poverty and the poor, and in the responsibility the state had to assume for its citizens.

SUMMARY QUESTIONS

The purpose of this section is to help you consolidate your thinking and understanding about the Liberal welfare reforms at the beginning of the twentieth century.

1 Study the cartoon 'Forced fellowship' (see page 87). Would you agree that the Liberal government introduced its social reform programme solely because it felt threatened by the up and coming Labour Party?

2 How far did the Liberal reforms make a break with the past?

3 Study the cartoon 'The Philanthropic Highwayman' (see page 95). Would you agree with the message the cartoonist was trying to get across to the readers of *Punch*?

4 Would it be fair to see the Liberal reforms as the foundation stone of the welfare state?

WERE THE LIBERAL REFORMS THE BEGINNING OF THE WELFARE STATE?

The welfare state, established by Labour governments between 1945 and 1951, aimed to provide central, national support for all British citizens 'from cradle to grave'. It was based on the Beveridge Report of 1941, the same William Beveridge who had been Winston Churchill's principal adviser in 1909. It aimed to attack five 'giants': want, disease, squalor, ignorance and idleness. It was established by a Labour government; the pressure from the embryonic Labour Party was an important driving force behind the earlier social reforms. It was funded by a redistribution of wealth through high taxes and high levels of public spending, much as Lloyd George's 'People's Budget' funded the earlier reforms. It is thus very tempting, using hindsight, to see in the Liberal welfare reforms at the beginning of the twentieth century the origins of the welfare state implemented 40 years later.

But how valid is the apparent continuity of purpose and outcome? What is the balance between change and continuity?

The range of reforms introduced by the Liberals was impressive, but it was not the result of a preconceived programme. It was no blueprint for change, as was the welfare state of the late 1940s and early 1950s. Rather, it was a response to economic and political circumstances. There were, therefore, huge elements of compromise and a lot of Victorian moral attitudes present in the Liberal reforms.

- Most of the Liberal reforms depended upon local government and local services to deliver them. While this had the effect of removing the stigma of the Poor Law, it also depended upon the priorities of the local authorities. The provision of school medical services, for example, was made possible by central government but was patchy in its implementation by local authorities because of their differing priorities.
- Most of the Liberal reforms used expertise already available and aimed to work with vested interests rather

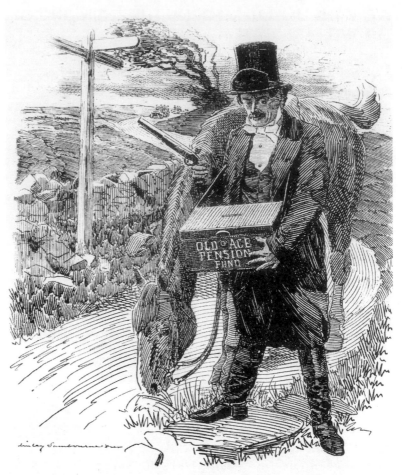

'The Philanthropic Highwayman', 'Punch', 1909.

THE PHILANTHROPIC HIGHWAYMAN.

Mr. Lloyd-George. *"I'LL MAKE 'EM PITY THE AGED POOR!"*

death duties on estates worth more than £5000, and introduced a new tax on profits gained from selling land.

This 'People's Budget' got through the House of Commons easily. It was a different matter when it came to the Lords. There was a tradition that the House of Lords never opposed a 'money Bill' which is what the budget was. However, the Lords had an inbuilt conservative majority and many of them were large landowners. They felt threatened by Lloyd George's budget and threw it out. This precipitated an enormous constitutional crisis that was, eventually, resolved in favour of the House of Commons and the 'People's Budget'.

Part 2 of the 1911 National Insurance Act dealt with insurance against unemployment.

- Employers, employees and the government each contributed 2½d to the scheme.
- Workers could claim unemployment benefit of 7s a week for up to fifteen weeks in any one year.
- No claim could be paid if unemployment resulted from a person being dismissed for misconduct.

The scheme at first applied to a small group of trades where people were generally well paid but which were prone to seasonal unemployment: shipbuilding and vehicle construction, for example. Insurance was compulsory, and 2.25 million men were insured by the end of 1912. Because of high employment, it was not really possible to evaluate the scheme before the First World War broke out in 1914. But it was important for what it represented: it established, as with pensions and health insurance, the principle that the relief of poverty was a national, and not local, responsibility.

HOW WAS IT ALL TO BE PAID FOR?

Clearly the Liberal reforms cost money and, equally clearly, they were not self-funding, nor could they be funded by savings made on Poor Law costs. It seemed, initially, that around £16m extra had to be raised in the budget of 1909. This came at a time when additional money was needed to fund the naval shipbuilding programme, intended to keep the Royal Navy abreast of the German one.

David Lloyd George, Chancellor of the Exchequer, found the money by, in the main, taxing the rich and better off. He increased taxes on tobacco and alcohol (always an easy moneymaker) and introduced a new tax on cars – a licence fee. Then he went for the big money. He raised income tax on a sliding scale, so that those with incomes of over £3000 a year paid 1s 2d for every pound they earned, and those with smaller incomes paid 9d; people earning over £5000 paid a super-tax of 6d in the pound. He increased

By the beginning of the twentieth century, this attitude was changing, and gradually people were coming to understand that, within a capitalist economy, there were bound to be periods of depression when people could not find work. The problem, too, was one of permanent underemployment, as men and women doing casual work competed with each other on an almost daily basis.

The Liberal government broke down the problem into two main parts: finding work, and insuring against unemployment when there was no work to be found. Winston Churchill's principal adviser at the Board of Trade was **William Beveridge**. Beveridge had at one time been warden of Toynbee Hall (see page 79) and was much influenced by the work of Charles Booth. He believed that workers needed help to find work and support when it was not available, rather than the 'punishment' of the workhouse.

The 1909 Labour Exchanges Act was clearly influenced by Beveridge. It set up a series of labour exchanges that were intended to help the unemployed find any work that was available. In February 1910, 83 labour exchanges were opened, and by 1914 there were over 450 throughout England and Wales. Despite the fact that some employers were afraid that labour exchanges would provide a marvellous excuse for those who were unwilling to work because they could claim they were 'still looking', and some workers were afraid they would be used to recruit blackleg labour during a strike, they were a great success.

Labour exchanges were, however, only one half of the story. Only by 'signing-on' at a labour exchange would it be known that a person was unemployed and could qualify for unemployment payments. Insurance against unemployment, however, clearly had to form one part of a national insurance scheme, and so Churchill waited until Lloyd George had finalised his work on national health insurance.

KEY PERSON

William Beveridge (1879–1963) An economist and social reformer, he joined Toynbee Hall where he worked with Beatrice and Sidney Webb. In 1908 he joined the Board of Trade and played a major part in drafting the 1909 Labour Exchanges Act and the 1911 National Insurance Act. In 1919 he became Director of the London School of Economics, which the Webbs founded, and in 1937, Master of University College, Oxford. During the Second World War he chaired an enquiry into post-war social services and produced the Beveridge Report which became the blueprint for Britain's welfare state.

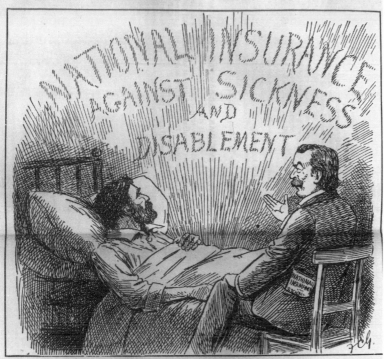

THE DAWN OF HOPE.

Mr. LLOYD GEORGE'S National Health Insurance Bill provides for the insuranc of the Worker in case of Sickness.

Support the Liberal Government
in their policy of
SOCIAL REFORM.

Poster, 'The Dawn of Hope', 1911.

the most important. Most workers resented having to pay 4d from their wages and in effect, because payment was flat-rate and every worker paid the same, the poorer workers were hit hardest. Many regarded it as a straightforward pay cut. There was no guarantee they were going to be ill and would reap any benefit at all from the scheme! But, by 1913 13 million workers had been insured in the scheme and an important safety net established.

Taking the unemployed out of poverty

The nineteenth-century attitude to unemployment was that, basically, it was the worker's fault. There was plenty of work available and only the feckless or idle would fail to find it. For these, there was relief – but inside a workhouse.

poverty, and many families tried to insure themselves against this. In the early 1900s between 6 and 7 million people were insured against sickness. But many poorer people found it difficult to keep up payments and, in times of financial stress, insurance payments of whatever kind were usually the first to go and the policies lapsed. Poor people, unable to afford to contribute even to friendly societies, faced a grave crisis when illness struck.

The Liberal government realised that the cost of funding any sort of health protection could not be carried by taxation. David Lloyd George, charged with spearheading the government's policies in Britain, was impressed by the approach pioneered in Germany through its social insurance scheme. Could such a scheme work in Britain?

Part 1 of the 1911 National Insurance Act was an attempt to support the poor when ill health struck the main breadwinner, while at the same time providing sops to the various vested interests, such as insurance companies and doctors, who might be harmed by a state insurance scheme.

- Employees contributed 4d, employers 3d and the state 2d to the state health insurance scheme.
- The scheme applied to all workers earning less than £160 a year and all manual workers aged 16–60.
- Insured people received 10s a week for up to 13 weeks and then 5s a week for a further 13 weeks in any one year, or 5s a week disability allowance and the right to treatment in a sanatorium.
- The payment of benefits was to be made by 'approved societies'.
- Maternity care was provided, with a benefit of 30s.
- Free treatment was given by a medical practitioner and all drugs and medicine were free.
- £1.5m was made available for the treatment of tuberculosis.
- The families of contributors were not included in the scheme.

This was probably the most unpopular of all the Liberal government's welfare reforms even though it was arguably

THE FIRST DRAWING OF OLD AGE PENSIONS

The first person to draw an old age pension, 1909.

- Pensions were paid out at local post offices, thus divorcing them from the Poor Law.
- Pensions were funded from national taxation, not from local poor rates.

To thousands of elderly people, the shadow of the workhouse and the stigma of poor relief had been removed forever. So had the threat of an impoverished old age. Collections of local material are full of evidence of the gratitude of the elderly poor for the freedom from anxiety that pensions – 'Lloyd Georges' – gave them.

Taking the sick and infirm out of poverty

The illness of the main breadwinner was a major cause of

Furthermore, it was argued, the cost of introducing such a scheme would be prohibitive: an estimated £16m in the 1890s, more than was spent on the Poor Law. On the other hand, those favouring a non-contributory fund pointed out that the poorest members of society would hardly be in a position to contribute from their meagre earnings. The **friendly societies** supported this view, believing a contributory scheme would hit them, as the poor could not afford to pay into their saving schemes *and* that of the state.

By 1908 there was a general consensus that some sort of pension scheme should be introduced, and in 1909 the Liberal government's proposal was put before Parliament.

The 1909 Old Age Pensions Act

* Pensions were non-contributory and were paid out of taxes.
* They were paid to men and women over the age of 70.
* A single person received 5s a week and married couples 7s 6d, later raised to 10s.
* Full pensions were paid only to those with incomes of less than 8s a week; those with incomes of between 8s and 12s received a reduced pension on a sliding scale; over 12s a week, there was no pension.
* To qualify for a pension, men and women needed to have been British citizens resident in Britain for 20 years.
* Pensions were not paid to people who had continually failed to find work; who had been in prison in the last ten years; who had claimed poor relief in the last two years; or who were drunkards.

Was this a break with the past? The number of people claiming pensions was around 600,000, roughly the same number as the elderly claiming poor relief before the Act. The cost, too, was roughly the same. The usual weekly outdoor relief payment was 5s per person – the same as a pension. And the idea of deserving and undeserving poor had not gone away. So what had changed?

* Pensions were paid as a right, not at the discretion of a relieving officer and guardians.

Taking the elderly out of poverty

By the beginning of the twentieth century, relatively few elderly people were getting support inside the workhouse (see page 73). Most who needed help were receiving outdoor relief. There was, however, a huge raft of poverty among the elderly poor and this was linked to the stigma of the workhouse. In many ways, the concept of less eligibility had been too firmly grasped by the general public. The workhouse had become a place of dread, to be avoided at all costs. It was becoming clear to many that some way had to be found of helping the aged poor, free from the shadow and the stigma of the workhouse.

The idea of providing old age pensions had first arisen as a serious proposal in the 1870s.

- In 1878 Canon William Blackley proposed a contributory pension scheme, whereby workers would pay into a fund that would then provide them with an income when they reached a certain age.
- In the 1890s Charles Booth urged the introduction of a non-contributory pension scheme whereby the elderly would receive a pension by right and it would be funded from taxation.
- In 1893 a Royal Commission on the Aged Poor was set up. It was less than helpful when it reported in 1895 that:

no fundamental alterations are needed in the existing system of poor relief as it affects the aged, and that it would be undesirable to interfere either by Statute or order ... At the same time we are convinced that there is a strong feeling that in the administration of relief there should be a greater discrimination between the respectable aged who become destitute and those whose destitution is directly the consequence of their own misconduct.

The distinction between 'deserving' and 'undeserving' poor was to dog the debate and cloud decisions for many years. Equally strongly argued were the cases for contributory or non-contributory schemes. Contributory schemes were strongly favoured by the Charity Organisation Society and all those who favoured self-help, prudence and thrift. Why, they argued, should people save for their old age if they could get a pension for nothing when they were old?

This cartoon 'Forced fellowship' by Bernard Partridge was published in 1909. What point does it make about the Liberal Party's motives in embarking on social reform? What does it suggest about the future?

FORCED FELLOWSHIP.

SUSPICIOUS-LOOKING PARTY. "ANY OBJECTION TO MY COMPANY, GUV'NOR ? I'M AGOIN' YOUR WAY "—(aside) " AND FURTHER."

- Poor Law authorities were made responsible for visiting and supervising children who had suffered cruelty or neglect.
- Nursing and private children's homes were to be registered and inspected.
- Publicans were forbidden to let children under 14 years old into public houses.
- Shopkeepers were forbidden to sell cigarettes to children under 16 years old.
- Juvenile courts and remand homes were set up to separate children from adult offenders.

The Liberal government built on these local initiatives.

The 1906 Education (Provision of Meals) Act allowed local authorities to use public money to provide free meals for children of needy parents. In some ways, the government had been bounced into this by the introduction of a private member's Bill by the Labour MP William Wilson. The government, partly through fear of being seen less radical than the Labour Party, took it on and, in doing so, established two important principles:

- The state could in some circumstances take over the role of parent where the needs of children (now regarded as a national asset) were concerned.
- Parents of children taking advantage of free meals were not regarded as paupers and were not to be disenfranchised. Under the Poor Law Amendment Act, paupers, even if they possessed the correct qualifications, had the right to vote removed from them. This, then, heralded a major philosophical and practical break from the Poor Law system.

The 1907 Education (Administrative Provisions) Act set up a school medical service, run by local authorities. This was no great Liberal government initiative, but more of a sleight of hand by Sir Robert Morant, the Permanent Secretary at the Board of Education. He wanted to force the hand of his political bosses, and managed to slip clauses relating to school medical inspection into a complicated and technical piece of legislation. Few MPs realised the significance of what they were debating. Once the Bill was passed, Morant issued directives and circulars to local authorities, regulating the service and authorising them to provide treatment as well as inspection.

The 1908 Children and Young Persons' Act was brought in on the initiative of the Liberal government after hard lobbying by the National Society for the Prevention of Cruelty to Children. It brought together several older Acts and carried their provisions further.

- Children were made 'protected persons' which made it possible to prosecute their parents for neglect or cruelty.

time the findings were published, the Liberal government was already embarked on its own programme of reform.

HOW DID THE LIBERAL REFORMS ATTACK THE PROBLEM OF POVERTY?

The Liberal government managed to avoid the problem of whether or not to reform the Poor Law by ignoring it altogether. It set about building new organisations that were completely separate from the Poor Law system. The measures it passed fell into two main groups. The early legislation, concerning children and the elderly, was the culmination of discussions that had taken place over many years. The later legislation, involving sickness and unemployment, took the government into new and uncharted territory.

Some, relatively uncontroversial, legislation was carried out in the early years of the Liberal government when Henry Campbell-Bannerman was Prime Minister. But, in 1908 when Herbert Asquith took over as Prime Minister, welfare reform speeded up. With 'progressive' Liberals – **David Lloyd George** at the Treasury and Winston Churchill at the Board of Trade – radical change was bound to come. The two men made a powerful duo. Lloyd George, in his mid-forties, was the first cabinet minister to have been born into relative poverty; Winston Churchill, in his early thirties, was the son of Lord Randolph Churchill and an aristocrat by birth. Both had the knack of capturing the mood of the people and using it to produce results.

Taking the children out of poverty

Many local authorities and private charities were, at the turn of the century, beginning to bring in schemes that helped the children of the poor when their parents were unwilling or unable to do so. They

- opened clean milk depots;
- appointed health visitors to give poor parents advice;
- started schemes for feeding poor schoolchildren.

- set up a string of national labour exchanges to help the unemployed find jobs,
- organise a schedule of training schemes,
- set up detention colonies for those who were deliberately idle;
- the Poor Law should be broken up into
 - education committees to deal with child poverty,
 - pension committees to deal with problems of the elderly poor,
 - health committees to deal with problems of the poor who were sick or infirm.

Initially, the majority report was well received. This alarmed Sidney and Beatrice Webb, who were the driving forces behind the minority report. They were so convinced they were correct that they launched themselves into a propaganda campaign for the break up of the Poor Law. In doing this, though they captured the imagination and support of the younger generation, they risked antagonising leading politicians in both the government and the opposition.

Why should any notice be taken of a Royal Commission when its 20 members could not agree among themselves as to what should be done? The problem in setting up a Royal Commission that then produces two diametrically opposed reports is that governments do not feel compelled to act upon either set of recommendations. In this case, the ranks of those who supported 'no change' were greatly strengthened by the majority report, and the changes it did recommend tended to be overlooked. The boards of guardians, in particular, vehemently opposed the proposal that they should be dissolved, and their opposition was supported by the Local Government Board and its political chief, John Burns. The divided Commission stood little chance of success.

On a more positive side, the work of this Commission, over a period of some four years, gave the problem of poverty, and investigations into the causes of poverty, a high profile. This in itself put the necessary pressure on the government to force it to come up with solutions. By the

Beatrice Webb (1858–1943) Beatrice Webb was an indefatigable social investigator, reformer and pioneer socialist. The daughter of a wealthy industrialist, she worked with Charles Booth on his survey of London poverty. Marrying Sidney Webb in 1892, together they founded the London School of Economics and Political Science (1895) and the journal the *New Statesman* (1913). They both served on the Royal Commission on the Poor Laws, and produced the minority report. Later, in 1918, when Sidney was on the executive of the new Labour Party, she wrote its policy statement 'Labour and the new Social Order'. Beatrice and Sidney visited Russia in 1932, and were enthusiastic about what they saw, writing *Soviet Communism: A New Civilization*? The question mark disappeared in later editions! Beatrice had a lasting influence on the early Labour Party and on socialist thinking.

Charity Organisation Society Founded in 1869, the aim of the COS was to regulate and organise existing societies so that charity was given only to those who deserved it. Its main period of action coincided with the efforts of the Local Government Board after 1871 to make certain workhouses harsh places for the undeserving poor. The deserving poor could be offered charity help to tide them over in hard times. The COS used 'researchers' who enquired into applicants' circumstances before they were given access to any charitable help. Relationships with Poor Law guardians were often strained. The COS was criticised, particularly by evangelical charities, for its lack of compassion in the way it worked out who was deserving of charity. Many people thought, too, that its continuing focus on deserving and undeserving poor stood in the way of progress. In the 1870s and 1880s the COS was supported by leading public figures, but was only really effective in London.

WHAT WAS THE IMPORTANCE OF THE ROYAL COMMISSION ON THE POOR LAWS, 1905–9?

A Royal Commission to enquire into the workings of the Poor Laws and the best way to relieve the poor was set up by the Conservative government. It first met in 1905. Members of the Commission had a wide range of appropriate expertise: Poor Law guardians, members of the **Charity Organisation Society** and the Local Government Board, religious and trades union leaders and social researchers Charles Booth and **Beatrice Webb**. They conducted thousands of visits and interviews in the course of their enquiry and collected nearly 50 volumes of evidence. But, when they came to report in 1909, they could not agree on the way forward for the poor. So they produced two reports.

The majority report

The findings of the majority of Royal Commission members were:

- the origins of poverty were basically moral;
- the Poor Law should stay as the main vehicle for dealing with poverty;
- boards of guardians allowed too much outdoor relief and should be replaced by public assistance committees;
- general mixed workhouses did not deter the able-bodied poor;
- there should be greater co-operation between charities and those administering the Poor Law, and voluntary aid committees should be set up to enable this to happen.

However, some members wanted to sweep the Poor Law away and start again with something quite different.

The minority report

The findings of the minority of Royal Commission members were:

- the origins of poverty were basically economic;
- a Ministry of Labour should be set up which should
 – introduce and oversee public works schemes,

concern that the British working people were somehow operating at a less than efficient level:

- The successful economies of Germany and the USA seemed to imply that Britain had a somehow inferior workforce with neither the stamina nor the intelligence and skills to compete.
- The studies of Booth and Rowntree seemed to confirm the findings of the recruitment boards.
- The British army – equipped with both superior weapons and training – had found it difficult to defeat the Boers.
- The belief of Major-General Frederick Maurice in 1903 was that 'neither the unskilled labourer who has been tempted into the towns, nor the hereditary townsman who, after two or three generations, has deteriorated in vigour, will be able to rear a healthy family'.
- The findings of the government interdepartmental committee, set up to investigate concerns expressed at the time of recruitment for the Boer war (and again in 1903), were that the physical state of the poorest sections of society did give rise to serious concern.

It seemed that, even though social and welfare reform did not form part of the Liberal Party's electoral platform, the stage was set for reform. The electorate expected it and the Liberal Party, for whatever reasons, had the political will to deliver it.

Boer war recruits, 1900. Two out of every three volunteers were rejected by recruitment boards because they were unfit.

'The Workers' May Pole' poster, from 1894, showing the promises of the Labour Party.

the Liberals as the main alternative to the Conservatives. It was possible, too, that, if the working classes did not get the reforms they sought from the Liberals, they would push Labour into a more extreme political position. It was just possible that the Labour Party would be prepared to embrace a more radical form of socialism, dedicated to the overthrow of the capitalist system. This was no idle fantasy. In Germany, the Chancellor Otto von Bismarck had been forced to introduce social reforms in order to limit the growth of radical socialism.

The condition of the people

The Boer war (1899–1902) was not a conscript war. Young men volunteered to fight in their thousands. And in their thousands they were rejected as unfit. In some industrial areas, two out of three potential recruits did not pass the basic army medical examination. Worrying in itself, this one episode seemed to reinforce a general

state had an increasingly important part to play in the provision of welfare.

- **1902** The Conservative government successfully introduced an Education Act that put the administration of state education firmly in the hands of local authorities and gave them the powers to provide secondary education.
- **1903** Joseph Chamberlain (the Colonial Secretary) linked the ability to fund welfare reforms with the success of his policy of **protectionism**.
- **1905** The Conservative government successfully introduced the Unemployed Workman Act. This enabled local authorities to set up distress committees to provide work for the unemployed.
- **1905** The Conservative government set up a Royal Commission to enquire into the workings of the Poor Laws.

Fear of the emerging Labour Party

The electoral changes of 1867 and 1884 had almost doubled the franchise and, in several industrial parliamentary constituencies, the majority of the electorate was working class. And the working classes were clamouring for change. In 1900 the Trades Union Congress set up the Labour Representative Committee intending it to be the political voice of the working classes. The LRC (in 1906 renamed the Labour Party) aimed, first, to make the trades unions legally secure, because they were the first line of defence for working people. It then turned its attention to social reform, calling for the abolition of the Poor Law, help for the unemployed, old age pensions and free education for all. Here was challenge indeed for the two main political parties.

The 1906 House of Commons contained 29 Labour MPs who supported, in the main, the triumphant Liberal Party. But the Liberals, with their landslide majority, were wary of them. The Labour Party had a programme of social reform that was attractive to the working classes. If the Liberals did not introduce a programme of major welfare reforms, and so steal Labour's thunder, then maybe, at the next election or the one after that, Labour would replace

Protectionism This term is applied to trade. It means the process of setting customs tariffs on foreign imported goods so that home-produced goods will be cheaper. It was believed that this would lead to a rise in demand for home-produced goods that would, in turn, lead to employers taking on more workers and a fall in unemployment.

Free trade Free trade means that goods should be imported and exported without hindrance of customs duties or any other legislation intended to control the markets. In this system, it was believed, consumers and producers would reach a proper balance and full employment would automatically follow. The Great Depression at the end of the nineteenth century challenged this view. If people were thrown into poverty as a result of foreign competition, could it be said to be their own fault? And should the state step in, either to help them, prevent foreign competition, or both?

The 'progressive' liberalism

In the 1890s new ideas were taking hold of the Liberal Party. Where had these come from?

- The findings of Charles Booth and Seebohm Rowntree about poverty in London and York (see pages 4–6 and pages 182–91) had a profound effect on important and influential Liberal writers and politicians such as Herbert Samuel, J.M. Robertson, J.A. Hobson and L.T. Hobhouse. Both Booth and Rowntree found that poverty was much more widespread than had been thought, and that low wages were as much a cause of poverty as idleness.
- The settlement movement, whereby young graduates lived in deprived areas and worked on various education and welfare projects, had brought many thinking Liberals face to face with the realities of poverty.
- Toynbee Hall, in east London, was the centre both of Booth's researches and the settlement movement and became a hotbed of new thinking about the relationship of the state with its most vulnerable members.
- The writing of philosophers like T.H. Green, popularised in newspapers such as the *Manchester Guardian* and the *Daily Chronicle*, gave intellectual weight and popular support to the ideas of the progressive Liberals.

Gradually, this new 'progressive' liberalism became the dominant force in the Liberal Party. The Liberal Party of William Gladstone had been a party that stood for low taxation and laissez-faire: minimal interference by the state in the ordinary, everyday lives of its citizens. This was now under question for good. The Liberal government of 1906 contained leading progressives: Winston Churchill, David Lloyd George and Herbert Asquith. Change of some sort was bound to happen. The new Liberal Party was one in which the majority believed the state should tax the rich in order to provide support for the poorest and most vulnerable in society.

The climate of change

It was not just the Liberal Party that was moving into reforming mode. The Conservatives, too, believed that the

CHAPTER 7

Liberal social and welfare reforms, 1906–14: a fresh attack on poverty?

The Liberal Party swept to a surprising landslide victory in the general election of 1906. Social reform had not been a major part of the party's electoral campaign and it had no coherent, predetermined programme regarding welfare. Yet, almost immediately the Liberal government launched a series of important welfare reforms that radically changed the ways in which governments dealt with poverty. The reasons for these reforms did, to some extent, determine their nature and here the Poor Law Commission of 1905–9 provides a useful context. Some of the reforms had been under discussion for many years and simply required the political will to carry them out; others pushed into entirely new and uncharted territory. By 1914 some elements of the old, Victorian attitudes remained within the developing welfare system, but some historians argue that it is possible to see, in these Liberal reforms, the beginnings of the welfare state, with its welfare provisions for all, regardless of income.

WHY DID THE LIBERALS INTRODUCE MAJOR SOCIAL AND WELFARE REFORMS AT THE BEGINNING OF THE TWENTIETH CENTURY?

The Liberals did not win the general election of 1906 because of their proposed programme of reform, because there wasn't one. But clearly the welfare reforms they introduced in the years before the First World War did not come from nowhere. There was a range of different pressures and imperatives that together combined to create the greatest government reforming programme that had ever been seen.

written in 1886 to the medical officer of the Local Government Board.

I beg to call your attention to the cruelty exercised by the Master and the Mile End Board of Guardians in sending a portion of their aged and infirm poor to the Whitechapel Test House, South Grove. The Master (Mr Waterer) said publicly: 'The rules and regulations of this House are necessarily very severe. I should like to make some distinction, but I cannot; all must be treated alike.' Now, if the Master acknowledges the treatment to be very severe, I leave you to judge if it is a proper place to send aged men, between 60 and 75 to, especially as most of them have some complaint which stops them following any of their usual activities.

Most of them sent there within the last two years have been sent to the infirmary, either to die, or to remain living specimens of this cruel treatment. I will only add, that such is the terror created at Mile End from the account given by those who have been sent there, that they are afraid to make the slightest complaint about anything, knowing that penal servitude at South Grove would be the consequence. Should a return be demanded of all the men over 60 that have been sent there from Mile End within the last two years, I think the death rate would cause some astonishment.

I am, Sir, your obedient servant

One of the Victims

Do you find any of these letters surprising, in view of what you know about the way the Poor Law was developing at the time they were written?

again much the better. And in a few days afterwards she was struck with the cholera ...

On 13th December 1849 she went to the Relieving Officer and he gave her an order for the workhouse and she asked him for a horse and cart for it is twelve miles from my cottage and I am sure my children cannot walk such a distance, but he answered he would not ...

2 This is part of a petition from paupers in the Bethnal Green workhouse in London. It was written in 1850. The master, when contacted by the Poor Law Board, said the men were troublemakers and they were being punished for general cheek and rudeness.

We your humble servants the Inmates of the above workhouse humbly ask your protection from the cruelties practised upon us by the Master. We are kept locked in the cell yard to break stones and kept on bread and water every other 24 hours because we cannot break 5 bushels of stone per day, being mechanics who never broke everything before. The stones being so that men that have been used to get their living by breaking them cannot do the task. We have been these last three weeks kept on bread and water, not having any meat but on Sundays, have become very weak. Most of us have large families and are not allowed a days liberty to look for work. So we have no chance of taking our families out of this place. The cruelty going on in this place is beyond description. It is a disgrace to a Christian land boasting of humanity.

3 This letter was written to the Poor Law Board from a pauper mother in the Bethnal Green workhouse in 1857. A Poor Law inspector scribbled on the letter that he would visit the workhouse as soon as possible.

Gentlemen

It is right you do cum and see oure children bad for months with hich and gets wors the Master nor gardens wont see to it and if we give oure names we shall get loked up Haste to see all and sum name Sarle and Sisel – soon as you can

A Mother

4 The Whitechapel workhouse was one of the deterrent workhouses set up by the Local Government Board. It was supposed to be a shining example of what could be done. The inmates thought differently! This letter was

elderly) became the basis of a network of social services. But the will to do so was not there. Instead, future developments were to depend upon efforts of administrators and legislators to free the poor from the stigma of pauperism.

LETTING THE POOR SPEAK

So far, we have not had any indication of what the poor themselves felt about the ways in which they were treated. All the arguments, philosophising, categorising and ordering have been made by those who were totally unlikely, ever, to become the recipients of the dubious benefits of the Poor Law Amendment Act. The records of the Poor Law Commission and, later, the Poor Law Board are full of letters written by, or on behalf of, paupers and the poor. They reveal the depths of poverty experienced in nineteenth-century England and Wales, the vagaries of boards of guardians in applying the law, and the relative powerlessness of the central administration to intervene on their behalf.

1 Part of a letter from William Martin to the Poor Law Board in 1850 about his treatment by the Clitheroe union. Across the letter is written 'State that the Board have no power to order relief, but will make enquiry of guardians as to his case.'

> I beg permission to lay a case before you of one name of Wm Martin hawker by occupation; which has a wife and five children ... who is reduced by five months sickness of his wife. The surgeon stated that she was in danger of losing her eyesight if she be not cautious. She asked him if moving to the seashore would help and he replied that he thought it would. So I appeared at the Board of Guardians the Tuesday following and I asked them if they would be so kind as to grant me a trifle of money to take her to the seashore. They asked me if I had got a certificate from the surgeon, I answered no sir, they answered if I had brought one they could have done better with me. So I prolonged the time one more week and I got a certificate from Mr Patchett the surgeon. So I appeared again at the Board, on the Tuesday following and they would not grant me one penny. So I resolved before she should lose her eyesight I would sell all my chattels. So on Sunday following I contrived for her to go down to Blackpool, and she remained there a few days, and returned home

In 1895, 1899 and 1900 the Local Government Board issued circulars specifically on the treatment of elderly paupers. It stated that boards of guardians should:

- give adequate outdoor relief to the 'aged deserving poor' and only receive the elderly into workhouses if they could not manage on outdoor relief;
- grant privileges to elderly paupers inside the workhouse so that they were made more comfortable than the other inmates. These privileges were to include such things as separate day-rooms, a flexible programme of eating and sleeping times, open visiting, tobacco and extra tea;
- remove most disciplinary rules, including the requirement to wear a pauper uniform;

Humanitarian for the time these arrangements might seem, nevertheless many poor working people viewed their old age with fear and trepidation. The workhouse cast a long shadow.

SUMMARY QUESTIONS

The purpose of this section is to help you consolidate your thinking and understanding about the ways in which the Poor Law developed after 1847 until about 1900.

1 Why, and with what effect, were changes made to the body responsible for the central administration of the Poor Law?

2 Why was it impossible to abolish outdoor relief for paupers?

3 How reliable do you find the two advertisements and the photograph of women paupers in 1900 as indicators of change in attitudes to paupers?

4 How far, by 1900, had those administering the Poor Law moved away from the principle of 'less eligibility'?

The Poor Law could have been developed so that its specialist services (in education, for the sick and the

Metropolitan Poor Act had organised London into 'asylum' districts, which provided general, specialist, isolation and mental hospitals. By 1882 there were six fever hospitals, four mental asylums and 20 infirmaries in London alone. Other Poor Law authorities followed suit. By 1900 the Poor Law was providing a national, state-funded system of medical care for paupers and poor.

The connections between medicine and less eligibility were well and truly broken. Gradually, the move had been made from stigmatised, pauperised medicine to a basic medical service for the poor for which they did not have to pay.

Elderly paupers

The separation of elderly, married paupers was perhaps the one provision of the 1834 administrative arrangements that caused most anguish among the paupers and most disquiet among the general public. Attempts were made to ease this compulsory separation. In 1847 the Poor Law Board ruled that separate bedrooms should be provided for couples aged over 60 if they asked for them. But few, in reality, were made available and in 1895 only 200 elderly couples were sharing a workhouse bedroom.

Elderly women paupers in the Cambridge workhouse, c.1900.

- **1860s** Poor people can receive medical help in their own homes for illness, accidents and childbirth.

Matters came to a head when Poor Law medical officers began complaining through the Poor Law Medical Officers' Association and through the Workhouse Visiting Society about the conditions in workhouse hospitals. Letters of complaint were published in *The Lancet* which itself initiated an enquiry into conditions in London workhouse hospitals. Gradually, the public became aware that something had to be done. 'Sickness and poverty are different things', thundered *The Times* in 1866. Gathorne Hardy, President of the Poor Law Board, agreed. In doing so, he signalled a major change of policy. Sick paupers were to be treated in hospitals that were separate from the workhouses. Thus began the separation of pauperism from illness.

These 'pauper' hospitals were often the only places where ordinary working people could get medical help. This was particularly the case in London, where the 1867

IMBECILE
WARD KEEPERS
WANTED.

The Guardians of Mile End Old Town require the services of a **MALE** and **FEMALE**, to take charge of the **HARMLESS LUNATICS** in the Workhouse Infirmary. Candidates must be active, healthy, patient, without encumbrance, and between twenty-five and fifty years of age.

SALARY } **MALE · · £25.**
FEMALE · £20.

With Board, Lodging, and Washing,

A MAN AND WIFE PREFERRED.

Applications in the Candidate's own hand-writing, marked on the outside " M " or " F," as the case may be, stating age, and where previously employed, accompanied by **THREE TESTIMONIALS**, of recent date, must reach me before Twelve o'Clock on **THURSDAY**, 19th instant, on which day at Three, applicants must attend at their own expense. A selection will then be made, and the appointment take place at Six in the Evening, of the said 19th. No one need apply whose character for honesty, sobriety, and competency, will not bear the strictest investigation. Canvassing the Guardians is prohibited.

(By Order,)

E. J. SOUTHWELL,

Clerk,

Workhouse, Bancroft Road, Stepney, N.E.
7th December, 1861

T. Prout, Printer, 121, Leman Street, Whitechapel.

Poster advertising for 'Imbecile ward keepers'.

BROMSGROVE UNION.

APPOINTMENT OF SCHOOLMISTRESS.

THE BOARD of GUARDIANS of this UNION, at their Meeting on TUESDAY, the 9th day of May next, intend to elect a SCHOOLMISTRESS for the WORKHOUSE. The person appointed will be required to instruct both boys and girls, and to perform such duties as are set forth in the General Consolidated Orders of the Poor Law Board. The salary will be £20 per annum, subject to such increase as may be awarded by the Committee of Council on Education, with Rations, Lodging, and Washing in the Workhouse.

Applications in the handwriting of the candidates, with testimonials as to character and ability, to be sent to me on or before Monday, the 8th of May next, and the applicants will be expected to attend at the Board Room on the following day (Tuesday), at Eleven o'clock in the Forenoon. No travelling expenses will be allowed.

By order of the Board,

THOMAS DAY, Clerk.

Board Room, Bromsgrove, 25th April, 1865.

Advertisement for a workhouse schoolmistress at the Bromsgrove union, 1865.

workhouse (see page 58). Boards of guardians frequently left their sick, injured and pregnant paupers to be treated in their own homes by Poor Law medical officers. Indeed, this was one of the major forms of outdoor relief after 1834. In this way, costs were kept to a minimum: in 1840 only £150,000 from a Poor Law expenditure of £4.5m went on medical services.

The change and development in Poor Law medical services happened, not in response to any plan or ideology, but in response to need and public opinion.

- **1841** A poor person receiving a smallpox vaccination from a Poor Law medical officer does not because of this become a pauper.
- **1850s** Poor Law unions set up public dispensaries which dispense medicines to the public as well as paupers.
- **1852** A poor person who cannot pay for medical treatment or prescribed medicines automatically qualifies for outdoor relief.

- **1834** Workhouse schools are established and become one of the first forms of state education. These breach the principle of less eligibility because they provide an education for pauper children that is better, although their curriculum is narrower than that provided by voluntary schools outside the workhouse. Indeed, the poorest children outside the workhouse rarely had any education at all.
- **1844** Poor Law unions are allowed to combine to provide district schools, where pauper children are educated in buildings often far distant from the workhouse in which they live. Some progressive boards of guardians, like those in Leeds and Manchester, set up industrial schools, where pauper children can live and take 'honest and useful industrial courses', enabling them to become 'good servants or workmen'.
- **1846** A government grant is available to boards of guardians to enable them to pay the salaries of workhouse schoolteachers.
- **1850s** Some boards of guardians abandon district schools in favour of smaller, on-site schools where boys are taught a trade and girls learn domestic skills.
- **1860s** Some boards of guardians begin to experiment with boarding pauper children with working-class families.
- **1870** Forster's Education Act sets up board schools and guardians are encouraged to send their pauper children to these, enabling them to mix with children outside the workhouse.
- **1890s** A system, developed by the Sheffield board of guardians, begins to spread whereby pauper children are housed in 'family' groups in various houses in a town or city, and are looked after by a married couple appointed by the guardians.

Sick and mentally ill paupers

Illness of the main breadwinner in a family was a major cause of poverty and eventually pauperism, yet the early Poor Law administrators paid little attention to the problem. It is true that the Poor Law Amendment Act allowed for the employment and payment of medical officers, but these were invariably poorly paid and were seen as being part of the disciplinary structure of the

remained constant. Although the ratio of paupers relieved inside the workhouse to those receiving outdoor relief changed over time, the greater number of paupers were always relieved outside the workhouse.

DID THE TREATMENT OF PAUPERS CHANGE?

The rigour and deterrent principles embodied in the 1834 Poor Law Amendment Act were directed at able-bodied men. It was never intended that boards of guardians apply them to the more vulnerable members of society: the elderly, the sick, the mentally ill and children. Indeed, the Royal Commission of 1834 recommended the separation of different categories of paupers within a workhouse and that the paupers within each category should be treated differently. However, this ideal stumbled over the enormous cost implications. Initially, therefore, the 'general mixed workhouse' became the norm, something to which Chadwick, for one, was never reconciled.

It was not until later in the century that Poor Law administrators returned to Chadwick's thinking. In the 1870s the Local Government Board advised boards of guardians to divide up paupers in their workhouses according to what it was that caused their poverty and to create a scale of 'comforts' for each category, with the most deserving receiving the most. This was all very well in theory, but in practice it was a difficult thing to do without government funding, which was not forthcoming. There were, as always, vast local differences in provision.

Pauper children
The special needs of pauper children were almost universally recognised. It was generally considered undesirable, even before 1834, that children should mix freely with adult paupers and there was a growing belief that education was the way to ensure that pauper children did not return to the workhouse as pauper adults. After 1834 children under the age of 16 made up, fairly consistently, around one-third of all paupers in workhouses. So what was done and how did provision for children change?

These child emigrants were sent to Canada by the Canadian Catholic Emigration Committee. They were part of a group of 64 lone youngsters (32 paupers and 32 poor) who left Britain on 11 July 1889. The youngest child was 6 years old.

- It issued a circular condemning outdoor relief on the basis that it took away from the poor all desire to save for bad times by offering relief to them in their own homes whenever they needed it.
- It supported local authorities when they took a harsh line with the able-bodied poor asking for relief. Poplar, in east London, for example, set up a deterrent workhouse that set the undeserving poor to harsh work. Others followed suit. They were able to do this because a growing number of charities were beginning to provide charity payments for the deserving poor.
- It authorised boards of guardians to take part in emigration schemes, whereby groups of paupers (either whole families or specific categories of poor and paupers) were sponsored to emigrate.
- Joseph Chamberlain (see page 157), President of the Local Government Board, issued a circular in 1886 to all boards of guardians. He advised them to provide paid schemes such as street cleaning for the able-bodied poor whom it was 'undesirable to send to the workhouse, or to treat as subjects for pauper relief'.

These measures worked. Although the actual number of paupers grew, they fell as a percentage of the population as a whole from 4.6 per cent in 1870 to 2.5 per cent in 1900. However, no matter how the percentage of paupers to the population as a whole changed over time, one factor

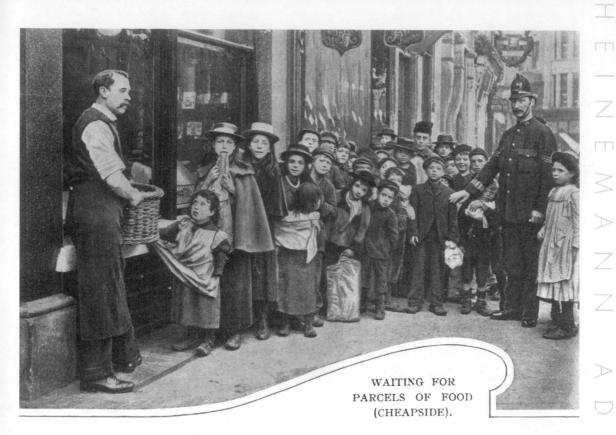

WAITING FOR
PARCELS OF FOOD
(CHEAPSIDE).

Children of the poor waiting for 'charity' food in Cheapside (London) c.1900.

The superiority of outdoor relief over indoor was endorsed in 1863. In the early 1860s, the American cotton crop failed, causing a crisis in the Lancashire cotton mills. Thousands of operatives needed short-term, outdoor relief. In order to ease the situation, the Public Works Act of 1863 allowed local authorities to borrow money to set up work schemes to employ paupers. It did not really work because the crisis passed before it could come into play. But the point was that a basic principle of the 1834 Poor Law Amendment Act – the ending of outdoor relief for able-bodied paupers – had been breached, and breached by Parliament.

The Local Government Board and relief

When the Local Government Board took over responsibility for the administration of the Poor Law in 1871, it tried desperately to reduce the number of paupers receiving relief:

retain their self-respect. This, at least, was the theory. Reality was, of course, different.

By 1847 it had become clear that it was going to be impossible to abolish outdoor relief in rural as well as urban areas. In 1844 the commissioners issued the Outdoor Relief Prohibitory Order, prohibiting outdoor relief for the able-bodied poor. At this time, the assistant commissioners were experiencing tremendous problems in implementing the new Poor Law in the industrial north, and so the order did not extend there. Instead, the Outdoor Labour Test Order was supposed to apply. This insisted that the workhouse test had to be paralleled by the 'labour test' whereby monotonous and unpleasant work had to be undertaken by the pauper in return for outdoor relief. This was intended to be temporary, to tide over the industrial areas while the problems of introducing the Poor Law Amendment Act were ironed out by the relevant assistant commissioners. But it was not to be. Their irregular and infrequent visits meant that local variations were not just possible but became the norm. In 1846 – the Commission's last full year – there were approximately 1,300,000 paupers in England and Wales. Of these, only 199,000 received relief inside union workhouses.

The Poor Law Board made an attempt, in 1852, to incarcerate all the able-bodied paupers in workhouses by issuing a general order forbidding outdoor relief to the able-bodied. It failed. Many boards of guardians used all the loopholes possible (the most common one being sickness in the family) to continue giving outdoor relief. Indeed, aware that poor rates were again rising, cost-conscious guardians preferred the cheaper alternative of outdoor relief.

- In East Anglia in 1860 it cost 3s 5½d a week to keep a pauper in a workhouse and 1s 9d if that same pauper were on outdoor relief.
- In London in 1862 it cost 4s 8d a week to keep a pauper in a workhouse and 2s 3d if that same pauper were on outdoor relief.

WHAT BALANCE WAS ACHIEVED BETWEEN INDOOR AND OUTDOOR RELIEF?

All legislation attempting to deal with the problems thrown up by the poor and destitute stumbled when it came to the problems of coping with the able-bodied poor. All legislators saw the need to distinguish between those who could not work and those who would not work. They differed in how they categorised able-bodied paupers and in how they treated them, once categorised. The prime movers behind the 1834 legislation had no inhibitions. The 1834 Report of the Royal Commission on the Poor Laws was adamant in recommending that all outdoor relief should end. Outdoor relief did, it was believed, encourage laziness as it removed from the poor the need to work. If all relief were obtainable solely in workhouses, only the truly desperate would apply and the much-vaunted principle of less eligibility would be seen to operate. With fewer able-bodied poor applying for relief, the labour market, and hence the economy, would remain buoyant, the poor rates would be kept low and the poor would

Paupers relieved in England and Wales, 1850–1914

	Indoor paupers		Outdoor paupers	
	Number	Percentage of population	Number	Percentage of population
1850	123,004	0.77	885,696	5.0
1855	121,400	0.65	776,286	4.8
1860	113,507	0.58	731,126	3.7
1865	131,312	0.63	820,586	3.9
1870	156,800	0.71	876,000	3.9
1875	146,800	0.62	654,114	2.8
1880	180,817	0.71	627,213	2.5
1885	183,820	0.68	585,118	2.2
1890	187,921	0.66	587,298	2.1
1895	208,746	0.69	588,167	2.0
1900	215,377	0.68	577,122	1.8
1910	275,075	0.78	539,642	1.5
1914	254,644	0.69	387,208	1.0

(Source: The Local Government Board's 31st Annual Report (1901–2), Appendix E, p. 312. The last two years do not include casuals and insane paupers.)

common fund and its contribution was based upon the rateable value of properties in the parish, not the number of paupers for whom the parish was responsible. Thus, richer parishes subsidised the poorer ones, and those owning larger properties paid higher poor rates than those living in more modest dwellings.

Even so, there was no uniform rating system in that, pound for pound, the owner of a property in, say, Hertfordshire would pay the same poor rate as the owner of a similar property in, say, Lancashire. Most boards of guardians, too, were middle class and committed to keeping the rates as low as possible. These factors combined to lead some Poor Law unions to claim they could not afford to build, for example, the separate accommodation required by the 1834 Act for different classes of paupers. The 1869 Poor Law Loans Act attempted to ease the situation by allowing guardians to extend the repayments on loans from the Public Works commissioners to up to 30 years. Guardians could thus contemplate applying for the level of loan that would enable them to upgrade their facilities without adding too much to the poor rate they levied.

Poor rate

	Average expenditure (in £000)	Per head of population	Percentage increase or decrease on previous period
1844–8	5290	6s 2d	+11
1849–53	5198	5s 10d	–2
1854–8	5791	6s 0d	+11
1859–63	5880	5s 10d	+2
1864–8	6717	6s 2d	+14

more than a couple of times a year. The way was open for unofficial local variation in response to local need.

Local government takes over

In the latter half of the nineteenth century, and particularly after the **Reform Act of 1867**, government became increasingly aware of and concerned with, the welfare of the people. The new legislation that affected, for example, housing and public health was dependent upon the local authorities for enforcement. It did not make any administrative sense to keep the Poor Law separate from this and so, in 1871, the Poor Law Board was replaced by the Local Government Board. However, the government still retained its control as the president of the Board was invariably a cabinet minister.

These administrative shifts reflected, too, a shift in the attitude to poverty among legislators and the public. Poverty, and therefore pauperism, came to be seen less as a disgrace associated with deliberate idleness and more of a misfortune associated with events beyond the control of an individual or with personal inadequacy and accident. This change in attitude was itself a part of a growing belief that society had a duty to protect its more vulnerable members.

DID THE FINANCIAL SITUATION IMPROVE?

One of the driving forces for change in 1834 had been the rising cost of the poor rate. The 1834 Poor Law Amendment Act grouped parishes into unions, but each parish within the union had to pay for the maintenance of its own paupers. The result of this was that struggling parishes with the most paupers levied the highest poor rates, and these parishes were the least able to afford them. Conversely, prosperous parishes with few paupers levied a low poor rate and their prosperity was further enhanced. In some areas, the burden of the poor rate was so heavy that parishes could not meet their commitments.

The situation was resolved in 1865 by the Union Chargeability Act, which placed the financial burden of relief on the union as a whole. Each parish contributed to a

extended the Commission's contract for a further five years to 1847. So why wasn't it extended beyond 1847?

- The Andover scandal (1845–6) revealed the worst abuses of the workhouse system and the apparent lack of willingness of the Commission to detect and correct such matters.
- The way the Commission itself pilloried the assistant commissioner responsible for the Andover workhouse, Henry Parker, alarmed those who knew how administrators should be treated in problematical situations.
- The Select Committee revealed that there were considerable tensions within Somerset House, where the Commission worked. Chadwick, for example, had never reconciled himself to the 'lowly' position of Secretary and had always wanted to be a commissioner. He used the Andover scandal to criticise his employers.

From Poor Law Commission to Poor Law Board

Gradually, Parliament became convinced that the Commission had served its purpose and had to go. In 1847 the government replaced the Poor Law Commission with the Poor Law Board. It was intended, not only to rid the administration of the Poor Law of arrogance, rigidity and cant, but also to link it more firmly to government. Thus, while a president and two secretaries undertook the day-to-day work, several cabinet ministers sat on the Board *ex officio*. Furthermore, the president himself was invariably an MP. In this way, those who were responsible for the administration of the Poor Law were answerable to Parliament and responsive to public opinion. But the switch from Commission to Board and from autonomy to parliamentary control did not signal an absolute break with the original administrators of the Poor Law Amendment Act. Most of the Commission's assistant commissioners stayed on as Poor Law inspectors. Here, the importance of their personalities became obvious. The skilled negotiator John Walsham, for example, was able to achieve more in the north-east of England than the irascible John Mott in Lancashire and Yorkshire. But, with large districts to supervise, inspectors were able to visit individual unions no

CHAPTER 6

How did the Poor Law develop between 1847 and 1900?

1847 was a watershed in the development of the Poor Law. The initial teething troubles, caused by the assiduous implementation of the main tenets of the Poor Law Amendment Act, had been dealt with by commissioners and assistant commissioners with some measure of success. Opposition had died down and virtually collapsed. Those seeking relief knew what to expect, and those paying for the relief knew what they were paying for.

But 1847 was a watershed in another, more concrete, way. The **Andover workhouse scandal**, although undoubtedly exaggerated, had brought some of the worst abuses of the new Poor Law system to the attention of Parliament and the public. The scandal had provided the trigger for the abolition of the Poor Law Commission. It was replaced by the Poor Law Board, whose president was a cabinet minister and accountable to Parliament. The stage was set for development and change.

WHAT CHANGES WERE MADE TO THE CENTRAL ADMINISTRATION?

Problems with the Poor Law Commission

The apparent autonomy given by Parliament to the three commissioners was largely driven by the need to implement the Poor Law Amendment Act quickly and efficiently. It was always envisaged that the power given to the commissioners would be temporary, and the 1834 Act limited the life of the Commission to five years. After 1839 the Commission's powers were renewed on an annual basis. However, by 1842 opposition to the implementation of the Poor Law Amendment Act was waning. It looked as though Parliament would not have to intervene and so it

Pay and conditions

Overall, the Poor Law did not attract well-qualified, dedicated people to work in its service. This was mainly because of the ludicrously low rates of pay the commissioners offered. A prison governor, responsible for, say, 900 long-term convicts, was paid around £600 a year. Yet a workhouse master and matron, responsible for a shifting population of around 600 paupers, received a salary of around £80 a year between them; the highest salary on record was £150. A prison chaplain received on average £250; a workhouse chaplain, £100. A surgeon, £220; a workhouse medical officer, £78. Apart from the pay, the other complaints from workhouse staff centred on long hours, few holidays and of being tied to the workhouse and the whim of the workhouse master.

SUMMARY QUESTIONS

The purpose of this section is to help you consolidate your thinking and understanding about the purpose and functioning of the workhouse as a central part of the provision of relief to the poor after 1834.

1 Why was the design of workhouses so important?

2 Would you agree that the workhouse system inflicted psychological, as opposed to physical, cruelty on pauper inmates?

3 With what success did workhouses meet the principle of 'less eligibility'?

4 How far would you agree that, by fostering the idea of a workhouse as a grim place from which the poor would do well to keep away, the Poor Law commissioners were responsible for creating a climate of fear that harmed the very people they were supposed to help?

Teacher

Poor Law teachers were kept firmly under the master's control. As well as teaching the pauper children, they were expected to be responsible for their cleanliness and general appearance. But here again the principle of less eligibility stumbled.

Teachers were supposed to teach – but what? Thousands of poor children never set foot in a school. Many boards of guardians were wary of teaching paupers to read: what would they do, it was believed, but read **Chartist** pamphlets or write Swing letters? But they did realise that to teach pauper children to read and write would make them less likely to become a charge on the parish when they grew up. In 1836 the Bedford board of guardians 'solved' the problem. The guardians would have their pauper children taught to read, but not to write. This 'solution' was disallowed by the commissioners on the grounds that this would stigmatise pauper children because, when other children learned to read, they also learned to write.

In many unions the problem solved itself. At Salisbury in 1840 the schoolmaster was an alcoholic and the schoolmistress could not read; at Coventry the teacher was a pauper who did not attempt to teach reading and writing because she was herself illiterate; in Deptford the 'teachers' were illiterate seamen who specialised in swearing, bullying and drunkenness.

Chaplain

Workhouse chaplains were usually poor curates, anxious to supplement their livings. Chaplains had to hold one service in the workhouse chapel every Sunday, visit the sick and minister to the dying. Here again, they were subject to the vagaries of the 'rule' of the workhouse master and matron as to when they could visit those of their flock who needed spiritual help and guidance. Many a poor, young curate would have struggled indeed against the tyranny of a workhouse master and the unruly and probably blaspheming nature of his workhouse flock.

corruption and murder, he finally threw himself under a
Great Western train.

- The master of Cerne Abbas workhouse (Wiltshire) lasted
as master for just two weeks. He had little education and
simply could not cope with the paperwork demanded by
the commissioners. The guardians appointed the
workhouse porter in his place.

Clerk

Some boards of guardians tried to save money by
combining the posts of master and clerk. This simply did
not work: both posts, done properly, were full time. It was
the clerk who ordered, and budgeted for, the food,
clothing, equipment, furniture and supplies coming into
the workhouse; he supervised building work, either new or
repairs. Under the master, he was responsible for just about
everything, from boilers to brushes. The opportunities for
corruption were enormous.

Medical officer

Medical officers were appointed on short-term contracts on
the lowest possible pay and had to supply all their own
drugs and bandages. Unlike other workhouse posts, the
Poor Law commissioners did not recommend specific
salaries for medical officers. Local doctors in each Poor
Law union were invited to tender for the job. In some
unions, they refused to tender, not wanting to undercut
each other; in other unions, they first agreed a minimum
salary among themselves. The job was not a popular one
and the status was low. At the beck and call of the
workhouse master, the medical officer was part of the
disciplinary structure of the workhouse. Masters could, and
did, ignore medical officers' advice regarding special diets
and restrictions on work. Medical officers, as well as
dealing with routine sickness, had to cope with the
chronic, venereal and infectious diseases that the voluntary
hospitals refused to treat.

Conditions in workhouse infirmaries, until the 1860s, were
pretty grim. Poor pay and workhouse accommodation
were hardly incentives to recruitment. The sick were forced
to depend on the ministrations of pauper 'nurses' who
were supervised by the workhouse matron.

master and matron of the workhouse: they were underpaid, overworked and frequently operated without close supervision from their board of guardians. The master was responsible for the discipline and economy of the workhouse; the matron for the female paupers and the domestic side of life. Cruel or kind, they both enjoyed tremendous power over staff and paupers. No member of staff could leave the workhouse without the master's permission and no one, not even the guardians, had an automatic right of entry except the paupers. Many were simply not up to the job. The very nature of the work meant that it attracted married couples with no roots: demobbed army non-commissioned officers and their wives, for example, who had no experience of managing large institutions. Many masters wielded power by interpreting rules and regulations with unnecessary and ignorant tyranny; many matrons saw in the paupers a ready supply of 'free' servants and aspired to a lifestyle beyond their means. But it was not all like this.

The 1238 masters and matrons in the 600 Poor Law unions that had been set up by 1846 were a mixed bag:

- At Ashford (Kent) the union workhouse was run by a retired, and much decorated, naval officer and his wife. It was renowned for its efficiency and for its compassion, and held up by the commissioners as a model to which others should aspire. When the master retired, paupers wept.
- Colin M'Dougal, an ex-sergeant major, ran the Andover workhouse in Hampshire. In 1846 it was the subject of questions in the House of Commons and a formal enquiry when it was reported that starving paupers were sucking the bones they were pounding into fertiliser in a vain attempt to find sustenance. Conditions in this particular workhouse pointed up some of the weaknesses in the Poor Law Amendment Act and were instrumental in bringing about the fall of the Poor Law Commission.
- George Catch, an ex-policeman, moved from workhouse to workhouse in London, inflicting terror and cruelty wherever he went. Boards of guardians gave him excellent testimonials simply to get rid of him, and it was not until the 1860s that, after a career of depravity,

tradespeople and taken far away. Children, unlike pauper adults, could not leave a workhouse of their own free will; if they ran away and were caught, they would be returned. They quickly became institutionalised and unable to cope with life beyond the walls of the workhouse. It was the **Education Act (Forster's Act) of 1870** that placed the education of pauper children firmly within the elementary school system and so helped their integration into society.

WORKHOUSE STAFF: APPOINTED TO INTIMIDATE?

The 1846 report from the Poor Law commissioners stated: 'The workhouse is a large household ... It resembles a private family on an enlarged scale.' Pious and laudable though these sentiments were, one is left wondering just what kind of family the commissioners had in mind. Even the most repressive Victorian patriarch did not aim to make life as unpleasant as possible for members of his family so that their main purpose in life would be to leave.

A workhouse, like any large institution, required staff for it to function at all efficiently. There had to be, for example, cleaners, porters, washerwomen, cooks, scullery maids and chimney sweeps. Some of this work was carried out by the paupers themselves; some by casual labour brought in from outside; most by the poor themselves who lived outside the workhouse and did menial work for long hours and low pay in order to keep themselves and their families out of the institution they helped to make function.

There were some key posts that were unique to the workhouse. Those who held these posts had enormous influence on the way the workhouse was run and on how it was perceived by the paupers inside and society outside. These people had it in their power to make a workhouse a place of grim terror and dread, or a place where the most vulnerable in society were given help when they most needed it.

Master and matron

The key individuals in a pauper's day-to-day life were the

KEY LEGISLATION

Education Act (Forster's Act) of 1870 This Act provided for local elementary schools to be set up where there were gaps in the church provision of schools. These 'Board' schools were to be financed from the locally levied rates. Many workhouses sent their children to Board schools rather than try to provide education within the workhouse walls.

No. of Case.	NAME.	OFFENCE.	Date of Offence	Punishment inflicted by Master or other Officer.	Opinion of Guardians thereon.	Punishment ordered by the Board of Guardians	Date of Punishment	Initials of Clerk	Observations.
25	Dunn Bernard	Visiting the women's Sleeping Yard & Day Room	14th	2 Meals low diet.			Sep 14th	W.H.yf	
26	Rudd... Stone	Playing truant	22	do	confirmed		Sep 22	W.H.yf	
27	Williams Jas Hy.	Brought in by Police for climbing boundary wall of Horton Farm, breaking glass of wall, & stealing stone at fruit trees	25	Caned.	confirmed		do 27	W.H.yf	
28	Kelly William	Insolent to the Boys Trainer and refusing to obey him	Nov 1st	Caned	confirmed		Nov 2	W.H.yf	
29	Larkin Jno Raper Jno Wm	Refusing to complete their Task of Corn grinding	Oct 30	Taken before the Magistrate. Larkin committed to 14 days & Raper to 5 days H.L.	confirmed		Oct 31	W.H.yf	
30	Gourley Elizabeth	Absconding with Corp. Workhouse Clothing		Sentenced to 5 weeks hard Labour	confirmed		do 29	W.H.yf	
31	Scanlon Mary	Using abusive language & striking the Matron in the face with a scrubbing brush.		Confined in the cell for 3 hours. Afterwards examined by Dr & transferred to Imbecile Ward.	confirmed		Dec	W.H.yf	

exploited this to the full. It was not until 1871 that an Act of Parliament gave guardians the power to limit the number of times in a week a pauper could leave a workhouse.

What about the children?

The very act of entering a workhouse meant that a pauper child's parents had relinquished responsibility for that child. Children, unlike their able-bodied parents, could not be held responsible for their own poverty. On the other hand, they were paupers and their situation, under the less eligibility rule, could not be made better than those of poor children outside the workhouse. But it was. Pauper children received a basic education in the workhouse, better medical attention than they could have hoped for outside and, when they were about 9 years old, they were apprenticed to a trade.

However, the education was often rudimentary in the extreme and they could be apprenticed to any passing

Extracts from a union workhouse punishment book.

and women, for example, could not be beaten; although the reduction of rations was a common punishment, there was a minimum below which they could not be reduced. Most workhouses had punishment cells, and paupers were shut up there for minor misdemeanours. Some workhouse masters developed their own refinements, such as forcing recalcitrant paupers to spend the night in the workhouse mortuary. For more serious crimes, the usual processes of the law came into play.

Part of the problem in trying to manage an orderly workhouse was that a proportion of the population of paupers was mobile. These transient, itinerant paupers – drifting in and out of relief – brought with them the tensions, stresses and petty crime of the outside world. Indeed, all paupers were free to come and go as they pleased: only three hours' notice was required if paupers wanted their own clothes returned so that they could leave. Workhouse staff could not prevent paupers from leaving, neither could they refuse to readmit them. Many paupers

There were, too, other ways to degrade. The meat, oatmeal, cheese and bread that formed the mainstay of pauper meals were of poor quality and often adulterated. The meals themselves were poorly and carelessly prepared and cooked. In the 1830s some workhouses did not allow paupers to use cutlery, and they were forced to scoop up their food with their hands and drink from bowls.

Discipline

The ways in which workhouses implemented the multitude of rules and regulations did of themselves bring about a discipline that was intended by those who drew up these rules.

Workhouses were often rowdy places. Staff and paupers frequently hurled verbal and physical abuse at each other. Disturbances ranged from full-scale riots to the swift exchange of foul language. Among the paupers themselves there were frequent outbreaks of bullying and blackmail, and there are recorded instances of sexual abuse between staff and paupers and between pauper and pauper.

Workhouse staff used a complicated system of rewards and punishments in order to maintain order. Paupers could be punished for being in the wrong part of the building, making too much noise, working too slowly or cheeking a member of staff. On the other hand, paupers could be rewarded with food, 'clean' jobs or pocket money. Paupers were usually very clear as to which of them were favoured by the authorities and which were not. Often, systems of rewards and punishments had no legal backing and had grown up through custom. There were, however, specific punishments laid down by the Poor Law commissioners, and a standard punishment book was kept in which all punishments were formally recorded.

In some ways, many punishments were enlightened. Under the old Poor Law, paupers were very much at the mercy of the overseer, who could, and did, abuse paupers with impunity. Operating within the new system, the guardians and staff did at least know that there were limits to their powers and that these limits were determined and universally applied by the Poor Law commissioners. Girls

Dietaries

The supply of food to paupers, while it just about kept them alive, served also to degrade and to discipline. The Poor Law commissioners issued six model diets from which boards of guardians could choose the one, or ones, that best suited their pockets and inclinations. Here, again, the principle of less eligibility had to hold sway, as far as possible. But many urban and rural able-bodied poor were only just about existing on what amounted to a subsistence level diet outside the workhouse. Not even the most badly disposed guardians would want to take their paupers right to the edge of starvation. So, the aim of the published dietaries was to sustain and maintain life but to make mealtimes as boring and tedious as possible. Paupers were to get no pleasure from the food they ate.

The way in which meals were taken was designed to instil repressive uniformity. Until 1842 all meals were to be taken in silence. Paupers had the right to have their food weighed in front of them; many workhouses used this regulation to delay the serving of food until it was stone cold, thus further adding to pauper humiliation.

This dietary was used by the Stafford union workhouse. Deviations from the standard dietary were permitted for children and old people, and, at the request of the medical officer, for the sick. Water was the only drink allowed to able-bodied adults.

DIETARY for able-bodied Men and Women.

		BREAKFAST		DINNER				SUPPER			OLD PEOPLE of 60 Years of Age and upwards, may be allowed 1oz. of Tea, 7oz. of Sugar, and 5oz. of Butter per Week, in lieu of Gruel for Breakfast, if deemed expedient to make this change.
		Bread.	Gruel.	Cooked Meat with Vegetables*	Lobscouse.	Soup with Vegetables*	Suet Pudding	Bread.	Cheese	Broth Thickened.	
		oz.	Pints.	oz.	Pints.	Pints.	oz.	oz.	oz.	Pints.	
Sunday......	Men......	7	1½	6	—	—	—	5	—	1½	
	Women.	6	1½	5	—	—	—	4	—	1½	
Monday.....	Men......	7	1½	—	—	1½	—	6	2	—	CHILDREN under Nine Years of Age to be allowed Bread and Milk for their Breakfast and Supper, or Gruel when Milk cannot be obtained, also such proportions of the Dinner Diet as may be requisite for their respective ages.
	Women.	6	1½	—	—	1½	—	5	2	—	
Tuesday.....	Men......	7	1½	—	—	—	14	6	2	—	
	Women.	6	1½	—	—	—	12	5	2	—	
Wednesday	Men......	7	1½	6	—	—	—	5	—	1½	
	Women.	6	1½	5	—	—	—	4	—	1½	
Thursday...	Men......	7	1½	—	—	1½	—	6	2	—	CHILDREN above Nine Years of Age to be allowed the same quantities as Women.
	Women.	6	1½	—	—	1½	—	5	2	—	
Friday........	Men......	7	1½	—	2	—	—	6	2	—	SICK to be Dieted as directed by the Medical Officer.
	Women.	6	1½	—	2	—	—	5	2	—	
Saturday....	Men......	7	1½	—	—	—	14	6	2	—	
	Women.	6	1½	—	—	—	12	5	2	—	

"SOUP" made in the proportion of One Pound of Beef or Mutton to One Gallon of Water, with Vegetables.
"PEAS SOUP" made in the proportion of One Pound of Beef or Mutton and One Pint of Peas to One Gallon of Water.
*The VEGETABLES are EXTRA, and not included in the above specified.

This illustration of accommodation for women and children, called 'Refuge for the Destitute' was produced in 1843. It shows the 'trough' type of sleeping accommodation that was common in workhouses in both male and female wards.

workhouse, and it had to be able to be done inside the confines of the workhouse. Nor could it diminish available employment outside the workhouse to the extent that the able-bodied working poor became paupers. The philosophical stance of the commissioners made the situation even more difficult. They held that work done inside the workhouse could not pay more than it cost the workhouse to maintain the pauper. If it did, they argued, there would be no incentive for the pauper to return to the labour market.

So, what work was done? Some paupers, mainly women and children, worked to help maintain the workhouse. They worked in the laundries, kitchens and sick rooms. They worked as cleaners, attendants, childminders and sloppers-out. If work that was economical and easy to perform within a workhouse could not be found, dispiriting and monotonous work was given to the paupers. They made sacks and unravelled ropes so that the fibres could be used again; they chopped wood and smashed limestone that was used to make roads; and they ground animal bones into dust to be used by farmers as fertiliser. Paupers were, by and large, doing the same work as convicts and with the same attendant degradation.

separated from wives and parents from their children, although mothers did usually stay with their children until they were about 7 years old. The assumption was that the pauper had given up all responsibility for his family and so was separated from it.

- Children were sent to the workhouse school and, when they were 9 or 10 years old, **apprenticed** (usually to the cotton mills of Lancashire) without their parents' consent and sometimes without their knowledge.
- Paupers had to wear workhouse uniform that sometimes fitted them and sometimes did not. Guardians were allowed to add variety to the uniform clothing, but few of them did.
- Men were given razors to shave once a week and all paupers had a weekly bath. Workhouse staff watched while this happened. This was to prevent any attempt at self-mutilation or drowning and to add to the sense of loss of personal privacy.
- No personal possessions were allowed and there were no lockers or cupboards in which paupers could put clothes or shoes. This was to prevent any expression of individuality.
- The daily routine was designed to be boring and monotonous:

07.00–08.00	Breakfast
08.00–12.00	Work
12.00–13.00	Dinner
13.00–18.00	Work
18.00–19.00	Supper
20.00	Bedtime

- Each day began and ended with prayers, and an hour earlier in the summer.

Work

It was essential, within the whole scheme of things, that workhouse inmates worked. The primary aim of this work was to rehabilitate the paupers and restore them to the workforce outside. As an aim, this was laudable. But, when translated into practice, huge problems arose, both of an ideological and practical nature. What work could the paupers do that would equip them for a useful working life outside? The work had to be available in the locality of the

Apprenticeship This was originally a medieval system whereby young people (usually boys) were apprenticed to a master craft worker for a certain number of years to learn a specific trade. It continued, with variations, into the twentieth century, where young people could obtain apprenticeships in shipbuilding and vehicle engineering, for example. In the nineteenth century, youngsters could be apprenticed to the many mills and factories in the industrial north and Midlands in order to learn skills that would make them self-supporting.

- the elderly, for whom the workhouse provided shelter and sustenance until death. In this group, old men were more prominent than old women. Women, when old, could more frequently be of domestic use to their families and so tended to be kept by their relatives rather than being sent 'on the parish';
- children, who made up between 25 per cent and 40 per cent of all admissions, were both long- and short-stay inmates. The offspring of the transient able-bodied poor went in and out with their parents. However, most workhouse children were abandoned, orphans or ill. Many were the illegitimate sons and daughters of other inmates and were likely to spend all their childhood and early adolescence in the workhouse;
- single women, who could not claim outdoor relief. They made up a significant proportion of any workhouse community and included widows, abandoned wives, single mothers and prostitutes;
- the mentally ill, whose number grew from 1 per 100 to 1 per 8 inmates as the century progressed.

WORKHOUSE REGIME: DESIGNED TO DEMORALISE?

Workhouses had to provide for the most vulnerable and needy members of society, both as transient and as long-term inmates. They had, too, to impose the workhouse test to ensure that the principle of less eligibility was being maintained. Inevitably, these demands and expectations conflicted as boards of guardians struggled to match their own prejudices and preconceptions with the demands of their localities and the requirements of the Poor Law commissioners.

Routine, rules and regulations

Every aspect of workhouse life was governed by a stream of rules and regulations laid down by the commissioners in London. The routine was designed to be unpleasant and was intended to deter people from seeking relief.

- On entry to a workhouse, the pauper family was given a medical inspection and then split up. Husbands were

enabled the workhouse officers to provide appropriately for each class of pauper; it added to the deterrence factor by splitting up families; and prevented the moral 'contagion' that would occur if the different categories mixed freely. Paupers were beginning to lose their individuality and were beginning to be treated as impersonal units.

WHO WERE THE NEW PAUPERS?

Outdoor relief continued to be the main form of support for paupers, despite the best efforts of the commissioners. This means that any analysis of the types of people opting for, or forced into, indoor relief cannot be taken as typical of the pauper population as a whole. But it is interesting to see just which people were given indoor relief and to bear this in mind when looking at workhouse provision, regimes and staff and evaluating these for fitness for purpose.

Workhouses provided both short-term and long-term care, and at any one time around one-fifth of all inmates had been inside for five or more years. There were, of course, regional and local differences, but by and large pauper populations within workhouses were surprisingly similar in structure:

- young people, for whom the workhouse provided a temporary shelter and a solution to a personal crisis. They moved in and out of workhouses, maybe several times a year, depending on variables such as the seasonality of employment, the harshness of the winter or the severity of a local epidemic;
- vagrants, who were considered less deserving than any 'settled' poor. They were given overnight accommodation in a 'casual ward', to which they were not admitted until the evening, when they were fed a meal of bread and water. In the better workhouses, they were stripped, deloused and had their clothes disinfected. These were the lowest of the low and considered to be beyond redemption: the only aim of workhouse staff was to get rid of them as soon as possible the following morning;

The master's rooms were in the middle of the Y, where he and his staff could watch the three exercise yards that were divided from each other by the wings of the Y.

- A cruciform-shaped building, two storeys high, inside a square boundary wall. The wall held workrooms and the cruciform shape divided the space into four exercise yards. Each 'arm' of the cross held dormitories and dining rooms, a chapel and kitchens, schoolrooms and stores – sufficient accommodation for between 200 and 500 paupers.

Look at the ways in which Kempthorne's design provided for the division and segregation of paupers. Before they could be segregated, paupers had to be classified. There were seven different categories into which paupers could be sorted: infirm men; able-bodied men over the age of 15; boys aged 7–15; infirm women; able-bodied women over the age of 15; girls aged 7–15; children under 7. Why were they so classified? What was the point of it? Segregation

This workhouse at Watford (Hertfordshire) was built in 1838 to Sampson Kempthorne's cruciform-shape design. This was the design most favoured by guardians because it was cheap and provided maximum flexibility when in use.

CHAPTER 5

Workhouses: pauper palaces or bastilles?

A cornerstone of nineteenth-century Poor Law policy was the workhouse, with its attendant principle of less eligibility. The workhouse had to offer a way of life that was less attractive than survival outside. And herein lay a terrible paradox. Conditions outside, for the poorest of the workforce, were pretty terrible. Urban workers in the midst of a depression and rural workers close to starvation lived and worked in conditions so poor that it would be hard for an institution to match them, let alone provide something worse. The state could not, in a civilised society, institutionalise dirt, disease and starvation. There had to be other ways of deterring the poor from asking for relief.

WORKHOUSE DESIGN: DETERRENT AND DISCIPLINE?

The design and structure of workhouses were intended, in themselves, to act as a deterrent to would-be paupers. They were also supposed to instil discipline in the paupers they were designed to house. How were they to do this? Sampson Kempthorne, an architect with a London practice, was appointed architect to the Poor Law Commission in 1835. He produced designs for the approval of the Poor Law commissioners that were then issued to boards of guardians as indicative of the standards to which they should work when commissioning new workhouses or altering existing ones.

Kempthorne produced two basic designs:

- A Y-shaped building, two or three storeys high, inside an hexagonal boundary wall. The boundary wall held workrooms; one wing of the Y, kitchen, dining hall and chapel; the other two wings, dormitories and day rooms.

SUMMARY QUESTIONS

The purpose of this section is to help you consolidate your thinking and understanding about the ways in which the Poor Law Amendment Act was implemented.

1 How critical to the implementation of the Poor Law Amendment Act was the way in which the Commission itself was set up?

2 To what extent did the Poor Law Commission meet its policy targets, 1834–46?

3 How important, in your view, were vested interests in the opposition to the implementation of the Poor Law Amendment Act?

4 Would you agree that the greatest flaw in the Poor Law Amendment Act was that it addressed poverty in rural, not urban, areas at a time when Britain was becoming urbanised and industrialised?

Apathy elsewhere

The new Poor Law was established relatively easily in other urban areas. The Metropolitan Anti-Poor Law Association, founded in London by Earl Stanhope, had little effect; there were few problems in the industrial north-east of England; a strike in the Potteries and a major recession in the stocking industry in Nottingham failed to push working people into protest. But absence of violent protest did not necessarily mean acceptance. It was still possible for local boards of guardians, with an eye on local feelings, to ignore, adapt and amend directives from the commissioners. And many of them did.

How did it all end?

Opposition was short-lived. In many places, it was a spontaneous reaction to unwelcome change and, because it was mostly unorganised, had no chance of success. Even where opposition was organised, as with the anti-Poor Law associations of Lancashire and Yorkshire, the unlikely combinations of paternalistic Tories and working-class radicals were bound to fall apart eventually. Those who remained to protest turned to Chartism, seeing in working-class representation in the Commons the only hope of improving their lot.

It ended, too, with the ratepayers in the parishes seeing an immediate change in the rates they paid:

KEY STATISTICS ABOUT THE COST OF POOR RELIEF

	Average expenditure (in £000)	Per head of population	Percentage increase or decrease on previous period
1829–33	6758	9s 8d	+12
1834–8	4946	6s 7d	−27
1839–43	4773	6s 0d	−3
1844–8	5290	6s 2d	+11

resented interference from Londoners who had little knowledge of industrial conditions and whose report and subsequent Act were based upon an understanding of the rural south and bore little relevance to them. Workshop, factory and mill workers, facing lay-offs and short hours, needed short-term relief to tide them over periods of temporary unemployment, not removal of whole families to workhouses.

Organised and fired up by the demands of **the Ten Hours' Movement**, they turned to oppose what many saw as yet another assault on working people. Anti-Poor Law associations sprang up, uniting Tory paternalists like Richard Oastler and **John Fielden** with radical printers like R.J. Richardson and socialists like Laurence Pitkeithly. Huge public protest meetings were held, at which the 'Three Bashaws of Somerset House' and their 'Bastilles' were roundly denounced. Indeed, the South Lancashire Anti-Poor Law Association quickly set up some 38 local committees, determined to stop the onset of the new Poor Law.

For a while, there was insurrection, as these examples show:

- Armed riots in Oldham, Rochdale, Todmorden, Huddersfield, Stockport, Dewsbury and Bradford were put down by the local militia.
- In Huddersfield the guardian George Tinker warned the commissioners in June 1837 that 'in the present alarming state of the district, it will be dangerous to put the law into operation'.
- In Bradford in 1838 the assistant commissioner Alfred Power was threatened by the mob and pelted with stones and tin cans.
- In Stockport in 1842 the workhouse was attacked and bread distributed to the poor outside.
- John Fielden, radical MP and philanthropic factory owner, closed his own factories in protest and refused to pay the new poor rate. His workers attacked the homes of local guardians; troops were required to restore order. The Poor Law Amendment Act was not implemented in Todmorden until 1877, long after Fielden's death.

KEY ORGANISATION

The Ten Hours' Movement
A sustained campaign in the 1830s for the reduction of hours worked in textile mills to ten per day. The campaign was led inside Parliament by Lord Shaftesbury and John Fielden, and outside by Richard Oastler. In 1847 the Ten Hours Act limited the work of women and young persons (aged 13–18) in textile mills to ten hours a day for five days a week and eight hours on Saturday.

KEY PERSON

John Fielden (1784–1849)
A wealthy mill owner in Todmorden (Lancashire), he believed that the welfare of working people should be one of the aims of political action. As MP for Oldham from 1832, he sponsored a number of Bills to reduce working hours, regulate wages and ban child labour. He fought hard against the implementation of the Poor Law Amendment Act and successfully kept it out of Todmorden during his lifetime.

kinds of protest exemplify, firstly, protest against centralisation and removal, and, secondly, protest against the regime and institutionalism of the workhouse.

- In Buckinghamshire people took to the streets when paupers from the old workhouse in Chalfont St Giles were being transported to the new union workhouse in Amersham. Only when the Riot Act was read, special constables sworn in and armed yeomanry put on the streets was it possible for the paupers to be transported the 3 miles to Amersham.
- In East Anglia newly built workhouses were attacked, the one at St Clements in Ipswich being particularly badly damaged, and relieving officers assaulted.

While the poor themselves took to the lanes and market squares of rural England, the more influential citizens used their positions to, for example, refuse strictly to apply the less eligibility rule, continue to provide outdoor relief to the able-bodied poor and generally to find all possible ways of circumventing what they saw as an inhumane and destructive law.

However, the recent fate of the Dorset labourers (**the Tolpuddle martyrs**), sentenced to transportation for swearing illegal oaths, had tended to depress rural protest. By and large, most farmers and landowners, aided by good harvests and a more or less quiescent workforce, enabled the Poor Law Amendment Act to be put into practice in the south of England.

Opposition in the north: industrial Lancashire and west Yorkshire

In the north of England, it was a different matter. Edwin Chadwick urged an early start on unionising the industrial regions of Britain, while times were relatively prosperous. The commissioners ignored him. It was not until 1837, during the onset of a trade depression, that they turned their attention to the north of England and in particular to industrial Lancashire and the West Riding of Yorkshire. Many areas had already adapted their relief provision to meet the cyclical depressions with which industry was beset. Guardians, magistrates, mill and factory owners

the belief that mill owners in the north wanted unemployed agricultural workers from the south to work for them, so limiting rising wages and bringing about a workforce that lived at subsistence level.

Genuine fears

The fears listed above all had their roots in some kind of reality. Other fears were even closer to reality and were based on individual perceptions of the way in which society should be organised.

- Many attacked the centralisation implicit in the new Poor Law. The commissioners were seen as being London-based, with no real concern for, or understanding of, the ways of life outside the metropolis.
- Many feared the replacement of the old Poor Law by the new would break the traditional, paternalistic bonds between rich and poor which resulted in a kind of social contract.
- Rural ratepayers realised that outdoor relief was cheaper than indoor relief and were worried that a programme of workhouse building would lead to higher, not lower, poor rates.
- Ratepayers in northern industrial areas, prone to cyclical unemployment, realised that to build a workhouse large enough to contain all those that might need relief in times of depression would be an enormously costly undertaking, if not an impossible one.

Protest in the rural south

In 1835 the commissioners began their work in the most heavily pauperised districts of southern England, which was where most of the evidence came from that supported the report of the Poor Law Commission. Even though the implementation of the Act began here in a period of economic recovery when employment prospects were good for most labourers and fear of want was retreating, there were still sporadic outbursts of opposition. Local magistrates and clergy, angered at what they saw as unnecessary centralisation and the removal of the traditional master–servant relationship with its attendant responsibilities, joined with those of the poor who were alarmed and fearful, to protest. Two examples of different

OPPOSITION TO THE POOR LAW AMENDMENT ACT: A SERIOUS THREAT OR A FUTILE PROTEST?

Out in the parishes, it was mostly fear and anger that greeted the Poor Law Amendment Act and the ways in which it was implemented. But this fear and anger were not universal and they found expression in different ways and at different times. In parts of Cumbria and north Yorkshire, where there were few able-bodied male paupers, the Act was considered irrelevant and protest against it unnecessary. Indeed, the Carlisle union continued to divide its applicants into deserving and undeserving poor and treated them accordingly. But where communities were outraged by the changes in tradition and practice brought about by the Act, there was an almost universal coming together of the powerful and influential with the poor and dispossessed to protest jointly.

Rumour and propaganda

Fear thrives on rumour and propaganda makes good use of both rumour and the fear that feeds it. This is common in all stressful situations and the period when the Poor Law Amendment Act was being implemented was no exception.

- Union workhouses were built some distance from the homes of most of those seeking relief. This fuelled the belief among the poor that they were extermination centres where paupers were helped effortlessly from life in an attempt to keep the poor rates low.
- The *Book of Murder*, widely circulated and erroneously believed to be the work of the Poor Law commissioners, contained suggestions that pauper children should be gassed.
- In Devon many of the poor believed that bread distributed as part of outdoor relief was poisoned in order to reduce those claiming this form of relief.
- Rumours circulated that all children over and above the first three in a pauper's family were to be killed.
- Many anti-Poor Law campaigners believed that the new Poor Law was introduced specifically to lower the national wage bill. Workhouses, it was argued, were supposed to force people onto the labour market, no matter how low the wages. A variant on this theme was

were responsible, but who lived elsewhere. The parishes were not, in other words, insisting on removal, and they continued to prefer this 'non-resident relief' after 1834. Despite the best efforts of assistant commissioners, over 80,000 paupers were still receiving relief in this way in 1846.

Two important planks of Poor Law policy after 1834 were thus not implemented as the Poor Law commissioners wished. The Poor Law Amendment Act was implemented unevenly and was implemented and interpreted in different ways by different boards of guardians in different parts of England and Wales. These differences were the consequence of many factors: the degree of local resistance to the Act, long-established local customs, the vested interests of those of power and influence in the parishes (those who had been overseers of the poor before 1834 frequently were returned as Poor Law guardians afterwards) and the persuasive skills of assistant commissioners. However, by the 1870s the vast majority of parishes had been incorporated into Poor Law unions. And, even though most paupers received relief outside the workhouse, it was the workhouse and, perhaps overwhelmingly, the fear of the workhouse that stood as an awful symbol of deterrence for the most vulnerable members of Victorian society.

The Fulham and Hammersmith union workhouse (London) 1849.This vast and well-planned workhouse, with its clear separation of different classes of pauper, represented the ideal of the Poor Law commissioners.

paupers to work in labour yards before they could receive relief payments.

- **1844 General Outdoor Relief Prohibitory Order.** Applied to all unions and forbade outdoor relief to the able-bodied poor.

However, the issuing of orders and directives was one thing. Their implementation and effectiveness, as the commissioners were to find, was quite another. Outdoor relief did continue, and continued to be the most common form of relief given to paupers, particularly in industrial northern towns. The north of England was subject to enormous swings of cyclical unemployment beyond the control of mill and factory owners. There outdoor relief was not only the most humane of alternatives, it was also the cheaper alternative to building huge workhouses that would remain half empty for most of a working year. In 1855, for example, over 700,000 paupers out of a total of almost 100,000 received relief outside the workhouse. This was, of course, before the full programme of workhouse building was completed by about 1870. Even so, by 1871 only one in six unions were operating under the 1844 order, and there is strong evidence to suggest that outdoor relief continued as the mainstay of those seeking temporary support in stressful periods of their working lives until well into the twentieth century.

The Settlement Laws

Settlement legislation had been in operation since the sixteenth century (see page 17) and here, in the mid-nineteenth century, the Settlement Laws were seen as necessary if the cost of maintaining paupers was to be fairly spread between urban and rural parishes, and if workhouses were indeed to be true deterrents. In 1840 around 40,000 paupers were removed from the parishes in which they were living and claiming relief, back to their parishes of settlement, theirs by virtue of birth or marriage. This was a costly process, both in practical and administrative terms, while the cost in terms of human suffering was incalculable.

The situation was complicated by the fact that before 1834 many parishes were paying relief to those for whom they

parliamentary scrutiny of the workings of the Poor Law. But what happened between 1834 and 1847? What were the priorities of the Commission? And how were they implemented?

Poor Law policy, after 1834, had two priorities:

- the transfer of out-of-work and underemployed workers in rural areas to urban areas where employment was plentiful;
- the protection of urban ratepayers from a sudden surge of demand from rural migrants prior to their obtaining regular employment.

It was possible to meet both priorities. A programme of workhouse construction met the first one: the setting up of a string of workhouses, offering relief to the able-bodied poor on the **less eligibility principle**, would, it was anticipated, drive potential paupers to find work in towns and cities. The Settlement Laws met the second: the poor rates would be kept low, and would not fall disproportionately on the towns, if the Settlement Laws were stringently applied, returning the seekers of relief to their home parishes.

A programme of workhouse construction

The programme of reducing able-bodied pauperism by building deterrent workhouses carried with it the assumption that outdoor relief for the able-bodied poor would stop, even though it was not expressly forbidden by the 1834 Poor Law Amendment Act. In this key area, the commissioners were only able to act fairly slowly. Amalgamating unions and building or adapting workhouses took time, even when there was no organised opposition (see page 40) against the implementation of the Act.

- **Late 1830s.** Commission began issuing orders to specific unions in the rural south of England, prohibiting outdoor relief to the able-bodied poor. This was extended to the rural north of England in 1842.
- **1842 Outdoor Labour Test Order.** Intended to enable unions whose building programme was not complete to apply the 'spirit' of the new Poor Law by requiring

In theory, a union should comprise about 30 parishes, one town and about 10,000 people. This, the commissioners believed, was the optimum unit for maintaining a reasonable sized workhouse and giving effective poor relief as efficiently as possible. The assistant commissioners went out into the parishes, held public meetings and canvassed local opinion. They quickly found that reality differed from theory.

One of the first problems to present itself was that many parishes were already amalgamated under Gilbert's Act of 1782. Most of them refused to re-amalgamate into different Poor Law unions. So did those parishes that had set up their own select vestries under the Sturges-Burne Act of 1819. By the middle of the century, 20 of the 50 most populous unions in Britain were dispensing poor relief not under the aegis of the Poor Law Amendment Act, but under other, older Acts.

Even when the assistant commissioners persuaded parishes to combine into unions, they had no powers to insist the new unions built a workhouse, although they could insist that alterations were made to an existing one. Assistant commissioners, grown skilled in the art of negotiation, managed to persuade most unions to indulge in purpose-built workhouses. But an obdurate **board of guardians** could delay the implementation of the Poor Law Amendment Act almost indefinitely. In Todmorden (Lancashire), for example, the guardians demolished the old workhouse and were not persuaded to build a new one until 1877. But, given the imperatives of the time, the assistant commissioners did a reasonable job of work. By 1840, 14,000 English parishes with a population of around 12 million people had been incorporated into Poor Law unions.

WHAT WAS POOR LAW POLICY, 1834–47?

In 1847 the Poor Law Commission was abolished and replaced by the Poor Law Board, headed by a president who was a member of the government and had a seat in the cabinet. From then onwards, there was increasing

The commissioners were originally assisted by nine assistant commissioners (the number varied over time) whose job it was to make sure that decisions made centrally were implemented at local level in the parishes.

What power did the Commission have?

The Commission was independent of Parliament which was at once its great strength and its great weakness. Independence meant that the Commission had no spokesman in Parliament to defend it against the criticisms levelled against it by MPs, **radicals**, parish officials and the poor. Outside Parliament – in the press, books and journals, songs and broadsides – the commissioners were lampooned as the 'Three Bashaws of Somerset House' and as the 'Pinch-pauper Triumvirate'. Out in the parishes, the commissioners and assistant commissioners were almost universally hated.

The Commission had a powerful constitutional position because it had been established by Parliament, but it did not have the direct power that many people assumed it could wield. The commissioners could issue directives, draw up regulations and monitor their implementation, but in reality there was no mechanism for making recalcitrant parishes do what they were told. The Commission did, however, have a considerable range of negative powers at its disposal. It could, for example, veto appointments it thought unsuitable; refuse to allow certain types of building; set dietaries for the workhouses; centralise accounting procedures; and generally make life very difficult for those parishes that opposed it.

Putting parishes together and building workhouses: how successful were the commissioners?

The first task of the assistant commissioners was to establish unions of parishes so that each union could set up its own workhouse. They were working under pressure: pressure to implement the Poor Law Amendment Act as quickly as possible and so reduce the cost of poor relief, and pressure because the new unions were to be used as the administrative units for the civil registration of births, deaths and marriages, due to be introduced in 1837.

Radicals Radicals are people who seek a fundamental change in political structures. In nineteenth-century Britain, radicals looked for reform within the existing constitutional framework: they did not look to overthrow the existing system, simply to change it legally and legitimately. There was never a single radical party. Radicals grouped differently under different causes: free speech, factory reform, free trade, for example.

CHAPTER 4

How was the Poor Law Amendment Act implemented, 1834–47?

Parliament, in passing the Poor Law Amendment Act, did not involve itself in the processes by which the Act was to be implemented. It merely set out the overall structure within which the Poor Law Commission was to work. Arguments that should, perhaps, have taken place on the floor of the House of Commons were worked out and fought out with the parishes as the commissioners tried to implement what they interpreted as the will of Parliament.

THE POOR LAW COMMISSION

How was the Commission set up?

A central Poor Law Commission was established to administer the Poor Law Amendment Act throughout the country. The Commission worked in Somerset House, London; there were three commissioners:

- Thomas Frankland Lewis, the Chairman of the Commission, had been a Tory MP;
- George Nicholls had been an overseer under the old Poor Law;
- John Shaw Lefevre was a lawyer.

Edwin Chadwick, who had been the driving force behind the report of the Commission into the Poor Laws, hoped to be a commissioner. Indeed, it has been argued that the recommendations of the report and the subsequent Act were less than specific because Chadwick had expected to be implementing them himself, along the Utilitarian lines he wanted. He was, instead, made Secretary to the Commission where, bitterly disappointed and clashing frequently with the commissioners, he used his influence to the full for fourteen years.

SUMMARY QUESTIONS

The purpose of this section is to enable you to consolidate your thinking and understanding about the reasons why the old Poor Law was reformed, and reformed in the way it was.

1 How convincing do you find the arguments of eighteenth- and nineteenth-century political economists that the Poor Law should be abolished?

2 Study the tables on page 26. Do they provide sufficient evidence that the Poor Law should be reformed?

3 There were several pressures on the Whig government to reform the Poor Law. Which do you think were, for them, the strongest?

individual making the interpretation. Modern historians generally hold to one of the three main interpretations:

The Marxist view is a straightforward one. Its proponents maintain that the Act was nothing more than naked class exploitation by the newly enfranchised (1832) middle classes. In holding down the poor rate by making harsh and unacceptable workhouses the way for the able-bodied to obtain relief, the poor were forced to work for lower wages. Thus, workers were forced to accept the **capitalist** principles of the market economy.

The traditionalist view is equally straightforward. It maintains that the Act in fact emphasised continuity more than change by reinforcing the traditional social and economic powers of the landowners and property-owning elite. Faced with unrest in countryside and towns, the traditionally powerful enforced a new Poor Law system that reasserted their authority.

The revisionist view attempts to synthesise the two previous viewpoints. It maintains the traditionalist view that, by the Act, the land- and property-owning classes had reasserted their dominance but makes a nod towards Marxism by maintaining that this dominance was asserted in favour of the new capitalist classes.

KEY CONCEPT

The Marxist view Karl Marx (1818–83) developed a philosophy of history and a programme of revolution that together are referred to as Marxism. Marx believed that capitalism was corrupt because it exploited the workers, who actually produced the wealth. He maintained that capitalism would be overthrown by socialism – the dictatorship of the proletariat. This, in turn, would be overthrown by communism which would be a society of equals, providing for all according to their needs, not their wealth.

KEY CONCEPT

Capitalism An economic system under which the ownership of the means of production is concentrated in the hands of a small class of people who are driven to make the highest possible profits.

The Bill reflected closely the recommendations of the report of the Poor Law Commission and the report itself, its supporters argued, was based on a mass of carefully collected evidence. What was more, the Bill did exactly what MPs and the Lords wanted: it reduced the cost of providing for the poor by providing for them efficiently. Significantly, what opposition there was to the Bill in the Commons came from MPs in the industrial west Midlands and north-west of England.

WHAT WERE THE MAIN TERMS OF THE 1834 POOR LAW AMENDMENT ACT?

The purpose of the Act was radically to reform the system of poor relief in England and Wales, making it cost effective and efficient. To this end, it laid down that:

- A central authority should be set up to supervise the implementation and regulate the administration of the Poor Law.
- Parishes were to be grouped together to form Poor Law unions in order to provide relief efficiently.
- Each Poor Law union was to establish a workhouse in which inmates would live in conditions that were worse than those of the poorest independent labourer.
- Outdoor relief for the able-bodied poor was to be 'discouraged' but, significantly, was not abolished.

However, the actual programme of reform was not laid down by Parliament. Parliament simply set down the administrative arrangements through which the three commissioners were to implement and, indeed, interpret the Act.

WHAT WAS THE POOR LAW AMENDMENT ACT REALLY ALL ABOUT?

There are many different interpretations of the Poor Law Amendment Act and they rest, as interpretations frequently do, on the political and ideological stance of the

The first and essential of all conditions is that his [the pauper's] situation on the whole shall not be made really or apparently so eligible as the situation of the independent labourer of the lowest class.

- A new, central authority should be established with powers to make and enforce regulations concerning the workhouse system.

HOW DID THE HOUSE OF COMMONS RESPOND TO THE POOR LAW AMENDMENT BILL?

The Poor Law Commission took two years to compile data and write its report. That the main recommendations of the report became law in less than a year is a measure of the strong all-party acceptance of its recommendations. Indeed, the Poor Law Amendment Bill passed through all its stages in Commons and Lords with never more than 50 votes being cast against it, and gained the royal assent in August 1834.

Why, indeed, should there be any opposition? The **Tories**, who might have stood out against it as an encroachment on **laissez-faire**, were in a minority in the Commons and were overwhelmed by the arguments of the Whigs, seduced as they were by Utilitarian arguments. Leading Whigs like Brougham, Althorp, Russell and Landsdowne were receptive to ideas of change. Indeed, several of them had helped create the climate of change. Brougham, for example, had contributed to the *Edinburgh Review*, which throughout the 1820s published a stream of articles on social problems of the day. Thus, it was not surprising that old-stagers – radicals like William Cobbett who argued that the poor had a right to relief and that the object of the Bill was to 'rob the poor man and enrich the landowner' – were barely listened to. Most of those who argued against the Bill were not concerned with its underpinning philosophy. They were more worried by the centralisation involved, and the increased opportunities for patronage this would provide. But theirs were voices in the wilderness.

KEY GROUP

Tories One of the two main political parties in Britain between the late-seventeenth and mid-nineteenth centuries, they were traditionally associated with a belief that the Crown and Anglican church were the mainstays of the political, religious and social order. The Tory groupings of the 1830s resulted in the emergence of the Conservative Party.

KEY CONCEPT

Laissez-faire Literally 'leave to be' or 'leave alone'. In other words, it is the belief that the government should involve itself as little as possible in the affairs of its people. This applied to welfare, taxation, industrial regulation, public health – any area, in fact, in which the government could intervene.

WHAT DID THE REPORT RECOMMEND?

Published in early 1834, the first part of the report attacked the old Poor Law, citing examples of corrupt practices and demoralised paupers. The second part contained the commissioners' conclusions and recommendations. Throughout, the reader is led inexorably to one conclusion: that the old Poor Law was itself the cause of poverty. At the core of the commissioners' analysis was their unshaken belief in the need to keep the distinction between poverty, which was part of the natural order of things, and indigence – the inability to earn enough to live on – which was not. The commissioners, too, had no problem with the impotent poor – those who could not work. They clearly had to be cared for in an appropriate way. Their problem, as generations before them found, and generations after were to find, was with the able-bodied poor who either could not, or would not, earn sufficient to keep themselves from grinding poverty.

The commissioners recommended radical changes, designed to save money and improve efficiency:

- Separate workhouses should be provided for the aged and infirm, children, able-bodied females and able-bodied males.

 At least four classes are necessary:
 the aged and really impotent
 the children
 the able-bodied females
 the able-bodied males.

- Parishes should group into unions for the purpose of providing these workhouses.
- All relief outside workhouses should stop, and conditions inside workhouses should be such that no one would readily choose to enter them.

 All relief whatever to able-bodied persons or to their families, otherwise than in well-regulated workhouses [places where they may be set to work according to the spirit and intention of the 43rd Elizabeth] shall be declared unlawful ...

legwork actually collecting and collating evidence, knew what they were supposed to find. Indeed, Nassau Senior had written the main sections of the report before all the evidence was submitted, let alone analysed. Thus, the 'evidence', when it had been collected, was used selectively to support conclusions the commissioners had already reached.

The data was collected in two ways. First, the commissioners devised three different questionnaires. Two were sent to parishes in rural areas and the third to parishes in towns. Around 10 per cent of the parishes replied: there was no compulsion to do so. But from this first trawl came an immense amount of information that was difficult to analyse. So difficult, in fact, that assistant commissioners were sent out to 'ascertain the state of the poor by personal enquiry among them, and the administration of the Poor Law by being present at the vestries and at the sessions of the magistrates'. The assistant commissioners were hardworking and unpaid. Between them they visited around 3000 places, about one-fifth of the Poor Law districts. All the information they collected was published by the commissioners in thirteen volumes of appendices to their report. They were confident that the evidence would support their conclusions.

Of course, the procedures used by the commissioners and their assistants did not have the sophistication of modern enquiries; many questions were badly phrased and tended to elicit the desired response; many of the interviews were similarly skewed, as witnesses were led along predetermined paths. Nevertheless, this survey was the first of its kind and it would be totally unrealistic and wrong to expect a more systematic and sophisticated approach to have been taken. Furthermore, the enquiry was not intended to be impartial. Its function was to focus specifically on how the old Poor Law worked with a view to reforming them. The maintenance of the status quo was not an option.

In February 1832, the Whig government set up a Commission of Enquiry into the Operation of the Poor Laws. This decision was prompted by long-term concerns and immediate problems.

Long-term concerns:

- the increasing cost of poor relief;
- the growing belief that those administering the Poor Law were corrupt, or, at the very least, had a tendency to exploit the laws to their own benefit. Contracts for supplying food, beer, clothing and maintaining the fabric of the workhouse, for example, usually went to local traders who were frequently either members of the local **select vestry** or closely related to them;
- fears that the commonly applied systems of relief, such as Speenhamland, that related the amount of relief given to the price of bread and the size of a claimant's family, were actually encouraging large families and perpetuating a cycle of poverty. Similarly, systems such as the Roundsman did nothing to encourage labourers to search for work, since the labourers grew to believe that the parish would supply all their needs.

Immediate problems:

- the Swing riots that hit the agricultural counties in the late 1820s and early 1830s;
- fear that unrest would turn to revolution. France was again embroiled in revolution in 1830 and there was genuine concern among the powerful and influential that this could spark off something similar in Britain.

HOW DID THE COMMISSION OF ENQUIRY SET ABOUT ITS WORK?

The Commission of Enquiry consisted, ultimately, of nine commissioners, the most influential of whom were Nassau Senior and Edwin Chadwick. Nassau Senior was Professor of Political Economy at Oxford University who deeply disapproved of the **allowance system**, and Edwin Chadwick was a committed Benthamite. It was not very likely that a survey of the old Poor Laws, and any recommendations for their amendment, would be impartial. The 26 assistant commissioners, who put in the

KEY TERMS

Select vestry In 1819 in an attempt to get rid of corruption in the administration of the Poor Law, an Act of Parliament allowed parishes to set up select vestries. These were small committees which were responsible for Poor Law administration in a parish and could, if they wished, employ salaried assistant overseers. Within ten years, almost 20 per cent of parishes had set up select vestries.

Allowance system Relief given to the able-bodied poor in the form of allowances to boost wages or to help in the upkeep of their families.

KEY STATISTICS
Average wheat prices, 1780–1839

	Yearly average price per imperial quarter	Peak price	Year
1780–9	46s 1d	54s 3d	1783
1790–9	57s 7d	78s 7d	1796
1800–9	84s 8d	119s 6d	1801
1810–19	91s 5d	126s 6d	1812
1820–9	59s 10d	68s 6d	1825
1830–9	56s 9d	70s 8d	1839

Expenditure on poor relief in England and Wales, 1783–1838

	Average expenditure (in £000)	Per head of population
1783–5	2004	5s 2d
1803	4268	9s 2d
1813	6656	12s 5d
1814–18	6437	11s 7d
1819–23	6788	11s 2d
1824–8	6039	9s 2d
1829–33	6758	9s 8d
1834–8	4946	6s 7d

(Source: B. R. Mitchell and P. Deane, *Abstract of British Historical Statistics*, 1962.)

WHY DID THE GOVERNMENT TAKE ACTION IN 1832?

There had been enquiries, investigations, comments and reports on the Poor Law since the end of the eighteenth century. Why, then, did matters come to a head in the early 1830s? The general election of 1831 brought about a change of government, with the reforming **Whigs** having a clear, and probably absolute, majority in the House of Commons. This, combined with a general consensus among the propertied classes that something had to be done about the escalating costs of maintaining the poor, pushed a willing government into action.

Whigs One of the two main political parties in Britain between the late-seventeenth and mid-nineteenth centuries, they were traditionally associated with political, religious and social reform. By the middle of the nineteenth century, Whigs had been absorbed into the new Liberal Party.

26 Poverty and Public Health, 1815–1948

In 1815 the Tory government tried to improve the situation. It introduced Corn Laws to protect British farmers. The new Corn Laws would not allow the import of foreign corn until the price of British corn reached 80 shillings a quarter. In this way the government hoped to hold the price of corn steady and so keep the price of bread steady, too. Since the landowners' profits would not fluctuate wildly, wages would also remain stable. That was the theory. In practice, many people resented the Corn Laws, which they believed kept the price of bread artificially high. There were riots and outbreaks of violence up and down the country.

Post-war distress meant that more people than ever before claimed relief and, to the horror of some observers, began to regard relief as a right. The crisis years were 1817 to 1819, when the problems experienced by returning soldiers, the continuing dislocation of trade and poor harvests resulted in expenditure on poor relief reaching an hitherto unimaginable £8m per year, somewhere between 12 and 13 shillings per head of population.

The situation was exacerbated by continuing radical protests which forced the government to suspend **Habeas Corpus,** pass a new Seditious Meetings Bill and introduce the **Six Acts,** confirmation of its policy of repression and the curtailing of individual liberties in the face of protest. Urban protest was matched, in the late 1820s and early 1830s, by rural discontent. In the **Swing riots** protesters burned ricks and smashed threshing machines. Effigies of Poor Law overseers were burned; others had their homes surrounded by chanting rioters. Clergymen, who were frequently magistrates involved in the administration of the Poor Law received similar treatment.

In the midst of all this, the 1817 Report of the Select Committee on the Poor Laws comprehensively condemned the evils of the Poor Law as being themselves the creators of poverty. While abolition might have seemed to some commentators to be the only way forward, no sensible government could go down that road at a time when distress was at its height and society seemed to many to be so unstable.

What were the pressures that brought about change?　25

society should, he argued, be so organised as to enable the greatest amount of happiness to be delivered to the greatest number of its people. He believed that this could be achieved if wages and prices found their true level in a free market and all state institutions, like the Poor Law, were centrally controlled to agreed standards.

Edwin Chadwick (1800–90) was the most fervent of Bentham's disciples and acted as his secretary in the years before his death in 1832. Chadwick developed Bentham's ideas in that he believed the able-bodied poor (a problem for all Poor Law reformers) should be kept in workhouses in conditions that were worse than those of the poorest 'free' labourer outside. In this way, only the genuinely desperate would ask for relief. The others would seek and find work outside the workhouse. This, combined with a centralised, controlling authority would reduce the poor rate, give relief only to the genuinely needy and ensure that the economy flourished by allowing wages and prices to find their true levels.

WHAT WERE THE PRESSURES FOR CHANGE?

During the wars with France (1793–1815), the difficulties of importing corn from Europe and a series of bad harvests enabled British farmers to profit by keeping their prices high. But high corn prices meant expensive bread. Even though there was plenty of work and wages were rising fast, the cost of food and other goods was rising even faster. More and more people were forced to ask for relief. The end of the wars brought no improvement. The harvests of 1813 and 1814 were good in England and on the continent. The ending of the blockade meant that cheap foreign corn could again be imported from Europe, which forced the English farmers to keep their prices low. They had wartime taxes to pay as well as large increases in the poor rate. Some, too, had interest to pay on loans to cover the cost of enclosure. Many went bankrupt, which meant unemployment for their labourers. Farmers who survived were forced to reduce the wages they paid to their workers. Those whom they employed were pushed closer to pauperism. The already creaking Poor Law was close to collapse.

made the situation worse because the poor would have more and more children so that they could claim more and more relief. He favoured the abolition of the Poor Law altogether. The poor would then keep their families small because there would be no financial advantage to them in having a lot of children; wages would rise because the poor rate would no longer be levied and employers could afford to pay more; everyone would prosper.

David Ricardo (1772–1823) was a political economist who reached the same conclusions as Malthus about the Poor Law, but by a slightly different route. In his *Principles of Political Economy* (1817) he put forward the idea of a 'wages fund' from which money for wages and poor relief was paid. It therefore followed that, the more was paid out in poor relief, the less was available for wages. Because less money was available for wages, more and more people were being drawn into pauperism, thus draining the wage fund still more. The only way to break out of this cycle was to abolish the Poor Law altogether.

Not all theorists favoured abolition!

Tom Paine (1737–1809) was a writer and republican who criticised the Poor Law because it was so inadequate. He proposed a property tax on the very rich to be used for a variety of support systems for the poor, among these being family allowances and old age pensions. He, like others, had a problem with the able-bodied poor and implied that they had to go into workhouses before they could receive relief.

Robert Owen (1771–1858) was a radical factory owner who blamed the capitalist economic system for creating poverty. He suggested that, if workers were employed in co-operative communities, everyone would share in the profits of whatever organisation they worked for. In this way, the harder they worked the greater would be their income and they would have no need for poor relief. Care would only need to be taken of the impotent poor.

Jeremy Bentham (1748–1832) was a philosopher and lawyer who developed the theory of **Utilitarianism**. Any

HEINEMANN ADVANCED HISTORY

CHAPTER 3

What were the pressures that brought about change?

By the beginning of the nineteenth century, many people were coming to believe that the Poor Law was ceasing to cope with the growing and very different demands upon them caused by a mobile and increasingly industrialised population. This belief was overshadowed, and possibly exaggerated, by the pressures placed on the Poor Law by the Napoleonic wars. Indeed, many of the attacks on the Poor Law were made against systems of relief that were introduced and applied as emergency measures during this time of war and blockade. However, the belief that reform was necessary was bolstered by the views of economists and political theorists who urged different 'solutions' to the problem of the poor. Reform was supported, too, by all those who viewed with delight the prospect of lower poor rates. Governments, aware of the growing pressures for change, instituted a series of enquiries, the most influential of which was the 1832 Commission of Enquiry into the Poor Laws. It was the report from this Commission which resulted in the 1834 Poor Law Amendment Act.

WHICH WERE THE MOST PERSUASIVE CONTEMPORARY THEORIES?

Reports from government commissions were not the only publications to suggest alternative ways of providing for the poor and needy. Philosophers, commentators, political theorists and economists all had views which they made known. Others adopted them as they thought fit and as they fitted in with their own perceptions of what should happen.

Thomas Malthus (1766–1834) was an economist specialising in demography – the study of population. He argued that population had an inbuilt propensity to rise and outstrip all available food supplies. The Poor Law

The Speenhamland system and its variations were widely adopted in the south and east of Britain at the beginning of the nineteenth century. It was rarely, if ever, used in the north. However, the system was never given statutory backing and it was often abandoned or modified out of all recognition as overseers struggled to cope with changing economic conditions, particularly after 1815.

The Labour Rate was a different way of providing relief. Overseers levied a parish rate to cover the relief of the able-bodied poor and then set a wage for each unemployed labourer. Ratepayers could choose to employ these labourers at the set wage or pay the parish rate. If a ratepayer paid out less in wages than his assessed parish rate, then he had to make up the difference. The popularity of this system is not clear, but it does seem that, by 1832, about one parish in five was operating some sort of Labour Rate.

The Roundsman system was a common variant on the Labour Rate. Here, able-bodied pauper labourers were employed in turn by parish ratepayers. The ratepayers paid part of their wages and the parish the rest.

SUMMARY QUESTIONS

The purpose of this section is to enable you to consolidate your thinking and understanding about the 'old Poor Law' and the ways in which it worked.

1 How were the principles underpinning the Elizabethan Poor Law of 1601 maintained through to the early years of the nineteenth century?

2 What do you consider to have been the strengths and weaknesses of using the parish as the unit of administration for the old Poor Law?

3 What had the different systems of outdoor relief in common?

The Speenhamland system

Price of a gallon loaf	Single man's income should be	Single woman's income should be	Man and wife's income should be	With one child	With two children
1s 0d	3s 0d	2s 0d	4s 6d	6s 0d	7s 6d
1s 2d	3s 6d	2s 2d	5s 2d	6s 10d	8s 6d
1s 4d	4s 0d	2s 4d	5s 10d	7s 8d	9s 6d
1s 6d	4s 3d	2s 6d	6s 3d	8s 3d	10s 3d
1s 8d	4s 6d	2s 8d	6s 8d	8s 10d	11s 0d
1s 10d	4s 9d	2s 10d	7s 1d	9s 5d	11s 9d

magistrates at Speenhamland in Berkshire. It was a way of providing relief by subsidising low wages and, as such, it was not new. What was new about it was that it established a formal relationship between the price of bread and the number of dependants in a family. This way of subsidising low wages became known as the 'Speenhamland system' and many parishes adopted it.

Parishes did not always give relief in cash. Newton Valance (Hampshire), for example, made up the wages of the parish poor by giving them flour. Some parishes took each child into consideration, while others did not increase the relief given until there were more than a certain number of children in a family.

Variation of the Speenhamland system

This simple sliding scale of subsidies is from the parish of Winfarthing (Norfolk): it provides a basic, flat rate allowance to each labourer which increases according to the size of the family.

Number in family	Allowance in the summer	Allowance in the winter
3	1s 9d	2s 4d
4	2s 4d	2s 8d
5	2s 11d	3s 4d
6	3s 6d	4s
7	4s 1d	4s 6d
8	4s 8d	8s 4d
9	5s 3d	6s
10	5s 10d	6s 8d

work for paupers and a place of deterrent, and by 1776 there were some 2000 workhouses providing around 90,000 places. Even so, outdoor relief remained the most common way of giving help to the poor.

In an attempt to combat the financial burden of relieving the poor in their own homes, Gilbert's Act of 1782 was intended to promote poorhouses as 'indoor' alternatives. It allowed parishes to join together, if they wished, for the purpose of supporting a poorhouse, and in doing so enabled the cost of maintaining the poorhouse to be shared between the parishes concerned. By 1834 over 900 parishes had joined together in some 67 unions, most of which employed a paid relieving officer. These poorhouses, however, were for the impotent poor – those who could not work. Parishes continued to provide outdoor relief for most of their able-bodied poor.

Outdoor relief

Parishes continued to provide outdoor relief for their able-bodied poor largely because it was easy to administer and could be applied flexibly. Families might, for example, have sudden and urgent calls upon their funds at a time when the principal breadwinner was ill; cyclical unemployment might cause only short-term distress and long-term provision of relief in a poorhouse or a workhouse would not be appropriate.

Inevitably, different parishes worked out different systems of outdoor relief which they had operated on an ad hoc basis since 1601. These were geared to a pre-industrial economy and were, more or less, effective. However, from about 1750 industrialisation and a growing, mobile population began to test to the limits the ingenuity of magistrates and vestries in devising effective ways of meeting the needs of the able-bodied poor. In the last years of the century, a series of bad harvests coupled with the stresses and strains of the **Napoleonic wars** brought the Poor Law almost to breaking point. Central government could not, or would not, provide any answers and it was the parishes themselves that had to find solutions to the crisis.

The Speenhamland system was introduced in 1795 by

KEY EVENT

Napoleonic wars A series of wars fought by different combinations of European states against revolutionary France and the French armies led by Napoleon. The wars were fought 1792–7, 1798–1801, 1805–7 and 1813–14. They ended at the Battle of Waterloo on 18 June 1815, when the forces of Prussia under Blücher and Britain under Wellington defeated the armies of Napoleon.

parish could be removed, if they were not working, within 40 days and the overseers considered they were likely to end up claiming poor relief. In practice, because of the cost of removing individuals to their own place of settlement, most people were left alone until they tried to claim relief. Then, removals were common.

Settlement legislation was tightened up in 1697, when strangers could be barred from entering a parish and finding work there unless they could produce a settlement certificate issued by their home parish which stated that they would be taken back and given relief there should they become needy.

The Settlement Laws were designed to control a migrant population and at the same time ensure that the burden of providing for the poor did not overwhelm some parishes. They were never applied consistently over time or from place to place. Hated and evaded by the poor and manipulated by administrators, they did not stop a mobile population creating the growing cities of the late eighteenth century.

Poorhouses, workhouses and houses of correction

The initial division of institutions for the giving of relief into 'poorhouses' for the impotent poor, 'workhouses' for the able-bodied poor and 'houses of correction' for the idle never really worked in practice. It simply was not cost effective to provide for paupers in this way, although some parishes tried out a variety of experimental approaches. The city of Bristol, for example, gained a private Act of Parliament in 1696 which allowed the city parishes to combine to create a 'manufactory', where the profits made from the paupers' work were ploughed back into the system for their maintenance. The aim was to make poor relief self-supporting. Obviously, parishes needed to combine before they could embark upon this sort of undertaking, and the Workhouse or General Act of 1722–3 encouraged them to do this without having to go to the expense of a private Act of Parliament. Under this Act, parishes could apply the **workhouse test** and make admission to their workhouse a condition of gaining relief. The workhouse was gradually becoming both a place of

Workhouse test Any able-bodied poor people applying for relief should be required to enter a workhouse where their lives would be regulated and their conditions less comfortable than those outside. This was itself a self-selecting test of destitution. Only the genuinely needy (and, some would say, desperate) would accept relief on these terms.

throughout the country by the beginning of the nineteenth century.

It can be argued that, because the administration of relief was based on an administrative unit as small as a parish, greater humanity and sensitivity could be shown to the poor and needy, because those seeking relief and those dispensing it would be known to each other. Local people would be better able to distinguish the deserving from the undeserving poor. On the other hand, the opportunities for tyrannical behaviour on the part of local overseers were manifold; and local class relationships and the habit of deference tended to prevail. Furthermore, any local crisis such as a poor harvest could place an almost intolerable burden on locally raised finances.

The importance of settlement

Each parish in England and Wales was to be responsible for its 'own' poor. But there were problems here of definition. Was a parish to be responsible for all the individuals who had been born within its boundaries, no matter how far they had travelled since? Or was a parish to be responsible for those who were currently living and/or working there, no matter how brief their sojourn? Elizabethan law stated that a person claiming relief had to be returned to the place of his or her birth in order to receive it; or, if the place of birth was not known, to a place where he or she had lived for a year or more, or to the last parish through which the person had passed without getting into trouble. This gave rise to an immense amount of squabbling, prevaricating and litigation between parish overseers, anxious to keep the poor rate as low as possible, as they struggled to stop paupers from becoming a charge on their particular parish. Local vestry minutes frequently recorded the fortunes of pauper families as they were shunted back and forth across parish boundaries.

KEY CONCEPT

Settlement The legal requirement of a particular parish to take responsibility for providing relief to specific, named individuals.

The Settlement Law of 1662 tried to clarify matters. After this date, legal **settlement** was by birth, marriage, apprenticeship or inheritance. So, for any one individual claiming relief, the responsible parish could be the one in which the person was born, married, served an apprenticeship or inherited property. Strangers staying in a

treated as vagrants and were punished as such with beatings, whippings and imprisonment. If they wanted any sort of help, they had to work for it. In 1576 local JPs were instructed to provide materials with which the able-bodied poor could work in return for relief. This was to be the basis of state assistance to the able-bodied poor for centuries to come.

WHAT WAS THE ELIZABETHAN POOR LAW?

The Elizabethan Poor Law of 1601, often referred to as the 43rd Elizabeth, was an important step away from earlier Tudor and medieval Poor Laws. It abandoned the more obvious sorts of repression in favour of 'assistance' and 'correction'. The impotent poor – the sick, old, infirm and mentally ill – were to be looked after in poorhouses or almshouses. The able-bodied poor who wanted relief were to be set to work in a 'workhouse' while they continued to live at home. Those who refused work and continued a life of begging and general vagrancy were to be punished in a 'house of correction'. Pauper children were to be apprenticed to a trade so that they could support themselves when they grew up. It all seemed so simple and straightforward. But was it?

Reliance on the parish

The basis of the administration of the Elizabethan Poor Law lay in the **parish** as a unit of government with unpaid, non-professional administrators. It was not until the mid- to late-eighteenth century that rapidly growing towns began to employ paid officials. Each parish was to administer relief to its own poor. Local magistrates appointed local overseers, who were empowered to levy a **poor rate** on property in the parish and use the money for the relief of the parish poor.

By embedding the administration of the Poor Law in the 1500 or so parishes in England and Wales, the Elizabethan legislators had ensured that local needs would be met appropriately. However, they had also laid the foundations for the immense diversity in practice, and therefore in fairness and in effectiveness, that was to be found

CHAPTER 2

How effective was the old Poor Law?

The 'old Poor Law' was not one law but a collection of laws that Parliament had passed between the end of the sixteenth century and the end of the eighteenth century. These were, in turn, based upon medieval and early Tudor Poor Laws. Overlaying central legislation was a host of rules and regulations agreed by a range of different local authorities throughout the country. This ragbag of laws, rules and regulations was driven by the assumption that the Elizabethan Poor Law provided the philosophical and practical basis for providing assistance to the needy. Indeed, there were no new ideas in Poor Law legislation between 1601 and 1834.

HOW DID MEDIEVAL AND EARLY TUDOR LAW TREAT THE POOR?

The medieval laws sought to prevent a specific type of **vagrancy**: labourers wandering the countryside in search of work. Images of bands of the disaffected unemployed, roaming between isolated villages, hamlets and farmsteads, struck fear into the hearts of otherwise worthy citizens who regarded these vagabonds as a threat to law and order. Thus, vagrancy, itself usually a product of poverty, was punished with whippings and the stocks.

The early Tudors adopted a slightly more constructive approach. In 1536 parishes were authorised to collect money in order to support the impotent poor (those who could not work) and so reduced the number of those obliged to beg. While the motivation for this approach can be seen as humanitarian, it was also prompted by a concern for social stability. The able-bodied poor presented problems. These people were clearly able to work and yet were not, for a variety of reasons, doing so. Early Tudor legislation took a hard line: the able-bodied poor were

4 Which measure of poverty, Dr Edward Smith's level of nutrition or Seebohm Rowntree's level of family income, gives the most useful guide when trying to determine the amount of poverty in nineteenth- and early twentieth-century Britain?

5 How reliable is the source material in this section as evidence of poverty in Britain in the nineteenth and early twentieth centuries?

6 What evidence can you find in the source material of primary and secondary poverty?

In his book *People of the Abyss*, Jack London paints a vivid picture of life among the poor in London before the First World War. In this extract, he explains just how tight were many families' budgets:

. . . there is no surplus. Does the man buy a glass of beer, the family must eat that much less; and in so far as it eats less, just that far will it impair its physical efficiency. The members of this family cannot ride in buses or trams, cannot write letters, take outings, go to social or benefit clubs, nor can they buy sweetmeats, tobacco, books or newspapers. And further, should one child require a pair of shoes, the family must strike meat for a week from its bill of fare.

This was echoing what Seebohm Rowntree had found in York. A family living on his poverty line could:

never go into the country unless they walk. They must never purchase a halfpenny newspaper or spend a penny to buy a ticket for a popular concert. They must write no letters to absent children, for they cannot afford to pay the postage. They must never contribute anything to their church or chapel, or give help to a neighbour which costs them money. They cannot save, nor can they join a sick club or Trade Union, because they cannot afford the contributions. The children must have no pocket money for dolls, marbles or sweets. The father must smoke no tobacco and must drink no beer. The mother must never buy any pretty clothes for herself or her children. Should a child die, it must be buried by the parish. Finally, the wage earner must never be absent from his work for a single day.

SUMMARY QUESTIONS

The purpose of this section is to enable you to consolidate your thinking and understanding about the nature of poverty and the lives of poor people in the nineteenth century and early years of the twentieth century.

1 Do you find Henry Mayhew's attempt to classify the poor more or less convincing than that of William Booth?

2 What are the inherent problems in categorising the poor as 'deserving' or 'undeserving'?

3 How helpful do you find the concept of a 'poverty line'?

Pound a Week. Below is the weekly budget of a Mr A., whose house was visited by members of the Fabian Women's Group between January 1911 and February 1912. He was a railway-carriage washer and was paid 18s for a six-day week alternately with 21s for a seven-day week. The Women's Group commented 'his wife was a good manager, but was in delicate health. He was an extraordinarily good husband, and brought home to her his entire wage. There were three children born and three alive.'

Budget of a railway-carriage washer, earning 21s a week, with a wife and three children, 1910–11

	s	d
Rent	7	0
Clothing club (2 wks)	1	2
Burial insurance (2 wks)	1	6
Coal and wood	1	7
Coke		3
Gas		10
Soap, soda		5
Matches		1
Blacklead, blacking		1
11 loaves	2	7
1 qtr flour		$5^{1}/_{2}$
Meat	1	10
Potatoes and greens		$9^{1}/_{2}$
$^{1}/_{2}$ lb butter		6
1lb jam		3
6ozs tea		6
1 tin milk		4
Cocoa		4
Suet		2

Poor nutrition meant that families were prone to infection. Influenza, measles and scarlet fever were all killers among the poor in the nineteenth and early twentieth centuries. Diphtheria, tuberculosis and typhus were common. This was compounded by poor-quality housing where people lived in crowded, damp conditions lacking basic amenities. This is looked at in detail in the AS section: Public Health, 1815–75.

Translated into modern terms, Smith calculated that the minimum subsistence level for an adult was roughly 2760 kilocalories and 70g of protein a day. Modern nutritionists suggest that the calorific intake was sufficiently low to affect growth and physical output. Given that the bulk of the energy-providing foods went to the man who was the main wage earner for the family, the protein intake was certainly inadequate for pregnant and nursing mothers, and for growing children and adolescents. Most labourers spent their days in a state of chronic tiredness bordering on exhaustion.

In 1901 Rowntree was collecting weekly budgets and menus from the poor of York. He was unable to obtain detailed budgets from the 'really poor' – those earning under 18s a week. However, by considering the budget and daily menus of a carter, with a wife and two children, who earned 20s a week, it is possible to work out that someone earning less and with, say, a larger family, would be able to buy little more than bread, tea, potatoes and margarine.

Menus collected by Rowntree in York, 1901

	Breakfast	Dinner	Tea	Supper
Friday	Bread, butter, tea	Bread, butter, toast, tea	Bread, butter, tea	
Saturday	Bread, bacon, coffee	Bacon, potatoes, pudding, tea	Bread, butter, shortcake	Tea, bread, kippers
Sunday	Bread, butter, shortcake, coffee	Pork, onions, potatoes, Yorkshire pudding	Bread, butter, shortcake, tea	Bread and meat
Monday	Bread, bacon, butter, tea	Pork, potatoes, pudding, tea	Bread, butter, tea	One cup of tea
Tuesday	Bread, bacon, butter, coffee	Pork, bread, tea	Bread, butter, boiled eggs, tea	Bread, bacon, butter, tea
Wednesday	Bread, bacon, butter, tea	Bacon, eggs, potatoes, bread, tea	Bread, butter, tea	
Thursday	Bread, butter, coffee	Bread, bacon, tea	Bread, butter, tea	

Between 1909 and 1913, the Fabian Women's Group recorded the daily budgets of 30 families in Lambeth, east London. In 1913 these were published in *Round about a*

in 1863. His enquiry covered some 370 families of 'the poorer labouring classes' and included farm labourers and certain badly paid domestic trades like silk weavers and needlewomen. Smith, unlike Booth and Rowntree who came after him, based his conclusions on the nutritional value of the food that was eaten, not on the wage going into a house. He found that bread was the principal food consumed (12¼lbs per adult per week) followed by potatoes (6lbs per adult per week). Comparatively little milk, cheese and eggs were consumed by farm labourers and their families. It may have been that farmers preferred to sell their dairy products in bulk to nearby towns rather than in small amounts to local workers.

Typical examples of the daily meals eaten by families in Smith's sample

DEVON	(Case 135)
Breakfast and supper	Tea-kettle broth, bread and treacle.
Dinner	Pudding, vegetables and fresh meat.
	(Case 163)
Breakfast	Wife has tea, bread and butter; husband has tea-kettle broth with dripping or butter added, and with or without milk, also bread, treacle or cheese.
Dinner	Fried bacon and vegetables or bacon pie with potatoes and bread.
Supper	Tea, or milk and water, with bread, cheese and butter.
LINCOLNSHIRE	(Case 248)
Breakfast	Milk gruel, or bread and water or tea and bread.
Dinner	Meat for husband only; others, vegetables.
Tea and supper	Bread and potatoes.
CUMBERLAND	(Case 301)
Breakfast	Husband has oatmeal and milk porridge; others have tea, bread, butter and cheese.
Dinner	Meat and potatoes daily, bread, cheese and milk.
Supper	Boiled milk, tea, bread, butter and cheese.

(Tea-kettle broth = bread, hot water, salt and milk. Pudding = flour, salt and water.)

support only if they entered a parish poorhouse or workhouse. Whether or not individuals received indoor or outdoor relief depended very much on their own circumstances: whether, for example, they were forced to ask for relief because they were old and infirm, sick or simply unable to find work, and on the attitude of parish officials to the giving of relief and to those who received it.

Thousands of families drifted in and out of pauperism. The death of the main wage earner could plunge a whole family into long-term pauperism, from which it could only be retrieved by, say, remarriage or the older children becoming wage earners. In a similar way, for a family existing at or around subsistence level with little or no money put aside for emergencies, the illness of the main wage earner, or more generalised crises like an economic depression, could force a family to ask for short-term relief.

THE EXPERIENCE OF POVERTY: WHAT WAS IT LIKE TO BE POOR?

Between the early 1830s and 1914, there was very little inflation in Britain. It is therefore possible to compare such things as individual family budgets and diets across the whole period. Such comparisons must, however, be treated with some caution. A direct comparison may conceal regional variations in, for example, rents or the price of firewood. 'Meat' in a weekly diet sheet may mean good butcher's meat, the scrapings off a carcass or an illegally poached rabbit. Much, too, would depend on whether a family could keep its own pig or grow its own vegetables.

It is, however, clear that most investigators agreed on the weekly cash income necessary for survival and this held good throughout the period. At the turn of the century, Rowntree settled for 21s 8d for a family of two adults and three children, and few would have disagreed with him. However, over 30 years earlier, Dr Edward Smith was suggesting a 'minimum subsistence level' below which civilised life was not possible. Smith conducted the first national food survey on behalf of the Medical Officer of the Privy Council (Sir John Simon) and this was published

- Individualist solutions came from those who firmly believed that it was the responsibility of every individual to look after his or her own welfare. Support, when it was given, should be minimal and aimed at getting the people concerned back on their feet so that they would become self-supporting as soon as possible. This, indeed, was the basis of the nineteenth-century doctrine of 'self-help'.

Changing attitudes to poverty

Nineteenth century	Early twentieth century
Poverty not seen as a problem but a fact of life. Less concern with its measurement than with defining and limiting an area of legitimate concern.	Poverty seen as a problem which could be solved. Defined as failure to reach an accepted minimum standard of living.
Use of anecdotal, qualitative material to support previously held beliefs about poverty.	Use of quantitative measurement and analysis to define poverty.
Emphasis placed on an individual's character and lifestyle in bringing about poverty. The poor are poor through their own fault.	Emphasis on social and environmental factors in causing poverty. The poor are poor through no fault of their own.
Emphasis on the role of less expensive, voluntary action.	Emphasis on increasingly expensive intervention by the state.
Evaluation of all forms of administrative activity by the tendency they had to reform.	Evaluation of all forms of administrative activity by the tendency they had to cure.

WHO WERE THE PAUPERS?

To be poor was not necessarily to be a **pauper**, but all paupers were, by definition, poor. Paupers were all those people who could not support themselves and their families at a level generally acceptable to society, and so were given **relief**. This relief could be 'outdoor' and come in the form of food, clothing or grants of money from the pauper's parish, enabling the pauper to stay in his or her own home and be supported there. Relief could, on the other hand, be 'indoor', whereby paupers were given

Pauper An individual in receipt of poor relief.

Relief Support given to paupers to enable them to maintain a basic standard of living. This relief could be 'outdoor' (in their own homes) or 'indoor' (in a workhouse or poorhouse).

of some sort of perceived moral failure like drunkenness or prostitution. While they would be kept from starvation, any help directed toward this group would have to contain within it elements of both punishment and improvement. One of the main reasons, then, for trying to categorise the poor in the nineteenth century was to determine those who were deserving of help and those who were not.

The great fear, of course, was that if too much help was provided for the undeserving poor they would see no reason to look for work. Worse, the deserving poor might see the attractions of an idle life with adequate support and be attracted into immoral, jobless living. The army of the undeserving poor would grow and fewer and fewer poor people would be leading responsible and independent lives.

Some kind of balance was required. A system was needed that would adequately support the genuinely needy while at the same time deterring the feckless and the work-shy from using it as a permanent solution to their needs.

Societies can give support to their needy in several ways:

- Welfare solutions provided by government are called 'collectivist'. Schemes organised by central government are less likely to break down than other sorts of initiatives, and have the backing of law. On the other hand, they tend to be impersonal and cannot always adapt successfully to local needs and conditions. In the nineteenth and early twentieth centuries, a combination of central and local collectivist schemes was used. After 1834 the Poor Law provided a national system of welfare controlled from London. However, the money to run the system was levied locally in the parishes; unions of parishes built workhouses that were run and staffed by local people.
- Collectivist solutions were also provided by non-governmental organisations. From the 1830s co-operative societies, friendly societies and trades unions all gave support to their members. But there was usually a joining fee or subscription to pay and many collapsed after a few years, usually because of financial difficulties.

poverty line and remained there until their children began to earn. After a period of relative prosperity when their children were grown, couples fell below the poverty line again when they were old and could no longer work.

In the twentieth century some researchers began talking and writing about poverty as being relative. By this they meant that **poverty was relative** to the society in which a person lived. Thus, a family living in, say, Victorian London – with a roof over their heads and dry bread in their stomachs – would not be considered poor in the port area of nineteenth-century Calcutta.

WHY WAS THERE SUCH AN INTEREST IN CATEGORISING THE POOR?

Poverty was regarded by many nineteenth-century social writers and reformers as being both inevitable and necessary. It was fear of poverty, writers like Patrick Colquhoun argued in 1806, that drove people to work:

Without poverty there would be no labour, and without labour there could be no riches.

What was wrong, however, was 'indigence', the inability of individuals to support themselves:

The natural source of subsistence is the labour of the individual; while that remains with him he is denominated poor; when it fails in whole or in part, he becomes indigent.

It was this desire to force the poor to stand on their own feet and participate in a healthy economy that drove much of the thinking behind legislation for and about the poor.

In the nineteenth and early twentieth centuries, social commentators and legislators were greatly concerned with establishing and quantifying the links between poverty and what they saw as morality. The poor, they saw as either being deserving of help or not. The 'deserving poor' were those who were poor through no fault of their own and were therefore deemed worthy of help and support. The 'undeserving poor' were those whose poverty was the result

<div style="float:right">

KEY TERM

Relative poverty People living in relative poverty have a standard of living below that which is generally acceptable to the society in which they live. As the general standard of living rises or falls, so does the standard of living of those in relative poverty. Their standard is 'relative' to that of the society in which they live.

</div>

poverty line: they lacked the money to buy reasonable food, shelter and clothing. Perhaps more significantly, he tried to sort out the causes of poverty. He determined that 85 per cent of those living in poverty were poor because of problems relating to employment: unemployment, short-time working or low pay.

Benjamin Seebohm Rowntree (usually referred to as Seebohm Rowntree) hoped to build on Booth's work by investigating poverty in York. He also hoped to give more precision to Booth's poverty line. Rowntree's findings were published in 1901. He found that around 28 per cent of the population of York were living 'in obvious want and squalor'. He calculated, too, that the minimum income required by a family of five simply to exist was 21s 8d. This was Rowntree's poverty line.

To live below the poverty line was to live in **primary poverty** and 10 per cent of York's population did just this. The total earnings of these families, Rowntree argued, 'were insufficient to obtain the minimum necessaries for the maintenance of mere physical efficiency'. These families didn't stand a chance.

Rowntree then categorised 'those families whose earnings would have been sufficient for the maintenance of mere physical efficiency were it not that some portion of it was absorbed by other expenditure'. These families were living on the edge. Their poverty Rowntree defined as **secondary poverty**. Rowntree began, too, to uncover a 'poverty cycle'. He found that childhood was a time of poverty; conditions improved when the children grew and became wage earners and continued into their early married years. As soon as children were born, couples slipped below the

Rowntree's poverty line and poverty cycle, from S. Rowntree, 'Poverty, a Study of Town Life', 1901.

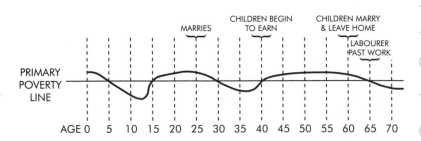

and diseases like pneumonia, tuberculosis, bronchitis and arthritis. The elderly, with neither the strength nor the health to work, formed Mayhew's final category. In an age with no state or occupational pensions, the childless elderly faced a desperate old age.

'Those who will not work'. In every society and at all times there are people who choose not to work. It was no different in Mayhew's time. Beggars and vagrants (Mayhew noted they were nearly always men and boys) were a common sight. He calculated that there were between 40,000 and 100,000 destitute men and boys tramping the roads and begging where they could.

William Booth, who founded the Salvation Army in 1865, defined poverty and the poor slightly differently. He thought of three 'circles of poverty' that nested within each other. At the centre were those people who existed by living a life of crime; in the second circle were people who lived by vice; and in the outer, larger circle were the 'starving and homeless, but honest, Poor'. Beyond Booth's outer circle were all those skilled workers in permanent employment, who could usually put a little money aside for emergencies and for their old age. But even these people could be hit by problems and disasters beyond their control. Hand-loom weavers, for example, once the élite of the textile industry, were forced into destitution by the introduction of mechanisation.

By the beginning of the twentieth century, more quantitative, scientific surveys were being carried out. Charles Booth, a wealthy Liverpool shipowner who moved his firm's offices to London, refused to accept official statistics that about 25 per cent of the working population were living in poverty. He conducted his own investigations into the life and labour of London's poor between 1886 and 1903 and published his findings in seventeen volumes. Whilst these did concentrate on poverty, there were volumes on industry, employment and religion. What he found, on the basis of information received from 4000 people, was that the proportion of Londoners living in poverty was closer to 30.7 per cent than 25 per cent. These people lived below the

who, when the demand was there, could command a reasonable wage. Finally, there was the largest group of all: the labourers. In an age only just becoming mechanised, most of the lifting and blasting, reaping, mowing, carrying, sweeping and scrubbing had to be done by hand. This was casual work and readily available when times were good; virtually non-existent in times of slump.

In 1851 there were over 1 million outdoor agricultural labourers and nearly half a million indoor farm servants. Most were general labourers, expected to turn their hands to anything. Some, however, had more specialised skills, such as shepherding and cheesemaking. Agricultural labourers frequently had a 'tied' cottage that went with the job. While this might seem to provide security, loss of work meant the loss of a roof over the heads of the farm labourer's family. Thousands were, in this way, thrown into destitution annually.

General urban labourers were less of an homogenised group than, say, miners, navvies or farm labourers. Urban labourers included dockers, carters, sweepers and porters who were employed on a daily basis. These were among the most insecure of the able-bodied labouring poor.

'Those who cannot work'. Some of the able-bodied poor could not work because there simply was no work for them to do. In bad weather, house painters and bricklayers could not work. A failed cotton crop in the USA meant that millworkers in England were laid off. The skilled artisans could, possibly, have been able to save some money against bad times. But, in an age when there was no redundancy money and no unemployment benefit, most of the labouring poor had to do the best they could. Pawnbrokers flourished and corner shops gave credit but, when these possibilities were exhausted, many took to begging or were forced to ask the **overseers of the poor** for help.

There were other categories of people who could not work. Labouring work brought with it its own dangers, from working with unfenced machinery to living in cramped, wet conditions. Many labourers could not work because of smashed limbs, cracked skulls, broken backs, ripped scalps

KEY TERM

Overseers of the poor
Each year, every parish appointed one or two overseers of the poor who were approved by the local magistrates. These people were usually churchwardens or landowners. Overseers were responsible for administering poor relief in their parish. They levied a poor rate and supervised its distribution. Under the 1834 Poor Law Amendment Act, boards of guardians took over the work of the overseers, and where overseers did remain, their job was usually one of simply assessing and collecting the poor rate.

countryside, looking for work? Oliver Twist, asking for 'more' in Charles Dickens' portrayal of a Victorian workhouse? An old man, gratefully collecting his 'Lloyd George' pension from the local post office? Barefooted girls with matted hair and dirty dresses, playing hopscotch on the pavement outside their slum homes? All of these images would be correct for some of the time between 1815 and 1914 and in some towns, cities and villages. None of the images would be correct for all of the time and all places in Britain.

WHO WERE THE POOR?

In the nineteenth and early twentieth centuries, administrators, legislators, investigative journalists and social scientists used words and phrases like 'working class', 'lower orders', **'proletariat'** and 'labouring poor' to define a group of people of whose existence they were well aware but who somehow evaded precise definition.

In 1849 Henry Mayhew, an investigative journalist working for the *Morning Chronicle*, began a series called 'London Labour and the London Poor' which captured the imagination of the reading public. Although this series was primarily concerned with London, Mayhew did place his findings for London in a wider national context. The point about Mayhew was that he visited the homes and workplaces of the poor and wrote about what he saw and heard and smelled and felt. He was, too, interested in classification. He divided the 'labouring poor', whose lives he was investigating, into 'Those who will work, those who cannot work and those who will not work.'

'Those who will work'. These were the able-bodied poor, who undertook an enormous range and variety of jobs. The élite of this group, Mayhew found, were the skilled artisans. These ranged from the cabinetmakers and jewellers of London to the machine-tool engineers and textile-mill overlookers in the Midlands and north. They were manual workers but they had specific skills which they could sell. Similarly, there were craftsmen like masons and bricklayers, mule spinners, weavers and ironworkers

AS SECTION: POVERTY AND THE POOR LAW, 1815–1914

CHAPTER 1

Poverty and the poor: the nature of the problem

What does the phrase 'the poor' conjure up? Men and women – ragged clothes clutched around them, desperation in their eyes – queuing outside a workhouse? Barefooted crossing sweepers, flower sellers and boot boys holding out their grimy hands for a few pence to keep themselves from starvation on the streets of Britain's nineteenth-century towns? A dispossessed farm labourer and his family – pathetic possessions piled on a handcart – trudging the muddy lanes of the nineteenth-century

'Applicants for Admission to a Casual Ward', painted in 1874 by Sir Luke Fildes.

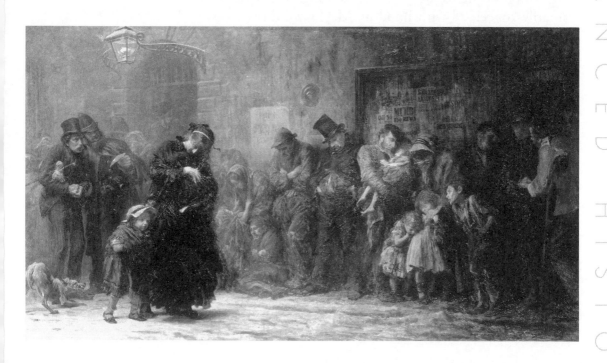

HOW TO USE THIS BOOK

This book is divided into three distinct sections. The AS sections 'Poverty and the Poor Law, 1815–1914' and 'Public Health, 1815–75' are similar in style. Both describe and explain the importance of social and economic changes in Britain relating to the understanding and treatment of the problems of poverty and public health. The text of this explained narrative gives the student in-depth information and some basic analysis. The summary questions at the end of each chapter will challenge the student to use the information in the chapter to explain, evaluate and analyse important aspects of the topic covered by that chapter. In this way, students will acquire a clear understanding of the key features of each topic.

The A2 section 'Social Policy and Debate, 1815–1948' is more analytical in style. It focuses on the main theories surrounding the development of social policy at this time. Students who are intending to use this section should refer back to the relevant AS sections that will provide the factual underpinning to the debates.

At the end of each AS section, and at the end of the A2 section, there are Assessment sections. These have been based on the requirements of the new History AS level and A2 level specifications published by the three Awarding Bodies – AQA, Edexcel and OCR – and approved by the Qualifications and Curriculum Authority. There are exam-style source and essay questions for each specification, relating to the AS and A2 sections of this book. There is detailed guidance on how students might answer these questions.

The bibliography suggests the mainstream books for each section that students may wish to consult. It also gives a selection of documentary readings, together with suggestions as to appropriate contemporary accounts and relevant fiction that might be found interesting. Students are strongly advised to broaden their understanding by reading as widely as possible.

CONTENTS

Heinemann Educational Publishers
Halley Court, Jordan Hill, Oxford, OX2 8EJ
a division of Reed Educational & Professional Publishing Ltd
Heinemann is a registered trademark of Reed Educational & Professional
Publishing Ltd

OXFORD MELBOURNE AUCKLAND
JOHANNESBURG BLANTYRE GABORONE
IBADAN PORTSMOUTH NH (USA) CHICAGO

© Heinemann Educational Publishers 2001

First published 2001

ISBN 0 435 32715 1
02 01
10 9 8 7 6 5 4 3 2

Designed, illustrated and typeset by Wyvern 21 Ltd

Printed and bound in UK by Bath Press

Photographic acknowledgements
The author and publisher would like to thank the following for permission to
reproduce photographs: Bradford District Archives: 54, 55, 115; Bridgeman Art
Library: 1, 195; Cambridge & Country Folk Museum: 73; House of Commons
Library: 152; Hulton Getty: 39, 92, 117, 159, 218; Illustrated London News: 90,
137; Mansell Collection/Rex Features: 51; Mary Evans Picture Library: 67, 81,
129; Punch: 87, 95, 153, 165, 222; Tower Hamlets Local History and Archives:
72; Victoria and Albert Museum: 196; Wellcome Foundation: 128; Wellcome
Institute: 126; Worcestershire Record Office: 71

Cover photograph: Punch
Picture research by Thelma Gilbert

Written sources acknowledgements
The author and publisher gratefully acknowledge the following publications from
which written sources in the book are drawn. In some sentences the wording or
sentence has been simplified:
A. Briggs *Victorian Cities* (London 1963): 221; M. Flinn *Public Health Reform in
Britain* (New York 1968): 162; J. London *People of the Abyss* (Panther 1963): 13;
J. Martell *A History of Britain from 1867* (Thomas Nelson and Sons 1988): 219;
M.E. Rose *The Relief of Poverty 1834–1914* (Macmillan 1972): 99–100; S. Webb
and B. Webb *English Poor Law History* (Cass 1973): 198

Conversion chart for general reference:

£1 = 20 shillings (20s)	1kg = 2.2 pounds (2.2 lb)	1 litre = 1.76 pints
1s = 12 old pence (12d)	1lb = 16 ounces (16 oz)	1 pint = 20 fluid ounces (20 fl.oz)

Dedication
This book is dedicated, with love, to my grandmother Agnes Harriet
(1883–1967) who showed me what it was to fear the shadow of the workhouse.

Poverty and Public Health, 1815–1948

Rosemary Rees

Series Editors
Martin Collier
Erica Lewis
Rosemary Rees